安老為罪九

或用義由代

備儻勤精借

母日夏孝壽

養性怡情　乾隆珍寶

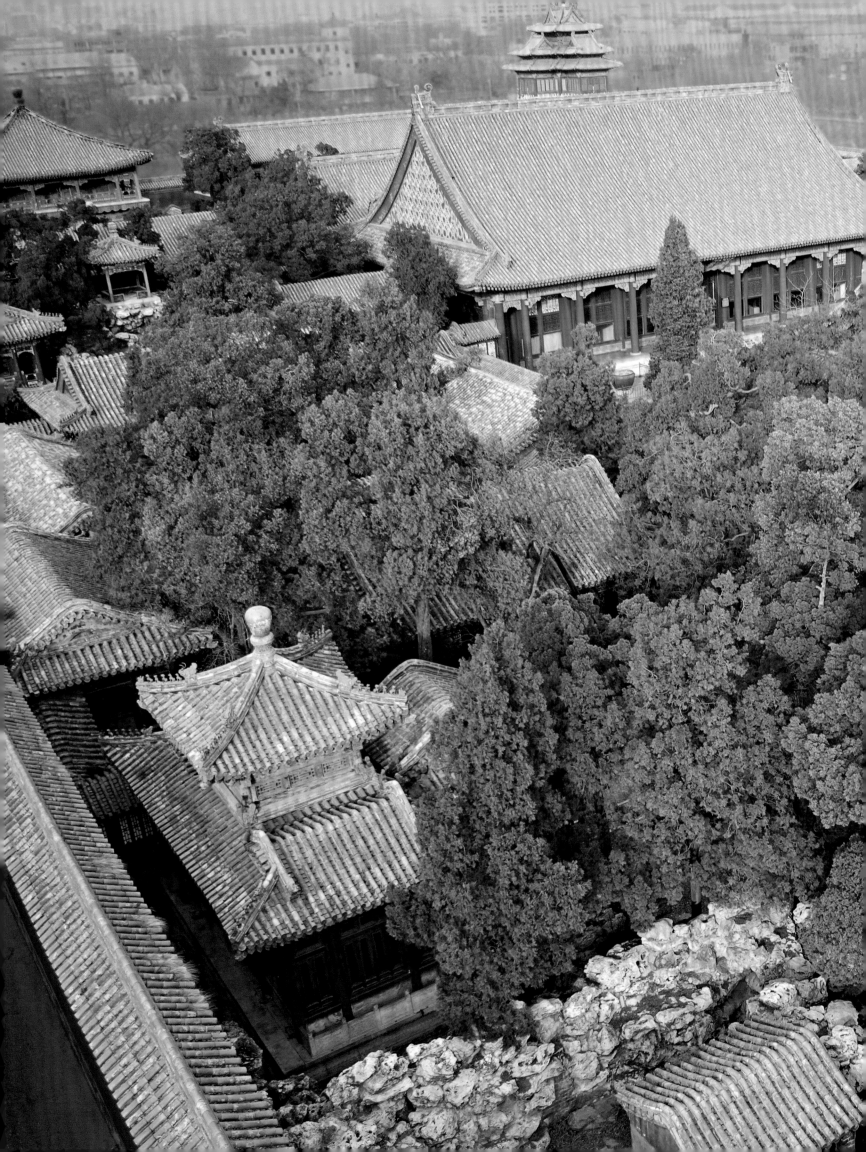

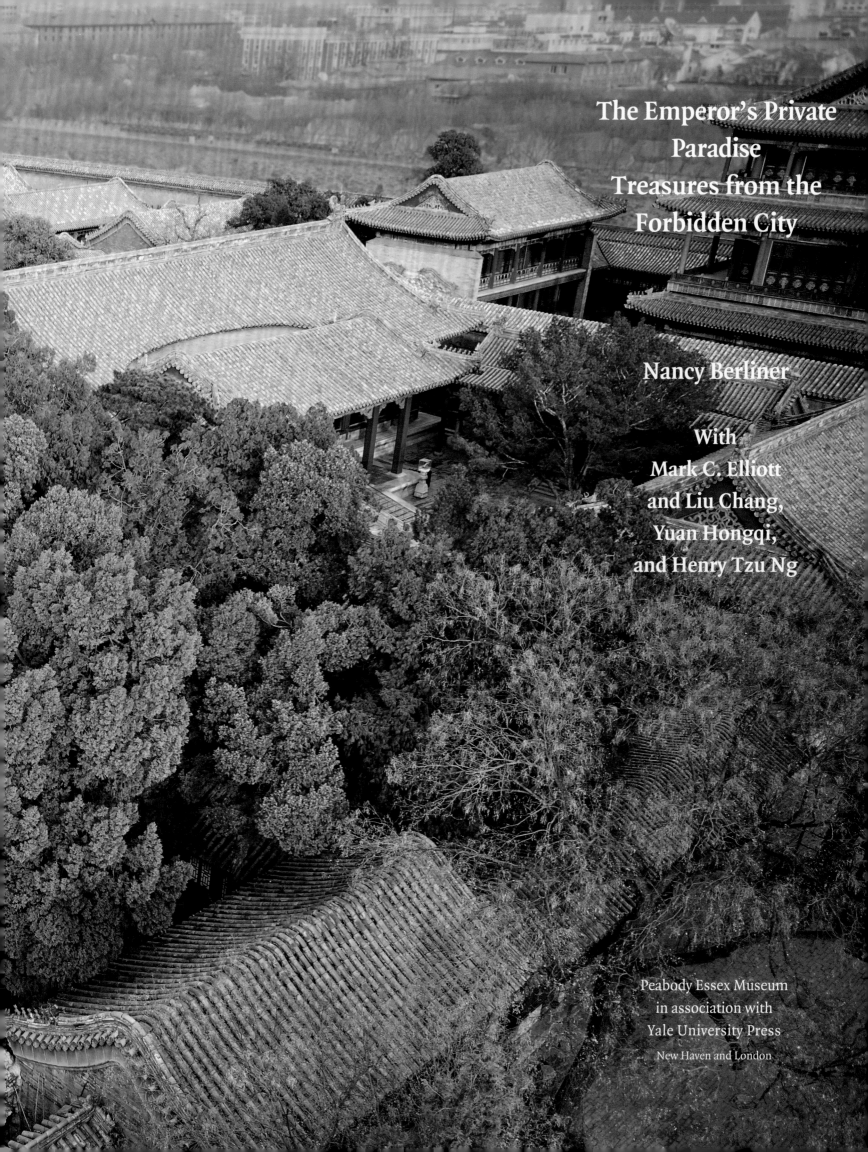

The Emperor's Private
Paradise
Treasures from the
Forbidden City

Nancy Berliner

With
Mark C. Elliott
and Liu Chang,
Yuan Hongqi,
and Henry Tzu Ng

Peabody Essex Museum
in association with
Yale University Press
New Haven and London

The Emperor's Private Paradise: Treasures from the Forbidden City accompanies the exhibition of the same name organized by the Peabody Essex Museum, Salem, Massachusetts, in partnership with the Palace Museum and in cooperation with the World Monuments Fund, on view from September 14, 2010 through January 9, 2011; and traveling to The Metropolitan Museum of Art, New York, from February 3, 2011 through May 1, 2011; and the Milwaukee Art Museum, from June 11, 2011 through September 12, 2011.

Peabody Essex Museum
East India Square
Salem, Massachusetts 01970
www.pem.org

Published in association with Yale University Press,
New Haven and London.

Yale University Press
302 Temple Street, P. O. Box 209040
New Haven, Connecticut 06520-9040
www.yalebooks.com

Library of Congress Control Number: 2010925513

ISBN: 978-0-87577-221-8 (Peabody Essex Museum, pbk)
ISBN: 978-0-300-16389-6 (Yale University Press, cloth)

MANDARIN ORIENTAL
THE HOTEL GROUP

AMERICAN EXPRESS

The exhibition and national tour are made possible in part by generous support from the Mandarin Oriental Hotel Group and American Express. Additional support has been provided by the E. Rhodes and Leona B. Carpenter Foundation, the National Endowment for the Arts, ECHO (Education through Cultural and Historical Organizations), and the East India Marine Associates (EIMA) of the Peabody Essex Museum.

NATIONAL
ENDOWMENT
FOR THE ARTS

EDUCATION THROUGH
CULTURAL AND
HISTORICAL
ORGANIZATIONS
ECHO ECHOSPACE.ORG

The Emperor's Private Paradise: Treasures from the Forbidden City introduces the public to an extraordinary site and an array of artworks that have been largely hidden for centuries. Deeply engaged by China, Doreen and Houghton Freeman have demonstrated intrepid vision and extraordinary generosity in their support of the efforts of the Palace Museum and World Monuments Fund to revitalize the Qianlong Garden for Chinese and international audiences alike.

Pages 11 and 13: Glazed roof tiles on a Ningshougong central axis building as viewed from Lutai.
Page 17: Glazed roof tiles viewed from Xiefangting.
Page 23: Glazed roof tiles of Fuwangge.
Pages 213–16: Entrance to Yanghe Jingshe from a rockery tunnel; decorative gateway into the second courtyard as seen from Guhuaxuan; winding pathway leading from the front entrance of the garden into the first courtyard.

Table of Contents

Foreword

A book is like a garden carried in the pocket.
proverb, author unidentified

Welcome to *The Emperor's Private Paradise: Treasures from the Forbidden City* – the first opportunity for an international audience to access a long closed, jewel-like cache of Chinese imperial art and culture. As with jewels, this exhibition and publication are multi-faceted, and several key facets merit reflection here.

The project encompasses the superlative artworks commissioned by the Qianlong emperor for what has become known as the Qianlong Garden. Reigning from 1736 to 1796, the Qianlong emperor moved China to its imperial zenith in terms of territory, wealth, military strength, and culture. Under his leadership, China's economy dwarfed those of England and France, and the Qianlong emperor controlled vastly greater territory than his key contemporaries – America's George Washington, England's Elizabeth I, France's Louis XIV, and Russia's Catherine the Great. That this ruler – from an ancient, vast, and geographically distant culture – is largely unknown today in the West is hardly surprising. Disparities in the perception of spheres of influence have long characterized the East and the West. Even in the 1700s, as these two realms began to take cautious stock of one another, Europe considered itself superior to the rest of the world, while China was comparably persuaded that it was the center of the world.

The Qianlong Garden and its artworks represent one of many monuments to the Qianlong emperor's power, wealth, and ingenuity. From his conception of the garden in 1771 to its completion in 1776, the emperor envisioned it as a very private enclave for his anticipated retirement within his aptly named Palace of Tranquility and Longevity, itself one of the several complexes that are part of the formidable and vast Forbidden City in Beijing. The Qianlong Garden encompasses twenty-seven buildings and numerous artworks within its two-acre site. It is a complex, constructed environment rather than a space devoted primarily to plantings, which the word "garden" typically conjures in the West. This very distinction highlights how art and culture are variously defined in different places and times and also underscores this project's fundamental challenge of interpreting artworks as a synthesis, rather than an illustration, of person, place, culture, and design.

The Qianlong Garden is a work-in-progress on many levels. Although the emperor built it for his anticipated retirement, he spent little time there once construction was completed. Closed since China's last emperor left the Forbidden City in 1924, it is now the beneficiary of intense restoration and conservation in preparation for opening to the public for the first time around 2019. This exhibition and publication are an unprecedented opportunity to share the garden's treasured artworks, which likely will never again travel outside China once this complex opens. The Qianlong emperor brought these works together to create a private, culturally explicit paradise resonant with connections between man and nature and among the arts of painting, poetry, calligraphy, architecture, and garden design. His deep understanding of Buddhist and Daoist beliefs and principles is also evident throughout. This thematic exhibition contextualizes the objects as expressions of these connections and presents them as compelling ambassadors of China's longstanding and reemerging richness.

The Qianlong emperor combined and displayed his passions as a scholar, patron, and collector to such a degree in this garden that he can readily be described as a masterful impresario and artistic director. In these roles, he venerated enduring values of Chinese art, culture, and philosophy, and also manifested an audacious openness to the new – represented especially by the Western painting techniques and imagery he encouraged in his many studios and workshops.

The artworks commissioned by the emperor for this private paradise shine. Gifted artists and crafts-people, their identities now largely unknown, designed, made, or built each element, from scrolls and murals to pavilions and theaters, from screens and furniture to rockeries and gateways. Their execution is exquisite and their materials, such as jade, bronze, and the precious wood *zitan*, are prized. Each work is a symbol of the excellence of traditional Chinese culture, expressed by individuals who understood art, architecture, and garden design as combinations of the sensuous and the cerebral, the spiritual and the esoteric. The forms they created embodied layers of meaning intended to incite discovery of a profound and ancient view of the world and man's place in it. Plays between symmetry and irregularity, subtlety and elaboration, naturalness and the re-created or artificial characterize many

of these objects, and this sense of balancing the complementary or opposite speaks to a sophisticated, metaphorical, and shared approach to creativity. Incorporating aspects of the ancient and contemporary, many of the works also reflect transformations in form, process, and ideas – a cornerstone of the emperor's visionary creativity. Ultimately, these treasures are a tribute to the potential and power of combining the old and new.

These art objects are also expressions of a whole, the Qianlong Garden, itself an artwork rather than simply a garden filled with art. The distinction is critical. Unlike the traditions of plantings, spreading lawns, and vistas that dominate Western garden design, Chinese gardens are conceived as cosmos that incorporate art, architecture, and natural elements within walled spaces. Both the composition and the experience of a Chinese garden are designed to be dense and cumulative, as spaces, views, activities, and natural and manmade details unfold in a succession of surprises and juxtapositions, all intended to inspire contemplation and appreciation of the harmony of the whole. Among the few relatively unaltered imperial gardens still existing in China today, the Qianlong Garden is also the most intimate of this emperor's numerous garden projects. Its highly confined, articulated elegance reflects his almost obsessive pursuit of this ideal harmony.

Just as the Qianlong emperor synthesized extraordinary creativity, collaboration, and expertise, so do this exhibition and publication. We are honored to have forged a historic partnership with the Palace Museum, Beijing, and the World Monuments Fund, New York, to bring this project to fruition. We extend our keen appreciation to Zheng Xinmiao, Director, the Palace Museum, and his staff for generously lending these artworks and providing us with unparalleled access to the Qianlong Garden and other resources of the Palace Museum. We thank Bonnie Burnham, President, and Henry Tzu Ng, Executive Vice President, of the World Monuments Fund for their gracious counsel and their organization's pioneering commitment to cultural and architectural preservation worldwide.

To Nancy Berliner, the Peabody Essex Museum's Curator of Chinese Art and the show's curator, we extend warm congratulations for sharing her deep knowledge of the Qianlong Garden and its relationship to Chinese imperial art and culture. Nancy's acknowledgments make clear the many contributions of the Peabody Essex Museum's staff, and we proudly commend them as well. We especially thank Josh Basseches, Deputy Director, Priscilla Danforth, Director of Exhibition Planning, Dave Seibert, exhibition designer, and Peggy Fogelman, former Director of Education and Interpretation at PEM and now The Frederick P. and Sandra P. Rose Chair of Education at The Metropolitan Museum of Art, for their seminal roles in working with us to implement the project's many interpretive and pragmatic facets. Additionally, we wish to recognize the exceptional talents of the book's editor, Terry Ann R. Neff, and Kathy Fredrickson and her design team at Studio Blue. We are honored to copublish this book with Yale University Press, and we express our great appreciation to Art and Architecture Publisher Patricia Fidler for guiding this partnership.

We also hasten to acknowledge the supporters who have made this project possible. The exhibition and national tour are made possible in part by generous support from the Mandarin Oriental Hotel Group and American Express. Additional support has been provided by the E. Rhodes and Leona B. Carpenter Foundation, the National Endowment for the Arts, and ECHO (Education through Cultural and Historical Organizations). To Thomas P. Campbell, Director, The Metropolitan Museum of Art, and to Daniel T. Keegan, Director, the Milwaukee Art Museum, we extend our appreciation for partnering with us as venues for this exhibition. It is immensely rewarding and indeed reassuring that such magnanimous support and collegiality have been forthcoming during difficult economic times.

To experience a Chinese garden firsthand is like navigating a magical landscape in which time and space seem limitless – as if a garden were a perennially unfinished artwork, to be consummated by individual visitors. We invite you now to embark on a journey of discovery and appreciation, led by these extraordinary artworks as they reveal superlative and rarely seen aspects of Chinese imperial art and culture.

Dan L. Monroe, *Executive Director and CEO*
Lynda Roscoe Hartigan, *The James B. and*
Mary Lou Hawkes Chief Curator
Peabody Essex Museum

The Palace Museum and the Qianlong Garden

The Palace Museum is intimately associated with the Forbidden City, which was built beginning in 1420. The museum was established on October 10, 1925, on the foundation of a palace of the Ming and Qing dynasties (the Forbidden City) and its collection of treasures. It is a large, comprehensive national museum that embraces the palatial architectural complex, ancient art, and imperial court history. The Forbidden City was designated by the State Council as a key national cultural heritage protection site in 1961 and in 1987 it was named a UNESCO World Cultural Heritage site. The Forbidden City boasts the largest and most intact ancient palatial architectural complex in both China and the world. The Palace Museum is dedicated to the conservation of its historic architecture, collections, and court history through archiving, research, and display so they may be enjoyed by people from all walks of life.

Much of the construction done in the Forbidden City during the Qing dynasty happened under the Qianlong emperor. The grandest project of that era took place in the Ningshougong district, and in this area of the complex the Qianlong Garden is the most distinguished.

The Qianlong emperor, one of the most remarkable of the Qing emperors, was also the longest living ruler in Chinese history. He prided himself on "The Ten Great Military Campaigns," yet at the same time he was highly accomplished in the realms of literature and politics. Although seeds of crisis remained hidden during his sixty years of governing, the country generally was stable and prosperous. His reign was a period during which Chinese society's politics, economy, and culture all underwent great advances.

When the Qianlong emperor assumed the throne at age twenty-four, he made a promise to retire should he succeed in completing a sixty-year cycle of service. At the most glorious period of his life, he began the construction of the Ningshougong district for his retirement. In its garden, the Qianlong Garden, the emperor replicated all the architecture he was most proud of and, in accordance with his vision, designed the dwelling where he would live after stepping down from the throne. He envisioned his retirement as a literati retreat, while also bestowing on the Qianlong Garden his desire to prolong his life. "Peace under heaven and longevity for all," and, as he said in one of his poems, "millions and millions of people should have millions and millions of years of longevity, and years of peace and security are to be valued like a life of peace and security." When the Qianlong emperor was eighty years old, he threw a banquet in the Huangjidian (Hall of Imperial Supremacy) in the Ningshougong for a thousand elderly citizens to celebrate the arrival of a time of peace and prosperity. Through the emperor's design, the Qianlong Garden espoused and projected Confucian culture everywhere, requesting longevity for all people in the nation and peace for the country. The architecture, interior decoration, and furniture in the garden are beautifully luxurious, plentiful, and elegant. These qualities embody the essence of Confucian culture and incorporate the Qianlong emperor's religious beliefs. Within the garden, there are places where one can make offerings to the Buddhist Western Paradise and contemplate the ideal of great peace and prosperity from the religious perspective.

Today, when we enter the garden, we not only pay homage to the life and times of the Qianlong emperor, but we also recognize the spirit of Chinese

culture. It is gratifying that the emperor not only oversaw a period of great prosperity, but also left for us this beautiful palace garden.

The objects exhibited in *The Emperor's Private Paradise: Treasures from The Forbidden City* are among the most beautiful that were originally in the northeast corner of the Forbidden City. It is the first time that the Palace Museum has authorized such a large-scale and comprehensive traveling exhibition of original historic cultural heritage objects and interiors. Included in the exhibition are many different types of art and artifacts, including paintings, calligraphy, porcelain, bronzes, and furniture, as well as architectural elements and garden rocks. These cultural and art objects represent the apex of the Qianlong period, and they have been quietly preserved in the Qianlong Garden. Since 2001, the Palace Museum and the World Monuments Fund have been working on the restoration of the Qianlong Garden. At the request of the Peabody Essex Museum, this exhibition constitutes the first time these rare and refined art objects are being put on display for the American public. The beauty and scenery of the Qianlong Garden and the Qianlong emperor's thoughts, interests, and pursuits will be apparent from the unique mix of interior décor and furnishings. We are looking forward to this display of China's splendid cultural relics and recognize this exhibition as an opportunity to advance further and deeper mutual understanding and friendship between China and the United States. Let us go forward with this exhibition together to experience and appreciate its treasures, and with best wishes that it will achieve a complete success.

Zheng Xinmiao
Director, Palace Museum, Beijing

The World Monuments Fund and the Qianlong Garden

A decade ago, the interiors of the buildings in the Qianlong Garden stood dark, silent, and in disrepair. They had been largely sealed up since the last emperor of China left the Forbidden City some seventy-five years earlier. Today, this two-acre garden and its twenty-seven buildings are being conserved as part of a large-scale effort by the Palace Museum and the World Monuments Fund. Our goal is to restore the site to its former glory by the year 2019.

The Emperor's Private Paradise: Treasures from the Forbidden City, draws from the imperial furniture, paintings, decorative objects, and garden elements from the Qianlong Garden and its historic interiors, on public view for the first time. The exhibition is unprecedented. The objects from the garden are among the finest of their kind to be found in the Forbidden City, if not China. Until now, none has ever left the Forbidden City. While restoration of the buildings is underway, we have a unique opportunity to share these objects with an international public. This exhibition is truly a once-in-a-lifetime opportunity. Once the tour concludes, the objects will be reinstalled permanently in their original home in the Qianlong Garden.

The journey of these treasures from their dusty rooms to their newfound prominence in the scholarship and understanding of Chinese imperial architecture and design has been a long but enriching one for all of us who have been involved with the Qianlong Garden. It is a testament to the significance of ensuring the survival of great cultural achievements and to the essential role conservation plays not only in the preservation of material objects but in enhancing understanding and interpretation for both scholars and the public at large.

The World Monuments Fund (WMF) is the leading private international historic preservation organization and has worked, since its founding in 1965, in over ninety countries to save more than six hundred historic sites around the world. The WMF has been working in the People's Republic of China since 1996, collaborating on the preservation of many aspects of the country's rich cultural heritage – imperial sites, ancient temples, village marketplaces, theaters, and archaeological sites. Our work in the Forbidden City began in 2001 when the WMF and the Palace Museum entered into a partnership for the conservation of Juanqinzhai (Studio of Exhaustion from Diligent Service). This was the first historic interior to be conserved in the Qianlong Garden. The Qianlong Garden has since become the centerpiece of the WMF's work in China and a model of international cooperation in the field of cultural heritage conservation because of the site's significance and visibility. The project is both the largest international conservation project at the Forbidden City and the most comprehensive and long-term project in the WMF's history, encompassing conservation, training, and interpretation. The WMF is honored to be part of the history and the future of this important site, now accessible to the public through this major exhibition and then permanently in Beijing.

The WMF's work includes providing financial support, technical assistance, advocacy, and education. Our financial assistance often supplements local support and promotes public/private partnerships, especially for large-scale conservation projects such as the Qianlong Garden. Our technical assistance ensures that the projects developed with local partners can serve as models or pilot programs, and build local capacity to face similar problems. In the case of the Qianlong Garden, there have been rich opportunities for technical exchange among Chinese and American institutions on many challenging issues. These topics have included conservation of paintings on silk and paper, fine woodworking marquetry and lacquer finishes, pest control, preventive conservation and climate control issues, and the interpretation and presentation of historic sites to the public. Key partnerships for this project were established with leading American institutions such as the Getty Conservation Institute, the Peabody Essex Museum, The Metropolitan Museum of Art, and the Smithsonian Institution, among others.

Conservation of the garden is being funded by the Palace Museum and the World Monuments Fund, with support from the Freeman Foundation; the Robert W. Wilson Challenge to Conserve Our Heritage; The Brown Foundation, Inc. of Houston, Texas; British American Tobacco; Starr Foundation; The Tiffany & Co. Foundation; Mr. and Mrs. Peter Kimmelman; and an anonymous donor.

Bonnie Burnham
President, World Monuments Fund

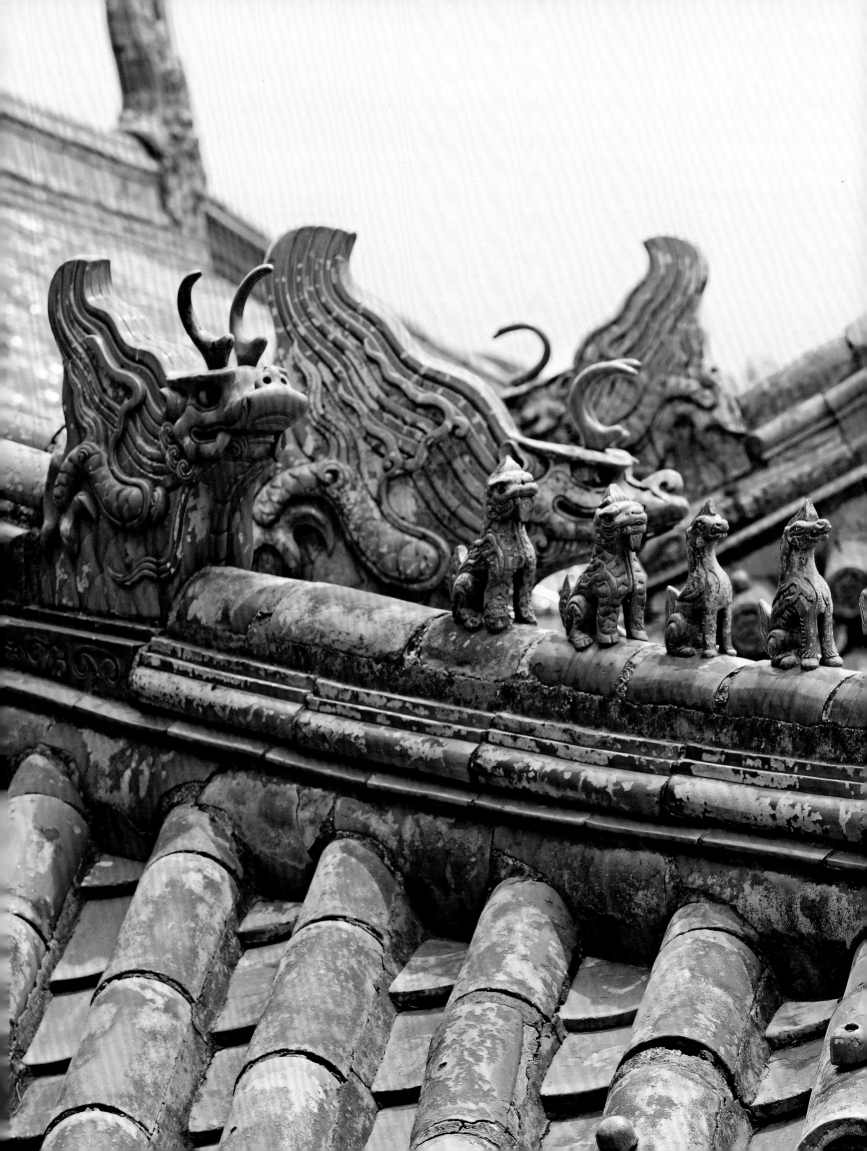

Sponsors' Statements

Mandarin Oriental Hotel Group

Mandarin Oriental Hotel Group is delighted to support the collaborative efforts of the Peabody Essex Museum, the Palace Museum, Beijing, and the World Monuments Fund on the unprecedented presentation of *The Emperor's Private Paradise*. As a leader in luxury hospitality steeped in the values of the Orient, we share this important exhibition's aim to deepen the appreciation for the rich culture of Asia. We are especially proud to support this public exhibition, which is directly engaged with the issues of cultural preservation and conservation that are so critical to our times.

China has long been a source of inspiration for the Western world. Over the past years, we have come to see China as the country of the moment and, perhaps, the powerhouse of the future. As any student of history knows, for a better understanding of the present we must be informed by the past. The extraordinary artworks of leisure and ceremony within *The Emperor's Private Paradise* reveal an ancient thread that ties us to our shared cultural values today. Indeed, many of the curatorial themes of refreshment and pleasure explored in the exhibition are close to Mandarin Oriental's own values: the enhancement of well-being is vital to the unparalleled guest experience we aim to provide at our hotels across the globe. The thoughtful design of one's surroundings, notably to promote a tranquil, harmonious, and restful environment, is as important in today's increasingly busy world as it was to the Qianlong emperor in the eighteenth century.

Thanks to the dedication and commitment of the Peabody Essex Museum, the Palace Museum, and the World Monuments Fund, we have the opportunity to explore fascinating interpretations of leisure embodied in the finest masterworks of Qing imperial art, meticulously preserved through the restoration of the Qianlong Garden in the Forbidden City. It is our sincere hope that as you ponder the artworks in the following pages, you will find inspiration in this extraordinary legacy of Chinese artistic achievement. Enjoy an enlightening journey of discovery.

Edouard Ettedgui
Group Chief Executive
Mandarin Oriental Hotel Group

American Express

Cultural heritage forms our individual, local, and national identities. It shapes relationships with our neighbors and with other communities around the world. At American Express, we believe that respect for, and celebration of, our diverse cultural heritage promotes human understanding and economic development in an increasingly interdependent world. We support organizations and projects that preserve or rediscover important cultural works and major historic sites in order to provide ongoing access and enjoyment for current and future audiences.

We are therefore pleased to support the Peabody Essex Museum and the exhibition *The Emperor's Private Paradise: Treasures from the Forbidden City*, the first-ever public view of elements from this imperial garden in China. It is our hope that these important cultural treasures will remain in the public's consciousness for generations to come.

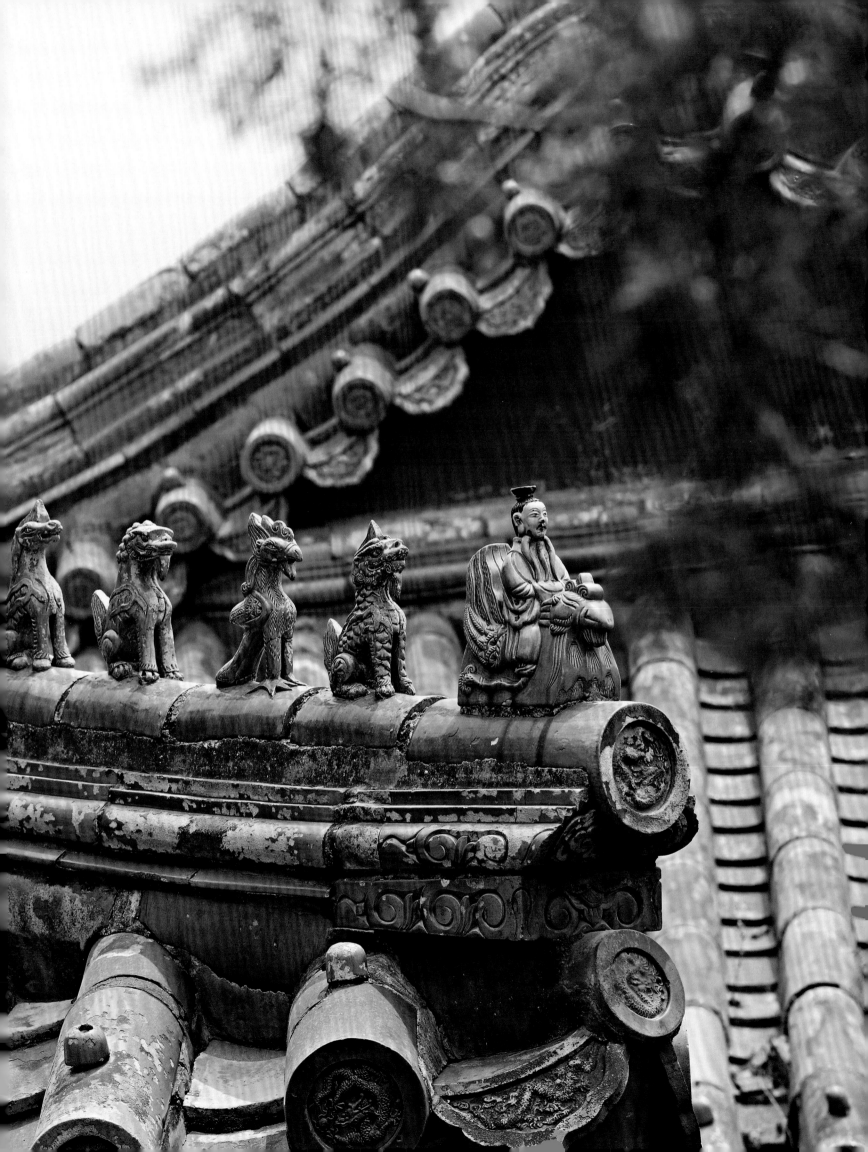

Acknowledgments

Like many collaborative creations, the concept of this exhibition and publication arose over a meal – at a Nanjing cuisine banquet graciously hosted three blocks from the Forbidden City by the Palace Museum Deputy Director Jin Hongkui and by Henry Tzu Ng, Executive Vice President of the World Monuments Fund, for the dedicated group of people involved in the Qianlong Garden preservation project. Back in the United States, at the Peabody Essex Museum, Dan L. Monroe, Executive Director and CEO, and Lynda Roscoe Hartigan, The James B. and Mary Lou Hawkes Chief Curator, immediately and enthusiastically supported the development of the exhibition and publication for the museum. Thanks to the unflagging support and energy of the Peabody Essex Museum, the Palace Museum, and the World Monuments Fund, we are able to bring the Qianlong Garden to the public in advance of the opening of the restored garden itself.

At the Forbidden City in Beijing, the Palace Museum's dedicated staff has been fundamental to the realization of this project. Director Zheng Xinmiao, Executive Deputy Director Li Ji, and Deputy Directors Jin Hongkui and Duan Yong have been wholehearted cohorts, easing the way through the many unexpected and unusual demands of this project. I have been truly honored by the friendship and professional generosity bestowed upon me by colleagues at the Palace Museum who literally opened long-closed doors into one of the most special and precious of man-made realms. Without the years of experience and accumulated knowledge of Wang Shiwei, Deputy Director of the Historic Architecture Department, and Yuan Hongqi, Deputy Director of the Palace History Department, this endeavor would be lacking in substance and spirit. We are thankful for the important and substantial contributions by Palace Museum historians Luo Wenhua, Wen Ming, and Wang Zilin, who are so thoroughly familiar with the many layers of material and knowledge embedded in the Qianlong Garden. Our thanks also for the assistance and guidance of Zhao Yang, Director of the Palace History Department, and historian Fang Hongjun, as well as Director of the Paintings and Calligraphy Department Fu Hongzhan and his departmental experts Yin Yimei and Nie Hui. Li Yue, of the Historic Architecture Department, cheerfully assisted in creating plans, images, and measurements of garden spaces and objects. Thanks are also due to members of the exhibition's preparatory team Ji Xiuyun and Liu Hongwu of the Historic Architecture Department. The expert photographers Hu Chui, Director of the Photographic and Information Department, and the ever generous head of the Photography Department Feng Hui, as well Media Resource Managers Guo Yalin and Zhang Yin, generously and readily supplied photography, photographers, and cinematographers – including the talented Tian Mingjie, Yu Ningchuan, Si Bing and Sun Zhiyuan – to record the garden and its treasures. Yang Zehua, in addition to his masterful mounting work, openly shared his thoughts, insights, and knowledge. Gratitude also goes to Director of the Conservation Department Song Jirong, and her staff members Sun Zhenying and Sun Ou, for their stunning work on the very special objects in this exhibition. We are also very grateful to Ma Haixuan, Director of the Foreign Affairs Office, and project coordinator Yang Fan, for their tireless and always gracious efforts in managing the challenging details for the exhibition loans from the Palace Museum.

Four years ago, Henry Tzu Ng generously welcomed me into the privileged family involved with the Qianlong Garden restoration and conservation project. Though the World Monuments Fund is chiefly concerned with the preservation of monuments, President Bonnie Burnham willingly undertook partnering in this complex museum venture. She and her staff, including Holly Evarts and Lisa Ackerman, have been obliging and delightful collaborators.

As the exhibition and this book developed, the project embraced an increasing number of indispensable individuals at the Peabody Essex Museum. Priscilla Danforth, Director of Exhibition Planning, masterfully managed the complexities of this exhibition with patience and calm. Josh Basseches, Deputy Director of the Peabody Essex Museum, has been a great source of balance through the entire process and I am appreciative of his professional and human oversight of the project. Exhibition designer Dave Seibert has brought optimism and a joyful open spirit to the enterprise. Mary Beth Bainbridge, Assistant to The James B. and Mary Lou Hawkes Chief Curator, heroically worked her magic to expedite and realize the organization of this publication's photography. Bruce MacLaren, former Associate Curator of Chinese Art, took on endless large and small issues, making invalu-

able suggestions and contributions from his trove of research and knowledge. Chris Reaske, Chief Philanthropy Officer, and Anne Butterfield, Director of Institutional Giving, were wonderful partners in both the financial and intellectual development of the exhibition and book. Photographer Dennis Helmar generously shared his expertise to enhance the visuals of this publication, and Senior Photographer Walter Silver warmly offered his immediate assistance whenever the need called. Many other colleagues at the Peabody Essex Museum, including Library Director Sid Berger and curators Daniel Finamore and Susan Bean, were sources of wise and warm advice. Chief Curator Lynda Roscoe Hartigan's steadfast attention to detail and presentation has been a significant factor in the success of the project. The project could not have been brought to realization without her ongoing assistance and management. And I am most thankful for Director Dan L. Monroe's leadership and support of this exhibition's exploration of art, architecture, and nature. PEM trustee Scott Offen, whose passion and foresight led to the creation of a special book and manuscript collection on Chinese architecture, gardens, and furniture at the museum's Phillips Library, provided the participants in this project – and scholars around the world – an inexhaustible resource for research.

The construction of a book, like that of a garden, requires a dedicated group of talented contributors. Editor and Project Manager Terry Ann R. Neff has been a delightful ally, brilliantly pruning and sculpting the text. At Studio Blue, Kathy Fredrickson masterfully oversaw the creation of the many textual, textural, and visual elements of the book into the objet d'art we all anticipated. We thank her and the rest of her design team, especially Lauren Boegen.

The contributions to the text by Mark C. Elliott, Mark Schwartz Professor of Chinese and Inner Asian History, Harvard University; Liu Chang, Associate Professor of Architecture, Tsinghua University; Henry Tzu Ng, World Monuments Fund; and Yuan Hongqi, the Palace Museum, bring perspective, insight, and new knowledge to the understanding of the Qianlong emperor and his "private paradise." Luo Wenhua, Wang Zilin, and Wen Ming of the Palace Museum also provided significant research that was incorporated into the publication. My knowledge of Chinese history and architecture has been wonderfully enriched by the privilege of

working with these *laoshi*. Hu Qiulei and Amy Huang assisted in the challenging task of translating Qianlong-period documents and the often complex poems composed by the Qianlong emperor, and Karl Metzner translated text from Palace Museum curators.

Several colleagues in the worlds of Chinese art and history generously reviewed the manuscript drafts and helped to search out the best English translations for thorny Chinese terms. These include my wise teacher and friend Raoul Birnbaum, Professor of History of Art and Visual Culture at the University of California Santa Cruz, who reviewed Buddhist-related texts; Mark C. Elliott, who reviewed elements related to Manchu and Qing history; and Alfreda Murck, Historian at the Palace Museum, who, along with Li Jianyun, Liu Chang, Yuan Hongqi, Henry Tzu Ng, and me, developed English equivalents for the names of the Qianlong Garden's buildings.

Henry Tzu Ng's diligence, exemplary leadership skills, and deep Confucian values have been an inspiration throughout this project; his tireless efforts, passion, and warmth have been critical to its success. He has been a muse whose influence will last a lifetime. My dear friend Zhu Chuanrong, Deputy Director of the Forbidden City Publishing Company, has for years provided my home away from home. She has been a devoted friend, guide, and a true paradigm of traditional Chinese values. Stimulating conversations with Tara Cederholm, Eugene Wang, Ellen Widmer, Andre Kneib, Liu Dan, and Edward C. Johnson have been wonderfully inspiring. And I will always be moved when I think of my older friends Wang Shixiang and Zhu Jiajin blazing pathways through the rich fields of Chinese furniture and interior design history, and their willingness to befriend a young American woman so many years ago.

As always, I am deeply grateful to my parents who first inspired my interests in art and architecture, and to my dear husband Bill Mellins, who daily and unconditionally has supported all of my pursuits and explorations.

Each one of us involved in this project has been touched by the original conception of the Qianlong emperor's Tranquility and Longevity Palace Garden. We are indebted to the palace courtiers, eunuchs,

officials, accountants, artists, artisans, and laborers who devoted immense energy and thought to manifesting his vision, and indebted as well to those who have cared for it in the ensuing years and those involved with the current preservation. At times, feeling my way through a dark grotto or down a narrow, slanted corridor lined with cracked-ice pattern marquetry, I have often felt like one of the minor members of the emperor's entourage, grateful for the privilege of being allowed entrance to such magnificent surroundings, and hoping to have made some small contribution to the vast vision of this poetic realm we now call the Qianlong Garden. While many others have made invaluable contributions to this endeavor, I take full responsibility for any mistakes or oversights in the following pages.

The present exhibition and this publication are intended as a welcome to readers and visitors into this special realm with all of its poetic moments and cosmic visions.

Nancy Berliner, PhD
Curator of Chinese Art
Peabody Essex Museum

Chronology of Chinese Dynasties and Reigns of Qing Emperors

Shang Dynasty
circa 1600–1046 BCE

Western Zhou Dynasty
1046–771 BCE

Spring and Autumn Period
770–476 BCE

Warring States Period
475–221 BCE

Qin Dynasty
221–206 BCE

Western Han Dynasty
206 BCE–CE 9

Eastern Han Dynasty
25–220

Six Dynasties
Three Kingdoms Period
220–265

Western Jin Dynasty
265–317

Eastern Jin Dynasty
317–420

Southern and Northern Dynasties
420–589

Sui Dynasty
581–618

Tang Dynasty
618–907

Five Dynasties and Ten Kingdoms
907–960

Liao Dynasty
916–1125

Northern Song Dynasty
960–1127

Southern Song Dynasty
1127–1279

Jin Dynasty
1115–1234

Yuan Dynasty
1271–1368

Ming Dynasty
1368–1644

Qing Dynasty
1644–1911

Shunzhi Emperor
1644–1661

Kangxi Emperor
1662–1722

Yongzheng Emperor
1723–1735

Qianlong Emperor
1736–1796

Jiaqing Emperor
1796–1820

Daoguang Emperor
1821–1850

Xianfeng Emperor
1851–1861

Tongzhi Emperor
1862–1874

Guangxu Emperor
1875–1908

Xuantong Emperor (Puyi)
1908–1912

Timeline
of China, Europe, and America in the 1700s

Bruce MacLaren

1680 1690

1700 | 1710 | 1720

1700

The population of China is approximately 138 million and the population of Europe (including Russia and Turkey) is approximately 120 million.

1707

Scotland and England form the United Kingdom of Great Britain.

1709

The Kangxi emperor (1654–1722), grandfather of the Qianlong emperor (1711–1799), begins construction of the Yuanmingyuan (Garden of Perfect Brightness).

1710

Augustus the Strong (1670–1733) commissions the establishment of the Royal Porcelain Manufactory at Meissen, making Saxony the first European producer of porcelain after centuries of imports from China.

1711

The future Qianlong emperor is born in Beijing.

1713

Matteo Ripa (1682–1746), a Neapolitan priest who served as a court artist under the Kangxi and Yongzheng emperors, publishes thirty-six copperplate engravings of the Kangxi emperor's summer resort and gardens at Chengde, 150 miles northeast of Beijing. Ripa would take the prints to London in 1724, and the images of winding paths and asymmetrical layouts would inspire the garden designs of Lord Burlington (1694–1753) and others.

1715

Louis XV (1710–1774) ascends the throne in France. The Italian Jesuit missionary Giuseppe Castiglione (1688–1766) arrives in Beijing. Until his death, he would work under three emperors as a court artist combining European and Chinese techniques.

1721

The Kangxi emperor delivers a decree banning Christian preaching in China, a response to the legate of 1704 issued by Pope Clement XI (1649–1721) that prohibited Confucian and ancestral rites to be performed by Chinese Catholic converts. Peter the Great (1672–1725) declares himself Emperor of Russia.

1722

The Kangxi emperor dies, ending a sixty-one year reign.

1723

The Yongzheng emperor (1678–1735), father of the Qianlong emperor, ascends the throne.

1724

Gabriel Fahrenheit (1686–1736) invents the first mercury thermometer in the Netherlands.

1725

The Yongzheng emperor commissions the *Qinding Gujin Tushu Jicheng*, the largest encyclopedia ever printed.

1727

Sir Isaac Newton (1642–1727), the English scientist who developed the theory of gravity, dies.

1730

The Qianlong emperor publishes his first collection of poetry.

1732

The agricultural handbook *Poor Richard's Almanac* by the American founding father, inventor, and author Benjamin Franklin (1706–1790) is published. George Washington (1732–1799) is born in Virginia.

1735

The Qianlong emperor ascends the throne at age twenty-four, upon the death of his father. To fill Russia's demand for tea, traders and three hundred camels travel eleven thousand miles roundtrip from China, a journey of sixteen months.

1739

Camellia plants from China arrive in Europe, the first of hundreds of Chinese species that would be introduced into gardens there and in North America.

1743

The French Jesuit missionary Jean-Denis Attiret (1702–1768) writes *A Particular Account of the Emperor of China's Gardens, near Peking*. This lengthy description of the Yuanmingyuan, published in Paris in 1749, proves widely influential for garden design in Europe.

1747

Construction of European-style architecture at the Yuanmingyuan begins. Expanding the suburban palace revived by his grandfather in 1715, the Qianlong emperor's "Western Ocean buildings" would eventually number forty structures and include four major pavilions and three major fountains upon their completion in 1783.

1750

The population of China is approximately 179 million, the population of Europe is approximately 140 million, and the population of northern America (comprising present-day Greenland, Canada, and the United States) is approximately two million. William (d. 1755) and John Halfpenny write *New Designs for Chinese Temples, Triumphal Arches, Garden Seats, Palings, & c*, the first of four parts of *Rural Architecture in the Chinese Taste* published in London from 1750 to 1752.

1753

The British Museum is founded in London. The original Chinese Pavilion at Drottningholm, Sweden, is presented as a birthday gift to Queen Lovisa Ulrika (1720–1782) from King Adolf Fredrik (1710–1771). Inspired by Chinese gardens and architecture, it would be rebuilt as a permanent structure in the 1760s.

1755

The Comédie-Française debuts the tragedy *L'Orphelin de la Chine* by Voltaire (1694–1778), which is based on *The Orphan of Zhao*, a Chinese story dating back to the fourteenth century. Voltaire sought to introduce Confucian principles to a new audience.

1757

Designs of Chinese Buildings, Furniture, Dresses, Machines, and Utensils: Engraved by the Best Hands, from the Originals Drawn in China by William Chambers (1723–1796) is published in London. A French edition is published the same year. The Prince of Wales (later George III, 1738–1820) commissions Chambers to construct a large pagoda in the gardens at Kew. Inspired by the porcelain pagoda at Nanjing, it is completed in 1761 and joins other foreign architectural imports at Kew such as the Alhambra, the Temple of Arethusa, and the Temple of Pan.

1759

The Qing empire reaches its greatest extent with the addition of present-day Xinjiang in western China. The empire encompasses almost 4.6 million square miles (12 million kilometers). (China today is 3.7 million square miles). A decree from the Beijing court establishes Guangzhou (Canton) as the only legal Chinese port for overseas trade, limiting foreign ships and their crews to the Pearl River Delta. The imperial order remains in place until the Treaty of Nanking in 1842.

1761

George III ascends the throne in England.

1762

Six-year-old musical prodigy Wolfgang Amadeus Mozart (1756–1791) tours Europe. Catherine the Great (1729–1796) of Russia purchases a group of paintings that will become the kernel of the Hermitage collections. French philosopher Jean-Jacques Rousseau (1712–1778) publishes *The Social Contract*.

1768

The Petit Trianon is completed on the grounds of Versailles. Louis XVI (1754–1793) later gives the building and grounds to Queen Marie Antoinette (1755–1793).

1770

English artist Thomas Gainsborough (1727–1788) paints *The Blue Boy*. The population of China under the Qing dynasty reaches 270 million.

1771

The Qianlong emperor commissions the expansion of the Ningshougong (Tranquility and Longevity Palace) and garden complex within the Forbidden City. The emperor also initiates work on the *Siku Quanshu* (Complete Library of the Four Treasuries), a comprehensive anthology of two thousand years of Chinese writing.

1773

Colonists disguised as Native Americans board East India Company ships and dump chests of tea into the harbor in what would become known as the Boston Tea Party.

1774

The Sorrows of Young Werther (Die Leiden des jungen Werthers) by Johann Wolfgang von Goethe (1749–1832) is published. Nineteen-year-old Louis XVI ascends the throne in France.

1776

The Continental Congress adopts the Declaration of Independence in Philadelphia. The Ningshougong (Tranquility and Longevity Palace) and its garden, also known as the Qianlong Garden, are completed in the Forbidden City.

1784

Grand Duke Pietro Leopoldo (1747–1792) establishes the Galleria del'Accademia to house examples of the schools of drawing that existed in Florence.

1785

The *Grand Turk*, the first trade ship to sail from New England to China, leaves Salem Harbor in Massachusetts for Canton and returns later with a cargo of silks, tea, and porcelain. Salem would subsequently become one of New England's most important ports in the early nineteenth century.

1786

The American painter Charles Willson Peale (1741–1827) establishes what would become known as the Peale Museum in Philadelphia, a scientifically organized natural history museum that would later become the Philadelphia Museum.

1789

The storming of the Bastille in Paris helps precipitate the French Revolution. George Washington is elected the first president of the United States.

1791

The first printed edition of *The Dream of the Red Chamber (Hong Lou Meng)* appears in China. Circulated in handwritten copies since the middle of the century, this epic novel details aristocratic Chinese family life in a luxurious garden compound.

1792

The population of China is approximately 307 million; Europe is approximately 188 million; the United States is approximately four million. France declares itself a republic.

1793

Lord Macartney (1737–1806) leads a British embassy to visit the Qianlong emperor at Chengde and Beijing in hopes of obtaining additional trade ports and a relaxation of fees. The mission fails, triggering over a century of bad relations between China and the West. French Neoclassical artist Jacques-Louis David (1748–1825) paints *The Death of Marat*. The Musée du Louvre is established in Paris. Queen Marie Antoinette of France is put to death by guillotine.

1796

The Qianlong emperor abdicates in favor of his son the Jiaqing emperor, officially ending his reign.

1799

The Qianlong emperor dies on February 7. Hešen (1750–1799), the corrupt imperial favorite, is sentenced to death by order of the Jiaqing emperor. Napoleon (1769–1821) and his troops sack and capture the city of Jaffa (present-day Tel Aviv) in four days in March. The East India Marine Society, an organization of Salem captains and supercargoes who had sailed beyond either the Cape of Good Hope or Cape Horn, is founded. It would evolve into the Peabody Essex Museum, the oldest continually operating museum in the United States. George Washington dies on December 14.

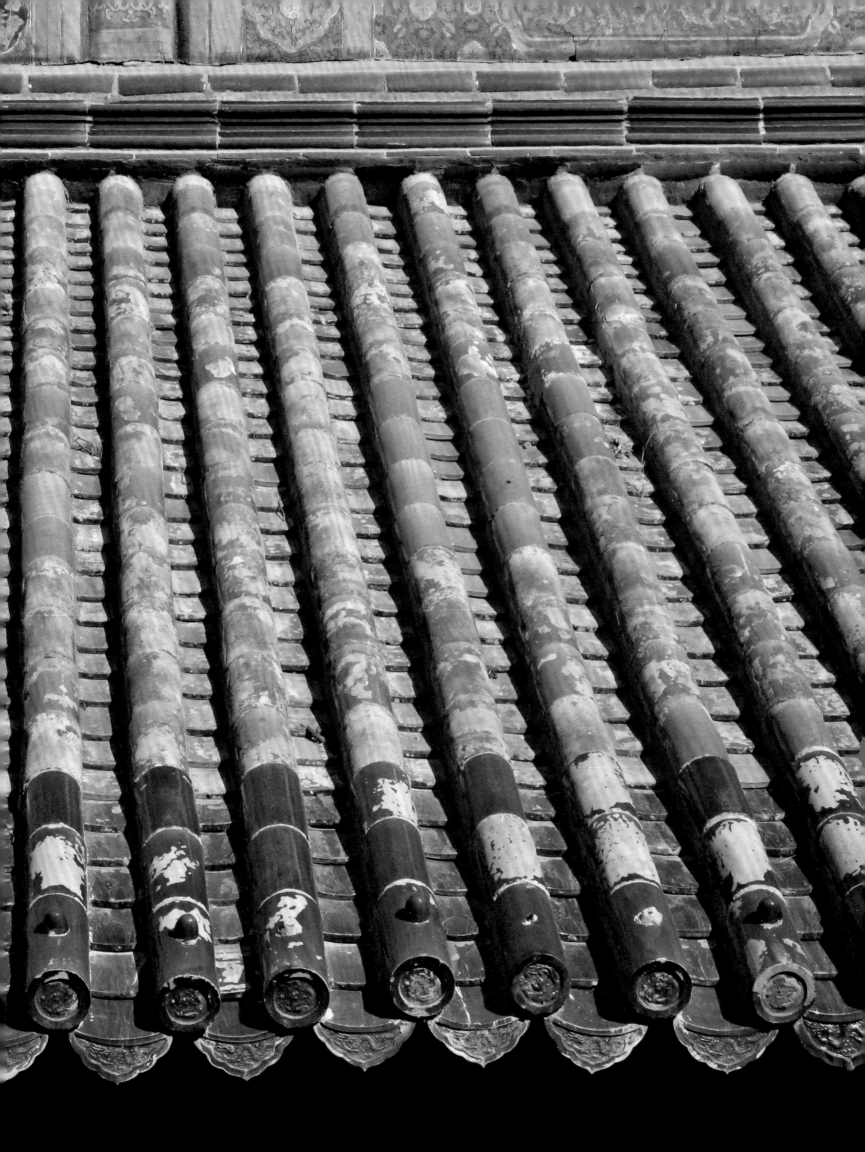

Map of the Qianlong Garden

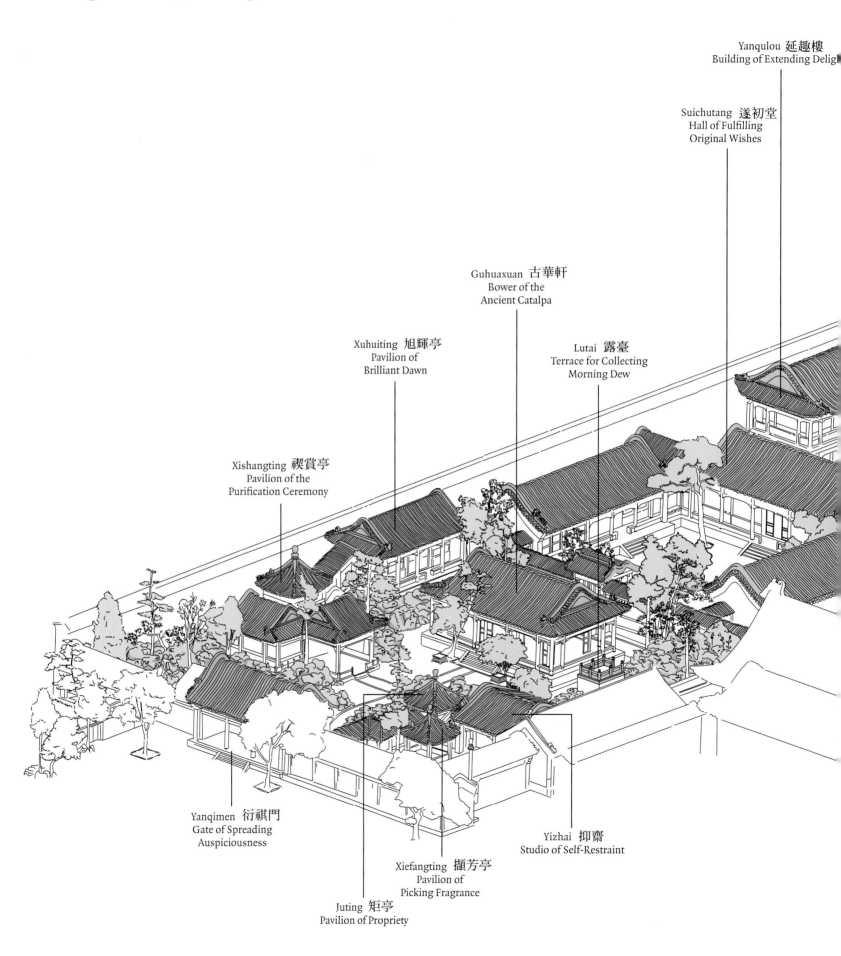

Yanqulou 延趣樓
Building of Extending Delig[ht]

Suichutang 遂初堂
Hall of Fulfilling
Original Wishes

Guhuaxuan 古華軒
Bower of the
Ancient Catalpa

Xuhuiting 旭輝亭
Pavilion of
Brilliant Dawn

Lutai 露臺
Terrace for Collecting
Morning Dew

Xishangting 禊賞亭
Pavilion of the
Purification Ceremony

Yanqimen 衍祺門
Gate of Spreading
Auspiciousness

Yizhai 抑齋
Studio of Self-Restraint

Xiefangting 擷芳亭
Pavilion of
Picking Fragrance

Juting 矩亭
Pavilion of Propriety

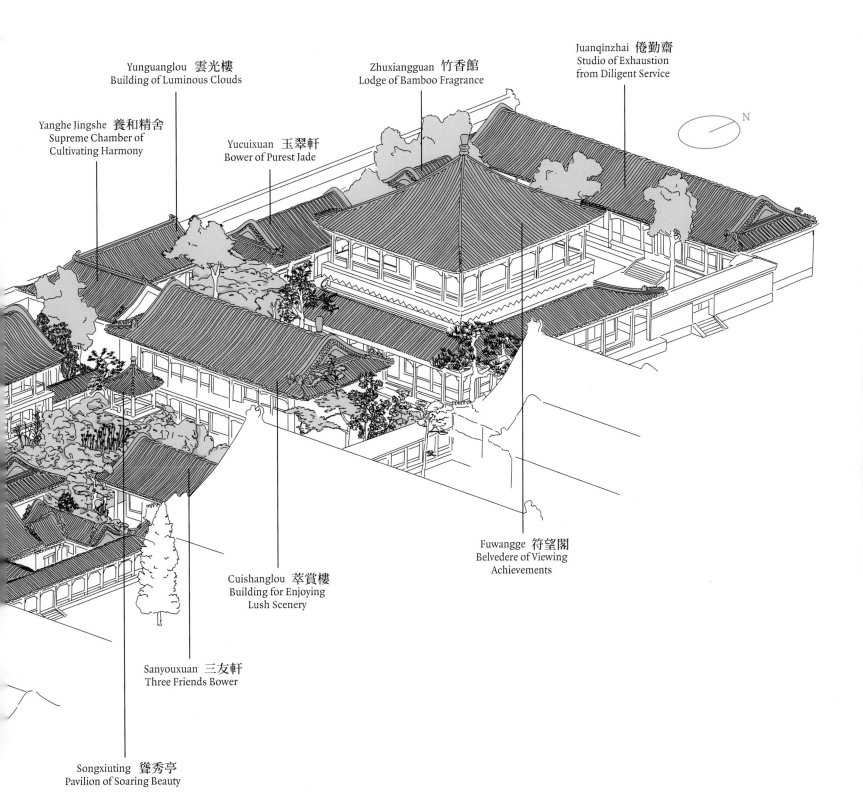

Yunguanglou 雲光樓
Building of Luminous Clouds

Yanghe Jingshe 養和精舍
Supreme Chamber of
Cultivating Harmony

Yucuixuan 玉翠軒
Bower of Purest Jade

Zhuxiangguan 竹香館
Lodge of Bamboo Fragrance

Juanqinzhai 倦勤齋
Studio of Exhaustion
from Diligent Service

N

Cuishanglou 萃賞樓
Building for Enjoying
Lush Scenery

Fuwangge 符望閣
Belvedere of Viewing
Achievements

Sanyouxuan 三友軒
Three Friends Bower

Songxiuting 聳秀亭
Pavilion of Soaring Beauty

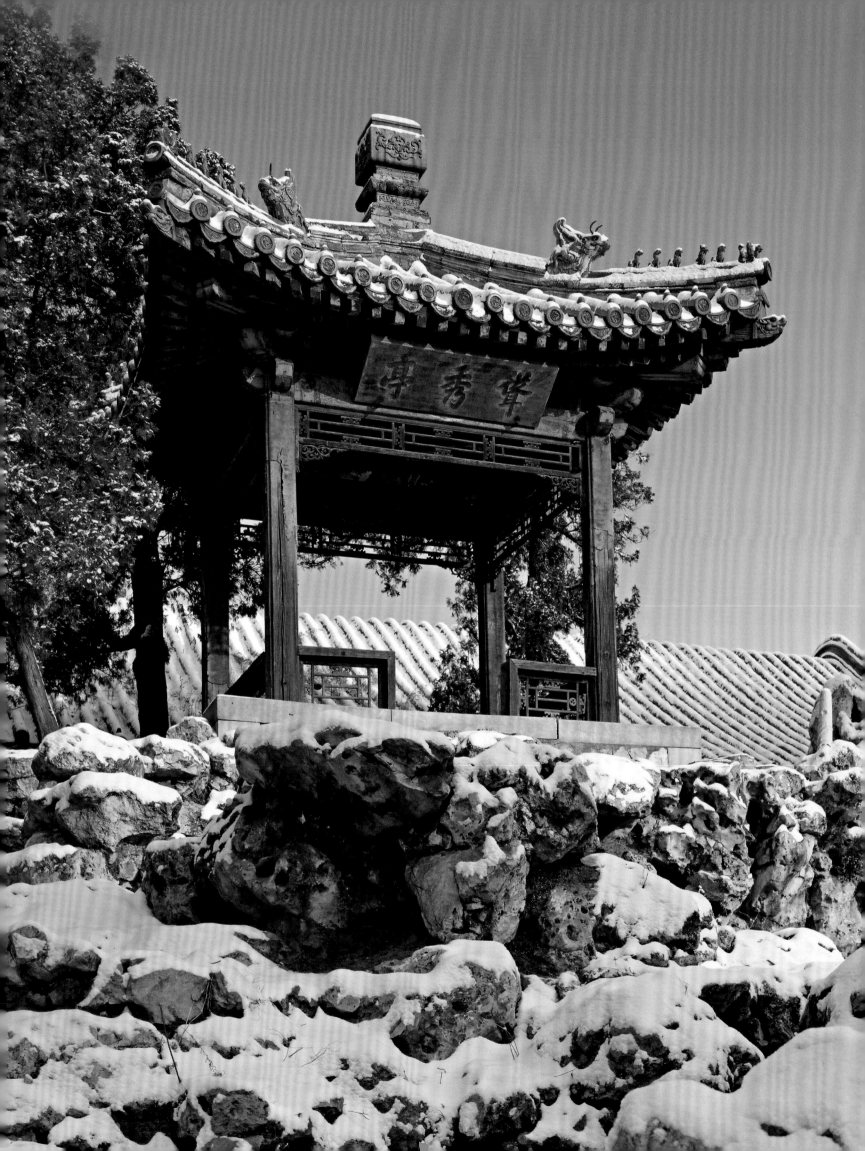

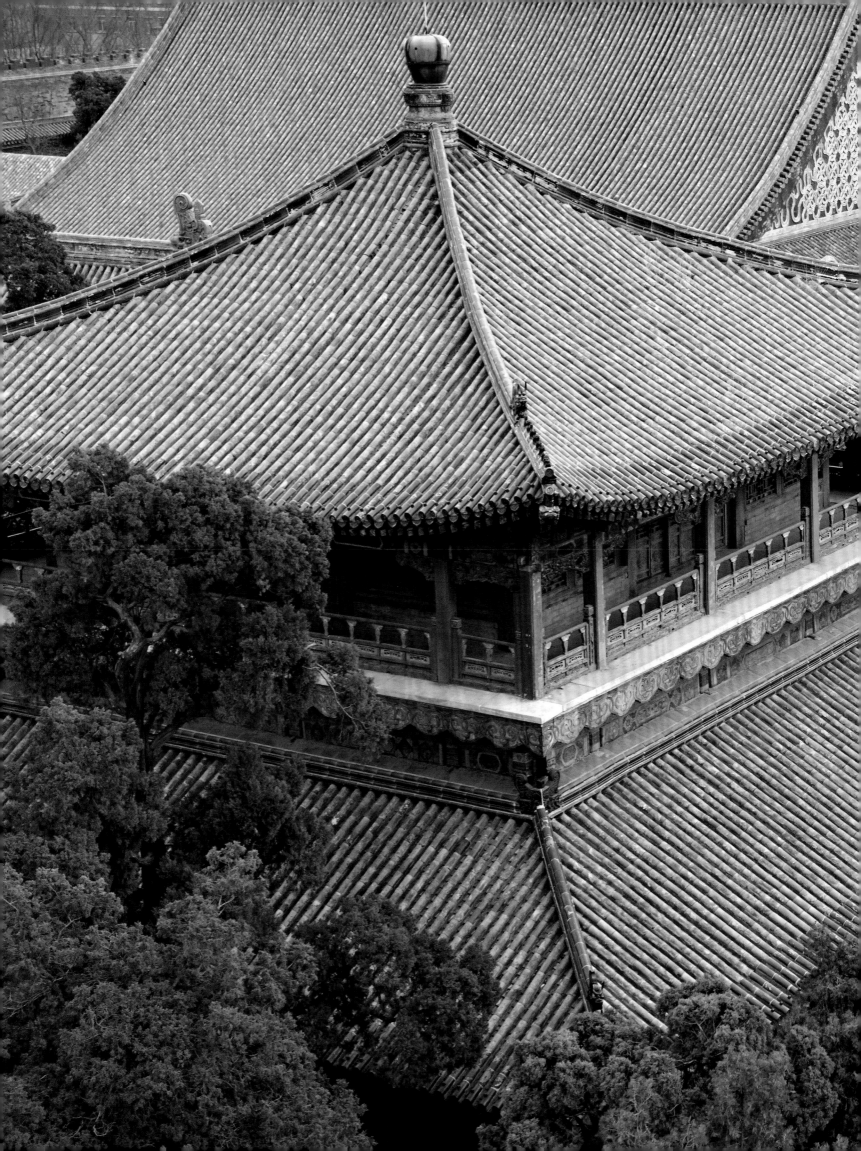

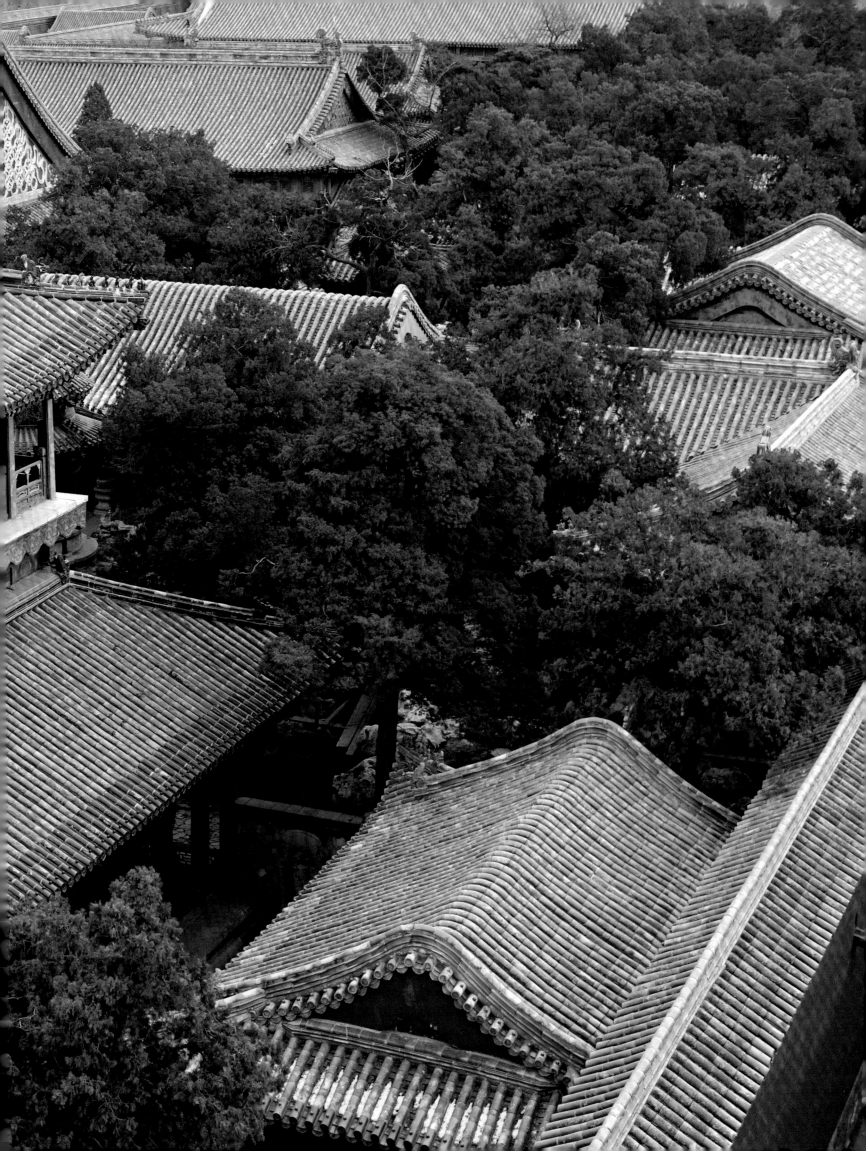

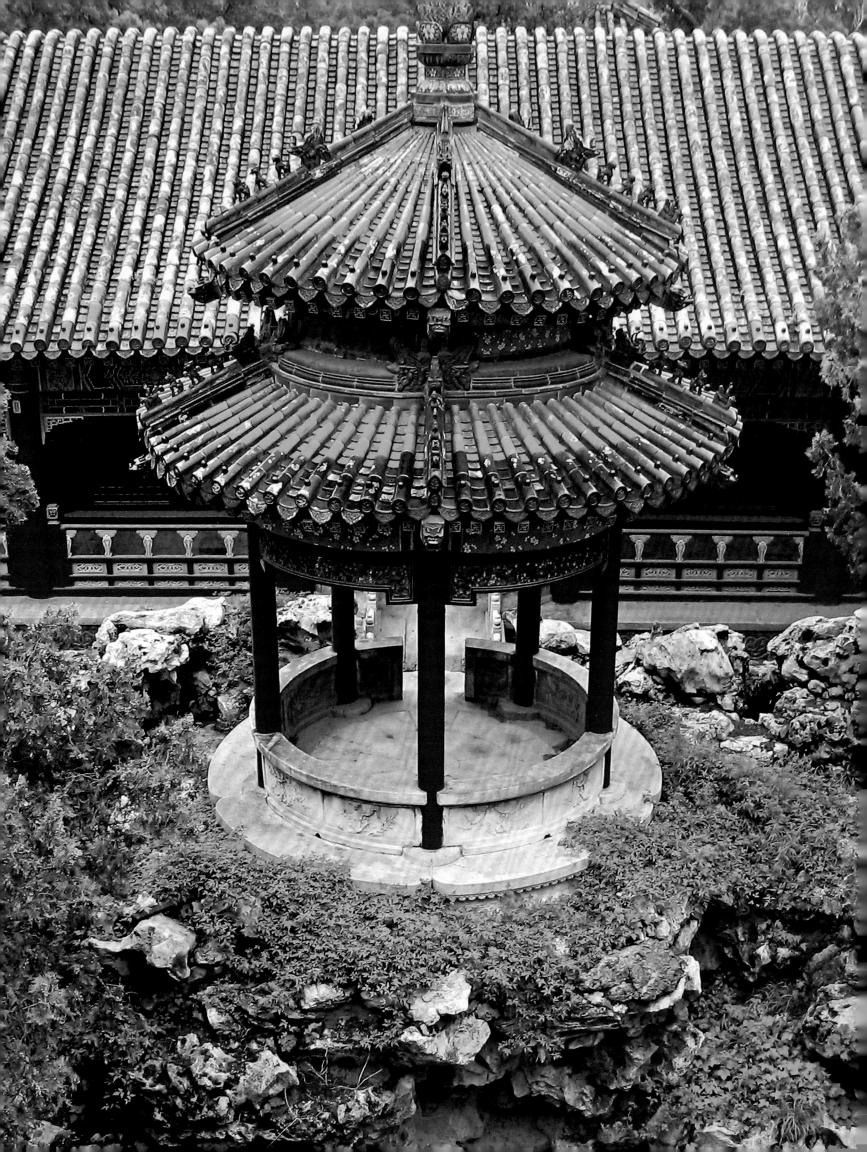

Introduction: The Qianlong Emperor and His Age

乾
隆
皇
帝
與
他
的
年
代

Mark C. Elliott

In the world as it once was, not so very long ago, venerable monarchs were like the weather. Their actions shaped the conditions, fair or foul, that prevailed in daily life, affecting everyone in some measure. Depending upon how they chose to wield their power, the sun might shine, the winds might blow, or clouds might gather and burst with fury. Long-lived sovereigns – think Elizabeth I (reigned forty-four years), Peter the Great (forty-three years), Victoria (sixty-three years), Franz Josef I (sixty-seven years), or Louis XIV (seventy-two years) – were like the weather in another sense, too: they could be difficult to predict, with influence accruing to those near the throne who learned the trick. And, again like the weather, their good and bad days, their heroics and foibles, were common topics of conversation and gossip, which later grew into legend and myth. Their names became one with the landscape, taking on a timeless, naturalized presence, as if they had always been on the throne and always would be. Generations were born and died, wars were won and lost, rivers changed course, and the face or name on the coin of the realm stayed the same. Seemingly ageless themselves, rulers like this embodied the age in which they lived.

Though outside of East Asia his is not a household name, the Qianlong (pronounced *chee'en-lohng*) emperor was such a ruler (plates 1 and 2). His sixty-year reign – from late 1735 to his abdication at the end of 1795 – was officially the second longest in all of Chinese history. Unofficially, it was in fact the longest, since even after stepping aside for his son he retained authority for four more years until his death in 1799. The extraordinary length of time granted him as emperor meant he left an indelible mark on all aspects of government, economy, society, and culture (plate 3). Indeed, when we think of the "splendor of imperial China" – its artistic achievements, its buildings and gardens, its clothing and furniture, its enormous size and vast productivity – many of the images we conjure up date from the 1700s and owe greatly to the tastes and fashions of the Qianlong court (plate 4). Celebrated in contemporary Europe as a philosopher-king and widely acknowledged in East, Central, and Southeast Asia as the most powerful individual in those worlds, the Qianlong emperor exercised an influence on his times that is hard to exaggerate. Like his European counterparts, he was as the weather;

unlike them, he was held responsible for it, too, and offered sacrifices at ritual altars to ensure that rain fell when needed.

To understand the age and the sensibilities that gave rise to the objects that form the present exhibition, *The Emperor's Private Paradise: Treasures from the Forbidden City*, it is important to understand something of who the Qianlong emperor was: his family and upbringing, the circumstances that brought him to power, his approach to the duties of being emperor, the importance to him of his distinctive heritage as a Manchu, and his accomplishments as the ruler of the Qing (pronounced *ching*, as in *searching*) dynasty, in the 1700s the world's largest and wealthiest empire. Even a few glimpses of his reign may serve to illuminate the life and times of one of the most influential men in world history.

1735: Taking Power

As any reference work will confirm, the first year of the Qianlong emperor's reign was, by Western reckoning, 1736 – the same year that England eliminated capital punishment for witchcraft. But he actually assumed power in 1735, on the morning of October 9, the day after his father died. Having been summoned to the Yuanmingyuan (Garden of Perfect Brightness), he was present when the old emperor breathed his last, shortly before midnight. This dramatic moment – one of a number of vital events in the Qianlong emperor's early life to take place in a garden setting – was preceded by the opening of a secret edict naming the emperor's fourth son his successor. A few hours later, he found himself on his knees in the Qianqing Palace, reading to the small crowd of assembled nobles and officials the proclamation naming him to the throne, and appealing to Heaven for guidance.

It was only at this time that the name "Qianlong" was promulgated. Before this, he was known either by his given name, which in Manchu was Hungli (in Chinese, Hongli), or by the title his father had given him in 1733, Prince Bao (Precious Prince). Qianlong (or Abkai wehiyehe in Manchu, meaning "supported by Heaven") was in fact not a personal name but the auspicious formal name for the reign, a temporal designation to be used in dating the calendar. The characters for his real name became taboo.

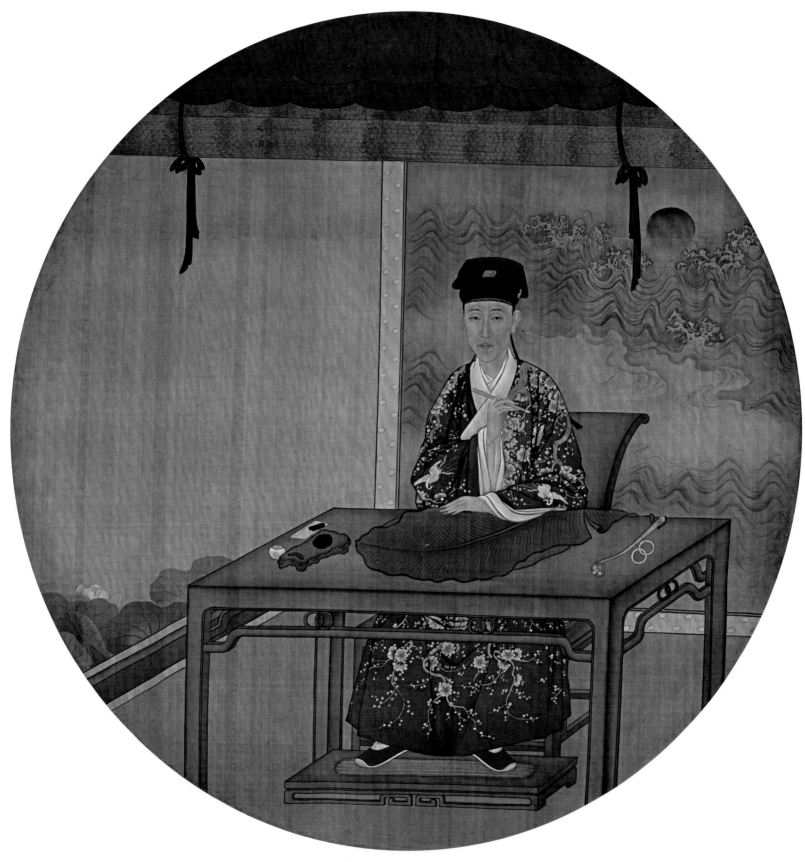

Plate 1. *Portrait of the Qianlong Emperor in Ancient Costume* (cat. 89).

Pages 27–30. Songxiuting in winter; an aerial view of
Fuwangge; and Biluoting, as seen from an upper
story of Fuwangge. Pages 26 and 31, Panel (hanging)
(cat. 23, detail).

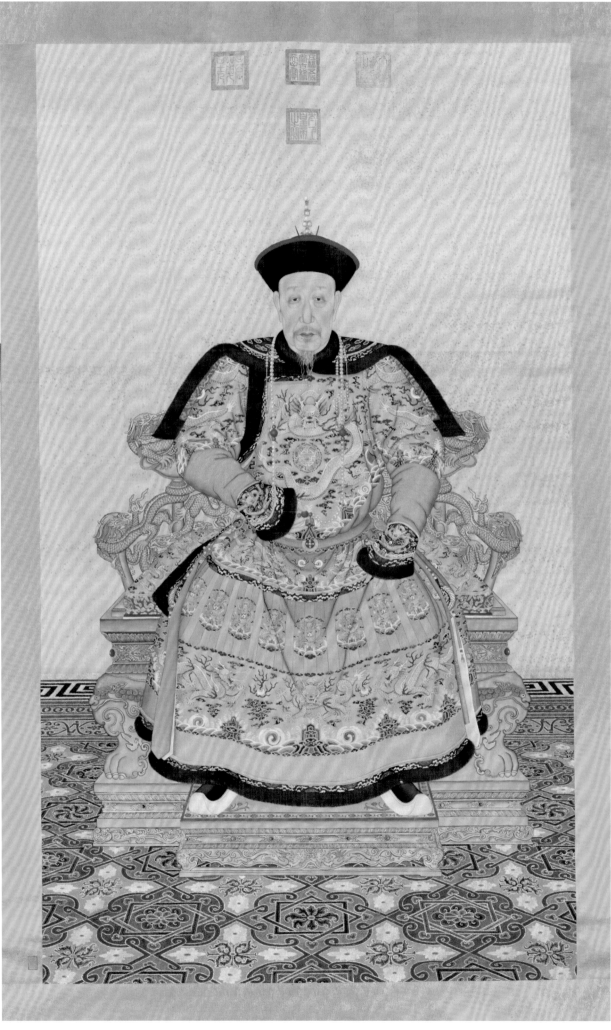

Plate 2. *Portrait of the Qianlong Emperor* (cat. 86).

屋閣延素肯題　楣意有存耄期　致勤倦願答謝　塵喧豫葺優　游地略慚恭伶　門其誠符我望　惟靜候　天恩

Plate 3. Qianlong Emperor, Calligraphic inscription (cat. 50).

Hungli was an obvious choice. Though he was not the oldest son, and though his mother, Lady Niohuru, was not a high-ranking consort when she gave birth to him in September 1711, he distinguished himself early in life as a gifted and serious child, committed to learning and eager to please his elders. In the prefaces they wrote for a collection of his poetry published when he was nineteen, Hungli's uncles and tutors praised him for his conscientiousness, his skill at composition, and his precocious knowledge of the works of literature, philosophy, and history that formed the backbone of elite education in premodern China.[1] His half-brother, Hungjeo, only three months younger and also in line for the throne, probably knew Hungli better than anyone. As boys, they were schooled together and shared the same quarters.[2] Hungjeo had boundless admiration for Hungli and deferred to him entirely: "I write as a younger brother looking at an older brother. Although we lived in the same place, there is no comparison between us two. His comprehension is profound, mine shallow; his talent is great, mine meager; his writing is artful, mine clumsy."[3] Hungli's own testimony was more modest and reinforces our picture of him as an earnest young man. He admitted that to remind himself of what he had studied in earlier years he made up fourteen notebooks filled with excerpts from his reading, which he kept on his desk and reviewed constantly. At the same time, he was not free of doubts, and confessed to episodes of sleeplessness when he contemplated the prospect of taking control of the empire his father and grandfather had built.[4]

Indeed, it must have been a daunting prospect. As a people from the "barbarian" north, the Manchus were regarded with both contempt and misgiving by the Han Chinese when they invaded in 1644. That they were vastly outnumbered made the task of establishing control even more difficult. Yet, over the space of some ninety years, and often against considerable odds, Hungli's father, the Yongzheng emperor, and his grandfather, the Kangxi emperor, had consolidated the fortunes of the Qing ruling house in the face both of open rebellion and secret resistance, so that by 1735 the Qing state was fiscally robust and politically mature. To be sure, there were problems to be sorted out, but tax receipts were brisk, most of the country was at peace, and officials in the field

had a healthy respect for central authority. In one sense, the greatest pressure upon the new emperor was to steer a steady course and not wreck the foundations of prosperity he had inherited.

The Qianlong emperor himself tended to see this task in terms of a filial duty. Indeed, his personal debts to his father and grandfather were great. The Yongzheng emperor had brought his son in as a prince to observe official policy in the making and over time entrusted him with a growing number of responsibilities, ritual and political. As his brother's remarks make plain, Hungli enjoyed the unmistakable partiality of both his predecessors: "When my older brother and I lived with our father, morning and night we slept in the same room and shared the same food. . . . Grandfather could not look at him but be pleased; father could not hear his voice but be glad."[5] Thus, at the time of the Yongzheng emperor's death, Hungli was the presumptive, if unofficial, heir.

Hungli's obligation to his grandfather, the Kangxi emperor, was of particular significance. Given that the Yongzheng emperor ascended the throne under a cloud, his blessing carried less weight than the approbation of his universally admired father. By the time Hungli became the Qianlong emperor, it was well known that there had been a soft spot in the Kangxi emperor's heart for this grandson; in fact, some people even believe that the Yongzheng emperor was named to succeed him in order to make sure that Hungli would one day be emperor. The story of their brief, but significant, relationship adds to our understanding of the Qianlong emperor at twenty-four.

The Kangxi emperor met the young Hungli for the first time in April 1722, when he was sixty-eight and Hungli eleven.[6] Prince Yong (the future Yongzheng emperor) had invited his father to dinner at his villa at the Yuanmingyuan and took the opportunity to introduce his son to him.[7] It seems that the old emperor took an instant liking to his grandson, for he invited him to move into the palace in order to attend school with other boys his age in the imperial family and also learn the arts of war, which formed an important part of the Manchu way of life. This gave him the chance to spend a great deal of time in the Kangxi emperor's company; a month later, when the emperor left Beijing for the imperial mountain retreat at

Chengde, Hungli went along, as did Prince Yong. Hungli spent the next six months there in the constant companionship of the emperor, then in the last months of his life. The emperor showed his affection for the boy by sharing his meals with him, granting him gifts of calligraphy, correcting his compositions, and training him in archery and riding.

When he had made sufficient progress, one fateful day the Kangxi emperor decided to bring Hungli with him on a hunt. This is the way he told the tale, fifty years later:

That year my grandfather went on the autumn hunt to Mulan. I remember that, as we entered the first clearing at the hunting grounds, a place known as "the sand dune," there was a bear. Grandfather shot it with his gun and the bear fell and lay still. After a while, he decided it was dead, and ordered one of his men to take me close to it so I could shoot it with an arrow. He wanted to make me look good, as though I had bagged a bear on my first hunt. I was just mounting my horse when the bear suddenly rose up and came running toward me. Grandfather finished him off with the tiger gun.

The near miss with a wounded bear, an encounter that could easily have cost Hungli his life, was widely interpreted as a sign of divine protection and of the boy's courage:

When this was all over, grandfather went back to his tent and related the bear incident to one of his consorts there, pointing to me and saying, "His life is precious! I wanted him to go over to where the bear was, and then the bear got up and his horse panicked. But he treated it all as if it were nothing."[8]

The Qianlong emperor made much of his grandfather's affection for him, noting that he was not worthy of the special attention he had received, which he would never forget.[9] The story became part of the mythology that surrounded him, and no one else would forget it, either.

1755: The Conqueror

In the twentieth year of his reign, the forty-four-year-old emperor faced one of the biggest trials of his life: the confederation of Western Mongols, known as the Dzungars, arose to challenge Qing rule. The emperor's military response to that threat decisively shaped the future, not just of Qing China, but of all East and Central Asia, too,

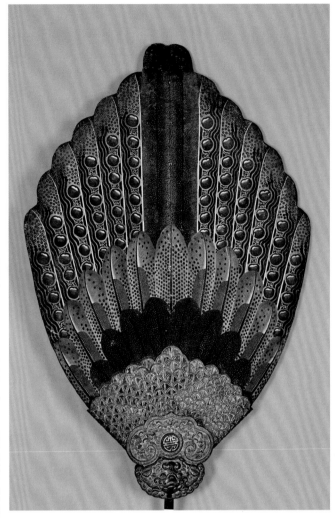

Plate 4. Court fans (pair) (cat. 21).

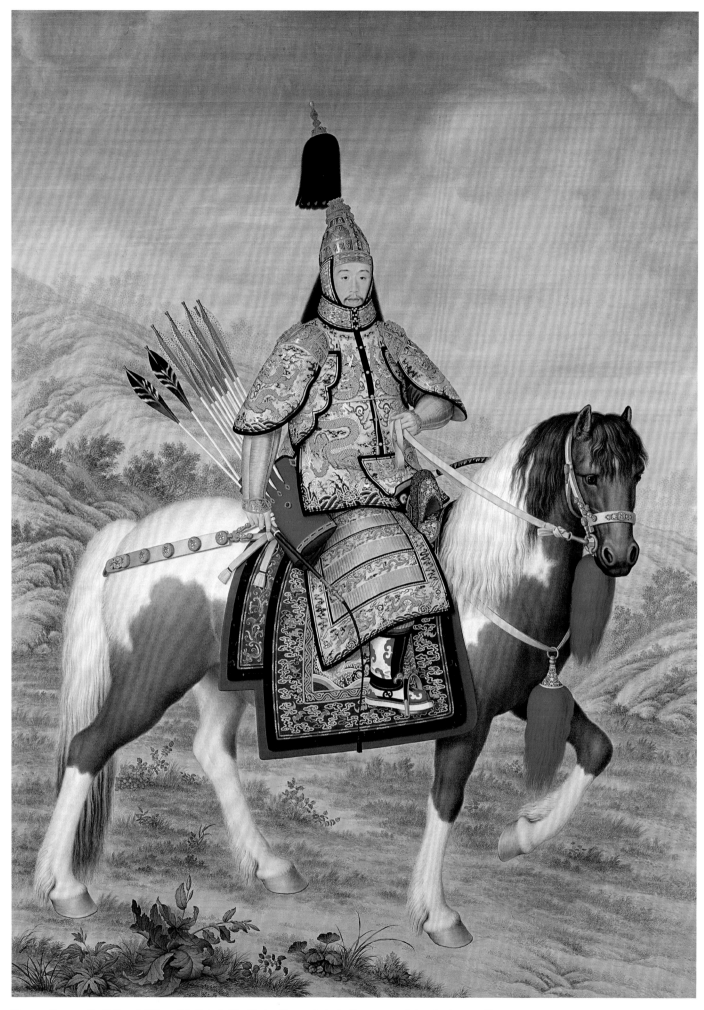

Figure 1. Giuseppe Castiglione (1688 – 1766), *Portrait of the Qianlong Emperor Reviewing Troops*, 1700s. Ink and colors on silk, 127 x 91 1/4 inches (322.5 x 232 cm). Palace Museum.

stamping the outline of the modern map on the region for the first time.

The problematic relationship between the Manchus and the Western Mongols centered on strategic domination of the Mongolian grasslands – long the launching point for nomadic strikes into China proper – and the loyalty of Tibetan Buddhists across Inner Asia. Recurrent political divisions within the Mongol world in the early 1600s, which prevented the resurgence of a unified steppe empire on the model established by Chinggis Khan, worked to the advantage of the Manchus, who sought to recruit not only Mongol allies but also Tibetan religious elites, who offered spiritual support for Manchu political legitimacy. In the second half of the 1600s, however, competition arose between the Qing and the Dzungar confederation, led by the ambitious Dzungar leader Galdan. This rivalry came to a head in 1696, when the Kangxi in pursuit of Galdan, defeating his forces in a battle joined a thousand miles from Beijing, near modern Ulan Bator.

The Dzungars retreated to the west at this point, but further trouble erupted in 1717, and again in 1729. When the Yongzheng emperor died, negotiations were underway to conclude a treaty with the Dzungars; one of the Qianlong emperor's first foreign policy achievements was the signing of that treaty in 1739, after which a border was drawn and a schedule of trade missions put in place. This arrangement fell apart in 1754, when internal power struggles and the resurgence of Dzungar imperial aspirations again sent thousands of refugees flooding east into Qing territory, creating a serious crisis on the northwestern frontier. The Qianlong emperor resolved to end the Dzungar problem once and for all. In 1755, just as he was sending troops west, he wrote:

In the past, my grandfather on many occasions attacked the Dzungars, but the barriers separating those tribes proved too tough, and, lacking an opportune moment, he had to settle for a temporary truce and withdrawal. In recent years, [they] have been fighting and murdering each other, causing endless internal disorder. As universal lord of the lands under Heaven, my authority covers all, so it is right that I should act to regulate the affairs of the nomads with an eye to the long run.[10]

The campaigns lasted from 1755 until 1760. They were successful beyond anyone's expectations. Not only was the Dzungar threat removed, but other destabilizing forces unleashed by the fall of the Dzungars were also brought under Qing control, extending the emperor's writ beyond the Gobi as far as the Kunlun and Pamir mountains – farther than under any other East Asian ruler since the days of the Mongols.

These substantial territories in the west – what would later become Xinjiang – increased the empire's size by one-third, cementing the Qianlong emperor's place among history's great conquerors. When he was much older, he fancifully styled himself "Old Man of the Ten Perfect Victories," in reference to his military accomplishments. Immediately following his victories in the west, he sought to broadcast the image of Qing greatness and his own personal power. He commissioned triumphal portraits of himself in glittering regal armor (figure 1) – never worn in battle, it should be said – along with one hundred large portraits of the heroes of the campaign, complete with the details of their valorous acts. A series of sixteen prints depicts key moments in the conquest of the western frontier (figure 2). Based on drawings made on the spot, the final versions were approved by the emperor before being sent to Paris to be engraved on copper plates and printed, which ensured their wide circulation in both Europe and China. In addition, there were countless celebratory songs and poems, official histories documenting the righteousness of the Qing cause, maps to formalize the inclusion of new territory within the empire's borders, and stone monuments erected with edifying inscriptions. The material record of this orgy of celebration largely survives, a testament to the power and wealth of the Qing empire at its height.

1775: The Little Princess
In 1775, the Qianlong emperor was sixty-four, which many would regard as retirement age. But he still had much to do and the resources to do it with. Prosperity was all around him. The population of the empire was around 275 million, up 50 million since he assumed the throne. Vast new areas of farmland had been brought under cultivation. A coordinated system of local granaries enabled the state to stabilize the price of rice and move quickly if drought or famine struck. A broad

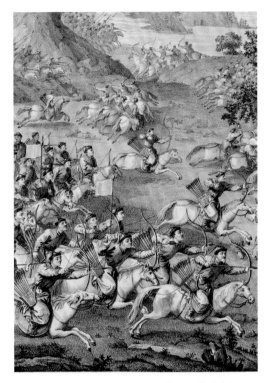

Figure 2. Jean-Denis Attiret (1702–1768), *Bataille d'Altchou gagneé par Fou-de contre les deux Hot-Chom Août 1759*, 1764 (detail). Copperplate print on paper, 12 1/2 x 17 1/8 inches (31 x 43.5 cm). Phillips Library, Peabody Essex Museum.

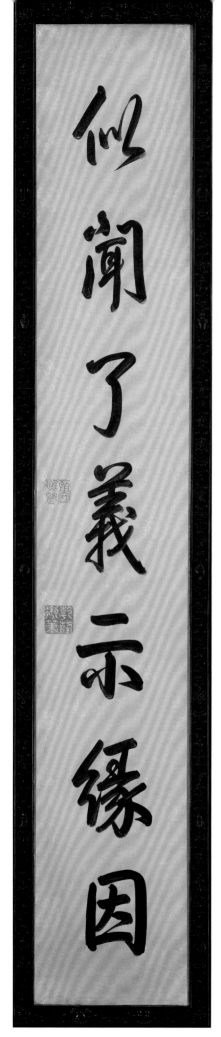

Plate 5. Qianlong Emperor, Calligraphic couplet (cat. 48).

assortment of goods flowed freely from province to province, and exports of tea, silk, and porcelain, mostly to Europe, were on the rise. Even limiting Western merchant ships to one port of call that year had not dented foreign demand for Chinese products. Urban culture flourished. If the emperor competed with other patrons who sought to hire the best opera troupes, buy the finest paintings and antiques, or assemble collections of rare books, his interests helped to spur artistic, literary, and scholarly production and its dissemination (plate 5).

Nothing illustrates this better than the Qianlong emperor's decision to compile a comprehensive anthology of two thousand years of Chinese writing. Begun in 1771, the titanic *Siku Quanshu* (Complete Library of the Four Treasuries), was well underway by 1775. The emperor's call for "all books . . . that clarify the essential methods of government or human nature" to be sent to the capital had unleashed a flood of material. An enormous staff was employed to sort through it all, select the most outstanding titles not already in the imperial collection, compare editions, and oversee the creation of the definitive text. This first phase was completed in 1782, with a single set totaling 36,000 volumes. But what with the emperor's demand for six additional copies, annotated indices, and tables of contents, work stretched on for another ten years. Three sets were sent as gifts to major libraries in the south, giving scholars access to rare items that otherwise were unavailable. Historians disagree as to whether the project's benefits outweighed the loss of nearly 3,000 titles deemed offensive to Manchu sensibilities, but the scale of the project – the contemporary literary equivalent of a particle accelerator – beggars the imagination. One cannot say that the Qianlong emperor was afraid to think big.

Whatever fulfillment the emperor drew from the *Complete Library* project, or any of the other massive editorial projects he undertook during these years – descriptive catalogues of the imperial art collections, a new edition of the Ming history, and Manchu-language translations of Buddhist sutras (figure 3) and the entire Tripitaka among them – it could not make up for the absence among his many children of a son upon whom he could confidently rely to take his place. Indeed, if the Qianlong emperor suffered any tragedy, it lay here, in his private life. By 1775, he had buried two empresses and eighteen of his twenty-seven children (four sons died before even receiving a name).[11] Considering this, one wonders whether in the generation of so many brilliant compilations and impressive paintings, in the construction of splendid palace buildings and elegant gardens, the emperor was seeking to compensate in some way for his own meager physical legacy. The sons he considered most promising had both died young; of those who lived beyond their twenties, only two demonstrated any ability for the rigors of governance and only one was still alive in 1795. More or less by default, this son, the fifteenth, became the new emperor (plate 6).

It would be a mistake to think that the sorrow that came with so much loss did not weigh heavily upon the emperor. When his seventh son, just one year old, succumbed to smallpox on the eve of the lunar New Year, January 29, 1748, he wrote:

The seventh imperial son, Yongcong, was born and died in the palace. . . . As he was her own son [i.e., not born of another consort], the empress loved him most dearly. I also held fond hopes of raising him. . . . From my great-grandfather down to me, there have been none who have become emperor in our house who were born of the empress herself. Surely this is not for lack of wishing it, only bad luck; but it seems that this nonetheless has become a family tradition. [With Yongcong] I was privately celebrating that the son of my empress would succeed me, that I would do something my forebears had not done, and that I would receive a blessing they had not known. Now this. Was it not my own fault?[12]

Apart from the emperor's guilt, the death of this son was a severe blow to the boy's mother, Lady Fuca (figure 4). Her delicate state caused the Qianlong emperor considerable concern, for he had been happily married for more than twenty-two years. To take her mind off things, he brought her and his mother (who went everywhere he did and lived to age eighty-four) along on a tour of Shandong Province to visit the birthplace of Confucius and other sites. The change of scenery seemed to benefit Lady Fuca, but an unexpected cold snap caught the imperial party by surprise. The empress, suddenly ill, took to her bed as snow fell outside, and died a week later. The emperor never got over this loss; fifty years later, he was still writing love poems to her.[13]

All this heartbreak may help explain why he grew so attached to the princess who was born in 1775, Hexiao. Her father's last child, Princess Hexiao was showered with gifts, and surely must have been one of the most doted-upon little girls in world history. Yet, she grew up strong and sensible. She was an able rider, often accompanying her father when he went hunting. On such occasions, we are told, she dressed in men's clothes, which must have accentuated the family resemblance to him that people noticed. Indeed, the story is that the emperor once told her: "Had you but been a boy, I would have made you my heir!"[14] When she was fifteen, she was married to the son of the Qianlong emperor's right-hand man, Hešen (in Chinese, Heshen), in a wedding famous for the sensational extravagance of the bride's dowry. For a few years, Princess Hexiao and her husband lived well. It all came crashing down after her father's death, however, when the extent of her father-in-law's corruption was finally revealed. He was stripped of his positions and titles and ordered to commit suicide; her husband was spared, but the couple was forced to surrender most of their possessions. They lived modestly afterward, the thirty-something Princess Hexiao carefully managing household expenses. By the time she died – also prematurely, at age forty-eight – the glories of the Qianlong age were a distant memory.

1795: Abdication

The young guardsman Hešen had been appointed in 1775 – the year of Princess Hexiao's birth – to the Grand Council, the highest decision-making body in the Qing empire. Just as his spectacular rise was unprecedented, so his spectacular disgrace at the end of the Qianlong reign was not unexpected. Everyone save the emperor knew of Hešen's unbounded avarice, but because of the emperor's unwavering support, even the most powerful ministers could not effectively challenge him. For two decades, corruption spread throughout all ranks of government. By 1795, the Qianlong emperor's early insistence on accountability and official integrity were long forgotten. The fall in 1799 of Hešen – who, it turned out, had amassed more wealth than the emperor himself – offered a damning commentary on the last years of the Qianlong age.

It was not supposed to be this way. When the young Hungli took the throne, he had already

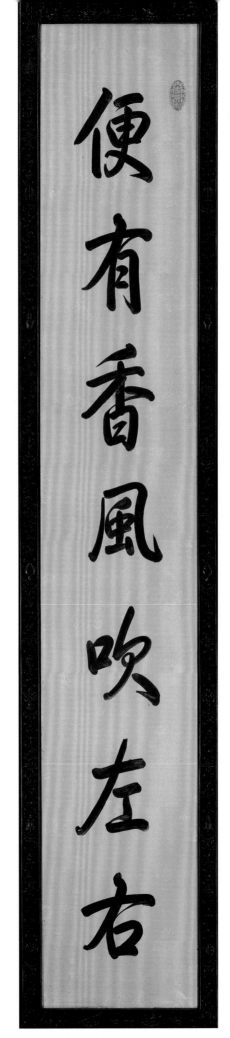

Plate 5. Qianlong Emperor,
Calligraphic couplet (cat. 48).

41

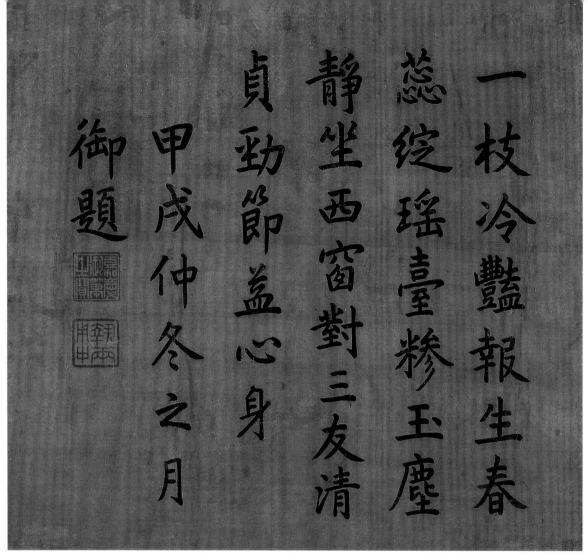

一枝冷豔報生春
蕊綻瑤臺糝玉塵
靜坐西窗對三友清
貞勁節益心身
甲戌仲冬之月
御題

Above, Plate 6. Jiaqing Emperor, Calligraphic inscription, 1814 (cat. 46).

Below, Figure 3. Draft of the *Sutra of Heroic Progression* (in Manchu, *Akdun yabungga sere nomun*) with corrections by the Qianlong emperor in vermilion ink, circa 1763. Harvard-Yenching Library, Harvard University.

planned a dignified exit for himself, announcing that his reign would not exceed in length that of his grandfather, the Kangxi emperor. Should he be fortunate enough to live so long, he would abdicate and go into retirement after the sixtieth year of his reign. In 1795, the sixtieth year had come. As he approached this milestone, the Qianlong emperor, in his early eighties, showed few signs of slowing down. He remained physically active, traveling to Shandong in 1790 and Shanxi in 1792, and hunting at the summer retreat at Chengde every year. The ongoing military campaign on the border with faraway Nepal retained his attention, as did the outbreak of a major rebellion in Hunan in 1794; nor did he need glasses to read the reports that came in. He was even spry enough to host an embassy from the British king, which arrived in 1793, uninvited, to pay its respects to the emperor and open negotiations for improved terms of trade and regular diplomatic contact. Though the ambassador, Lord Macartney, achieved few of his stated aims, he was cordially received and recorded a generally positive impression of the emperor: "He is a very fine old gentleman, still healthy and vigorous, not having the appearance of a man of more than sixty."[15]

Strong as he was, the emperor meant to keep his promise. In 1771, he began designing the retirement compound that included what we now call the Qianlong Garden. In 1772 and 1778, he repeated publicly his intention to step down after his sixtieth year. After 1793, concrete plans for the formal transfer of power began to take shape. The dynasty's jade seal, the token of imperial authority, would be transferred to his successor and the Qianlong emperor would get a seal with his new title, *tai-shang huang*, "supreme emperor." He would move out of the main parts of the palace and occupy a new residence, the Ningshougong, in the northern precincts of the Forbidden City.

The lunar New Year came, a generous tax amnesty was announced, and the reign of the Jiaqing emperor was officially proclaimed with fanfare – but little else changed. The Qianlong emperor continued to occupy his old quarters; he retained the right to use the personal pronoun, *zhen*, used by the emperor alone; dates at court continued to use the Qianlong reign name (public calendars switched to Jiaqing); and he reserved the power to issue edicts and take part in policy discussions

and decisions. He even could remove people from office.[16] In short, his filial abdication was an empty gesture; for all practical purposes, the empire now had two rulers.

This state of affairs lasted for some three years. The Jiaqing emperor, beholden to the same filial standards that bound his father, had little recourse but to stand by and reign while the Qianlong emperor continued to rule – or, as he put it, to "train" his son in politics. Perhaps one reason he found it difficult to let go was that major rebellions had broken out across several provinces of central China, and he hoped to secure one last personal triumph on top of the "ten complete victories" to guarantee his historical legacy.[17] In the end, this satisfaction was denied him. He died on February 7, 1799, holding his son's hand and telling him how sorry he was to be leaving unfinished business behind.

During his later years, the Qianlong emperor thought carefully about where he would live as an old man, devoting a great deal of attention to creating the Ningshougong and the attached grounds we now know as the Qianlong Garden. He never actually took up residence there. But there was another part of the Forbidden City that he also refurbished at this time, and where he did regularly go. This was the Chonghua Palace, which contained the rooms he had occupied while his father was emperor, after he was first married, and which he now had turned into a kind of museum. The furnishings were restored to what they had been in the early 1730s, when he and Lady Fuca lived there together, including twin cabinets that were part of her dowry. In the cabinet on the eastern side of the room were displayed items given him by the Kangxi emperor; in the cabinet on the western side were things given to him by his father and his mother. Elsewhere were displayed other possessions he had used as a boy. "Let my descendants visit whenever they will to have a good look," he said in 1795, "for here they will find preserved the traces of my deeds and words."[18]

We may find it audacious that the emperor created his own memorial hall, filled with objects of purely personal significance. Indeed, it is tempting to dismiss this as yet another of those grandiose and egotistical excesses so often associated with the Qianlong emperor. Yet, it is worth

recalling that the Chonghua Palace paid homage not to him but to the most influential people in his life. Its main purpose, it seems, was to produce a kind of home movie of his younger days, a place where time stood still and he could return to a better, happier past. With the Ningshougong and its garden, these two spaces bookended the emperor's life. Invested in them as he was, by putting his individual stamp on the design of these private places, now miraculously being restored, the Qianlong emperor reveals much about himself to us today, if we will take the trouble to look.

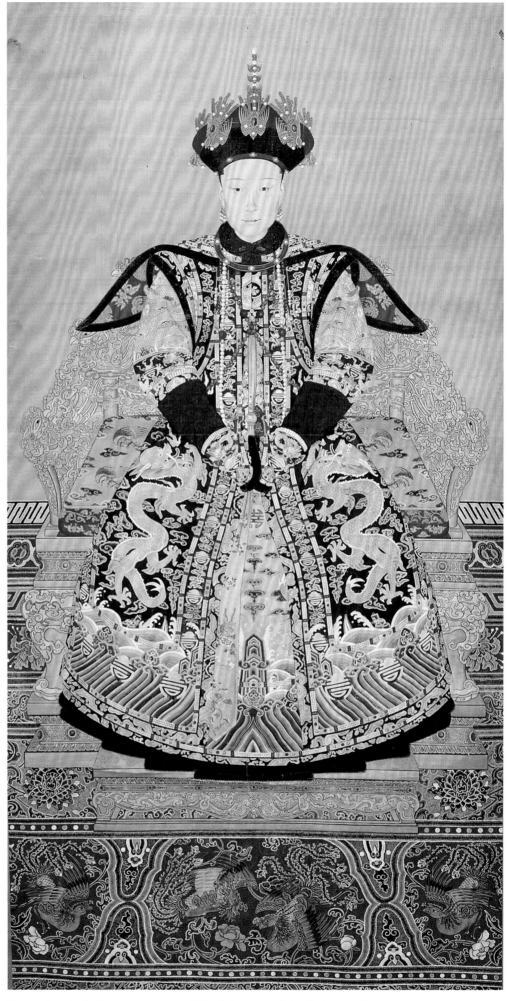

Figure 4. Portrait of a Qianlong empress, possibly Lady Fuca, 1700s. Ink and colors on silk, 108 1/4 x 51 1/2 inches (275 x 131 cm). Peabody Essex Museum.

Notes

1. Qing Gaozong, *Leshantang quanji dingben* (Beijing: Neifu, 1758), prefaces.

2. Ibid., *juan* 7, pp. 15a–16a, "Jiguzhai wenchao xu."

3. Ibid., prefaces, pp. 10a–11a. Hungjeo's preface repaid his brother for the preface Hungli had written for Hungjeo's own collection of poetry a couple of years earlier. When Hungjeo turned thirty *sui* (twenty-nine years old), Qianlong wrote him a congratulatory poem. Qing Gaozong, *Yuzhishi chuji* (Bejing: Neifu, 1749), *juan* 4, pp. 26a–b.

4. Qing Gaozong, *Leshantang quanji dingben*, prefaces, p. 1b.

5. Ibid., prefaces, pp. 10a–11a.

6. This was reported by the Korean ambassador in Beijing at the time. See *Kyongjong sillok*, vol. 10, 1722/12/17 (lunar calendar), from the online *Yijo sillok (Annals of the Choson Dynasty)*, provided by the National Institute of Korean History, http://sillok. history.go.kr/ (accessed October 15, 2009).

7. Hungli's father hosted dinners for the Kangxi emperor twice in quick succession, once on April 27, just before the emperor's birthday, and on May 10. *Qing Shengzu shilu* (Taibei: Huawen, 1964), *juan* 297, pp. 3a–4b. The initial meeting between Hungli and his grandfather could have taken place on either occasion.

8. Qing Gaozong, *Yuzhishi wuji* (Beijing: Neifu, 1795), *juan* 93, p. 14b, "Entang ji."

9. Qing Gaozong, *Leshantang quanji dingben*, *juan* 8, pp. 1a–2b, "Huangzu shengzu renhuangdi enci yushu ji."

10. *Qing Gaozong shilu* (Taibei: Huawen, 1964), *juan* 490, p. 21a.

11. His first empress, Lady Fuca (later Empress Xiaoxian), died in 1748; the second, Lady Ula Nara, in 1766. Of seventeen sons born between 1728 and 1766, only six were still alive in 1775; of nine daughters born during this same time, only two survived. The average lifespan of a child born to the Qianlong emperor amounted to a mere twenty-two years.

12. *Qing Gaozong shilu*, *juan* 305.

13. Here is the last one, written in 1798: "I wanted to drive past without stopping, / But hiding my feelings earns no comfort, either. / No harm in offering three cups; / The four seasons announce another winter. / The pine trees I planted are old now, tall and scaly; / They open to the clouds and the broad blue sky. / Holding hands, I lead you back to the house; / What joy is there in longevity?" Qing Gaozong, *Yuzhishi wuji*, *juan* 95.

14. Zhaolian, *Xiaoting xulu* (Taibei: Wenhai chubanshe, 1967), *juan* 5.

15. J. L. Cranmer-Byng, ed., *An Embassy to China: Lord Macartney's Journal, 1793–1794* (Hamden, Connecticut: Anchor Books, 1963), p. 123.

16. *Qing Gaozong shilu*, *juan* 1496.

17. *Qing Gaozong shilu*, *juan* 1499.

18. *Qing Gaozong shilu*, *juan* 1489.

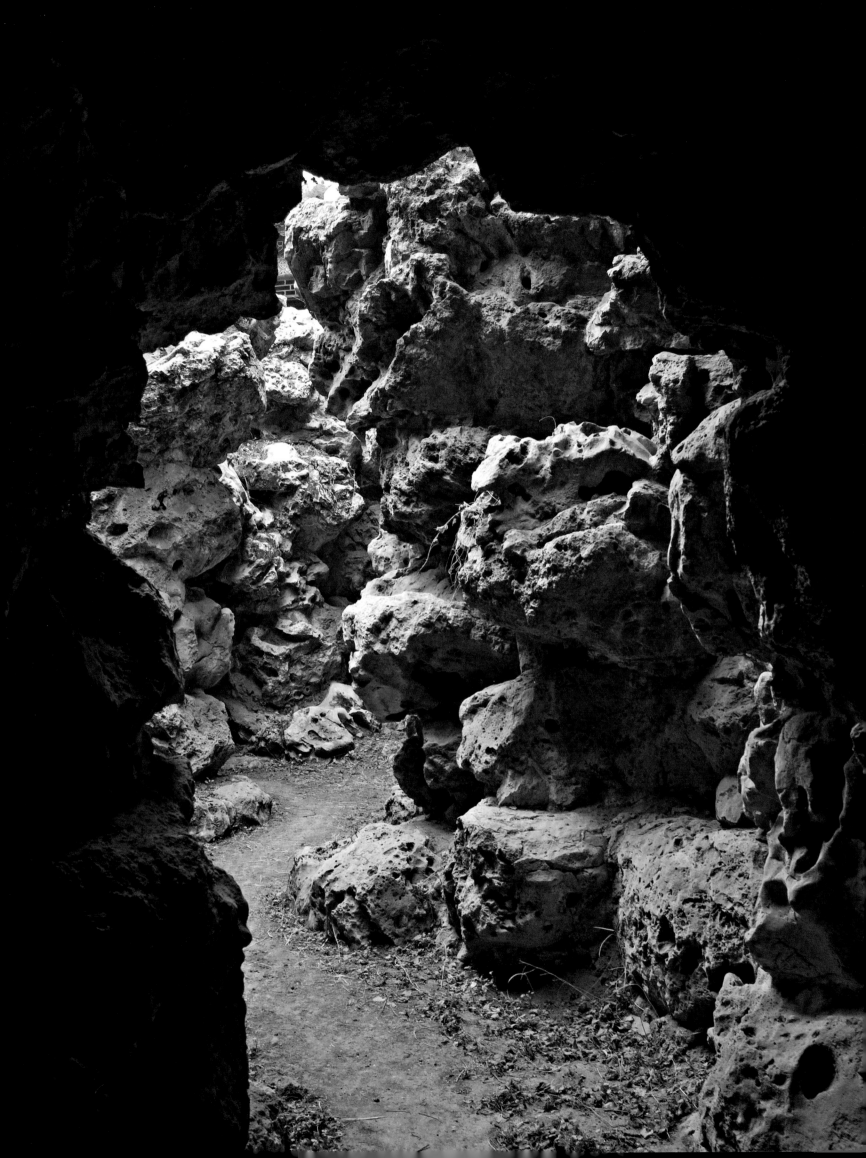

Gardens for Emperors and Scholars

皇
帝
與
文
人
的
花
園

Nancy Berliner

When the Qianlong emperor, one of the great art connoisseurs of all times, conceived of an enclosed garden within the Forbidden City for his future private leisure and inner cultivation, he was building on a Chinese artistic tradition that had evolved over three thousand years. As early as the Shang dynasty (circa 1600–1046 BCE), powerful rulers created landscaped spaces to refresh their spirit and escape the demands of politics. The art of these spaces evolved into a highly sophisticated form incorporating rocks, trees, paths, and architecture, as well as literary and historical references and the reflection of the owners' morality, wisdom, and values. These retreats came to encompass a multitude of other art forms, such as painting, poetry, calligraphy, and even antiquities – disparate and stimulating elements to be experienced in an aesthetically appropriate rhythm.

Early Imperial Expanses and the Escape into Nature

The fundamental literary and artistic elements and standards for these enclosures developed over time, adopting characteristics and features appropriate to their epochs. During the Shang dynasty – an organized, hierarchical society in the Yellow River Valley area – kings put aside large landscape enclosures for hunting. Under the Zhou dynasty (1045–256 BCE), a time that saw the introduction of the social and political theories of Confucius and the Daoist philosophical concepts of "non-action," the enclosures began to include pavilions, terraces, and guest houses – indicating longer and more activity-filled times within the domains. Records from 206 BCE to 220 CE – while the conquering Han dynasty expanded westward and the Chinese were beginning to hear about Buddhist teachings in India – reveal grand palaces, rare and exotic plants, animals, and minerals within the confines of these grounds.[1] With possessions from far and wide and palaces in which to fête and flatter important guests, the estates had become excellent means for a ruler to flaunt his affluence and dominion.

Increased urbanization and the politicization of Chinese governing and educated classes, in parallel with the growing influence of Buddhism and Daoism that encouraged flowing with the ways of nature, prompted scholarly members of society to seek more humble and ascetic retreats. The master calligrapher Wang Xizhi (303–361) in his *Preface to the Orchid Pavilion Collection*, described how

he and his friends delighted in the richness of nature (figure 1).

In the ninth year [353 CE] of the Yonghe [Everlasting Harmony] reign, which was a guichou [cyclical] year, early in the final month of spring, we gathered at the Orchid Pavilion. . . . Young and old congregated, and there was a throng of men of distinction. Surrounding the pavilion were high hills with lofty peaks, luxuriant woods and tall bamboos. There was, moreover, a swirling, splashing stream, wonderfully clear, which curved round it like a ribbon, so that we seated ourselves along it in a drinking game, in which cups of wine were set afloat and drifted to those who sat downstream . . . what with drinking and the composing of verses, we conversed in whole-hearted freedom, entering fully into one another's feelings. The day was fine, the air clear, and a gentle breeze regaled us, so that on looking up we responded to the vastness of the universe, and on bending down were struck by the manifold riches of the earth. . . . Indeed, for the eye as well as the ear, it was pure delight![2]

References to Wang Xizhi, his calligraphy, sentiments, and the assembly of friends by the stream – later referred to as the "elegant gathering" – became popular in Chinese gardens (figure 2). Fourteen hundred years later, the Qianlong emperor would put toward the forefront of his garden an abstracted stream alluding to the event (figure 3).

Political upheavals and court corruption during the three centuries following the end of the Han dynasty had a profound impact on many scholars more interested in finding harmony than wielding power. Caught between the proper, accepted ethics of serving in the government and their own moral principles, they turned to Daoist ideals and withdrew to the mountains, far from the scandals and "dust" of politics. Such men, their writings and their lifestyles, became enduring icons in Chinese painting and poetry, models for pure living and ultimately archetypes of sensibilities to be pursued in gardens. The Seven Sages of the Bamboo Grove, a quasi-historical third-century group of Daoist scholars often depicted in art and poetry, would gather for music and "pure conversation" in the mountains outside the capital of Luoyang (in modern Henan Province), to value the simple and rustic over the wealth and superficiality of court life (plate 7).

The poet Tao Qian (365–427; also called Tao Yuanming), disappointed with government politics

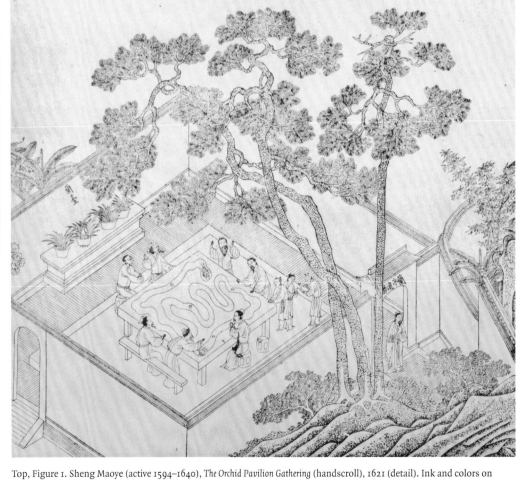

Top, Figure 1. Sheng Maoye (active 1594–1640), *The Orchid Pavilion Gathering* (handscroll), 1621 (detail). Ink and colors on silk, 12 3/8 x 86 inches (31.4 x 218.4 cm). University of Michigan Museum of Art, Museum Purchase made possible by the Margaret Watson Parker Art Collection Fund, 1974/1.244.

Left, Figure 3. The Xishangting waterway in the Qianlong Garden.

Right, Figure 2. Qian Gong and Huang Yingzu, *Huancuitang yuanjingtu* (Illustration of the Gardens of the Hall Encircled by Jade), circa 1610 (detail). Original woodblock print on paper published by Wang Tingna. Reproduced in Beijing: Zhongguo Meishu Chubanshe, 1981. Phillips Library, Peabody Essex Museum.

Pages 47–50. Passageway through rockeries below Lutai; detail of a rockery in the first courtyard; chasm and grotto in the rockeries of the third courtyard. Pages 46 and 51, Panel (hanging) (cat. 23, detail).

Plate 7. Du Yuanzhi, *Seven Sages in a Bamboo Forest* (scroll) (cat. 83, detail).

Figure 4. Chen Hongshou (1599–1652), *Scenes from the Life of Tao Yuanming* (handscroll), 1650. Ink and colors on silk. Honolulu Academy of Arts, Purchase, 1954 (1921.1).

and corruption, retired to the pastoral life (figure 4). He wrote about himself in the third person:

Quiet and of few words, he does not desire glory or profit. He delights in study but does not seek abstruse explanations. Whenever there is something of which he apprehends the meaning, then, in his happiness, he forgets to eat. . . . His house with surrounding walls only a few paces long is lonely and does not shelter him from wind and sun. His short coarse robe is torn and mended. His dishes and gourds are often empty, yet he is at peace.[3]

The purity of life in the mountains came to exemplify a desirable lifestyle in Chinese society and eventually was incorporated into gardens within the urban environment. The savoring of nature as expressed in poetry and painting reached one of its first apogees during the Tang dynasty (618–907), a time of great urbanization and bureaucratization. The capital of Chang'an (today's Xi'an) attained a population of one million people. Half of them lived within the gridded streets of the enclosed fifty-two square miles and half lived just outside the walls. To the north of the walled city, the imperial palace boasted an expansive and luxurious garden and park. Many others among the privileged in this teeming city also found refreshment in more modest retreats.

An often referenced, transformative moment in garden design during this period was the creation and subsequent visual depiction of the Wangchuan Bieye (Wang River Retreat) or Wangchuan Villa as it is sometimes referred to in English. It was established by the poet, artist, and musician Wang Wei (699–759) in the outskirts of Chang'an. Wang Wei had already set new standards in Chinese art for initiating an expressive style of monochrome landscape painting. His sensitive use of the brush caused the later Song artist, poet, art critic, and government official Su Shi (1037–1101) to remark that "in [his] paintings is poetry, and in [his] poetry are paintings" – a comment that would inspire literati, *wenren*, painters of the Yuan and Ming dynasties.

Wang's evocations of his retreat would also be a revolutionary and influential integration of poetry, painting, and gardens. He created his retreat in order to lead the life of a recluse after years of a metropolitan existence. Depicted in his celebrated painting *Picture of Wangchuan* (today known only

in copies), his estate consisted of a series of spaces or enclosures for growing vegetables and fruits, and modest buildings (figure 5). The artist assigned each scene or place a name: Bamboo Lodge, Sophora Path, and so on. *Wangchuanji*, the Wang River Collection, with twenty of his poems, describes the garden and his feelings about being there. Wang did not exclude the human presence or architecture from his landscapes. His paintings show him in his house; his poetry reveals him standing at his thatch door and looking out onto the world around him. "Within the window, are all the lands of Chu,"[4] he wrote, encapsulating the microcosm concept that would become a basic element of both landscape painting and garden design: seeing the large within the small, or, as is commonly said in Chinese garden building: "Heaven and earth within a jar." As Jiaoran (730–799), a contemporary of Wang Wei, wrote: "A thousand peaks can all be counted, without leaving this small window."[5]

A good distance from the bustling city and with a distinct agricultural base, Wang's retreat was not yet the mature paradigm of later Ming and Qing gardens: tightly designed compact spaces within an urban setting with man-made mountains of imported rocks. However, it does represent an initial and forceful example of the amalgamation of the nature retreat with the other arts and philosophies of China. Natural surroundings, painting, poetry, and architecture were merging into the art form that would characterize later gardens. As social and bureaucratic constructs evolved, isolated retreats for leisure and contemplation became of ever greater interest to nonimperial members of society. Some were simply enclosed expanses of natural land but others were man-made constructs of waterways, bridges, and pavilions. Rockeries to create models or symbols of mountains had entered the repertoire by the sixth century. "Rhapsody on the Courtyard Mountain," a poem from this time by Jiang Zhi (dates unknown), praises garden aficionado Zhang Lun and the artificial peaks in his Luoyang garden: "foliated crags and layered ranges, pointy and precipitous, leading into one another."[6]

Imperial Landscapes
One legendary and grandiose garden arose at the beginning of the twelfth century under the direction of Song Huizong (1082–1135, r. 1100–1126).

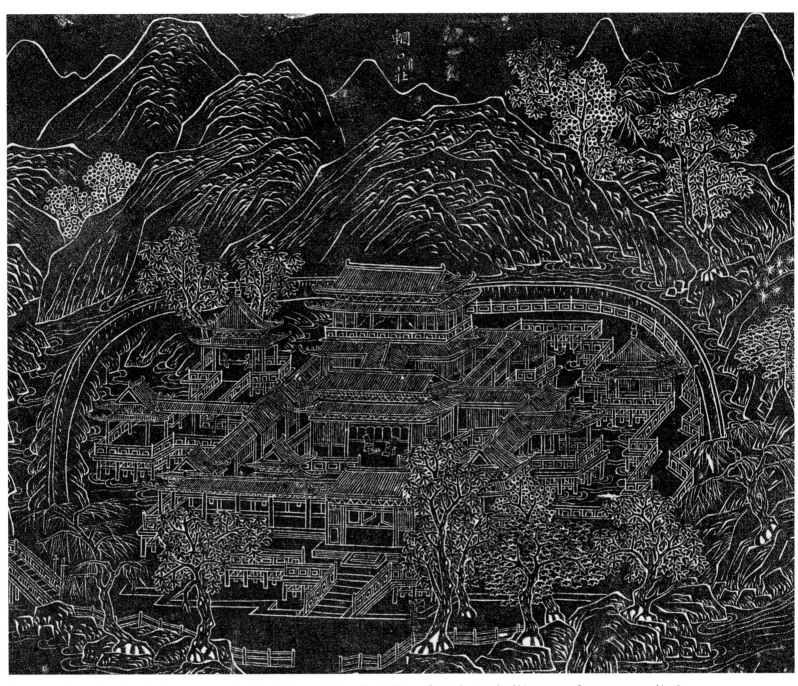

Figure 5. Attributed to Guo Zhongshu (circa 910–977), after Wang Wei (701–761), *Wangchuantu* (Picture of Wangchuan). Ink rubbing on paper from stone engraved in 1617, 325 x 12 1/2 inches (825.5 x 31.8 cm) (detail). East Asian Collection, University of Chicago Library.

Figure 6. Emperor Song Huizong (r. 1101–25), *Tingqin tu* (Listening to the Lute), Song dynasty (960–1279). Ink and colors on silk. Palace Museum.

This emperor, ultimately blamed for the downfall of the empire, amassed over six thousand paintings and calligraphies and commissioned a catalogue of the collection with biographies of the artists,[7] which the Qianlong emperor would consult when looking at ancient paintings; Huizong also assembled and had catalogued a substantial collection of ancient bronzes.[8] He was a poet, adept on the refined qin zither, a superb painter, and a long-imitated calligrapher (figure 6). In his pursuit to be the exemplary connoisseur, he also created a garden compound of lasting, monumental reputation.

The estate, Genyue (Northeast Marchmount), lay just outside the Song capital of Bianliang (modern Kaifeng). Its stated purposes were to build monumental "mountains" in order to promote the birth of male heirs and to develop a microcosm of the emperor's domain containing its finest plants, animals, and "mountains." Unlike earlier imperial retreats, this garden did not merely enclose and rely on the existing contours of the land but utilized imported natural components to compose a landscape.

Knowing of Huizong's love of rocks, courtiers and officials sought to curry favor by sending the most outstanding examples for his compound. An official agency was established in Suzhou, the source of the emperor's silks and embroidery, to obtain rare and precious rocks and plants. They were conveyed via the "Flower and Rock Network," a route along rivers and canals to the capital. Dark, sonorous rocks came from quarries in Lingbi (in modern Anhui Province), the famed Taihu rocks with dramatic cavities came from the depths of Lake Tai near Suzhou. Still others were confiscated from personal collections. The transport of one particular massive boulder was said to have required one thousand laborers and the destruction of bridges, city walls, and water locks. To construct Genyue, the emperor also imported artisans from Wuxing on Lake Tai (modern Huzhou), which was famous for its gardens and rockeries. A contemporary record describes the impressive energy that went into constructing Genyue and the overpowering result:

They mobilized myriad numbers of irregular troops to construct hillocks and mounds, more than ten ren [approximated to be 164 yards] in height, to which rocks were added from Lake Tai and Lingbi. . . . Imposing and upthrust, jagged and erect, in achievement they surpass heavenly creations. All of the rocks are furious and angry, pushing and shoving, as if they were kicking and biting. Teeth, horns, mouths, noses, heads, tails, claws and spurs – a thousand postures, ten thousand shapes, thoroughly marvelous and completely fantastic.[9]

Smaller than the hunting estates of Han and Tang rulers,[10] Genyue was designed to create the sense of infinite spaces within tighter confines. It included luxurious pavilions, pools, waterfalls, a plethora of flora and fauna, and countless scenes and vistas to evoke the breadth of the emperor's domain.

Genyue was totally destroyed in 1126, even before Huizong's own tragic demise. In the turmoil of an assault by Jin invaders from the north, the local populace felled the trees and tore down the palaces for firewood. Soldiers hunted the animals. And, the conquering Jin seized some of the most magnificent rocks to decorate their new capital in Zhongdu (modern Beijing). Over six hundred years later, some of these very rocks would find a place in the gardens of the Qianlong emperor.

Garden traditions and arts remained very much alive under the Yuan (1271–1368), the Mongol dynasty that finally overthrew all of China in 1279, and then during the Ming dynasty (1368–1644) among the literati gentry, particularly in the Jiangnan region where the Song court had fled after their defeat by the Jin. The story of a wondrous imperial estate established by Khubilai Khan (1215–1294), founder of the Yuan dynasty and grandson of Genghis Khan, spread to Europe. Marco Polo first described the enclosure, made vivid centuries later with the publication in 1797 or 1798 of Samuel Taylor Coleridge's haunting poem "Kubla Khan."

In Xanadu did Kubla Khan
A stately pleasure-dome decree:
Where Alph, the sacred river, ran
Through caverns measureless to man
Down to a sunless sea.
So twice five miles of fertile ground
With walls and towers were girdled round:
And there were gardens bright with sinuous rills,
Where blossomed many an incense-bearing tree;
And here were forests ancient as the hills,
Enfolding sunny spots of greenery.[11]

According to Marco Polo's description of the garden palace of Khubilai Khan:

When the traveler leaves this city [the capital city of Dadu, modern Beijing] and journeys north-north-east for three days, he comes to a city called Shang-tu, which was built by the Great Khan now reigning, whose name is Kubilai. . . . Another wall . . . encloses and encircles fully sixteen miles of park-land well watered with springs and streams and diversified with lawns. . . . Here the Great Khan keeps game animals of all sorts, such as hart, stag, and roebuck. . . . In the midst of this enclosed park, where there is a beautiful grove, the Great Khan has built another palace, constructed entirely of canes, but with the interior all gilt and decorated with beasts and birds of very skilful workmanship.[12]

Both fantastical descriptions were based on some reality. The Mongols had built their first capital city in Shangdu (in what is now Inner Mongolia): a gridded, walled layout very much in accordance with Chinese city planning. When the capital moved to Dadu (modern Beijing) in 1272, Shangdu became the summer hunting preserve and garden estate described by Marco Polo. Four centuries later, its impression on the Qing rulers was significant. The Qing, who likewise were non-Han Chinese from the north and intolerant of Beijing's summer heat, were tightly allied with the Mongolians and in many ways saw themselves as descendants of Khubilai Khan and the Yuan. They established their own hunting grounds at Mulan very close to Shangdu and built the 1,400-acre summer estate Bishu Shanzhuang (Mountain Villa for Escaping the Heat) in Chengde,[13] later greatly enriched by the Qianlong emperor's building projects, just 110 miles (180 kilometers) from Shangdu.

Formulating the Art of the Garden

Shizilin While the Mongol emperors were taking their leisure in Shangdu, a Chinese Buddhist monk created a temple garden on a sixty-acre tract that would also become an influential design for the Qing emperors. Tianru Weize (1286–1354),[14] after studying Chan Buddhism for many years, moved to Suzhou around 1342 to establish with his disciples a Buddhist temple and the customary adjoining garden to evoke the grove where Gautama Buddha reached enlightenment and to provide a similar setting for Buddhist masters to teach students. The temple was named Shizilin Puti Zhengzongsi (Lion Grove Temple of the

Enlightened One Zhengzong) to honor Tianru's master and the place where he had taught. In the temple's garden, dramatic rocks from nearby Lake Tai were piled into a most admired labyrinth of rockeries (figure 7). Peaks, paths, vales, grottoes, and tunnels awed visitors. Tianru himself noted: "People say that I live in the city, but I imagine I am located among ten thousand mountains."[15]

The garden's fame spread quickly. During the Yuan period (1279–1368), the temple became a gathering place for the local sophisticates who wrote about it or painted it. Ni Zan (1301–1374), whose subtle ink-on-paper landscapes became the revered standard of restrained elegance in literati landscape painting, depicted the garden in one of his very few paintings with a human figure. In his description, he noted how these rockeries fully capture the sense of mountains, "even turning a face partially toward the rocks, one can embrace the five mountains." "Why," therefore, he asked, "live in the mountains?"[16] Such praise from a most distinguished gentleman accorded Shizilin unparalleled status. And this creation by a humble monk would then attract the attention of the Qianlong emperor, who was eager to experience and express literati sensibilities.

By the sixteenth century, the garden, still part of the temple, fell into a state of disrepair, but during the early Qing it was acquired by a private family and regained its luster. When the Qianlong emperor went on his second tour of the south in 1757, he was so enchanted with Shizilin that he produced a calligraphic compliment to be carved in stone and displayed there. He returned five more times, brought court artists to sketch the environs, and replicated Shizilin within his own estates, not once, but twice – at the Yuanmingyuan and the Bishu Shanzhuang. He also owned Ni Zan's painting of Shizilin, lavished it with multiple calligraphic inscriptions, and copied it three times.[17]

Wen Zhenheng's Manual *Zhang Wu Zhi* **(Superfluous Things)** In the years between the inception of Shizilin and the Qianlong emperor's many garden design projects, the art of the garden underwent numerous developments and formalizations. During the mid- and late Ming dynasty (1368–1644), a number of literati wrote critiques of lifestyles, focusing on art – that is, calligraphy, painting, and antiquities – as well as interior

Rocks lead a person
to antiquity;
water leads a person
to remoteness.
In a garden *(yuanlin)*,
water and rocks are
the most indispensable.

石　水　園　最
令　令　林　不
人　人　水　可
古　遠　石　無

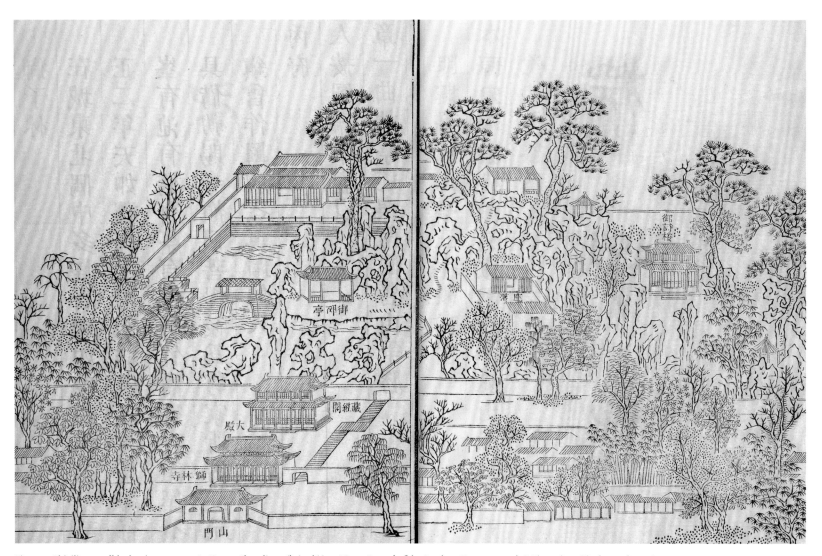

Figure 7. Shizilin, woodblock print on paper. In *Nanxun Shengdian, yibai ershi juan* (Great Record of the Southern Tours, 120 vols.) (Jiangning: Qianlong 36, 1771). Harvard-Yenching Library, Harvard University.

decorations, buildings, and gardens. Their assessments implied a marriage of aesthetics and virtues, and intimated that refined surroundings reflected sophistication and high moral character. The garden – now a place for inner cultivation – was a prime subject for such aesthetic, moralistic, and principled analysis.

The late Ming writer Wen Zhenheng (1585–1645) described all manner of material culture and explicitly delineated what is vulgar (su) and what is elegant or refined (ya) in accordance with the literati standards of the times. His manual Zhang Wu Zhi (Superfluous Things) gives explicit guidance for those wishing to appear refined according to the literati aesthetic of restraint. He noted, for example, that a gentleman's bed should not have excessive carving, which might suggest it belongs in a woman's bedroom.[18]

The guidebook's twelve chapters describe a proper literati household, indoors and outdoors – basically a residential garden complex and its contents. It opens with: "Living amongst mountains and water [landscape] is the best." Wen then took a practical turn, advising readers on how to come close to that pure mountain atmosphere within an urban setting. The book addresses garden compound elements: buildings and dwellings, flowers and trees, water and rocks, and birds and fish. It also provides guidance in regard to calligraphy and painting, furniture, utensils, clothing, boats and vehicles, object arrangement, vegetables and fruits, and incense and teas. In his explication, Wen both quantified acceptable garden details and aesthetics for his contemporaries and at the same time demarcated and articulated for later readers the basic components and priorities of a garden during the early seventeenth century.

For Wen, rocks were the most desirable natural accouterments: "Rocks lead a person to antiquity; water leads a person to remoteness. In a garden (yuanlin), water and rocks are the most indispensable."[19] Taihu rocks should be piled up outside houses to create "imitation mountains" and Lingbi rocks (sonorous rocks from quarries in northern Anhui Province) should be awkwardly (zhuo) shaped. As for trees: "The most noble of the trees is the pine. At your studio, plant one. Below have scholar rocks or Taihu rocks as a barrier."[20] Other critical elements are bamboo,

old trees, ugly trees, and strange vines. Much of the "taste" Wen delineated – including "meditation chairs" made of the roots of old trees[21] – would be reflected in at least the exterior elements of the Qianlong Garden 150 years later.

Ji Cheng's Manual *Yuan Ye* (The Craft of Gardens)

The earliest known Chinese garden manual, *Yuan Ye* (The Craft of Gardens),[22] was written circa 1631 by Ji Cheng, a painter who became a garden designer.[23] It reflects a new awareness and growing definition of the art of the garden. Ji Cheng noted that a visitor to a garden he had designed remarked that "it was just like a painting by Jing Hao or Guan Tong" (two great classical landscape artists of the late Tang, early Five Dynasty period). Just as Wang Wei began the process of amalgamating poetry, calligraphy, painting, and the composed natural environment, Ji Cheng made the arts of painting and garden design analogous.

In a preface to Ji Cheng's manual, the scholar, poet, and dramatist Ruan Dacheng (1587–1646) began: "As a young man it was my dream to live the hermit's life like Xiang Changping and Qin Qing [hermits of the later Han period], but to my chagrin I was constrained by my official career."[24] Ji Cheng taught that the urban garden offered a way to replicate the wild mountain ambiance: "Although they are really just fragments of mountains and chunks of stone, they should have a feel of the wilderness about them."[25] With his text, he established "that a 'garden' is purely a place of rocks and pavilions"[26] – no longer a hunting ground or an agricultural endeavor.

Ji Cheng tackled the aesthetics of rockeries and rocks like an artist: "The depths of your imagination should be full of pictures, and your feelings should overflow into hills and valleys."[27] He discouraged symmetrical compositions, confused arrangements, and mechanical placements of "caves below and terraces above, pavilions to the east and gazebos to the west. . . . Precipices, peaks, caves and gullies should look as if they were boundless. . . . As you wander wherever your feet take you, you may doubt that there is any boundary to the place; as you raise your head to gaze around, deep emotions will be stirred in you."[28] In other words, there is an art.

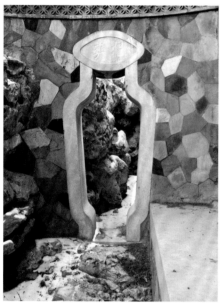

Top, Figure 8. Vase gateways, in Ji Cheng, *Yuan Ye* (The Craft of Gardens) (Beijing: Chengshi jianshe chubanshe, 1957). Originally published 1628–44. Phillips Library, Peabody Essex Museum.

Bottom, Figure 9. Vase-shaped gateway in the Qianlong Garden.

Ji Cheng demanded a strong linkage between the architecture and the landscape, emphasizing the importance of window views that "make use of the scenery outside"[29] and stating that "buildings will only be right if they harmonize with the landscape."[30] This harmonization did not prohibit appropriate ornamentation. Numerous woodblock illustrations present options for walls, brick designs, and paving materials and patterns (figures 8 and 9). He indicated which patterns are more vulgar and which most refined and appropriate for the context. "The cracked-ice pattern is the most suitable for shutters. The pattern of it is both simple and elegant; you may vary the design as you please. The subtlety of it is that it can be more widely spaced at the top and denser at the bottom" (figures 10 and 11).[31] While numerous texts had been written in China about the aesthetics of brushstrokes, Ji Cheng was possibly the first to expound critically on elements of the constructed environment.

Li Yu's Mustard Seed Garden and *Xianqing Ouji* (Casual Expressions of Idle Feeling) The later Ming period was a time of decline for the imperial household, but examples in Suzhou and Yangzhou indicate that gardens flourished in the south. Beijing saw its own versions of these in the early Qing years with the arrival of Li Yu (1611–1680), the somewhat eccentric, influential dramatist, essayist, publisher, and garden designer. He had resided most of his life in Hangzhou and Nanjing where he owned a book and print shop, selling his exquisite color-printed stationery, and where he designed for his own use in 1668 the famous "Mustard Seed Garden," named in accord with the literati predilection for modesty. Among Li Yu's printed masterpieces was the *Jiezi Yuan Huazhuan* (Mustard Seed Garden Painting Manual), a multiblock color-printed guide to landscape painting, first appearing around 1679 and still available today. Developed from a late Ming painter's teaching materials, it emphasizes the brushstroke components of landscape painting and displays an extraordinary enthusiasm for depicting rock types and forms (figure 12). This same passion was evident in Li Yu's garden designs. Summoned to Beijing in 1666 to create a garden residence for the Governor of Shanxi, he began by digging a pond and bringing in massive rocks, which "were all arranged by Li Yu himself, some straight, some on their side, slanted to the right or to the left, all in their original shape."[32]

Li Yu's *Xianqing Ouji* (Casual Expressions of Idle Feeling) (1671), articulates his aesthetics and philosophy for living, addressing house building, rocks and mountains, women, health, and housecleaning.[33] He discussed how one can live in the city and still be among the mountains and the forests through the art of piling rocks. "In ancient times the famous people for making mountains were all poets and artists. . . . [You] must create as if you were going to walk into a painting. . . and must know to differentiate between the elegance of awkward and vulgar. . . ."[34] Li Yu critiqued rock types, stipulating venerable characteristics such as penetrable (*tou*, referring to an intricate surface on all sides), leakable (*lou*, referring to holes), and lean (*shou*). Along with additions from other critics, such as wrinkled (*zhou*) and the all-important awkward (*zhuo*), these qualities would continue to hold value for the Qianlong emperor and his contemporaries.

As for Ji Cheng, architecture and landscape were part of a whole for Li Yu. Patrick Hanan, author of numerous books on Li Yu, summarized his approach as "design, simplicity, naturalness, refinement, novelty."[35] Ji Cheng's and Li Yu's texts and desire to formulate and critique gardens suggest a proliferation of gardens among the general urban population and the status of such gardens. In their differentiating between elegant and vulgar, both authors also hinted at the boorish gardens created by some of their less sophisticated but aspiring neighbors.

Fictional Gardens

Late Ming and early Qing novels (considered the lowliest form of writing in China and usually issued anonymously) include detailed descriptions of life and the man-made landscapes in magnificent garden compounds of wealthy patrons. One late Ming and one Qianlong-period novel, both later considered among the five most important novels in Chinese history, narrate the social (and sexual) relations among a myriad of characters inhabiting garden compounds. The luxurious settings become metaphors for the decadence of the families as the stories relate the eventual downfall of overly ambitious characters along with their gardens.

In 1610, the first block-printed edition of what became China's most renowned erotic novel, *Jin Ping*

冰裂式

冰裂惟風窗
之最宜者其
文致減雅信
畫如意可以
上踈下密之
妙

Top, Figure 10. Cracked-ice pattern diagram, in Ji Cheng, *Yuan Ye* (The Craft of Gardens) (Beijing: Chengshi jianshe chubanshe, 1957). Originally published 1628–44. Phillips Library, Peabody Essex Museum.

Left, Figure 11. Cracked-ice stone wall pattern in the Qianlong Garden.

Right, Figure 12. Rock from a Song dynasty collection, in Lin Youlin, *Suyuan shipu* (Stone Catalogue of the Plain Garden) (Beijing: Zhongguo shudian chubanshe, 1997). Originally published 1614. Phillips Library, Peabody Essex Museum.

**Among the exquisite
Taihu rocks,
There's a building
with an
honorific title of Calm.**

玲
瓏
湖
石
間

有
樓
謚
以
靜

Mei (*The Plum in the Golden Vase* or *The Golden Lotus*[36]), appeared under the pseudonym Lanling Xiaoxiao Sheng.[37] The book takes as its starting point an episode in an earlier Ming novel, *Shuihu Zhuan* (*Water Margin*), in which a licentious medicine shop owner, Ximen Qing, seduces the beautiful Pan Jinlian, persuades her to murder her husband, marries her, and brings her into a garden compound already filled with numerous women.

Though the novel is set during the Song dynasty, and contains references to the Genyue Garden, descriptions of the material culture – from gourmet food to textile design to the pavilions and rocks in the extensive gardens – reflect life in the late Ming period. Like any proper garden of the time, there were ornamental rocks on pedestals and grand rockeries, fake mountains, grottoes, and pine trees. The activities within those suggestive spaces are treated with equal imagination, filled with descriptions of dalliances rather than the contemplation of spiritual matters (figure 13).

The novel *Jin Ping Mei* undoubtedly influenced Cao Xueqin (circa 1720–circa 1763),[38] the author of China's most beloved novel, *Hong Lou Meng* (*The Dream of the Red Chamber*, also known as *Shitou Ji*, *Record of the Stone*). As in *Jin Ping Mei*, the master in the *Hong Lou Meng* household decides to expand his garden. In proper Chinese garden composition, carefully placed rockeries or other obstacles block full views and unexpected vistas appear at every turn – a format the Qianlong emperor would follow just a few years later.

Cao Xueqin's complex drama is set in the fantastic Daguanyuan (Grand View Garden), long celebrated in Chinese texts and woodblock prints, and more recently through television programs and actual re-creations of the garden in Beijing and Shanghai. The author introduced a delightful dramatic ploy to guide his readers through the garden. The master of the household has invited his friends to stroll through the spaces; he asks his son to join them in selecting names and poetic couplets for the edifices and vistas. Providing textual and calligraphic embellishments was as significant in garden design as the arrangement of rocks and pavilions. Proper titles have been an important principle in life and art in China since antiquity. Appropriate building names and poetic plaques could demonstrate the classical knowledge,

the literary sophistication, and the personal philosophy of the individual behind the garden. For example, Cao Xueqin's fictional characters respond to one outdoor setting with blossoming trees, bamboo, and a meandering spring emerging from an opening in a surrounding wall by a small lodge:

Two of them suggested that the name given to this retreat should be a four-word one. Jia Zheng asked them what four words they proposed.

"Where bends the Qi [river]," said one of them, no doubt having in mind the song in the Poetry Classic which begins with the words "See in that nook where bends the Qi / The green bamboos, how graceful grown!"

"No," said Jia Zheng. "Too obvious!"

"North of the Sui," said the other, evidently thinking of the ancient Rabbit Garden of Prince Liang in Suiyang – also famous for its bamboos and running water.

"No," said Jia Zheng, "still too obvious."

"You'd better ask Cousin Bao again," said Cousin Zhen, who stood by listening. . . .

"Neither of them seems quite right to me," said Baoyu in answer to the question. . . . "This is the first building our visitor will enter when she looks over the garden so there ought to be some praise for the Emperor at this point. If we want a classical reference with imperial symbolism, I suggest 'The Phoenix Dance,' alluding to that passage in the History Classic about the male and female phoenixes alighting 'with measured gambolings' in the Emperor's courtyard."

"What about 'Bend of the Qi' and 'North of the Sui?'" said Jia Zheng. "Aren't they classical allusions?"

"Yes," said Baoyu, "but they are too contrived. 'The Phoenix Dance' is more fitting."

There was a loud murmur of assent from the literary gentlemen.[39]

The garden in *Hong Lou Meng* was not only about being a retreat, it was also a place to parade a family's sophistication and currency in modern styles. During these same years in the eighteenth century, influences from Europe were becoming fashionable in private homes as well as in the court. Printing establishments in Suzhou were producing very sizable, finely carved, brightly colored prints depicting literary garden compounds. Interestingly, many of these prints reveal a strong interest in European perspective and foreshortening techniques. The garden and its image had both entered the realm of popular fashion. In his novel, Cao Xueqin described the wonder his characters experienced in coming upon exotic and "modern"

surprises from distant Europe, identified then as the "Western Ocean" (figure 14).

She came to a round moon-gate, which she entered. Ahead of her was a channel of crystal-clear water. . . . After she had crossed the bridge there was a raised cobbled path which, after a couple of right-angled bends, brought her up to the door of the house.

The first thing she saw on entering it was a young woman smiling at her in welcome. Grannie Liu smiled back.

"I'm lost, miss. . . I've wandered here by mistake."

Surprised that the girl did not reply, Grannie Liu stepped forward to take her hand and – bang! – hit her head a most painful thump on the wooden wall. The girl was a painting, as she found on her closer inspection.

"Strange!" she thought. "How can they paint a picture so that it sticks out like that?"

Granny Liu was ignorant of the foreign mode of light-and-shadow painting. . . .

She looked for the way – but where was it? To her intense surprise, approaching her from the opposite direction and causing her a momentary palpitation of the heart, was another old woman. . . .

"I've heard of rich folks having what they call 'dressing mirrors' in their houses. Mayhap I'm standing in front of one of them and it's myself I'm looking at."

She stretched out her hand again to feel and closely examined the surface. Yes, no doubt of it: it was a mirror. . . . She laughed at her own error.

"Yes, but how do I get out of here?" she thought, as she continued to finger the mirror's carved surround.

Suddenly there was a loud clunk!. . . . The mirror was in fact a kind of door. It had a West Ocean mechanism by which it could be opened or closed. . . .[40]

In the Forbidden City and Beyond

While the Ming literati and nouveau riche grappled with their household compounds and gardens, the emperors at first followed a disparate approach. When the Yongle emperor moved the Ming capital north from Nanjing to Beijing, and began designing the Forbidden City Palace in 1406, no garden was in the plan. The poetics of landscape seem to have held scant appeal to a court focused on reestablishing rule over the country. Nevertheless, within fifteen years an order went out to construct a Gonghouyuan (Rear Palace Garden) in the private, residential portion of the palace along the central axis. Unlike the meandering realms of literati gardens, this imperial garden's design was strictly symmetrical.

Top, Figure 13. "Yuxiao Acts as a Lookout by Yueniang's Chamber; Jinlian Eavesdrops Outside Hidden Spring Grotto." Woodblock print on paper. In *Jin Ping Mei* (The Plum in the Golden Vase), 1617 edition. Private Collection.

Bottom, Figure 14. *Daguanyuan Jingxi Quan Tu* (Complete and Meticulous Picture of the Grand View Garden), 1800s (detail). Woodblock print on paper, 19 x 23 1/2 inches (48.3 x 59.7 cm). Phillips Library, Peabody Essex Museum.

Renamed Yuhuayuan (Imperial Garden) by the Qing emperors, the layout today remains fundamentally unchanged. Absent are the spontaneity, surprise vistas, and winding paths that brought such vibrancy to the Shizilin (Lion Grove) garden in Suzhou.

Ming rulers also generously provided a garden compound for the most powerful older women of the palace. Empress dowagers resided in the Cininggong (Compassion and Tranquility Palace) in the western section of the private quarters in the "rear palace" of the Forbidden City. During the Jiajing period (1521–67), the Garden of the Compassion and Tranquility Palace was constructed for their use. It, too, is completely symmetrical along a north-south axis, and devoid of the organic sensibilities of the Jiangnan region literati gardens.

A less formal environment was developed west of the Forbidden City by excavating two new lakes and enlarging the Yuan palace's Taiye Lake (Lake of Grand Liquid, today's Beihai, Northern Sea). The parklike expanse, called Xiyuan (West Garden), encompassed three lakes connected by bridges, islands, and pavilions along the shores. The Qing emperors continued to develop this area, building celebratory edifices, temples, and even artisan workshops and holding outdoor banquets there.

Toward the end of the Ming dynasty, a modification in the Gonghouyuan signaled an imperial shift toward integrating literati aesthetics. In 1583, the eleventh year of the Wanli emperor's reign, the Guanhuadian (Flower Watching Hall) in the northernmost section of the garden was razed and replaced with a *jiashan*, an artificial mountain created from Taihu rocks called Duixui (Pile of Elegance). Sporting a pavilion atop its peak, a cave with two entrances, and an interior passageway to the pavilion, it presaged a more organic imperial garden culture.

Economic destabilization, official corruption, and natural calamities during the first decades of the seventeenth century prevented the Ming court from focusing on pleasure realms for emperors. Manchu forces conquered the country in 1644. It was under their Qing dynasty that imperial gardens would enthusiastically integrate literati aesthetics and poetics and bring the art to a new pinnacle.

The Forbidden City was the ritual center of the country and ancient Chinese traditions obliged the Manchu emperors to reside there for annual New Year rites. Its urban density and formality were not congenial to rulers whose ancestors roamed the hills and forests north and east of China, and who still loved horse-back riding, hunting, and archery. Once the Manchu emperors therefore had settled into a less defense-oriented mode of rule, they began developing grand garden estates. In 1703, the Kangxi emperor initiated the planning and then the construction of a grand estate, the Bishu Shanzhuang (Mountain Villa for Excaping the Heat), 150 miles north of Beijing, beyond the Great Wall, in an area that eventually became known as Chengde. The Bishu Shanzhuang incorporated formal palaces, gardens, temples, and vistas (figure 15). It was far more than a retreat. Its location and architectural styles would broadcast a message to Mongols and Tibetan neighbors about Qing loyalty to their Central Asian origins and allies. At about the same time, the Kangxi emperor began building the Changchunyuan (Garden of Enduring Spring), five miles northwest from the Forbidden City in Beijing; his son and grandson would develop the site into the 857-acre suburban palace complex now known as the Yuanmingyuan (Garden of Perfect Brightness) (figure 16).

The Yuanmingyuan became widely known for its pavilions and palaces, hills and valleys, lakes and streams, gardens and gardens within gardens – many copied from Jiangnan literati gardens. A French Jesuit artist, Jean-Denis Attiret (1702–1768; known in Chinese as Wang Zhicheng), who served in the Qianlong imperial atelier and lived in the Yuanmingyuan, captured its spirit in letters to France in 1743. He savored the literati-style, natural environment so unlike the rigid symmetry of court architecture. Translated and disseminated in England by 1752, Attiret's descriptions would eventually exert a strong influence on English garden design. Calling the Yuanmingyuan a "veritable paradise on earth," he noted the difference between the formality of the official court palace halls and the lack of orderliness of the garden palace:

The Sides of the Canals, or lesser Streams, are not faced, (as they are with us) with smooth Stone, and in a strait Line; but look rude and rustic, with different Pieces of Rock, some of which jut out, and others recede inwards . . . They go from one of the Valleys to another,

Figure 15. "Yuanjin Quansheng" ("Sounds of a Brook Resonate Near and Far"), 1713. Copperplate engraving on paper. In Matteo Ripa, *Yuzhi Bishu Shanzhuang Shitu* (Imperial Produced Illustrated Poetry on Summer Mountain Retreat), pl. 13. Phillips Library, Peabody Essex Museum.

Figure 16. Scene at the Yuanmingyuan, 1745. Woodblock print on paper. In Tang Dai, *Yuzhi Yuanmingyuan tuyong* (Imperial Produced Illustrated Poems on the Yuanmingyuan) (Tianjin: Shiyin shuwu, Guangxu 13, 1887). Phillips Library, Peabody Essex Museum.

not by formal strait Walks as in Europe; but by various
Turnings and Windings, adorn'd on the Sides with little
Pavilions and charming Grottos . . . in their Pleasure-
houses, they rather chuse a beautiful Disorder, and a
wandering as far as possible from all the Rules of Art.[41]

The Qing emperors had created a new imperial
garden culture.

Born into this rich sensibility, the Qianlong
emperor would passionately take garden design
to a still higher level. The Qianlong Garden was
his ultimate accomplishment – a rich, multi-
layered artwork encompassing everything he had
learned from his predecessors as well as unique
gestures of his own, all within a two-acre walled
area that offered much greater challenge than a
vast estate. The seventeenth-century French writer
Blaise Pascal confessed that he would have written
a shorter letter had he had the time. A hundred
years later, the Qianlong emperor created an exqui-
sitely concise jewel expressing the immense riches
of his literary, spiritual, and artistic heritage.
His microcosm would be the ultimate "universe
within a jar."

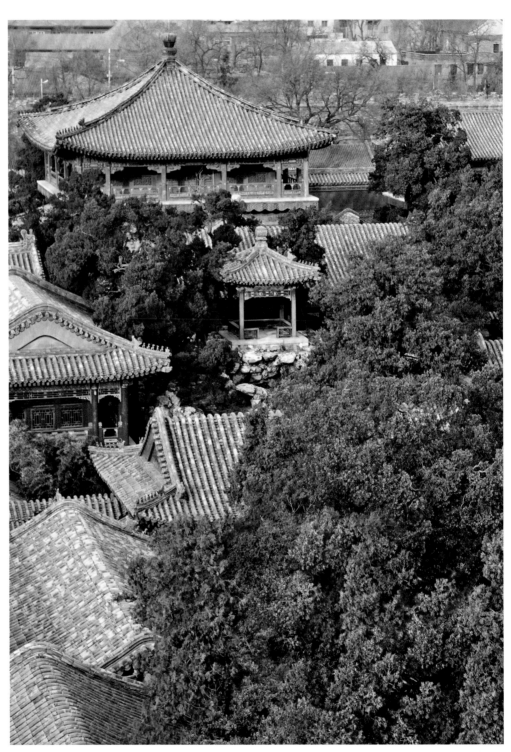

Aerial view of Suichutang, Yanqulou, Songxiuting, Cuishanglou, and Fuwangge from the south.

Notes

1. Edward H. Schafer's studies are thorough examinations of these early domains. See Schafer, "Hunting Parks and Animal Enclosures in Ancient China," *Journal of the Economic and Social History of the Orient* 11, 3 (October 1968), pp. 318–43.

2. H. C. Chang, trans., *Chinese Literature: Volume Two: Nature Poetry* (Edinburgh: Edinburgh University Press, 1977), pp. 8–9.

3. *Wuliu xiansheng zhuan* (Biography of the Gentleman of the Five Willows), trans. Rick Davis and Daniel Steelman, available online at http://www.hermitary.com/articles/tao_chien.html.

4. Wang Wei, "Deng Bian Jue Si," in *Wang Youcheng ji jian zhu* (Shanghai: Guji chubanshe, 1961), p. 150, as translated and quoted in Wang Yi, "Interior Display and Its Relation to External Spaces in Traditional Chinese Gardens," *Studies in the History of Gardens and Designed Landscapes* 18, 3 (1998), pp. 232–47.

5. "Ti Shen Shaofu shu zhai," quoted in Zhongguo Shige Ku [Chinese poem and Song Storehouse], available online at http://www.shigeku.org/shiku/gs/tangshi/qts_0817.htm.

6. Lothar Ledderose, "The Earthly Paradise: Religious Elements in Chinese Landscape Art," in *Theories of the Arts in China*, eds. Susan Bush and Christian Murck (Princeton, New Jersey: Princeton University Press, 1983); and James Hargett, "Huizong's Magic Marchmount: The Genyue Pleasure Park of Kaifeng," *Monumenta Serica* 38 (1989–90), pp. 1–48, n. 12.

7. Song Huizong, *Xuanhe huapu* (Taibei Shi: Shijie shuju, 1962).

8. Song Huizong, *Xuanhe bogutu: fusuoyin* (Taibei Shi: Xinxing shuju, 1969).

9. Hargett, p. 38.

10. According to Hargett, p. 16, it had a perimeter of just under three-and-a-half miles.

11. Samuel Taylor Coleridge, in J. R. De J. Jackson, *Coleridge: The Critical Heritage* (London: Routledge & Kegan Paul, 1970), p. 564. Originally written circa 1797.

12. Marco Polo, *Marco Polo, the Travels*, trans. Ronald Edward Latham (New York: Penguin Classics, 1958), p. 108. Originally dictated to Rustichello da Pisa in 1298/99.

13. Philippe Forêt, *Mapping Chengde: the Qing Landscape Enterprise* (Honolulu: University of Hawaii Press, 2000), p. 117.

14. Tianru Weize's surname was Tan. For a full and excellent discussion on this garden, see Bruce Gordon Doar, "Acquiring Gardens," *China Heritage Quarterly* 9 (2007), available online at http://www.chinaheritagenewsletter.org/features.php?searchterm=009_gardens.inc&issue=009.

15. *Shizilin ji jing*, quoted in Wei Jiazan, *Suzhou gudian yuanlin shi* (Shanghai: Sanlian Shudian, 2005), pp. 169–700, and translated in Doar.

16. Wang Ting, *Hui yuan kua sheng-zaoqi de shi zilin ji xiangguan shi, hua* published online by the Shanghai Academy of Social Sciences 5/29/06, p. 8, available online at http://www.historicalchina.net/ReadArticle.asp?BIgClass=1&ArticleID=302

17. Miao Bulin, "Qianlong yu Shizilin," *Urban Construction Archives* 3 (2003), pp. 46–47.

18. Craig Clunas, *Superfluous Things, Material Culture and Social Status in Early Modern China* (Chicago: University of Illinois Press, 1991).

19. Wen Zhenheng, annotated by Chen Zhi, *Zhang Wu Zhi Jiaozhu* (Jiangsu: Kexue Jishu Chubanshe, 1984), p. 102, available online at http://www.scribd.com/doc/6961921

20. Ibid., p. 64.

21. Ibid., p. 230.

22. A Japanese garden manual *Sakuteiki* was published in the eleventh century. Much – but not all – of the contents seems to be derived from Japanese awareness of Chinese gardens. The question of whether the book was a result of Japanese people traveling to China and learning pointers while there, or if they were reworking an earlier unknown Chinese manual still needs further research.

23. For an excellent annotated translation, see Ji Cheng, *The Craft of Gardens*, trans. Alison Hardie (New Haven and London: Yale University Press, 1988).

24. Ibid., p. 33.

25. Ibid., p. 12.

26. Ibid., p. 106.

27. Ibid.

28. Ibid., p. 59.

29. Ibid., p. 64.

30. Ibid., p. 85.

31. Ibid.

32. Wanyan Xuhe (dates unknown), recorded in Banmu Yuan Sheying Ji, as translated and quoted in J. L. Van Hecken and W. A. Grootaers, "The Half Acre Garden," *Monumenta Serica* 18 (1959), pp. 360–87.

33. Francesca Bray, *Technology and Gender: Fabrics of Power in Late Imperial China* (Berkeley: University of California Press, 1997), p. 65.

34. Ibid.

35. Patrick Hanan, *The Chinese Vernacular Story* (Cambridge, Massachusetts: Harvard University Press, 1981), p. 166.

36. Shi Nai'an, *The Plum in the Golden Vase or, Chin P'ing Mei*, trans. David Tod Roy (Princeton, New Jersey: Princeton University Press, 1993) is the most thorough translation and analysis in the English language. André Lévy's French translation is also superb.

37. Scholars today believe the author was probably Shi Nai'an.

38. Cao Xueqin, *Story of the Stone*, trans. David Hawkes (New York: Penguin Classics, 1977) is the best translation in the English language. The website http://calhounnet.com/bibliography/ has an excellent list of other English-language books on *The Dream of the Red Chamber*. Mary Scott, "The Image of the Garden in Jin Ping Mei and Hongloumeng," *Chinese Literature: Essays, Articles, Reviews (CLEAR)* 8, 1/2 (July 1986), pp. 83–94. Other consulted books include Guan Huashan, "*Hongloumeng*" *zhong de jianzhu yu yuanlin* (Tianjin: Baihua Wenyi Chubanshe, 2008).

39. Cao Xueqin, vol. 1, pp. 331 – 32.

40. Cao Xueqin, vol. 2, p. 320.

41. Jean-Denis Attiret and Joseph Spence, *A Particlar Account of the Emperor of China's Gardens near Pekin: In a Letter from F. Attiret, a French Missionary, Now Employ'd by That Emperor to Paint the Apartments in Those Gardens, to His Friend at Paris* (London: Printed for R. Dodsley, and sold by M. Cooper, 1752), available online at http://inside.bard.edu/ffilouis/gardens/attiretaccount.html.

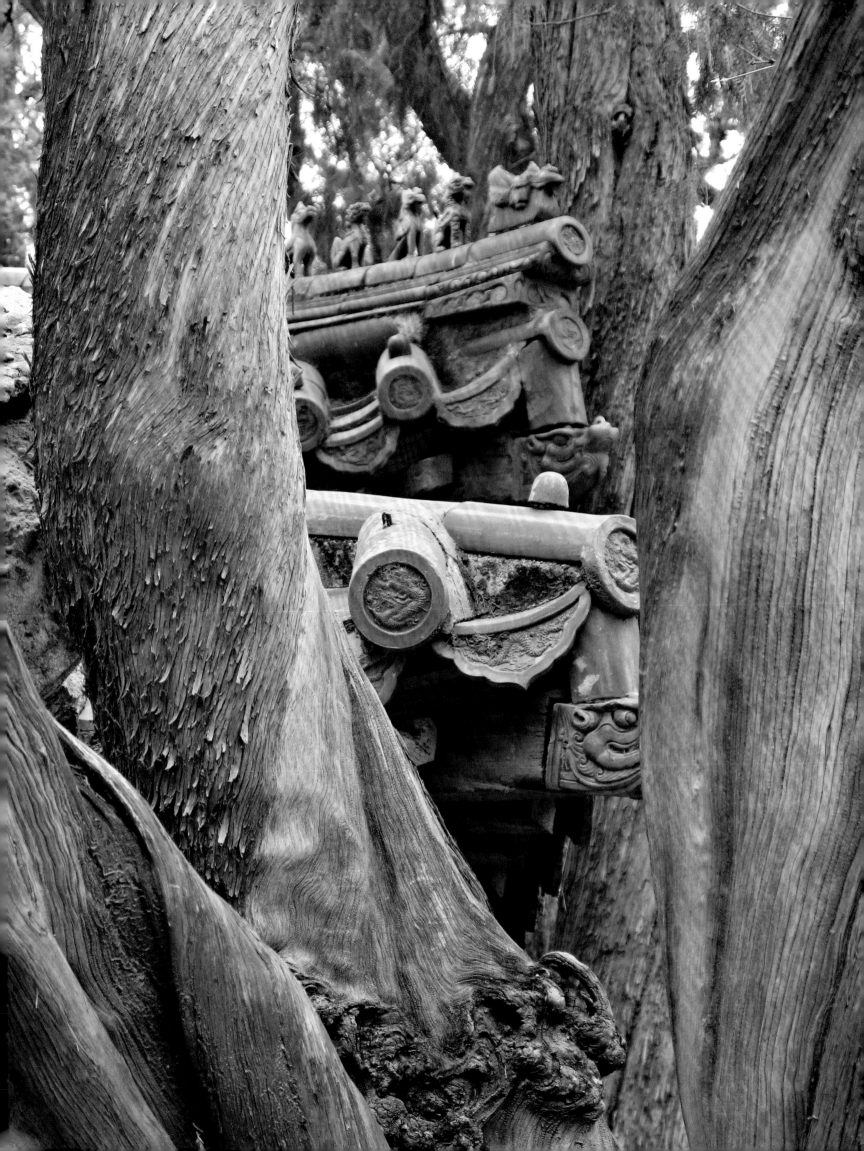

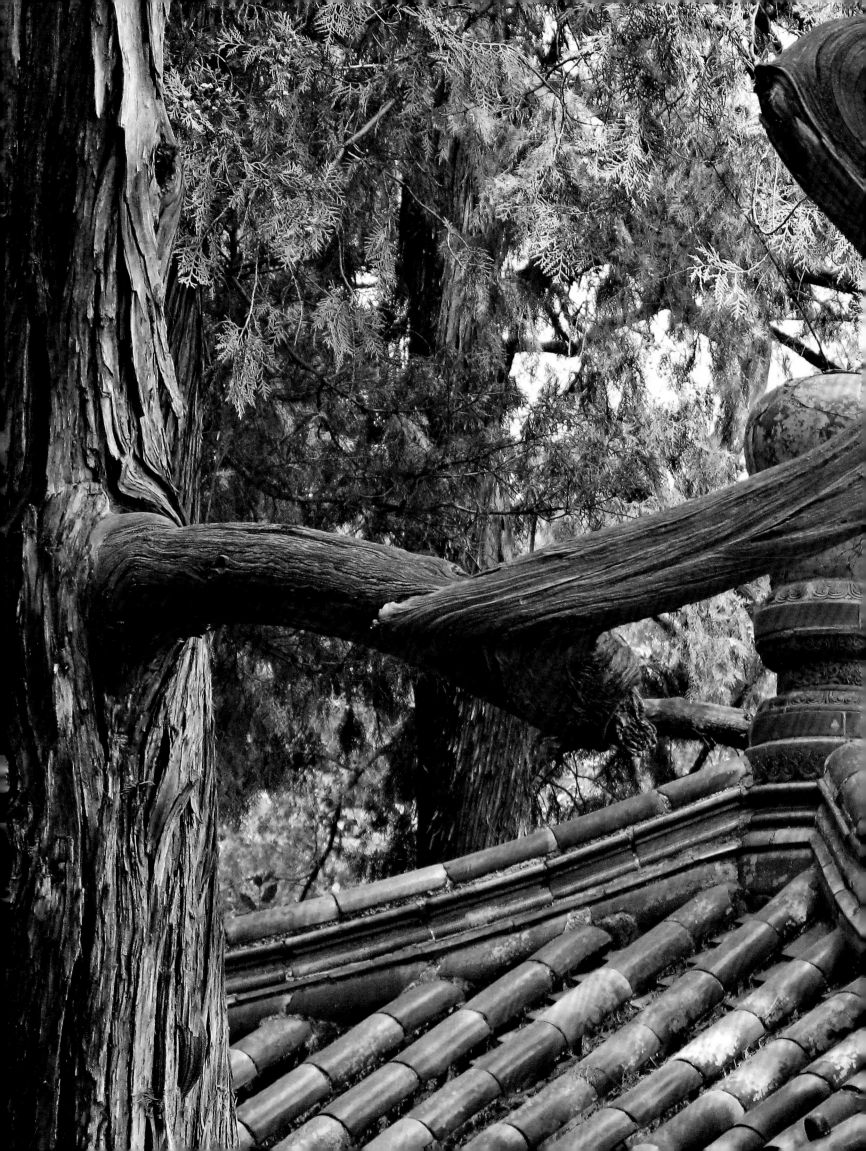

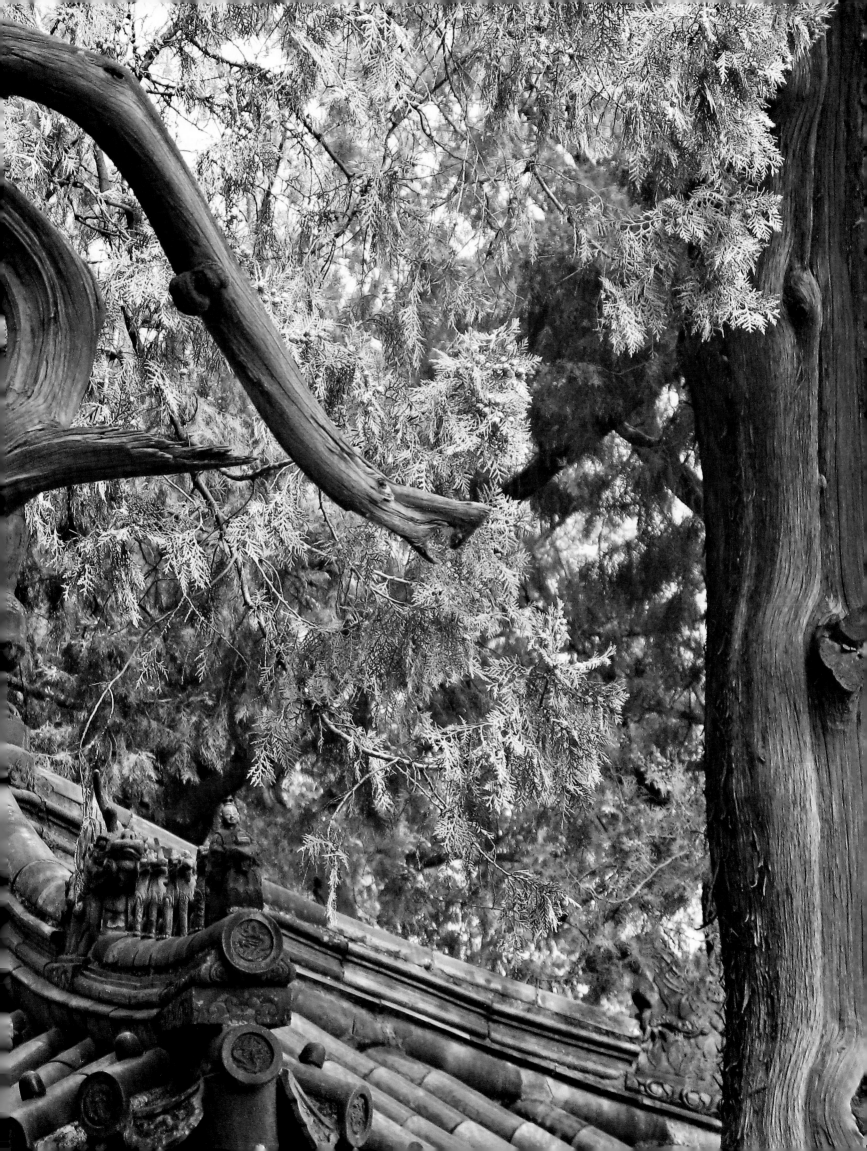

The Qianlong Emperor's Earlier Gardens

乾隆皇帝的早期花園

Nancy Berliner

An emperor or king, when he has time before holding an audience or attending to the affairs of state, should have extensive grounds to stroll in, and lovely vistas to enjoy. If he has such a place, he will be able to cultivate his mind and refine his emotions; otherwise, he may take pleasure in trivial things and that will only sap his energies and willpower.[1]

The visitor approaching the Qianlong Garden at the Ningshougong (Tranquility and Longevity Palace) is greeted by a red gate whose name, Yanqimen (Gate of Spreading Auspiciousness), appears in gold Chinese and Manchurian script on a blue plaque above the doorway. Just beyond the gate, a rockery wall appears to obstruct further entry (figure 1) but that obstruction is only an illusion: there are several possible routes into this ingeniously composed series of spaces that offer surprises around every corner. In the garden's worlds within worlds, its intended occupant, the Qianlong emperor, could find respite among trees and rockeries, meditate in closeted niches, write poetry, study the classics, and delight in his collections and artistic creations. In its totality, this stunning garden encapsulates ancient Chinese traditions, the culture of its time, and the insights and visions of its master.

The creation of the two-acre garden began with a proclamation in 1771 – the emperor's sixtieth year, a significant age in a culture based on a sexagenary calendar cycle – announcing the construction of the Tranquility and Longevity Palace within the Forbidden City for his future retirement and inner cultivation. His intention was to retire after sixty years on the throne so as not to exceed the sixty-one-year rule of his grandfather the Kangxi emperor (r. 1661–1722), the longest official reign in Chinese history.

The Qianlong emperor devoted immense funds and energy to creating his Tranquility and Longevity Palace with its reception halls, Buddhist shrines, libraries, residential rooms, studies, theaters, and gardens. The layout mimicked that of the Forbidden City itself: the formal, official area in the front and the residential portion, divided along three axes echoing the larger palace, at the rear. A long, narrow strip that formed the westernmost axis would be the garden. With the emperor's passion and intense involvement in its concepts, compositions, designs, and details, this garden became a masterpiece.

Its artistic success resulted from the Qianlong emperor's intimate knowledge of gardens built by his predecessors and contemporaries and his own garden design experiences in the previous forty years of his reign. He had grown up with gardens as a fundamental lifestyle, and along with the throne, he had inherited the Bishu Shanzhuang (Mountain Villa for Escaping the Heat) in Chengde, the Yuanmingyuan (Garden of Perfect Brightness) estate outside of Beijing, and numerous other imperial garden spaces. As an active connoisseur and scholar, he was determined to perfect the art of garden design. Like any artist, he returned again and again to the same themes and concepts in his gardens. And, while incorporating classic Chinese garden building blocks – elements of nature, expressions of morality, and Chinese architecture – he also added new concepts and realms of aesthetics, including European painting styles.

The Jianfugong (Palace of Established Happiness)
In 1742, the young emperor and novice garden designer decided to create a garden in the Forbidden City where he could refresh his energies during winter months when ritual duties obligated him to remain in the urban center. He selected a site in the palace district where he had spent time as a child and named his newly constructed compound Jianfugong (Palace of Established Happiness) (figure 2).

Within the 44,000-square-foot L-shaped site, the emperor created a series of small north-south palace buildings and, to their northwest, a grouping of seven buildings with a central five-bay-wide, four-story tower, Yanchunge (Pavilion of Prolonged Spring). Around this dominating edifice were courtyards, smaller one- and two-story buildings, decorative rocks on pedestals, trees, greenery, and several massed rockeries, one topped with an open pavilion and a stone table and stools where the emperor might play chess. Despite the rigid axial geometry, the architectural variety, curving walls, and the rockeries contributed a sense of informality to the space. These architectural and garden elements presaged spaces within the Qianlong Garden, as did the interior décor of one structure, the Jingshengzhai (Studio of Esteemed Excellence). Itself a copy of an unusual room within the Banmuyuan (Half-Acre Garden) in the Yuanmingyuan, the building contained a stage constructed as a small pavilion

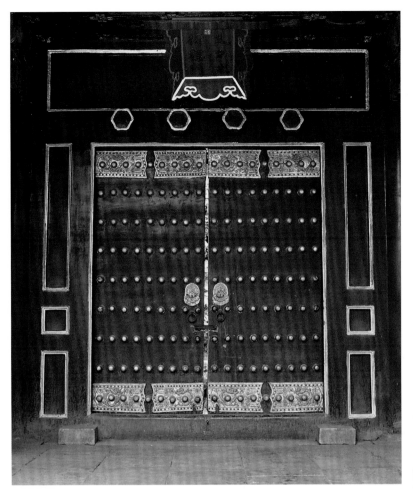

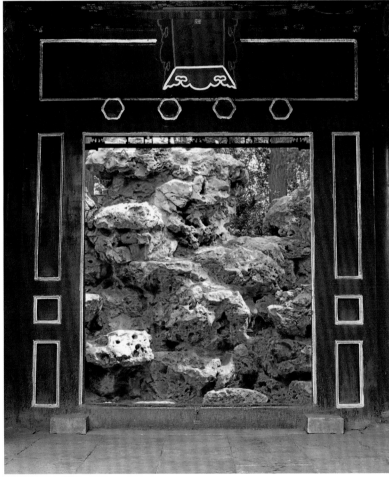

Left and right, Figure 1. Yanqimen, entrance to the Qianlong Garden.

Pages 71–74. Glazed roof tiles of Juting with a tree dating
from before the Qianlong era; glazed roof tiles and the
crowning knob of Juting; an ancient tree in the first courtyard.
Pages 70 and 75, Panel (hanging) (cat. 23, detail).

inside a narrow, high-ceilinged building with one throne on the first floor, and a second in an upper loft viewing space.[2] The theater room also featured a spectacular painted ceiling depicting clusters of wisteria dangling from a bamboo trellis, in perfect European-style perspective that created a striking three-dimensional effect.

Palace archives from 1742 (Qianlong 7), note a special request from the emperor: "The four western bays of Jianfugong's Jingshengzhai should copy the pasted silk in Banmuyuan and have Lang Shining [the Italian Giuseppe Castiglione, a missionary working in the Qing imperial atelier since 1715] paint the wisteria."[3] Interestingly, just one month earlier, the emperor had requested that a wisteria trellis painting be created by Castiglione, assisted by imperial artists Lu Jian and Yao Wenhan, in the Xianfugong (Palace of Universal Happiness), a building primarily for concubines, but occasionally used as the emperor's residence.[4] Including the Jingshengzhai ceiling, there were apparently at least three wisteria lattice ceilings in existence by 1743. These trompe-l'oeil fabrications continued to play significant roles in the emperor's later creations, including the Qianlong Garden.

The Jianfugong Garden anticipated additional elements of the Qianlong Garden. In 1747, the emperor placed three important scrolls in a room in Jianfugong's Ninghuitang (Hall of Concentrating Brilliance), on the west side of the retreat: *Prunus Blossom Scroll* (Song or Yuan dynasty), *Forest of Gentlemen* depicting bamboo (Yuan dynasty) (figure 3), and *Eighteen Lords*, a landscape of eighteen pine trees attributed to the Yuan artist Cao Zhibai (1271–1355).[5] Together, the paintings represented the Three Friends, a motif in classical Confucian texts, art, and poetry. The emperor then aptly named the room Sanyouxuan (Three Friends Bower).[6]

A cultivated person of the emperor's time would have recognized this name as an abbreviation for "Three Friends of Winter" (*suihan sanyou*): the botanical triad of bamboo, pine, and prunus. Pine and bamboo remain green during the winter and the prunus blossoms around Chinese New Year, as winter is waning. These three stalwart flora, able to withstand the brutal winter, symbolized the steadfast and upright gentlemen who remained virtuous even under a harsh regime. For

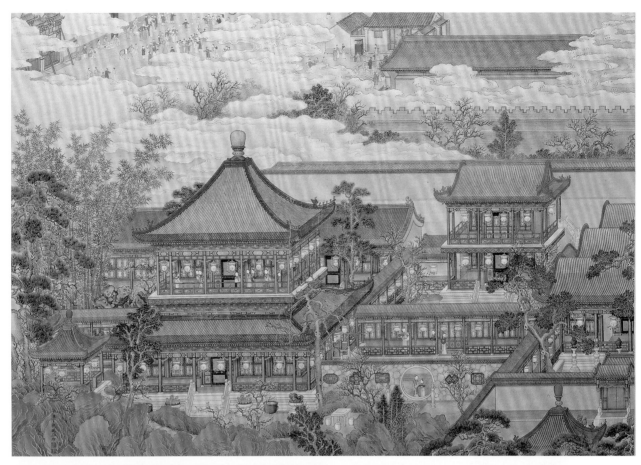

Top, Figure 2. Ding Guanpeng (active 1708–1771), *Peace for the New Year*, 1748 (detail). Ink and colors on paper, 70 1/2 x 42 5/8 inches (179.3 x 108.4 cm). National Palace Museum, Taipei.

Bottom, Figure 3. *Junzilin tu* (Forest of Gentlemen), Yuan dynasty (1279–1368). Ink on paper. Palace Museum.

The depths of your imagination should be full of pictures, and your feelings should overflow into hills and valleys.

a scholar like the Qianlong emperor, the phrase "three friends" would bring to mind a teaching from Confucius: "There are three friends which are advantageous, and three which are injurious. Make friends with those who are upright; friends who are honest; and friends who have heard much."[7] By the seventeenth century, the motif had entered the realm of fashion, appearing on textiles, furniture, and other domestic furnishings, but the Qianlong emperor's use was intended to evoke numerous historic, scholarly, poetic, and moral references. He would continue to identify with this theme throughout his life and construct other buildings with this same name, including a lavish one within the Qianlong Garden.[8]

The Yuanmingyuan (Garden of Perfect Brightness)
The Qianlong emperor preferred to spend his time in the open spaces on the outskirts of Beijing, in the Yuanmingyuan or Bishu Shanzhuang, rather than in the congested and formal Forbidden City. Annual archives suggest that he usually spent about 150–200 days a year at the Yuanmingyuan as opposed to 40–50 within the Forbidden City. Consequently, it is hardly surprising that he decided to expand the Yuanmingyuan. By 1744, judging that it was complete, the emperor produced a commemorative album of paintings, by the court artists Tang Dai and Shen Yuan, depicting the forty finest views, with the emperor's companion poems on each site (figure 4). In his poems, the emperor watches swallows build new nests; he feels the refreshing air of the morning after a late spring evening rain; and in winter he sits indoors by his glass windows gazing at ice on the garden lakes.[9]

The Changchunyuan (Garden of Enduring Spring)
In 1749, to the east of his grandfather's garden-lake creation, the Qianlong emperor began a massive expansion project, the Changchunyuan (Garden of Enduring Spring), which would cover over 400 acres. The new gardens there were inspired by trips to China's southern Jiangnan region, a cultural center and home to renowned gardens, as well as his encounters with images of European gardens and palaces, and his own fervent imagination.

Copying and imitating earlier works is part of Chinese artistic practice. Like musicians playing compositions created centuries earlier, Chinese

calligraphers, including the Qianlong emperor, have for more than a thousand years copied calligraphic masterpieces such as the *Preface to the Orchid Pavilion* by Wang Xizhi. The copies and imitations are respected in their own right. Likewise, the Shizilin (Lion Grove) garden of the Yuanmingyuan, inspired by the fourteenth-century original in Suzhou, joined the estate's anthology of gardens, palaces, and collected artworks.

Within the Changchunyuan was a significant grouping of gardens and waterways that the Qianlong emperor named Hanjingtang (Hall for Storing the Classics). Among the plantings, waterways, and grand structures being built there in 1770 was a small enclosed courtyard packed with rockeries and rimmed on each of the four sides with buildings partially forming and delineating the walls of the courtyard. The smallest building, on the east side, partially jutted into the central artificial mountain area and threw the entire composition into an asymmetrical imbalance. The building was called Sanyouxuan (Three Friends Bower),[10] the same name the emperor had used in the Jianfugong. Though destroyed during the 1860 European occupation and total obliteration of the Yuanmingyuan, recent excavations have revealed more about the building.[11] Facing south, the triple-bay building was set upon a platform with centrally placed stone steps leading to the primary entrance and another set to a supplementary northern central entrance. Looking out from his windows at the rockery filling the courtyard, the emperor must have felt like he was in a deep mountain valley. Two large rocks on elaborately carved round marble pedestals on the western side of the building enhanced the view. Enamored with the Three Friends concept and this particular layout, the emperor would repeat them again in the Qianlong Garden.

European Palaces and Gardens and Trompe l'Oeil
The Qianlong emperor was equally inspired by images of European gardens presented to him by Jesuit court artists. The fountains of Versailles aroused his desire for waterworks in his own gardens. He summoned Castiglione to design and construct a series of European-style palaces on sixty-five acres and a fountain with twelve bronze Chinese zodiac animal heads that spewed water in accordance with the hours of the day. A Father Michel Benoit (1715–1774; known as Jiang Youren

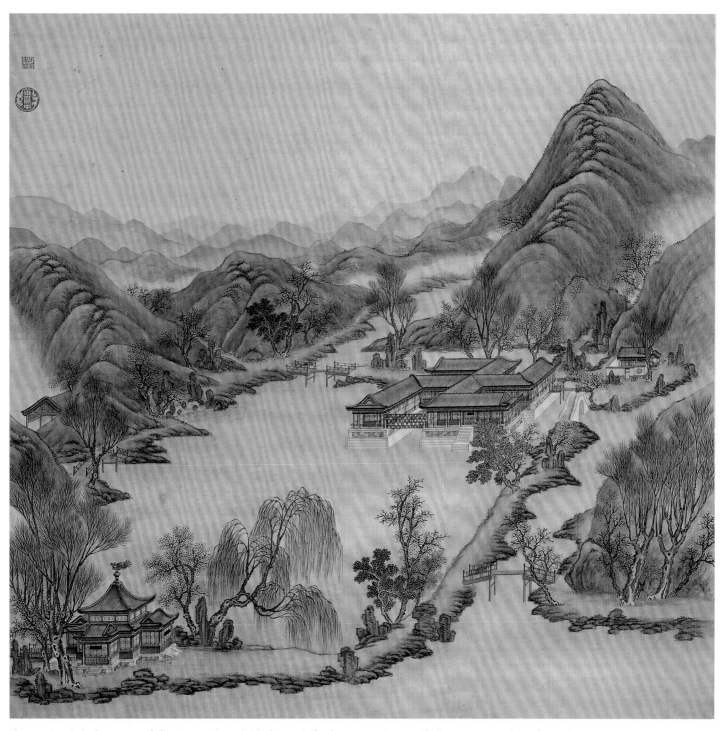

Figure 4. Tang Dai (1673–1752) and Shen Yuan (active early Qianlong period), Plate 13, *Yuanmingyuan sishi jing tuyong* (Forty Views of Yuanmingyuan), 1744. Ink and colors on silk. Bibliothèque nationale de France.

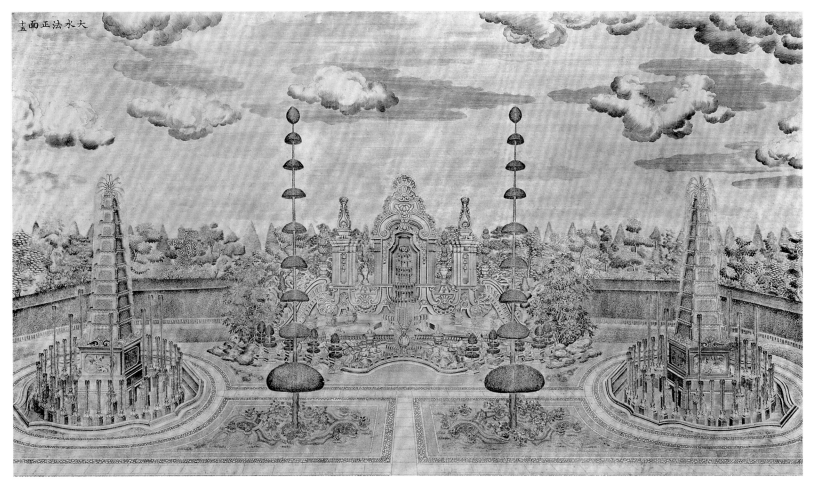

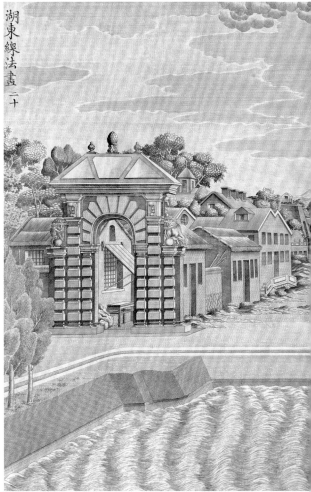

Left, Figure 5. Yi Lantai (active 1749–1786), *Dashuifa zhengmian* (The Great Fountains, Front View), 1786. Copperplate engraving from a suite of twenty engravings of the Yuanmingyuan European palaces, 19 3/4 x 34 1/2 inches (50 x 87.5 cm). Peabody Essex Museum, Museum purchase, 2006, E303400.

Right, Figure 6. Yi Lantai (active 1749–1786), *Hudong Xianfahua* (Perspective Painting East of the Lake), 1786. Copperplate engraving from a suite of twenty engravings of the Yuanmingyuan European palaces, 19 3/4 x 34 1/2 inches (50 x 87.5 cm). Print Collection, Miriam and Ira D. Wallach Division of Art, Prints and Photographs, The New York Public Library, Astor, Lenox and Tilden Foundations.

in Chinese), who was knowledgeable in mathematics and hydraulics, assisted Castiglione along with other Europeans including Jean-Denis Attiret (1702–1768) and Ignatius Sichelbart (1708–1780; known to the Chinese as Ai Qimeng). Books from Europe aided the inexperienced architects. The first buildings were completed by 1751: palaces with marble balustrades, glass windows, a maze, and, of course, the fountains. Here and there were Chinese touches, such as glazed roof tiles and decorative Taihu rocks. The polycultural interiors of these unusual buildings were equally magnificent. Chinese scroll paintings and Gobelins tapestries depicting European women sent in 1767 as a gift from the French king Louis XV (r. 1723–74) decorated the walls. Documents tell of glass windows, floors, clocks, hanging lamps, and oil paintings.[12]

To celebrate their completion in the 1780s, the Qianlong emperor ordered a series of copper-plate engravings (created under the supervision of Yi Lantai, a Manchu court artist and student of Castiglione) depicting the European palace buildings that were later destroyed, with the rest of the Yuanmingyuan, in 1860 (figure 5). The prints, along with photographs taken over the years of the ruins,[13] became an important record of the grandly scaled small corner of the garden. One surprising work, *Hudong Xianfahua* (Perspective Painting East of the Lake), divulges the emperor's fondness for visual trickery (figure 6). An apparent European street scene reveals itself to be a massive trompe-l'oeil construction of the main street of a European mountain town seen from the edge of a lake, a metaphorical ocean. To create the panorama, it seems a series of paintings were hung or painted on walls flanking a central road.[14] The artist Castiglione no doubt masterminded the illusion.[15] Imperial archives note numerous requests for Castiglione to paint European-style works on the walls at the Yuanmingyuan almost up until the artist's death in 1766.[16]

The Bishu Shanzhuang and More
Despite the emperor's considerable interest in European gardens and architecture, his ambitions for perfecting the classical Chinese garden never faded. Among the other major antecedents to the Qianlong Garden was the Bishu Shanzhuang mountain resort in Chengde, about sixty-seven miles north of Beijing (figure 7). In 1703,

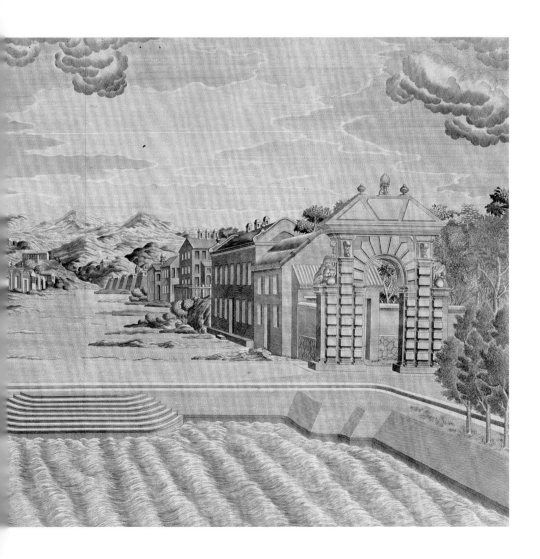

the Kangxi emperor chose the site for the imperial
summer resort. His son and especially his
grandson, the Qianlong emperor, enriched its 218
square miles with temples, palaces, lakes, and
gardens, including reproductions of some
southern gardens and Tibetan- and Chinese-style
temples. On additional acreage closer to the
capital, the Qianlong emperor developed the Jingyi
Garden (Garden of Tranquility and Pleasure) in
the Fragrant Mountains west of Beijing, with
temples and halls within a natural mountainous
setting, as well as scenic spots around the
lakes Zhonghai, Nanhai, and Beihai (Central Sea,
Southern Sea, and Northern Sea) abutting the
western wall of the Forbidden City (figure 8).
Having carried out these copious garden projects
during the first forty years of his reign, devising
landscapes and pavilion arrangements primarily
within the vast expanses of the Yuanmingyuan,
Chengde, and the Fragrant Mountains, the
Qianlong emperor was ready for the ultimate
garden design challenge. Within a narrow and
confined enclosure, surrounded by the high
walls of the densely built palace, he would create
a tightly designed landscape and architectural
microcosm. It would convey the breadth and
spaciousness of the monumental universe with the
intimacy that natural surroundings provide.

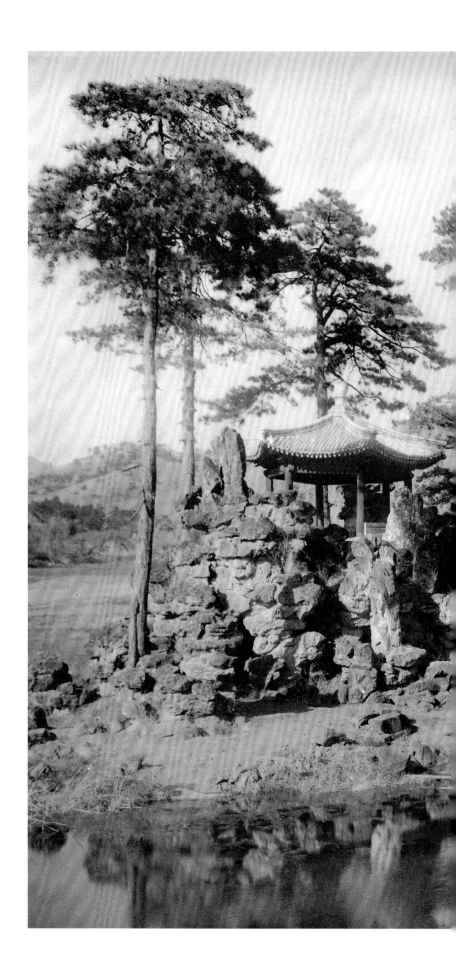

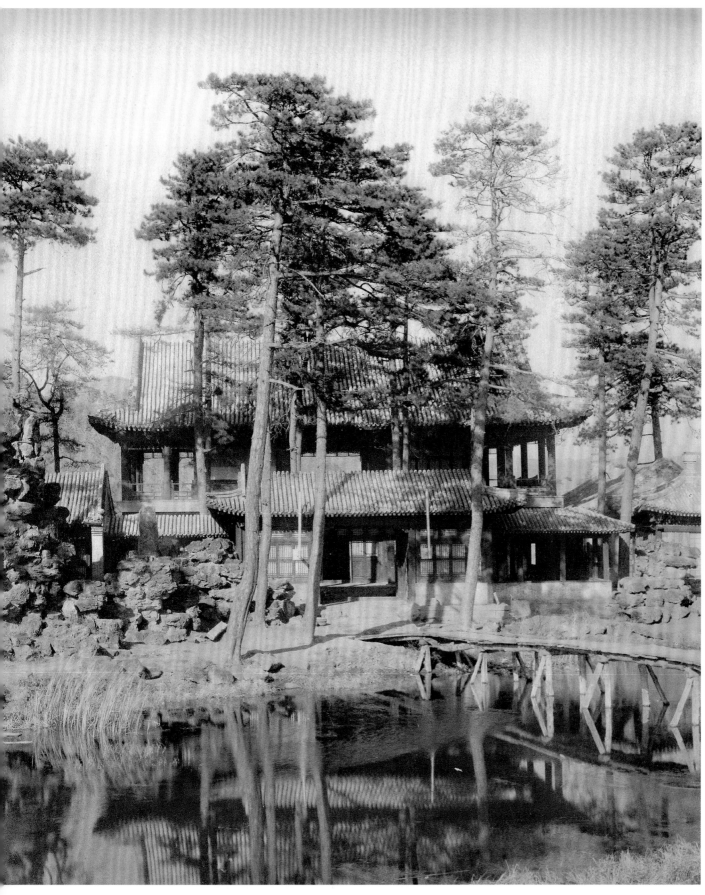

Figure 7. Yenyu Lou at the Bishu Shanzhuang, in Sekino Tadashai, *Nekka Jehol* (Tokyo: Kokusai bunka shinkokai, 1935). Phillips Library, Peabody Essex Museum.

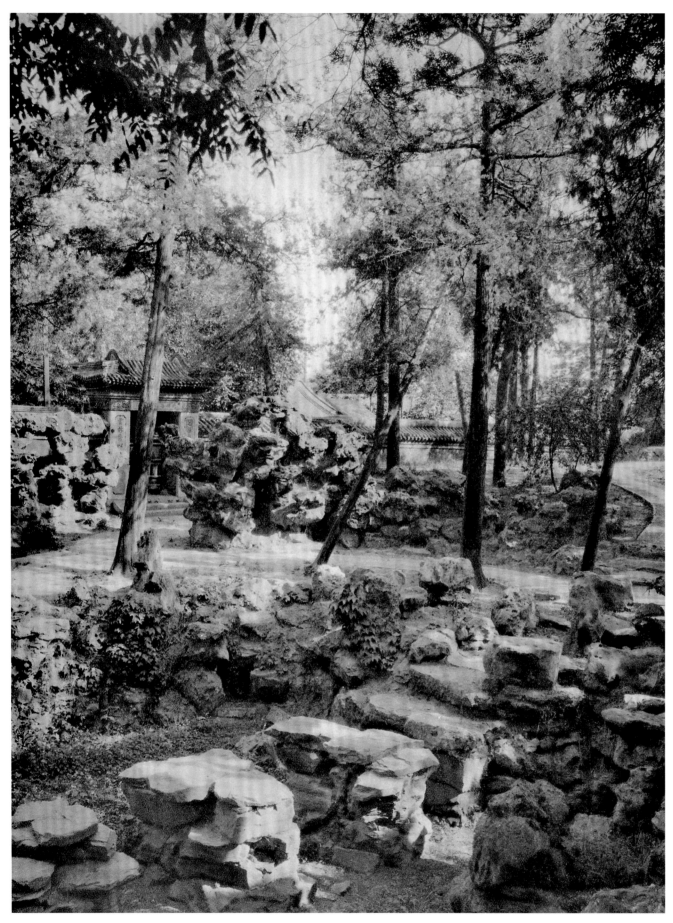

Figure 8. View of Nanhai, plate 19, in Osvald Sirén, *Gardens of China* (New York: Ronald Press Co., 1949). Phillips Library, Peabody Essex Museum.

Notes

1. Qing Gaozong, *Yuzhi Yuanmingyuan tu shi* (Tianjin: Shiyin Shuwu, 1887), reprinted by Wenhai chubanshi. Translation from May Holdsworth, *The Palace of Established Happiness: Restoring a Garden in the Forbidden City* (Beijing: Forbidden City Publishing House, 2008), p. 27.

2. The Yuanmingyuan Banyuan was located at a spot called Tantan Dangdang (Content and Composed). See Liu Chang, Zhao Wenwen, and Jiang Zhang, "Cong Banmuyuan dao Juanqinzhai" ("From Half-Acre Garden to Studio of Exhaustion from Diligent Service"), *Zijincheng* 4, 171 (April 2009), pp. 30–37.

3. Records note that the Qianlong emperor visited the Banmuyuan, which was most likely built during his father's reign, numerous times in 1755 to view its goldfish pond. He must have seen the theater and its unusual ceiling much earlier, since its design was repeated at Jingshengzhai thirteen years prior in 1742.

4. Nie Chongzheng, "Architectural Decoration in the Forbidden City: Trompe-l'oeil Murals in the Lodge of Retiring from Hard Work," *Orientations* 26, 7 (July and August 1995), pp. 51–55.

5. In the 1920s, China's last emperor, the already-deposed Xuantong emperor, known as Puyi (1906–1967), spirited all of these scrolls and many others out of the Forbidden City, stored them in Tianjin, and eventually had them brought to his new base in Manchukuo. *Prunus Blossom* is now in the Liaoning Provincial Museum; *Forest of Gentlemen* and *Eighteen Lords* came back into the collection of the Palace Museum in 1953. See Duan Yong, *Qianlong Simei Sanyou* (Qianlong Emperor's Collection of the Four Beauties and the Three Friends) (Beijing: Zijincheng Chubanshe, 2008), pp. 125–28.

6. His selection of the name echoed his establishment two years earlier of the chamber Sanxitang (Hall of the Three Rarities) within Yangxindian (Hall of Mental Cultivation) where he stored three precious rubbings by the great calligraphers Wang Xizhi (321–379), Wang Xianzhi (344–386), and Wang Xun (350–401).

7. Confucius, *Confucian Analects, The Great Learning, and the Doctrine of the Mean*, trans. James Legge (New York: Dover Publications, 1893), available online at http://www.sacred-texts.com/cfu/conf1.htm.

8. In the last years of the Qing dynasty, the buildings in this garden still comprised one of the primary storehouses of imperial paintings, calligraphies, and antiquities, including many scrolls placed there by the Qianlong emperor. While these paintings had already been removed, most of the other artworks long stored in the Jianfugong repositories were lost in a fire in June 1923.

9. Young-tsu Wong, *A Paradise Lost: The Imperial Garden Yuanming Yuan* (Honolulu: University of Hawaii Press, 2001), p. 82.

10. The buildings on the south, west, and north were poetically named, respectively, Hanguangshe (Chamber Containing Light), Daiyuelou (Waiting under the Moon Building), and Jinglianzhai (Studio of the Calm Lotus).

11. Beijing Shi wenwu yanjiusuo (Beijing Municipal Cultural Relics Research Institute), *Yuanmingyuan Changchunyuan Hanjingtang yizhi fajue baogao* (Excavation Report of the Ruins of the Hanjing Studio at Changchunyuan in Yuanmingyuan) (Beijing: Wenwu chubanshe, 2006).

12. Young-tsu Wong, p. 65.

13. See Régine Thiriez, *Barbarian Lens: Western Photographers of the Qianlong Emperor's European Palaces* (Amsterdam: Gordon and Breach, 1998).

14. Richard Strassberg, "War and Peace: Four Intercultural Landscapes," in Marcia Reed and Paola Demattè, *China on Paper: European and Chinese Works from the Late Sixteenth to the Early Nineteenth Century* (Los Angeles: Getty Research Institute, 2007).

15. The missionary Ignatius Sichelbart and Chinese artists He Guozong, Chen Yuan, and Su Hu supposedly assisted Castiglione in the street illusion. See Maurice Adam, *Yuen ming yuen. L'Oeuvre architecturale des anciens jesuites au XVIIIe siècle* (Beijing: Imprimerie des Lazarites, 1936), p. 36.

16. For example, there are records from Qianlong 13 (1748), Qianlong 21 (1756), and even Qianlong 30 (1765), one year before the master passed away, noting requests for Castiglione to paint murals and ceilings using the "Western techniques."

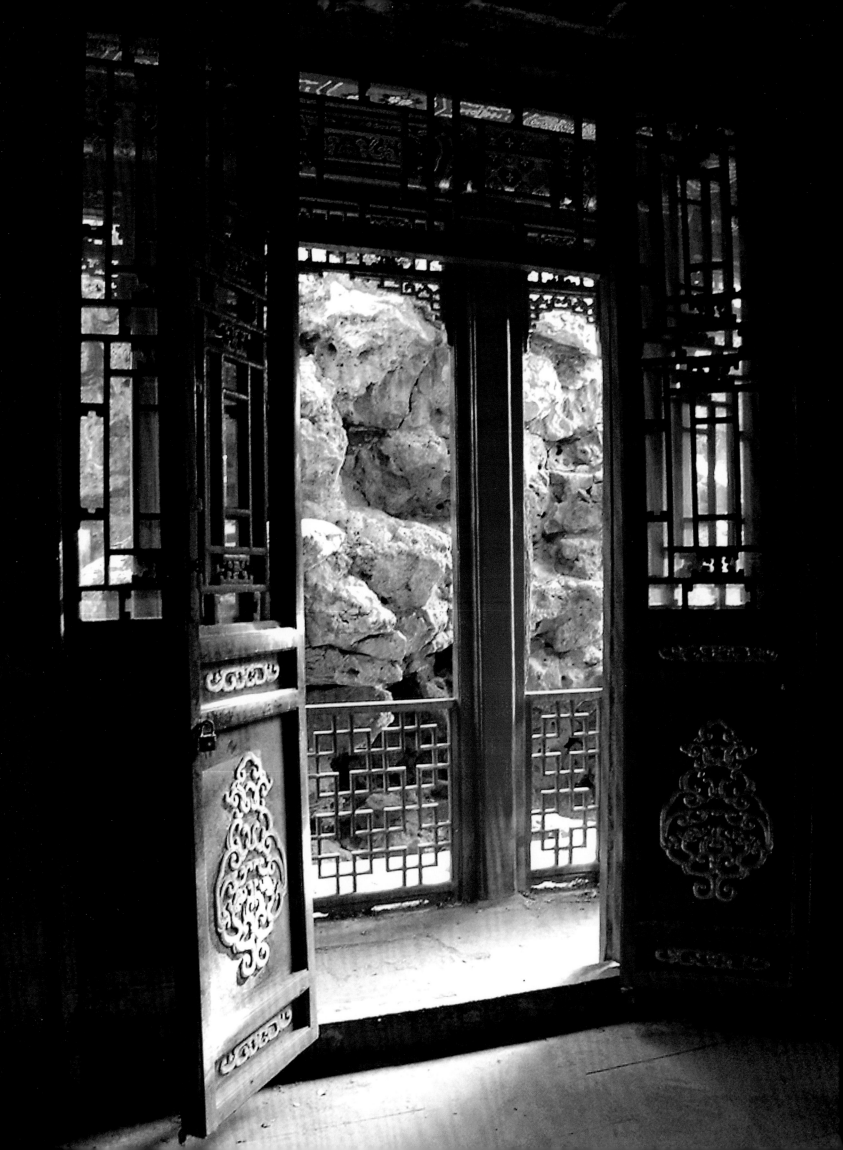

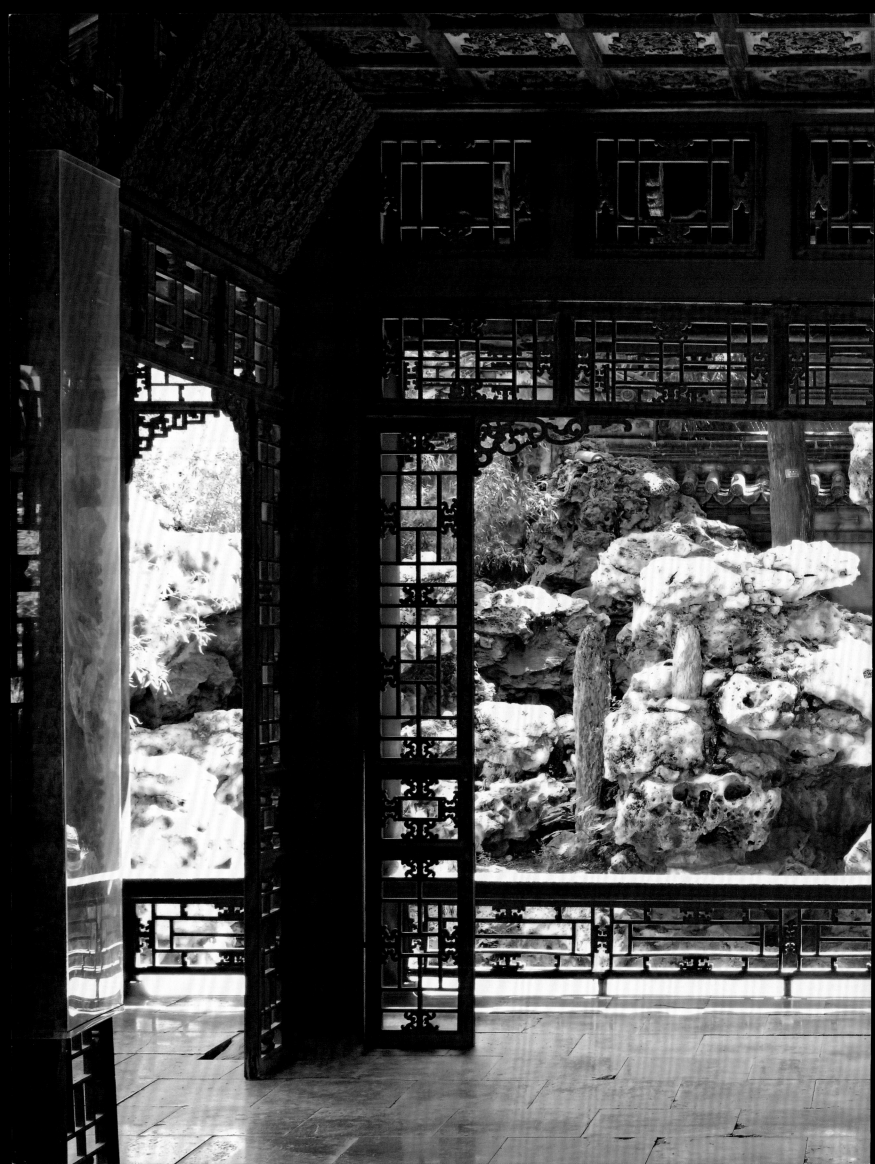

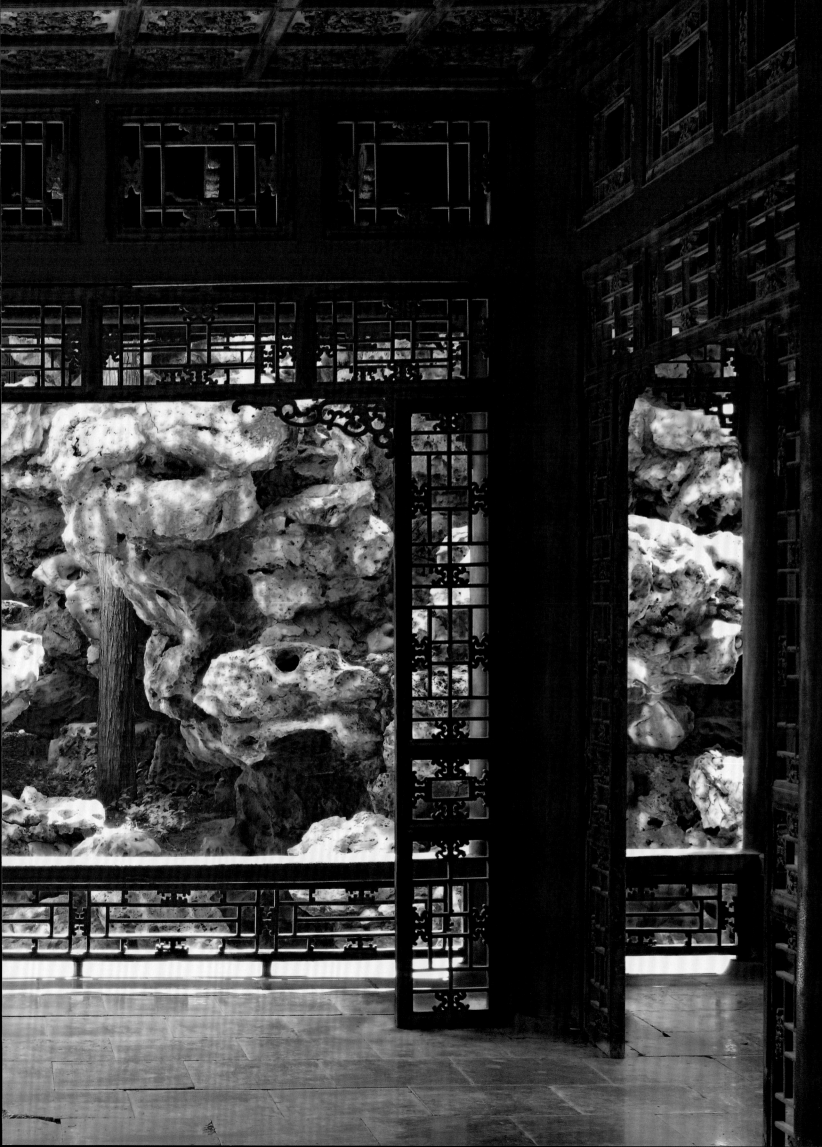

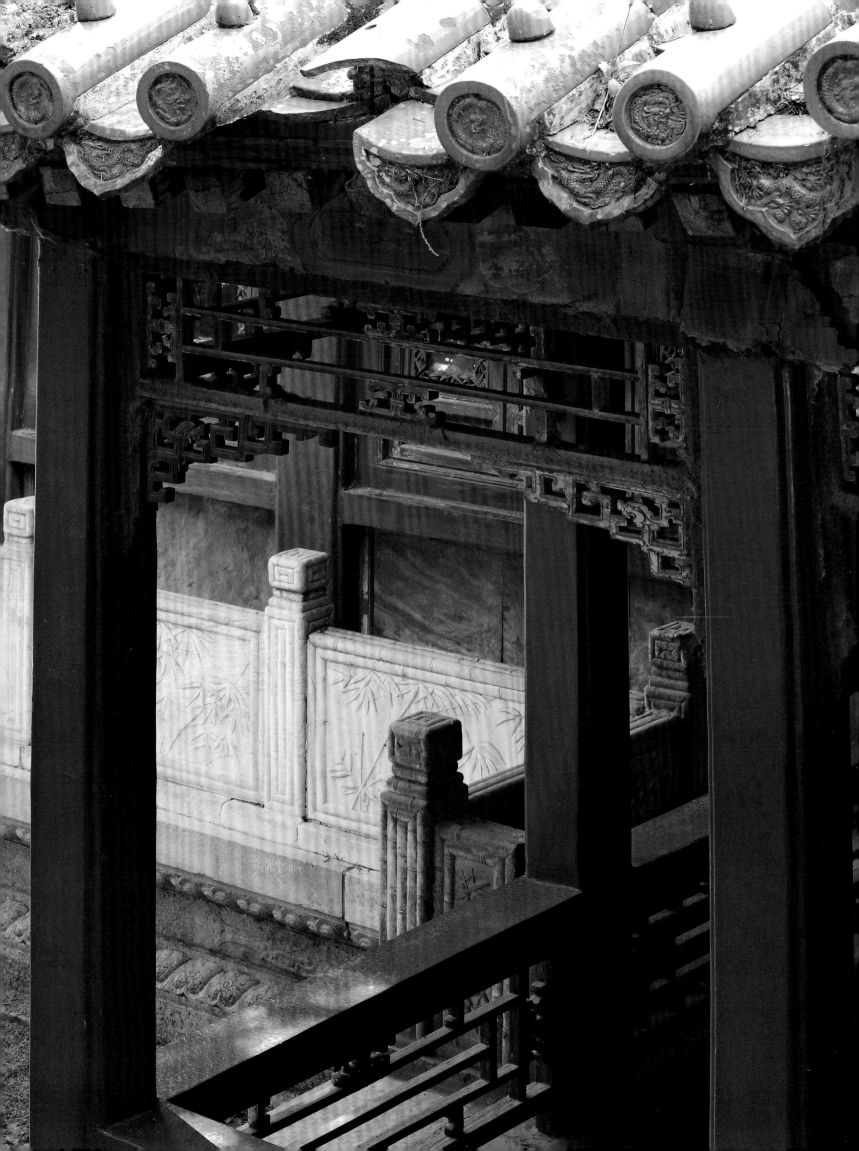

The Qianlong Garden in the Palace of Tranquility and Longevity

寧
壽
宮
的
乾
隆
花
園

Nancy Berliner

In my eighties, exhausted from diligent service,
I will cultivate myself, rejecting worldly noise.[1]

When the Qianlong emperor sat down to plan the Ningshougong (Tranquility and Longevity Palace) and its accompanying garden, his stated intention was to create a district in which to spend his retirement. He was just entering his sixtieth year of life, a full cycle always noted and celebrated in the Chinese tradition, and his mother had reached her momentous eightieth. Vowing not to outrule his grandfather and with two decades left before that deadline, the emperor set to work. The area he selected in the northeastern section of the Forbidden City had, during the Ming and early Qing periods, been dedicated to living quarters for the empress dowagers. The Kangxi emperor further developed these quarters and named them the Ningshougong. The new palace planned by the Qianlong emperor would serve first as a residence for his mother and then as a home for his own future retirement. Its plan was to echo in miniature the composition of the Forbidden City (figure 1). While the Ningshougong palace buildings in the central axis of the three-axis district had numerous halls and rooms for official tasks and rituals, the two-acre, twenty-seven pavilion garden on the western axis would reference nature and inner harmony, with places for leisurely contemplation, poetry writing, Buddhist meditation, and delighting in the visual arts. Lest anyone think it self-indulgent, the emperor repeatedly made clear in poems and prose that he was following the lead of the ancient legendary Emperor Yu who, according to the sixth-century BCE text the *Shangshu* (Book of History), first mentioned the notion of an official's retirement at the point of "exhaustion from diligent service."

The Layout of the Garden

To simulate the natural cosmos, to offer "concealments" and visual surprises, and to be fashioned using the finest craftsmanship in the land, all within a strip of land 525-by-121 feet, required a masterful imagination. According to Ji Cheng's 1631 *Yuan Ye* (The Craft of Gardens), the primary components of a garden were buildings: halls (*tang*), studios (*zhai*), terraces (*tai*), bowers (*xuwwan*), and pavilions (*ting*); and then gateways (*menlou*); covered corridors (*lang*); connecting buildings, pavings, walls, artificial mountains, caves, rocks, curving waterways, and

borrowed scenery (the inclusion of distant views in a garden, though they may be far beyond the perimeter of a garden wall). It went without saying that to these should be added calligraphy, poetry, and literary references. These elements added personal sentiments and values as well as aesthetics. In his garden, the Qianlong emperor would incorporate Buddhist spiritual pursuits, Confucian morals, poetry writing, reverence for traditional literati characteristics of virtue and righteousness, theater and musical performance, as well as environments for immersion in nature and spaces for the display and presentation of his art collection.

The fundamental design solution was to divide the area into four courtyards arranged in a north-south sequence, thereby establishing a rhythm and preventing the long, narrow space from being viewed and experienced in its totality. The distinct composition of each courtyard also creates its own rhythm. Buildings and high rockeries along the perimeters of the courtyards obscure the sense of being enclosed by walls. A formal gate building, Yanqimen (Gate of Spreading Auspiciousness), with a yellow- and blue-edged glazed-tile roof and a pair of red doors with gilt escutcheons, bosses, and metal plates, is the ceremonial entrance to the garden, but beyond that portal awaits a very dissimilar realm (Chapter II, figure 1).

The First Courtyard The visitor enters the first courtyard by following a curving path through a slit between two seemingly obstructing rockeries. Within are several buildings, open pavilions, a curving waterway, rockeries, a terrace high upon an artificial mountain with rugged stairs leading to it, a Buddhist cave below, and even a miniature courtyard with its own Buddhist shrine and gazebo perched on a rockery. Straight and curving paths of inlaid pebbles or geometrically shaped stones and covered corridors with colorfully painted beams connect buildings and sites. Expressive rocks on carved marble pedestals punctuate spaces and entries. Ancient trees, bamboo, and other botanicals add color and vibrancy. The ostensibly erratic (though always on a north-south grid) placement of the five buildings and their varying heights and sizes create a dynamic and organic environment. The building types range from open pavilions to terraces to covered corridors to caves and small enclosed shrines. At the intersection of two

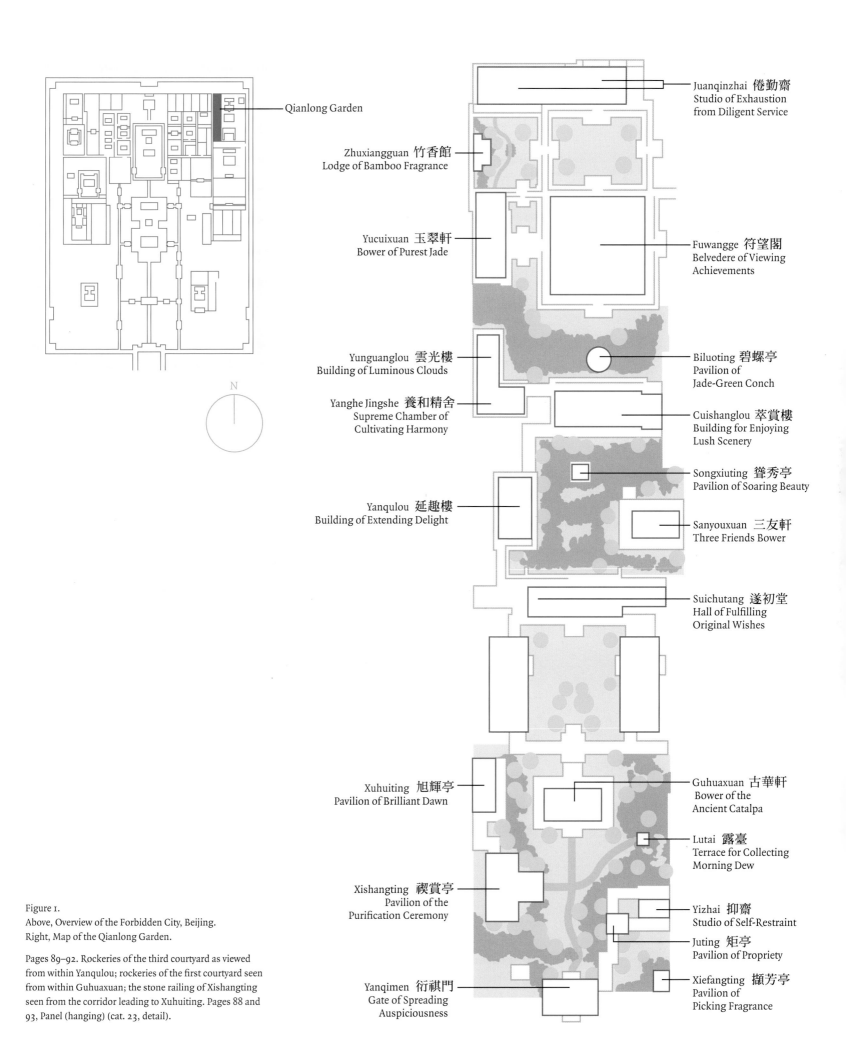

Qianlong Garden

Juanqinzhai 倦勤齋
Studio of Exhaustion
from Diligent Service

Zhuxiangguan 竹香館
Lodge of Bamboo Fragrance

Yucuixuan 玉翠軒
Bower of Purest Jade

Fuwangge 符望閣
Belvedere of Viewing
Achievements

N

Yunguanglou 雲光樓
Building of Luminous Clouds

Biluoting 碧螺亭
Pavilion of
Jade-Green Conch

Yanghe Jingshe 養和精舍
Supreme Chamber of
Cultivating Harmony

Cuishanglou 萃賞樓
Building for Enjoying
Lush Scenery

Songxiuting 聳秀亭
Pavilion of Soaring Beauty

Yanqulou 延趣樓
Building of Extending Delight

Sanyouxuan 三友軒
Three Friends Bower

Suichutang 遂初堂
Hall of Fulfilling
Original Wishes

Xuhuiting 旭輝亭
Pavilion of Brilliant Dawn

Guhuaxuan 古華軒
Bower of the
Ancient Catalpa

Lutai 露臺
Terrace for Collecting
Morning Dew

Xishangting 禊賞亭
Pavilion of the
Purification Ceremony

Yizhai 抑齋
Studio of Self-Restraint

Juting 矩亭
Pavilion of Propriety

Xiefangting 擷芳亭
Pavilion of
Picking Fragrance

Yanqimen 衍祺門
Gate of Spreading
Auspiciousness

Figure 1.
Above, Overview of the Forbidden City, Beijing.
Right, Map of the Qianlong Garden.

Pages 89–92. Rockeries of the third courtyard as viewed
from within Yanqulou; rockeries of the first courtyard seen
from within Guhuaxuan; the stone railing of Xishangting
seen from the corridor leading to Xuhuiting. Pages 88 and
93, Panel (hanging) (cat. 23, detail).

Figure 2. Directional paving stone, first courtyard.

stone pathways featuring the cracked-ice pattern, an unusually incised stone indicates the center of the space with abstracted arrows noting the directions of the compass (figure 2). The design may have been related to Chinese concepts of the five elements comprising the universe and geomancy. Directly to the west is the Xishangting (Pavilion of the Purification Ceremony), the only area devoted to flowing water in this primarily winter garden created for the season when the emperor resided in the Forbidden City (figure 3).

The floating cup pavilion (liubeiting), in which a roof covers a regularly curving waterway, was a building type formulated by or even before the Song dynasty. It features a waterway – this example is a trough carved into stone (figure 4) – along which cups of wine set on leaves were floated to be consumed by members of a gathering on the appointed third day of the third month. As early as the Zhou period, a day in the third month was selected for a ritual purification in water. Over time, the ritual evolved into an occasion to feast, drink, and write poetry. Wang Xizhi's *Preface to the Orchid Pavilion* was the most famous account of such a gathering. While early *liubeiting* were primarily for purification and drinking parties, later pavilions were specifically intended to reenact the scene described by the master calligrapher Wang Xizhi and invoke his memory.

Furnishings archives state that a set of rootwood furniture filled the Xishangting pavilion looking out onto the *liubeiting* (plates 8, 9, and 10). Shown in paintings as early as the Song period, this seemingly primitive furniture had symbolic meaning for Buddhist priests and Daoist monks: the organic forms reflected their indifference to worldly goods and their synchrony with the cosmos. By the Ming dynasty, literati scholar officials had adopted the furniture as symbolic of their approach to life as well. By the eighteenth century, the Qianlong emperor was announcing that such motifs suited his bent for inner cultivation (plate 11); on one occasion at least, he even had his portrait painted seated in a rootwood chair in a garden (plate 12).

With the prominent placement of his Xishangting so near the entrance, the Qianlong emperor, who was proud of his distinctive calligraphy and poetry that appear throughout the garden (plate 13), announced his embrace of the literati approach to life epitomized by Wang Xizhi and his calligraphy. In 1792, as he was nearing the end of his reign, he wrote:

There are stones, cliffs and bamboo gatherings.
In the Pavilion of Floating Goblets, there is a stone curving [waterway] slab.
In the future when I want to imitate the rubbing of Wang Xizhi [calligraphy],
I will look at the Pavilion and imagine the old times.[2]

The last line refers to the emperor's past as well as to Wang Xizhi. All of these references – to calligraphy, the gathering of friends to write poetry, the original Orchid Pavilion and its meandering stream, to Wang Xizhi, and to the eventual and inescapable end of life – would have been instantly apparent to a learned visitor. The many layered symbols in this single structure offer a sense of the wealth of literary references and sentiments throughout the garden.

On the central northern axis of the first courtyard is Guhuaxuan (Bower of the Ancient Catalpa), another open-sided pavilion. It honors a catalpa tree – one of the many ancient trees that the emperor insisted on preserving at the site both for the visual and reverential atmosphere and for their contributions to the auspicious ambience effecting longevity. Today, this tree, now listing and supported by a pole, still stands next to the steps ascending into the pavilion. Two bronze cranes, likewise symbols of longevity, atop marble pedestals carved to imitate vigorous waves hitting island shores, most likely flanked the stairs. Now, only the pedestals remain. One bears an area incised to fit the foot of a crane and a hole for a metal rod; a hole for a second rod and a faint, shallower footprint are visible among the waves. Two organically shaped boulders on finely carved ovoid marble pedestals in turn flank the cranes' pedestals. This parade of symbols proclaimed longevity for the aging emperor:

Although the bower is recently built
The Forbidden Palace is from ancient days.
There are old trees from that time,
Two or three lined up in the courtyard
Enormously rising up are the cypress and catalpa
It's difficult to count their years
The cypress will never wither

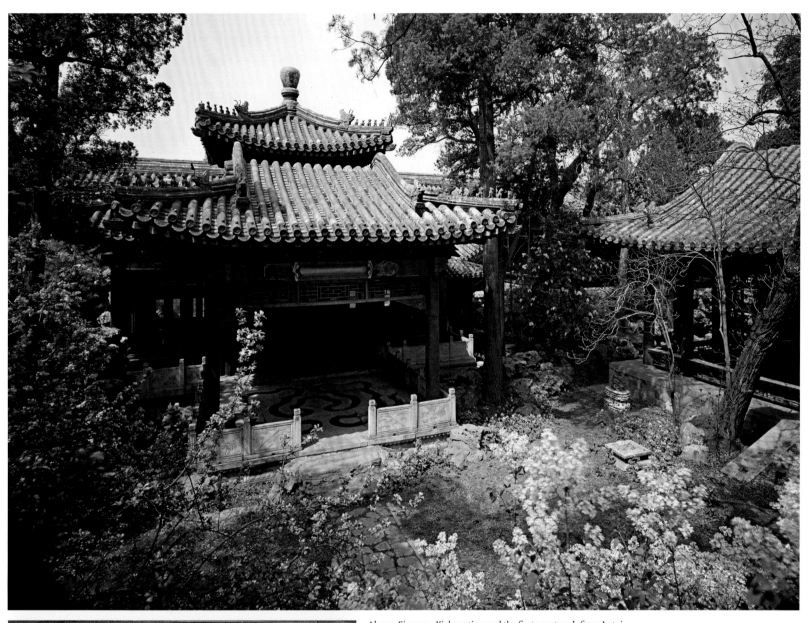

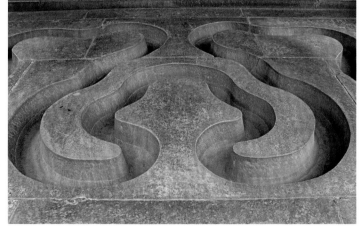

Above, Figure 3. Xishangting and the first courtyard, from Lutai.

Left, Figure 4. The Xishangting artificial waterway.

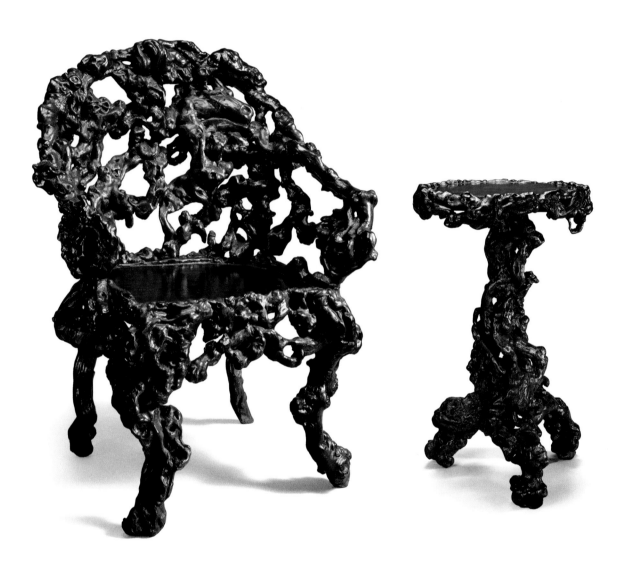

Plate 8. Chair (cat. 19) and Table (cat. 34).

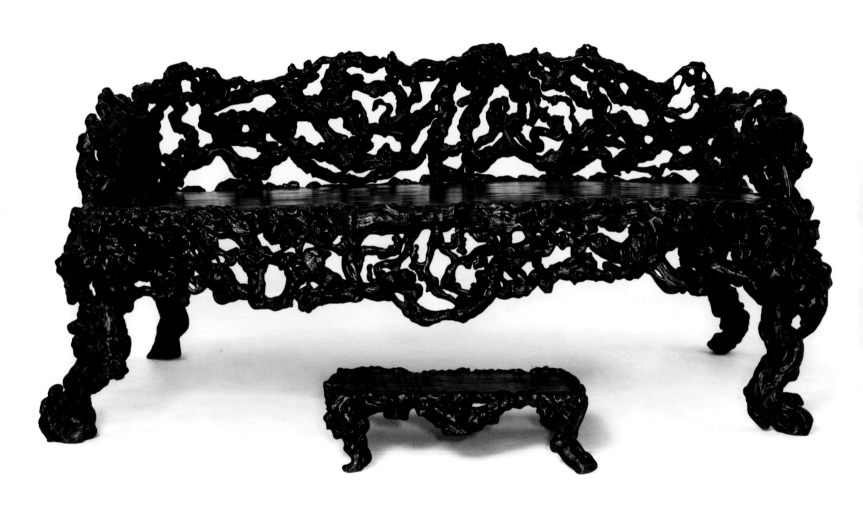

Plate 9. Couch bed with foot stool (cat. 20).

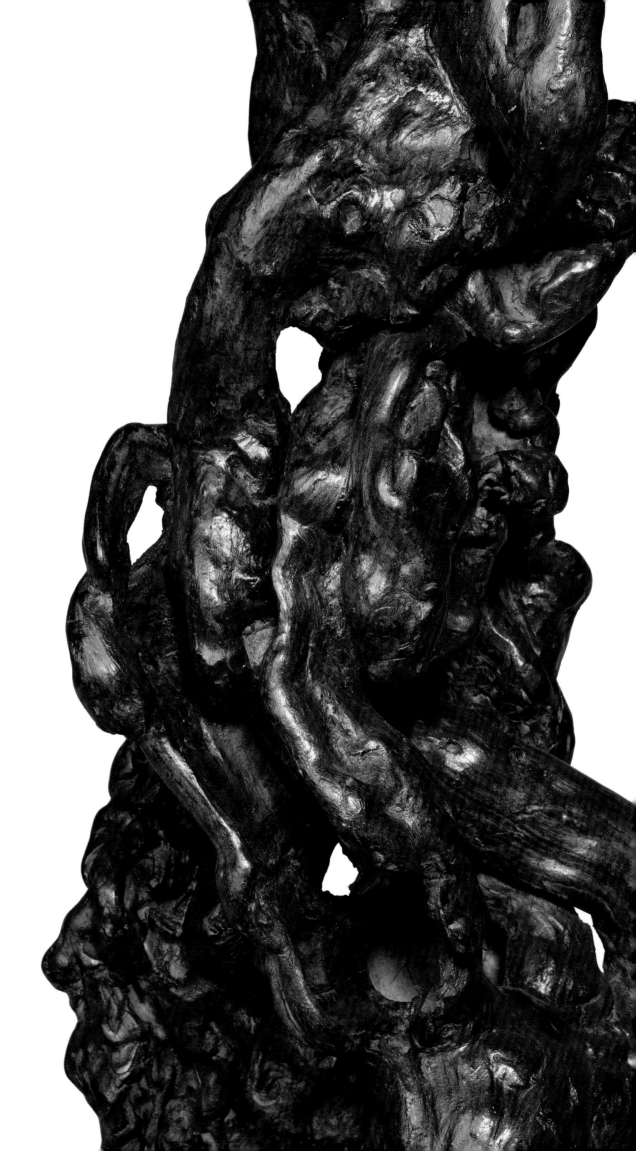

Plate 10. Table (cat. 34) (detail of plate 8).

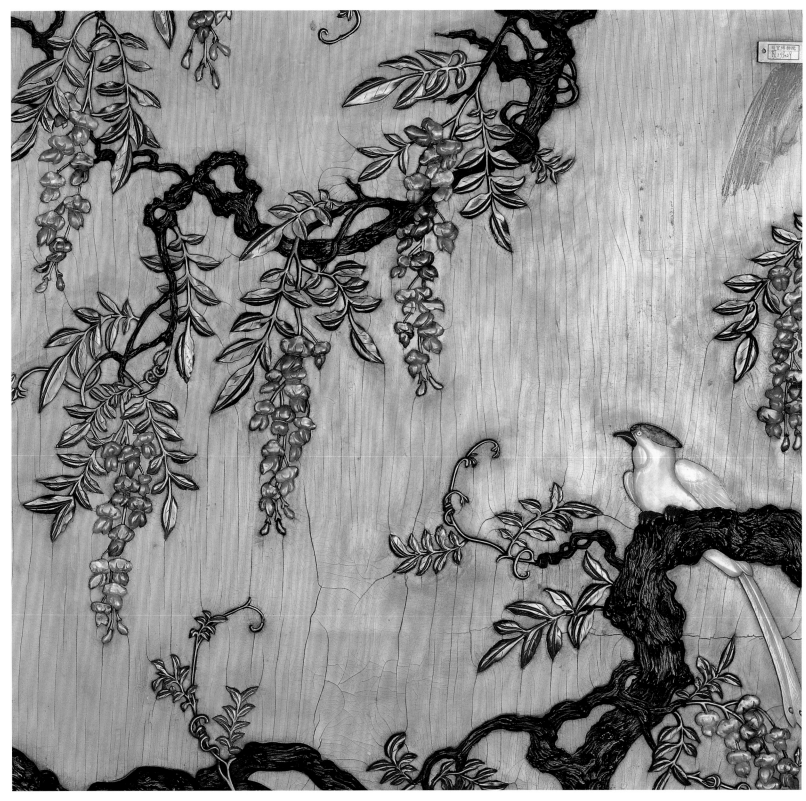

Detail of plate 11.

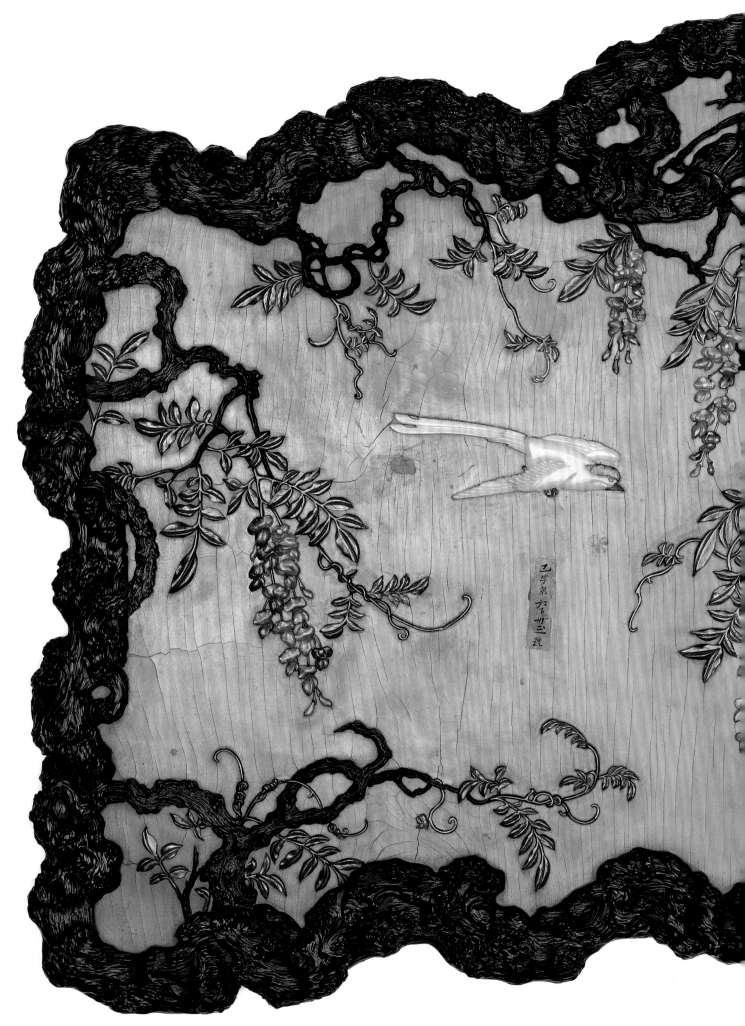

Plate 11. Panels (hanging) (cat. 25, one of a pair).

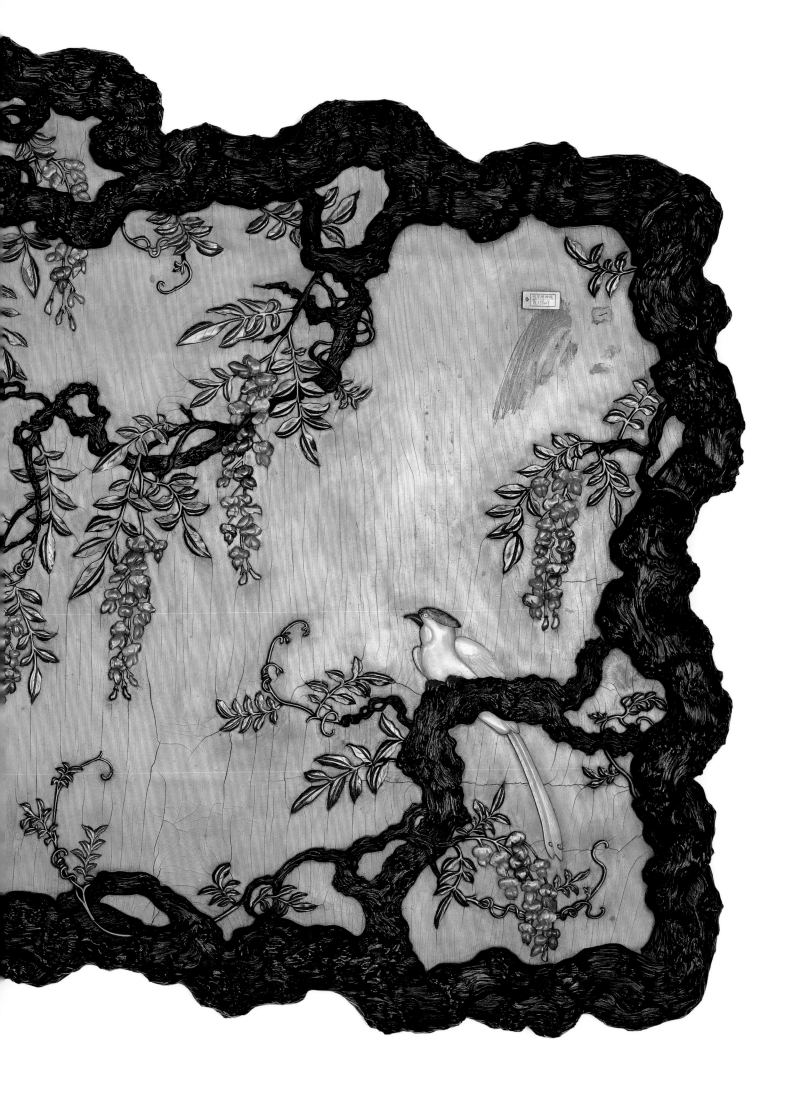

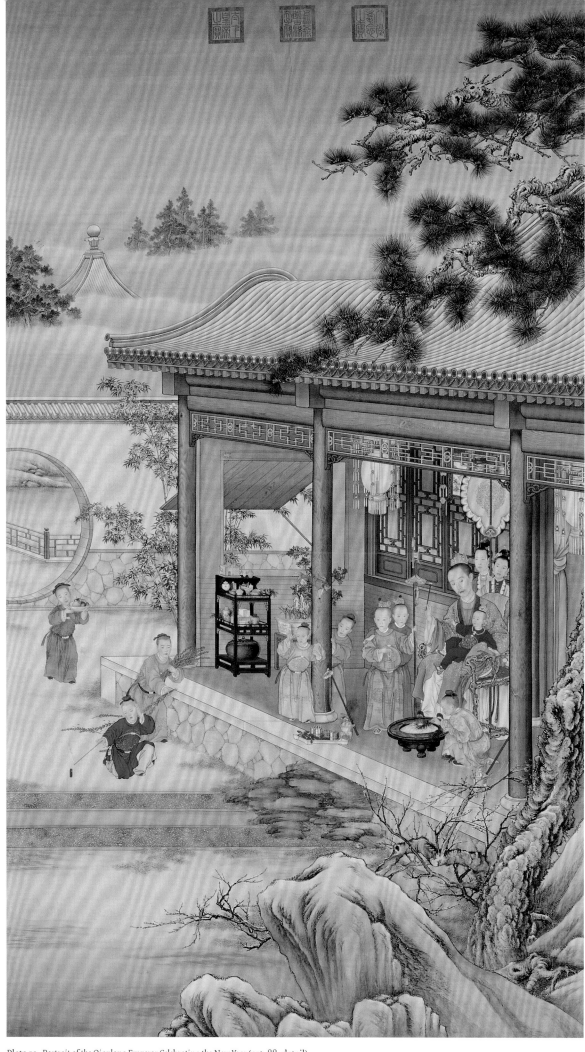

Plate 12. *Portrait of the Qianlong Emperor Celebrating the New Year* (cat. 88, detail).

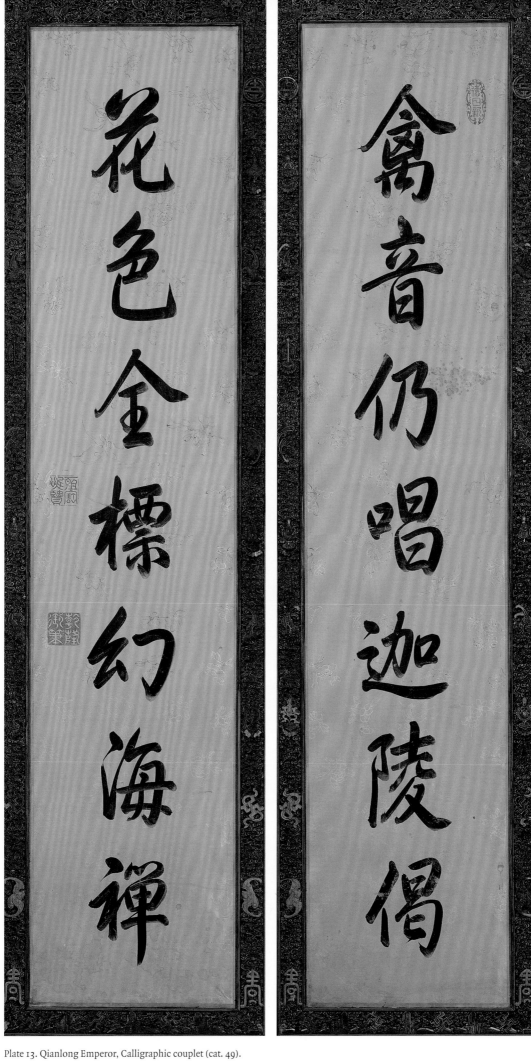

禽音仍唱迦陵偈

花色全標幻海禪

Plate 13. Qianlong Emperor, Calligraphic couplet (cat. 49).

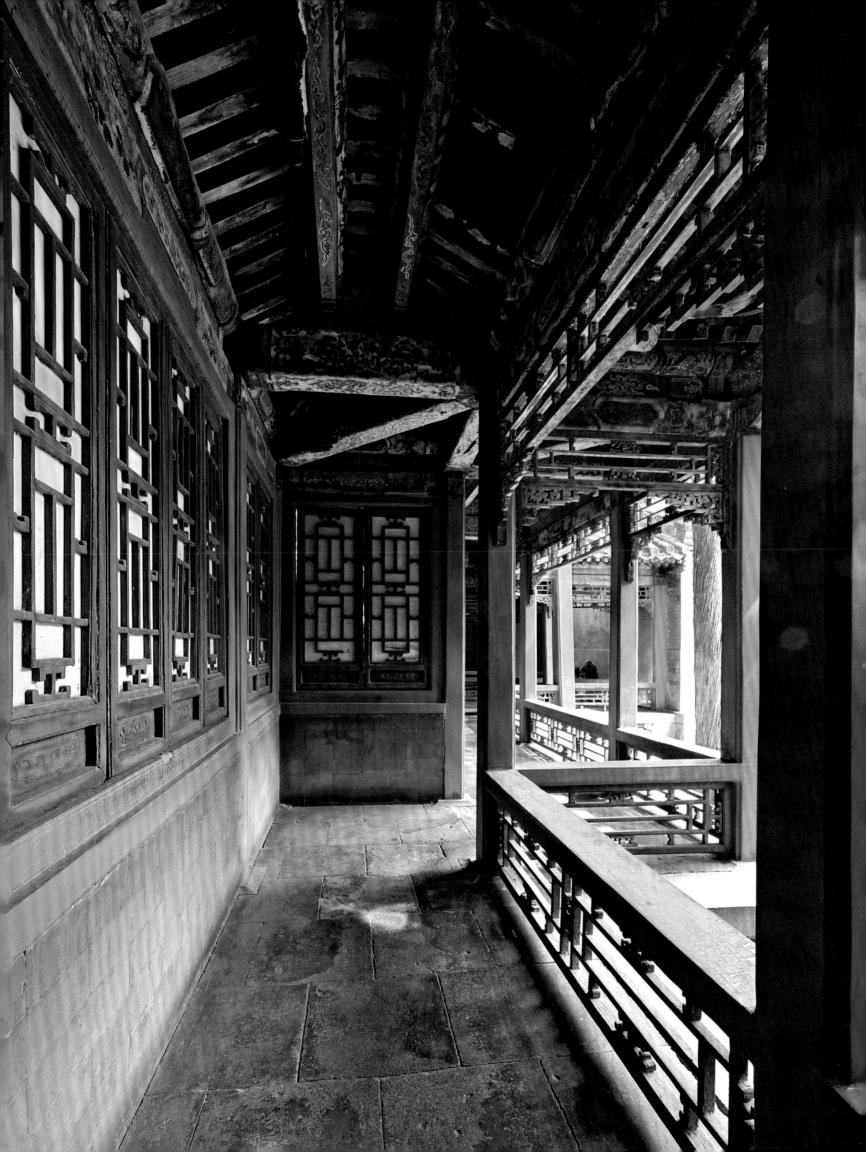

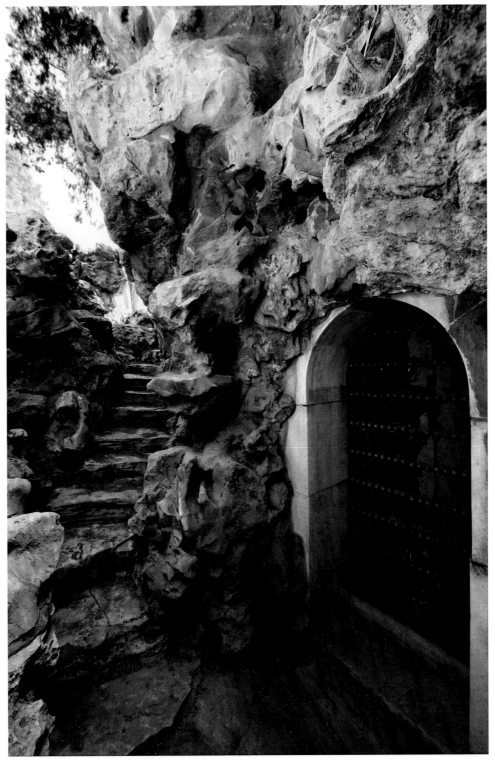

Left, Figure 5. Covered corridor leading to Yizhai.

Above, Figure 6. Entrance to the cave below Lutai, first courtyard.

Plate 15. Vessel (cat. 40A and B, one of a pair).

Plate 14. Stand (cat. 40A and B, one of a pair).

The catalpa has branches as its companions
The trees standing side by side
Like envied lovers meeting
Flowering even without flowers.
I facing them, gaze at their transformability.[3]

The bower is open on all four sides providing framed views from within that encapsulate a sense of the universe. Looking east from under the cover of Guhuaxuan's roof, there are piled rockeries that give the impression of being in the mountains. The Qianlong emperor was so inspired by the ancient tree, the bower, and its views, that he had his own poetry carved on elaborate lacquer panels hanging throughout the structure.

Paths around the courtyard offer multiple options – through rockery tunnels, around corners, up stone steps, along covered corridors, and through doorways – and an array of vistas (figure 5). One doorway leads into a miniature courtyard with its own artificial mountain topped with the Xiefangting (Pavilion of Picking Fragrance), built "because of the blooming of wild flowers," as the emperor noted in a poem in 1791.[4]

In a small Buddhist building within that courtyard, Yizhai (Studio of Self-Restraint), are exquisite examples of Buddhist art: a pair of gold-brushed paintings on black backgrounds, each depicting eight of the sixteen *luohan* (disciples of the Buddha who achieved enlightenment). One is by the Qing court artist Yao Wenhan and the other purportedly by the Yuan master Zhao Mengfu, but most likely by Yao Wenhan.[5] On the opposite wall is a Tibetan-style shrine featuring intricate gilded and painted clay Buddhist deities (*tscha-tscha*, in Tibetan) placed within different-shaped niches in a mandalalike arrangement.

While this tiny building is one of many examples of a functional space doubling as an opportunity to display great artworks, its Buddhist-laden spaces foretell the Buddhist themes sprinkled through the garden. Another Buddhist shrine, a dark cave entered through an arched door at the foot of a rockery (figure 6), has a small niche for a Buddha image and on a side wall, the emperor's calligraphy of the Buddhist *Sutra of the Worthy*, the *Xianshou jing*, carved in stone (figure 7). Steps that wind above the cave lead to a marble platform, Lutai

(Terrace for Collecting Morning Dew), where dawn's moisture was to be collected for a longevity elixir. This Lutai imitates a terrace of the same name in the palace of Han Emperor Wu (r. 141–87 BCE). Ascending the rockery to the Lutai mimics the sense of climbing a mountain, and the view provides a refreshing perspective of the courtyard, its buildings, bamboo, and trees.

The Second Courtyard Just beyond an ornate gate guarded by two stone lions, a small rockery blocks the view of the second courtyard. Past the rockery is a small, balanced, and symmetrical courtyard such as in the Beijing homes of many officials during the Qianlong period, exhibiting a striking contrast to the lush wildness of the first courtyard. Two buildings at the east and west face each other; a third, Suichutang (Hall of Fulfilling Original Wishes), on the central axis, marks the limit of the space to the north. Marble pedestals bearing bronze vases flank each set of steps up to the buildings (plates 14 and 15). Cut flowers would have graced the vases during the emperor's visits. The bulbous lower half of the marble pedestals is a stylized vein-patterned lotus leaf drooping down on itself. The upper section depicts the open flower, with layers of its distinctive petals. Versions of these white marble stands were known as early as the Song dynasty. In the center of the open square is a large jade boulder depicting the auspicious image of three rams. Four rocks of the prized Lingbi variety sit on rectangular pedestals regularly arranged, one in each corner of the yard (figure 8). Each rock presents the highly desired aesthetic criteria for rocks in Chinese culture – wrinkled surfaces, penetrability, and awkwardness. Together, along with the central rockery, their organic forms provide a quiet relief from the otherwise balanced regularity of this courtyard. And through the north-facing glass windows of the northern hall, Suichutang, the emperor would also have glimpsed rockeries towering beyond his view – a harbinger of what lay ahead.

The Third Courtyard This courtyard brims with rockeries. Only from an aerial perspective can one see that four structures, one in each direction but none symmetrically situated in relation to another, hug the outer edges of the space. In the center, a looming rockery ensures that the first-floor windows of all the buildings yield only vistas of rockery walls. There are a variety of potential

Figure 7. Qianlong Emperor, Calligraphy of the Buddhist *Sutra of the Worthy* carved in stone within a cave, first courtyard (detail).

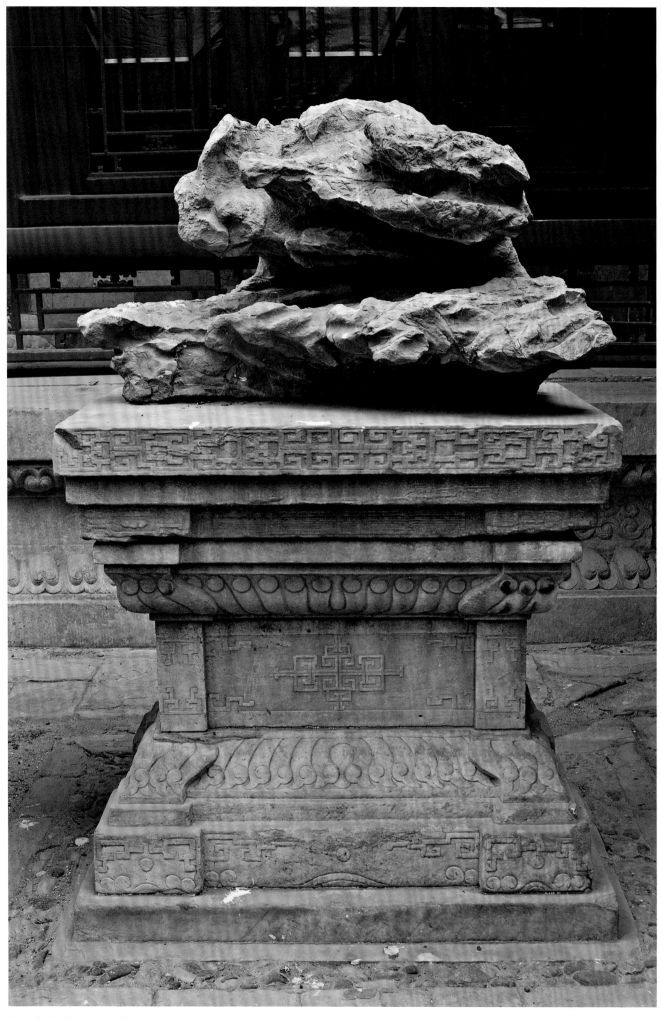

Figure 8. Lingbi rock, second courtyard.

paths, ranging from covered galleries along the courtyard's edges to vase-shaped gateways with colorful "tiger-skin" – patterned stone walls (Chapter I, figure 9), through dark grotto passageways leading to rough stone steps up the mountain. Atop the rockeries, across a bridge of a rock slab traversing a treacherous crevasse, sits a small, square, viewing pavilion.

This courtyard is an almost exact replica of one built six years earlier in the Hanjingtang area at the Yuanmingyuan with four buildings surrounding a rockery-filled courtyard. In the Qianlong Garden version, the emperor added to its dynamism by offsetting the northern and southern buildings, so that no building is directly across from another. He also topped the rockery with a pavilion (figure 9). The names of three buildings in this area – Yanqulou (Building of Extending Delight), Cuishanglou (Building for Enjoying Lush Scenery), and Suichutang (Hall of Fulfilling Original Wishes) – bear no relation to their Yuanmingyuan twins, but the emperor could not resist retaining the name Sanyouxuan (Three Friends Bower) for the special building on the east side of the courtyard and repeating the details of its design and setting (figure 10). Excavation drawings reveal that the two marble pedestals for displaying rocks outside the building's west window duplicated two in the exact same position at the Yuanmingyuan Sanyouxuan. Likewise, the rough stone steps to the southern entrance and the northern openings to the building emulate the ascent and access to the Yuanmingyuan structure. Here, we see the emperor's passion for both copying and perfecting his own designs.

The interiors of the three buildings on the west, east and northern edges of the courtyard reveal the Qianlong emperor's propensity for lavish and experimental interior decoration – a sharp contrast to the wild rockeries. This harmony of divergent styles – the highly manipulated and the organic – is a hallmark of the Qianlong Garden and the style of the emperor.

Emerging from a dark grotto tunnel, the visitor walks up two flat rocks that constitute the steps leading into the triple-bayed Sanyouxuan, which is filled with precious materials brilliantly

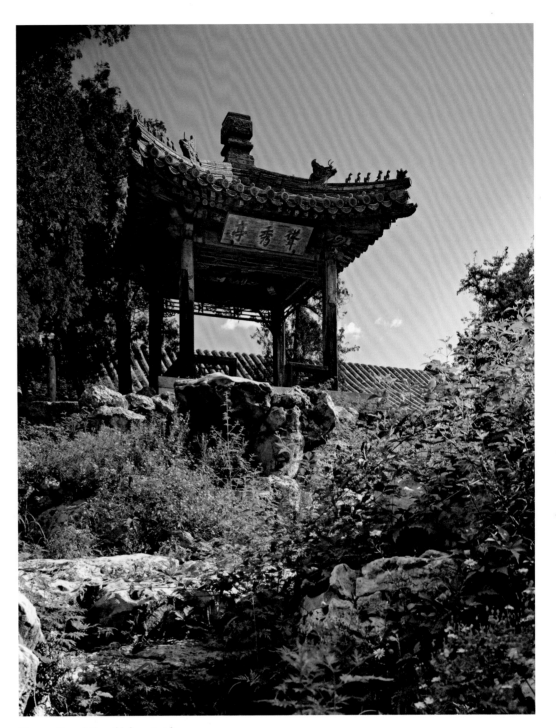

Figure 9. Songxiuting, third courtyard.

There are three friends which are advantageous, and three which are injurious. [Make friends with] those who are upright; friends who are honest; and friends who have heard much.

益者三友損者三友友直友諒友多聞益矣

wrought to portray the theme of the building: jade, mother-of-pearl, rare, imported *zitan*, and bamboo. Thin bamboo threads arranged side by side in geometric patterns form a partition wall with a moon-shaped opening. Inlaid into that bamboo marquetry are relief images of bamboo leaves, pine needles, and plum blossoms carved from jade; and, fashioned from *zitan*, bamboo stalks, twisted, knotty plum trunks and branches of *zitan* so buckled and bowed by their apparent age that they leave the marquetry surface and intrude into the round moon gate. This dark, lustrous, rare wood is often compared to jade both for its beauty and difficulty to carve. Perpendicular to the moon gate hangs an equally superbly carved filigree *zitan* window covering that also depicts the three friends, pine, bamboo, and prunus (plate 16). Through its openings and a large exterior plate of glass, the rocks and trees of the courtyard are visible: artifice and nature side by side in a single frame.

On the opposite side of the rockeries is yet another form of ornamentation. The room partitions on the first floor of the two-story Yanqulou, like most Chinese decorative partitions, contain wood lattice supports for the light-transmitting silk stretched across them. The lower sections of the Yanqulou partitions are faced with intricate bamboo thread marquetry in a geometric pattern. Further enhancing the visual impression of the room, both the marquetry and the lattice strips are inlaid with variously shaped glazed porcelain tiles. The glazing techniques represented include *qinghua* (underglaze cobalt) (plate 17); *doucai*, a technique that first appeared during the Ming dynasty, combining underglaze cobalt designs with multiple overglazes; and *fencai* (also known as *yangcai* or *falancai*), an overglaze enamel for porcelain (plate 18). Only developed in the eighteenth century, *fencai* is usually associated with export ware and may have been developed in answer to foreign requests for porcelain in the soft hues of Chinese silks. Its presence in the Qianlong Garden signals that the emperor also appreciated its delicate effect. The combination of the colored tiles with the wooden surrounds creates a festive but quiet atmosphere in the room, entirely distinct from the rockery boulders that stare in from the east windows. The emperor delighted in this intriguing juxtaposition, and in 1790 wrote a poem about the building:

Delight is indeed born in the heart
It sometimes also depends on its surroundings
Among the exquisite Taihu rocks
There's a building with an honorific title of Calm.

Vertical and horizontal peaks and pinnacles have the
sense of solidity
The shadows of the pine and bamboo whoosh in
the wind.
All of them help the heart to reach comprehension,
How could they just exist only to make the eyes gallop?[6]

The courtyard's northern building, Cuishanglou, has a similarly colorful air but it was produced by using other newly introduced artistic techniques: glass imported from Europe instead of silk or paper was fitted into the room partitions' lattices. Glass had existed in China as early as the Han dynasty, but primarily for use as beads or small decorative objects. Large plates for window panes began arriving from Europe only during the Qing dynasty; with them came the art of painting glass on its reverse side. This ancient Roman technique, revived in Europe during the fifteenth century, created a dazzling, jewellike effect. For Cuishanglou, Chinese artisans painted European-influenced baroque geometric and floral designs in bright hues with gold outlines. Sunlight from the north- and south-oriented windows illuminates the numerous colorful panes around the room, creating an ethereal atmosphere (plate 19).

The Fourth Courtyard The northern side of Cuishanglou looks out onto another high rockery and beyond it, dominating the fourth courtyard, is the towering Fuwangge (Belvedere of Viewing Achievements), the tallest building in the garden and one of the tallest buildings in the entire Forbidden City. The second-floor northern balcony of Cuishanglou offers multiple entrances into this next courtyard. To the west is the entrance to the attached Yunguanglou (Building of Luminous Clouds), containing numerous Buddhist niches for the emperor's contemplation and appreciation. To the north is a short marble bridge leading across a chasm to a high rockery on which perches Biluoting (Pavilion of Jade-green Conch), a plum-blossom-shaped, five-pillared gazebo.

For this northernmost section, the emperor turned again to one of his own designs, the

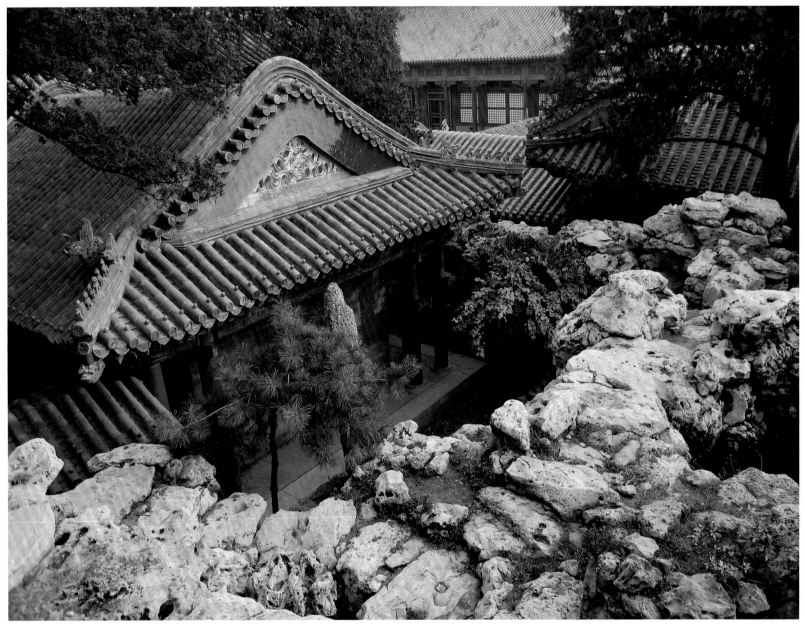

Figure 10. Sanyouxuan, third courtyard.

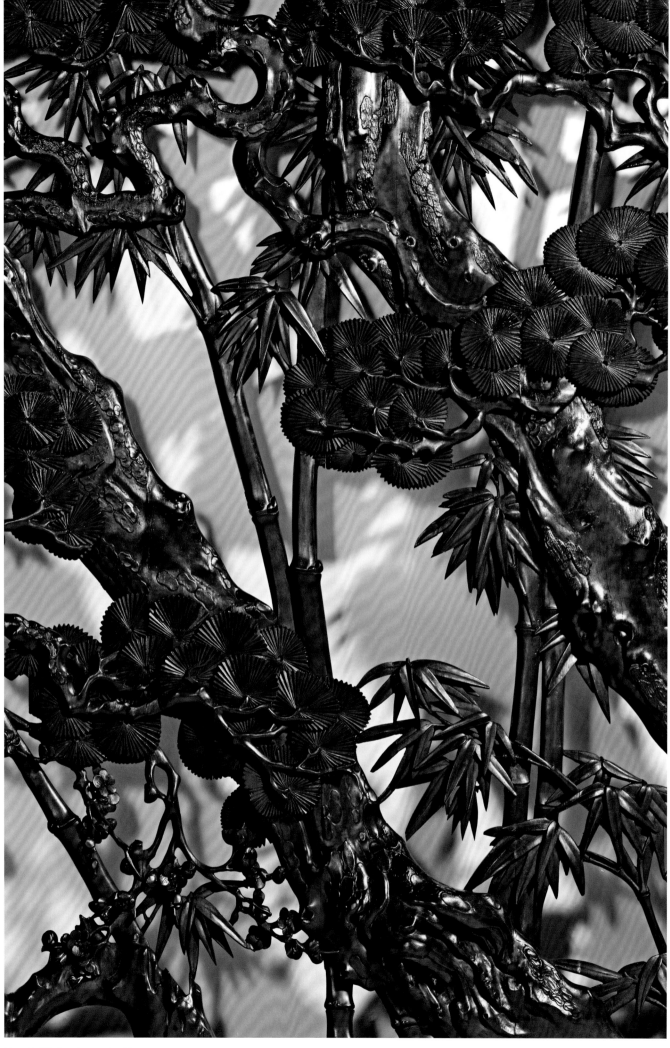

Plate 16. Window (cat. 7, detail).

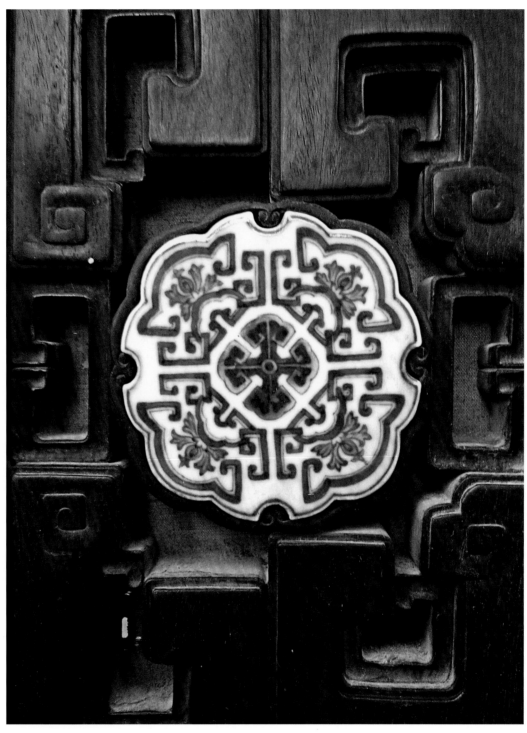

Plate 17. Window surround (cat. 8, detail).

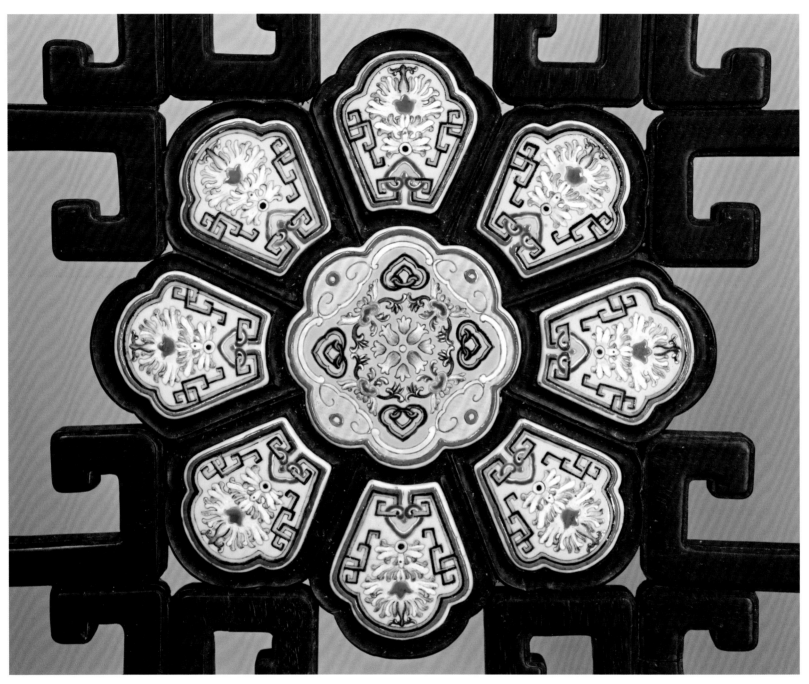

Plate 18. Partition (cat. 4, one of a pair, detail).

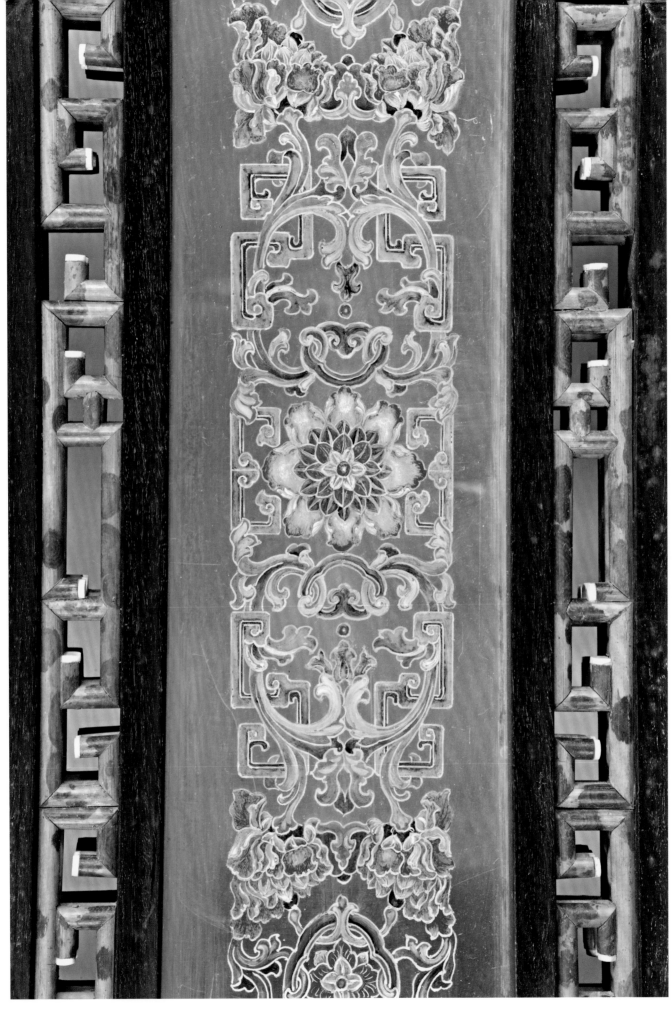

Plate 19. Partition (cat. 2, one of a pair, detail).

This is a tower on an artificial mountain. It can be compared to a heavenly palace where immortals and Buddhas live.

層屋假山巔

可以供金仙

Jianfugong Garden, his first garden effort in the Forbidden City, built three decades earlier (Chapter II, figure 2). The fourth courtyard of the Qianlong Garden would be an eastern counterbalance to the Jianfugong, on the opposite side of the Forbidden City, where he had spent some of his youth. He borrowed the design and arrangement of five buildings in the northwestern corner of the Jianfugong, including Ninghuitang (Hall of Concentrating Brilliance), Bilinguan (Lodge of Viridian Jade), Jingshengzhai (Studio of Esteemed Excellence), Yanchunge (Belvedere of Extending Spring), Yuhubing (Chamber of Crystalline Purity), a span of rockery and the small pavilion atop it, Jicuiting (Belvedere of Abundant Greenery).[7] Even the pavilion's chess table and stools were replicated on the rockery's ridge (plates 20 and 21).

Just as *jing*, or vistas, are fundamental elements in Chinese gardens, places from which to take in those vistas are equally essential. A pair of elaborately carved drum-shaped marble stools presents a striking contrast to both the uneven rockery and the austere table whose four plain square legs, with curved protrusions halfway up, support a slab of stone called *huaban*, mined in nearby Hebei Province. Highly prized for its dynamic, colorful patterning, it was only for imperial use. The table's style echoes elegant Ming furniture which, like many of the literati who commissioned it, was concerned with form and the beauty of the material more than ornamentation.

Almost all of the buildings in this courtyard preserved the shapes and relative locations of the Jianfugong Garden buildings; however, the emperor gave them names befitting a retiring emperor, such as Fuwangge (Belvedere of Viewing Achievements) and Juanqinzhai (Studio of Exhaustion from Diligent Service).

North of Biluoting is the tall, square Fuwangge with its multicolored glazed roof tiles (figure 11). Reaching it entails snaking down the rockery on a trail leading east from the pavilion or heading west and north along the second-floor gallery, over another marble bridge, and down steps at the western end of the rockery. There are four entrances to Fuwangge, one on each side. Inside the luxuriously decorated and perplexingly composed spatial arrangement are four symmetrically placed

thrones, or raised platforms for the emperor to sit, each facing a tall entrance door and thus one of the cardinal directions. Palace Museum scholars believe the edifice (and the Yanchunge in the Jianfugong Garden) may have been used for rituals requiring the acknowledgment of the four directions and possibly the four seasons. Architectural historian Liu Chang believes the building might be modeled after a *mingtang*, a Han dynasty type of ritual hall.

Each throne area is completely distinct and a celebration of innovative eighteenth-century decorative techniques. The upper section of the spatial partitions on the south-facing throne, for instance, are filled with a silk gauze with an appliqué of archaic Chinese and European-inspired patterns created from a paste of copper, gold, and an adhering solution; the designs seem to float in the air (Coda, figure 9). The elegant technique is unknown elsewhere in the palace or beyond. Ornamental horizontal panels just below the ceiling of the two-story room display another unusual mixed-media technique in the extravagant blooming wisteria twisted around a rose bush on a patterned background of plum blossoms floating on cracked ice. Semiprecious stones, lacquer, mother-of-pearl, porcelain, and still unidentified materials create a series of such sumptuous panels around the room.

Traveling clockwise around the building through dark and circuitous corridors, the visitor passes the west-facing throne room with its cloisonné, semiprecious stone, and lacquer décor; then the north-facing throne area with inlaid mother-of-pearl on lacquer panels and a large *kang* platform seating surface framed by gauze-backed carved wood with inlaid jade peach trees. Next, one walks through one of two arched doorways flanking a large European-style metal-and-enamel clock-face set into the wall marked *Qianlong nianzhi* (made in the Qianlong era), clearly revealing its Chinese manufacture (plate 22). Passing through one of the doorways reveals that it is a two-sided clock, one side smaller than the other, with the clock fittings inside the wall. The visitor then arrives at the east-facing throne area displaying decorative metals and cloisonné.

Custom-made cloisonné fittings adorn the complex lattices on both sides of the soaring

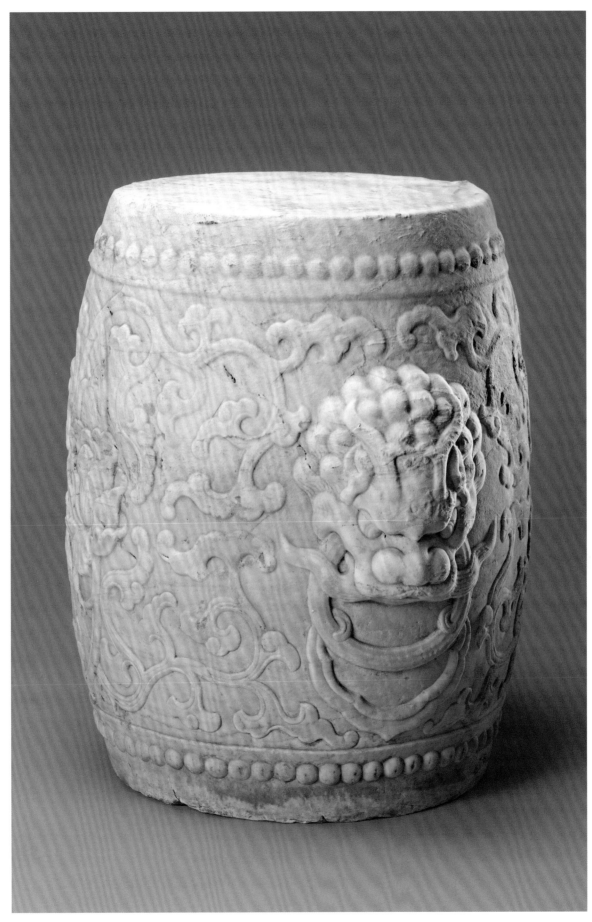

Plate 20. Stool (cat. 41, one of a pair).

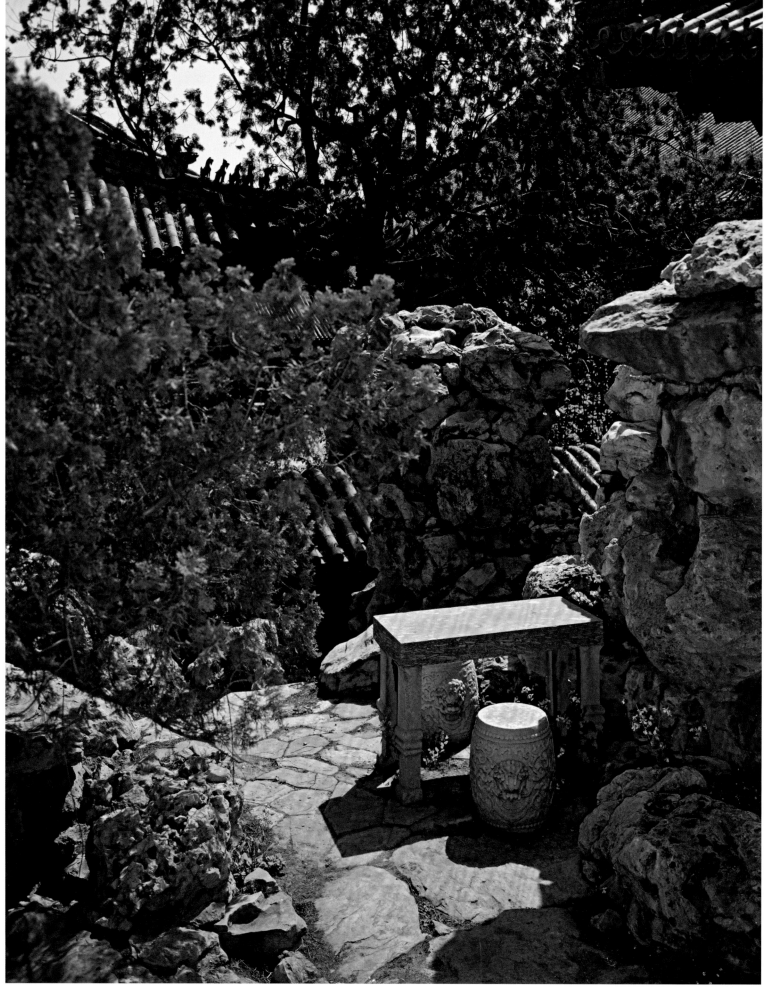

Plate 21. Table and stools on fourth courtyard rockery (cats. 41 and 42).

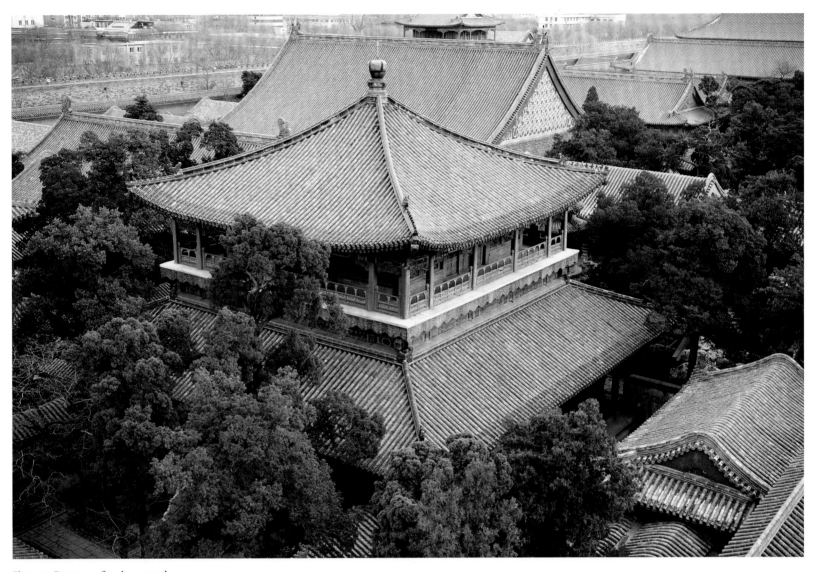

Figure 11. Fuwangge, fourth courtyard.

Plate 22. Clock (wall) (cat. 9).

Plate 23. Partitions and entablature (cat. 5, detail).

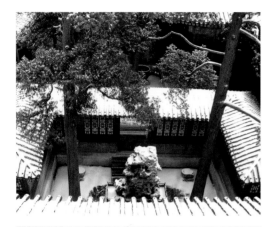

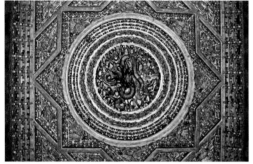

Figure 12. View from Fuwangge's eastern terrace.

Figure 13. Fuwangge's top floor ceiling.

twelve-foot-high *zitan* room partitions and horizontal entablature. Paintings and calligraphies are nestled within the archaic-styled cloisonné-and-wood labyrinth (plate 23). Interior lattice partitions (*geshan*) were standard in Qing architecture. Originating as non-load-bearing walls that separated spaces within rooms, the flexible partitions allow light to penetrate though silk or paper pasted on the lattice. Over time, room dividers were largely abbreviated into paired partitions against opposing side walls to demarcate and celebrate spaces within spaces. Lattice partitions exist throughout the garden and the entire palace. They offered exciting canvases for artists and artisans of the Qing court. Their combinations of cloisonné, woodcarving, paintings, and calligraphy are characteristic of the Qianlong emperor's constant pursuit of visual amalgamations.

The four throne areas back onto a central core whose narrow interior staircase with its *zitan* handrail leads to the upper stories. On the fourth floor is an 1,800-square-foot room whose corner-to-corner lattice doors admit light and views in all four directions. A surrounding terrace offers the option to walk out into the fresh air for an unobstructed view of the Forbidden City that is unique within the garden (figure 12). The room's gilt-wood inset caisson ceiling features a high-relief dragon within an eight-pointed star at the center of a dome (figure 13). Such ceilings exist in several other important edifices in the Forbidden City, such as Taihedian (Hall of Supreme Harmony), as well as in some smaller pavilions. These caissons usually hovered over the emperor's throne. They announced the round dome of heaven with its beneficent dragons watching over the emperor and haloed those within its sphere while bringing light and height to an interior space. The remainder of Fuwangge's lofty ceiling is covered with square, painted silk panels, imitating traditional wood coffers, inset into a wooden framework.

This grand space needed fittingly grand furniture. Indeed, the furnishings here are so monumental that they would have had to have been assembled in place; they bespeak a grandiosity that is in contrast with the otherwise intimate garden. A substantial *zitan* shelving unit, known as a *duobaoge* ("many treasures" display cabinet), presented treasured porcelains and acted as an honorific screen behind the throne (plate 24). Screens had

Plate 24. Throne surround screen and display case (cat. 37, detail).

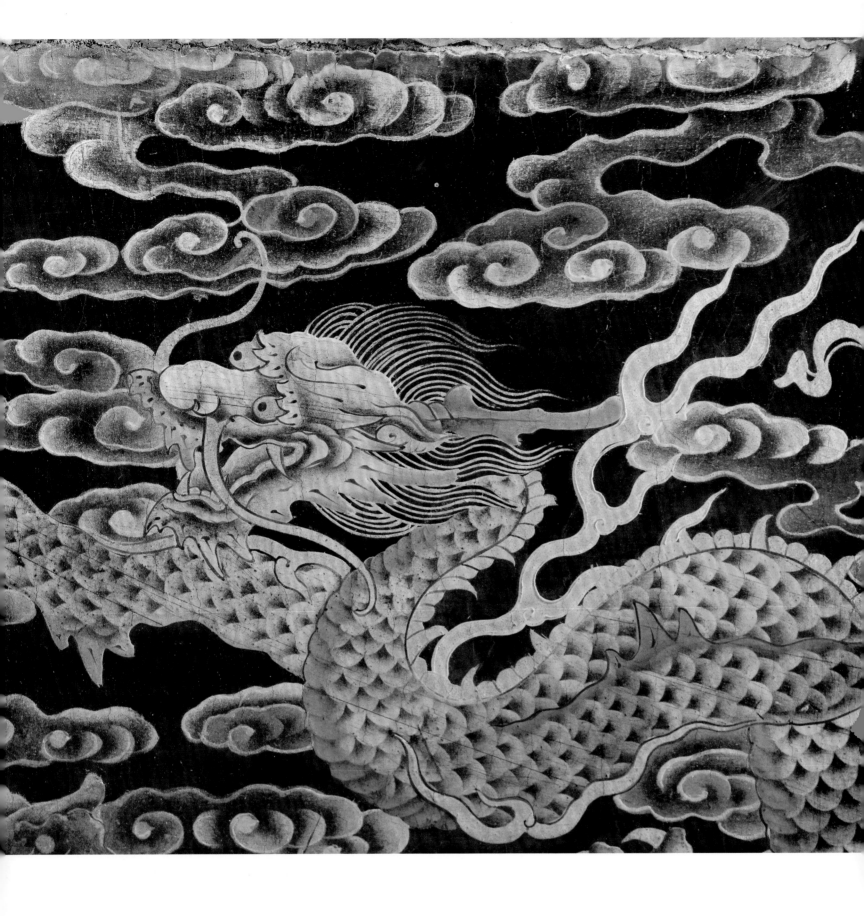

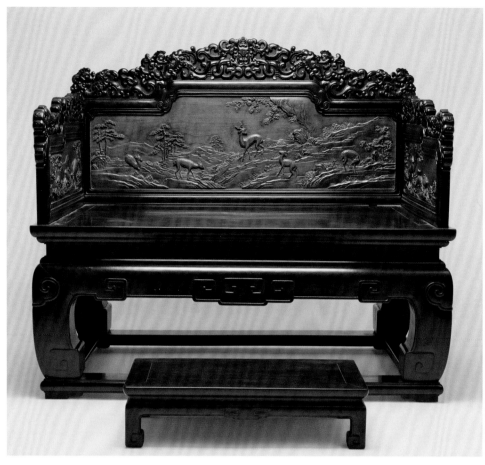

Plate 25. Throne with foot stool (cat. 38).

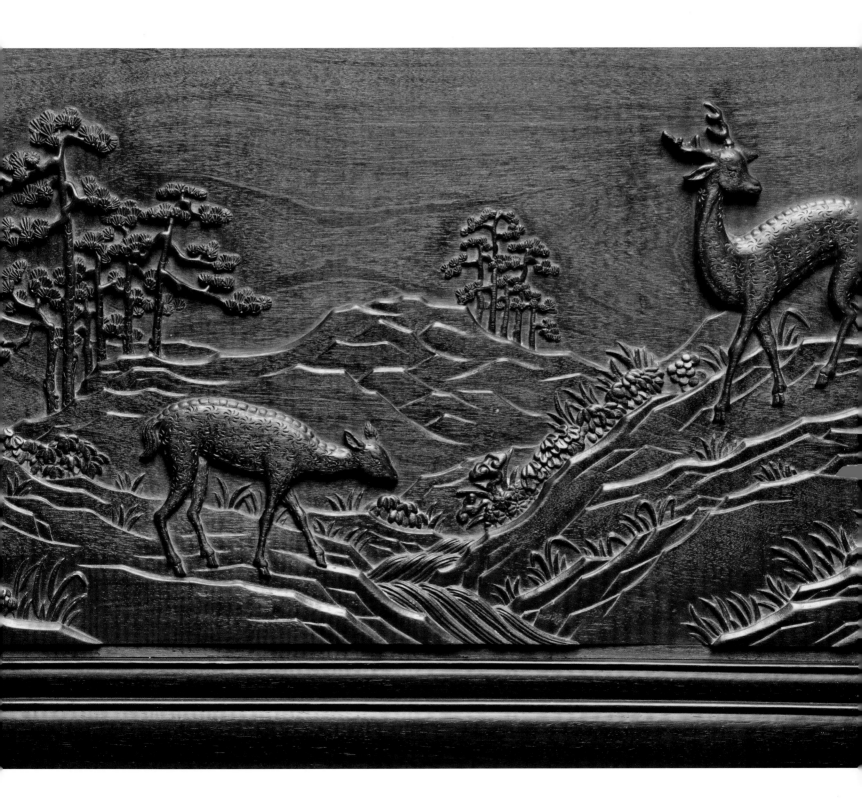

Figure 14. *Twelve Beauties*, one of a set of twelve, circa 1732. Ink and colors on silk, 76 3/8 x 38 9/16 inches (194 x 98 cm). Palace Museum.

been used as background framing devices for important seated personages since at least the Han dynasty and the arrangement is repeated throughout the palace.

A lacquered crowning element with gilt-drawn dragons tops the *duobaoge* and equally fine gilt designs ornament the black lacquer apron at its base. The immense shelving unit contains one hundred compartments for precious decorative arts. A *duobaoge* depicted in one of a series of paintings of palace women of the Yongzheng period (1722–35) offers a sense of the appearance of such a unit filled to capacity (figure 14). Throughout his reign, the Qianlong emperor commissioned numerous such units, massive and miniscule, to contain and exhibit his collection. The *duobaoge* first appeared in China in the seventeenth century. Its typically asymmetrical shelving suggests that the form may have been a result of stylistic influence from Japan. Like many other instances in the Qianlong Garden, its presence reflects the emperor's interest in the fusion of Chinese and foreign aesthetics. In front of the *duobaoge* facing the south – the most auspicious direction – was a proportionately sized *zitan*-and-cedar throne and foot stool (plate 25). The fine carving ornamenting the sides of the throne depicts deer in a mountainous landscape.

Descending to the ground level and exiting through the northern doors of Fuwangge, the visitor arrives at the last building of the garden, the northernmost Juanqinzhai (Studio of Exhaustion from Diligent Service), one of the artistic pinnacles of the garden, and indeed in the history of Chinese interiors. In the western half of the studio is an intimate theater with a small stage surrounded by a two-story-high trompe-l'oeil mural depicting palace pavilions in a summer garden (figure 26). It includes two cranes, symbols of longevity, and a ceiling painted to imitate clusters of wisteria suspended from a bamboo lattice. The archives indicate that this stunning artistry is a copy of Castiglione's painting in the Derixin Room (Virtue Renewed Daily Chamber) in the Jingshengzhai building of the Jianfugong thirty years earlier. At least four magnificent wisteria trellis paintings were created by command of the Qianlong emperor or his father. The example in the Qianlong Garden is the only one to survive over two centuries of history. Through the mural's

moon gate in the fence, through the gaps and over the bamboo lattice fence, appears a peaceful garden with walkways, palace buildings, flowers, multicolored cracked-ice pattern "tiger skin" walls – as in the garden outside – and distant mountains and waterfalls. Real wood lattice fencing painted to imitate bamboo winds around parts of the room to meet its virtual self in the mural. And an actual stage in the form of a minute pavilion is a further element in the faux world where two- and three-dimensional objects blend into a complex reality.

In Chinese calligraphy, to create a proper horizontal line, for example, for the character one, *yi*, the brush moves from left to right. When it reaches the termination point at the right, the brush moves back to the left, creating a small but distinct endpoint. Similarly, musical compositions often build up to a climax, then punctuate the conclusion with a coda. Traversing the four courtyards of the Qianlong Garden is a structurally similar experience. This finely orchestrated composition with calligraphic flourishes, poetic references, and a series of scales and descents, open spaces and intimate rooms, raw textures and refined polishes, ends with Juanqinzhai, a magnificent coda that reflects the visitor back into the garden scene just as the journey seems to be ending. The Qianlong Garden masterfully accomplishes the traditional Chinese garden criteria but also goes far beyond the expected standards. The emperor's years of experience in creating gardens and the many talented artists, artisans, and project managers laboring to fulfill his vision all contributed to this precious universe.

The Construction of the Garden

The mammoth Qing imperial archives reveal the meticulous planning, accounting, construction, and decorating of the Ningshougong and its accompanying garden. Notations in the Imperial Household Archives (*Gongting neiwufu dang'an*), and subsections including the Archives on Handicrafts (*Huojidang*), Furnishings Inventory (*Chenshedang*), and Archives on Expenditures (*Zouxiaodang*) allow us to reconstruct the process involved in creating this garden complex.

In 1771, the emperor laid down his initial conception. Members of the Imperial Household Department (*neiwufu*) then passed orders on to the many managers and specialists. Designers

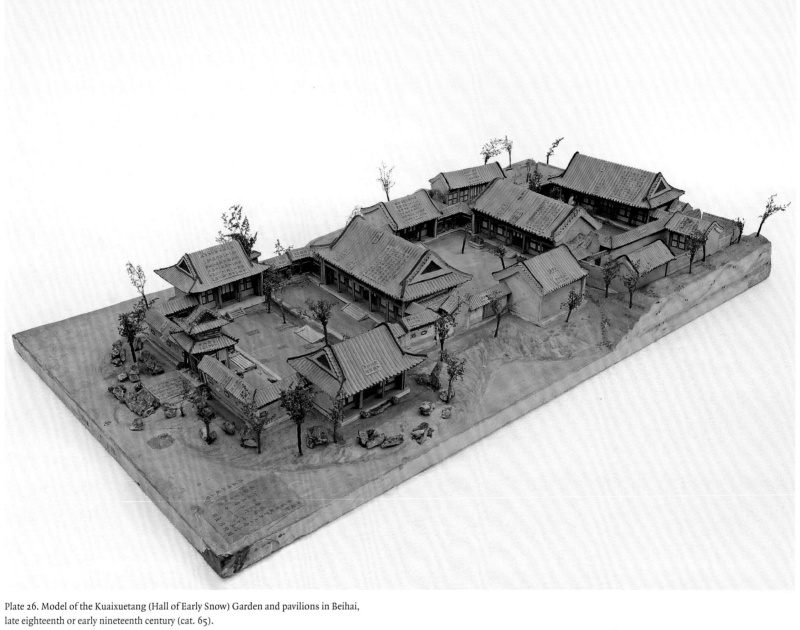

Plate 26. Model of the Kuaixuetang (Hall of Early Snow) Garden and pavilions in Beihai,
late eighteenth or early nineteenth century (cat. 65).

presented their ideas to the emperor for his approval or changes. Accountants estimated the costs. Calculations considered the removal of old buildings on the site, the construction of rockeries, the gathering of materials from places as distant as Sichuan Province (1,300 miles), as well as new construction costs. Managers obtained raw materials and supplies. Administrators brought designs to the artists and craftspeople. The razing of the old buildings began that very year.

While the Qianlong emperor as a matter of course receives the primary credit for the garden, and while artisans and lower bureaucrats tended to be anonymous, the records do provide a remarkable number of names associated with this undertaking. Foremost among them was the official Fulong'an (circa 1746–1784), of the Manchu Fuca clan that was long intertwined with the Qing government. Fulong'an was the son of Fuheng (d. 1770), a prominent general whose older sister was the emperor's adored first wife, Xiaoxian (Introduction, figure 4). Fulong'an himself married the emperor's fourth daughter (not from Xiaoxian). Fulong'an's vast duties included supervising the Jesuit missionaries serving the court.[8] His oversight of the garden construction was interrupted shortly after the death of his father when he was called away to mediate territorial disputes in western China. Other high-ranking officials then became the primary managers of the garden project.

Manchus dominated the team concerned with the garden. Among them were Ying Lian (1707–1783), minister of the Imperial Household Department, Sanhe (dates unknown), an official in the Board of Works, and the infamous Hešen (1750–1799). The young handsome Hešen had begun his career in the palace as a bodyguard. He caught the eye of the emperor and quickly rose to be a grand councilor and then minister. He strengthened his connections by having his son marry a daughter of the Qianlong emperor. Later officials accused him of having abused his power. Only after the emperor's death did his son, the Jiaqing emperor, dare to prosecute Hešen for corruption. Interestingly, the thirteenth charge was "having built his residence with Nan wood and following the layout of the Ningshougong."[9] At Hešen's confiscated estate in Beijing, now renamed Gongwangfu (Prince Gong's Mansion), a floating cup pavilion is a clear nod to the Qianlong Garden. Hešen was condemned to suicide; a fellow conspirator, Fuchang'an, brother of Fulong'an, was beheaded.

Below these powerful ministers, eunuchs, mainstay employees of the imperial household, also conveyed assignments to artisans. For instance, the archives frequently mention eunuch Hu Shijie issuing imperial decrees. Though little information has been uncovered about him, as early as the second year of the Qianlong reign, he was transmitting information to and from the emperor in regard to porcelain, furniture, and decorative interiors.

A critical stage in the design of Qing imperial buildings was the production of detailed, scaled sketches and models (called *tangyang*) constructed of a coarse cardboard, straw, wax, and wood, often with removable parts that allowed interior views of lattice partition designs. These models had advantages beyond their three-dimensionality. They could be presented to the emperor for his comments and directives, which were always tended to, and then sent to the artisans and contractors who would carry out their designated specialties. Handwritten yellow notes pasted on them carried explicit instructions. *Tangyang* for many Qing buildings and garden complexes do exist and most likely are very similar to those fabricated for the garden (plate 26). Although none remain, the archives mention at least five *tangyang* and one hundred and two drawings that were made of buildings in the Qianlong Garden and sent to the responsible contractors.[10]

The names of the garden's designers or architects – positions not recognized as such in China at the time – are still unknown. A family surnamed Lei served the Qing court for many generations making *tangyang* and probably creating the buildings' designs.[11] Legends hold that their ancestor began working under the Kangxi emperor, but their presence during the Qianlong era has not yet been confirmed.

Cleared of old architecture but with the ancient trees intact, the site was ready for the rockery stones. As for the Song Emperor Huizong's Genyue Garden seven hundred years earlier, the stones for the Qianlong Garden came from many sources, including Lake Tai, Qingshan, and from the

nearby Yuanmingyuan. In 1772, the "piling" of the rockeries began, "in compliance with the *tangyang*."[12] While no known imperial archives describe the construction of the rockeries, Ji Cheng had outlined the process in his *Yuan Ye* (The Craft of Gardens) (circa 1631):

When starting to raise a mountain, first set up wooden posts, calculating the correct length and examining the firmness of the ground. According to what the ground requires, dig holes and set up a pair of pillars, then estimate the final height of the mountain and set up a block and tackle. All ropes should be fastened firmly so that any lifting can be done securely. Lay the base of the mountain with rough stones, and use large pieces of stone to conceal completely the ends of the pillars. Fill your trench with rubble and mortar, and in wet places drive in the "bones" of the mountain as far as you can. Start by piling up large, solid rocks, and then gradually build up with smaller, jagged stones.[13]

By the end of 1772, the perfectionist emperor already needed to make a change in the rockeries. A directive asks that those in front of Fuwangge be adjusted to accommodate a pavilion on the peak (figure 15). Buildings were underway as well. Records mention the Sanyouxuan, Yanqimen, Juting, Yizhai, and Xiefangting, Xishangting, Xuhuiting, Suichutang, Songxiuting, Yucuixuan, Juanqinzhai, and Fuwangge. Only the "turning corner building" in imitation of Yuhubing (Chamber of Crystalline Purity), a building in the Jianfugong Garden, had still to be named. It would become Yanghe Jingshe (Supreme Chamber of Cultivating Harmony), and the emperor would name its second-floor areas Yunguanglou (Building of Luminous Clouds).

With the larger constructions in hand and even the bronze water vats in case of fire in their proper locations, by 1773 serious attention could be paid to the buildings' interiors. On his travels within the Jiangnan region, the Qianlong emperor must have been impressed by the lavish artistry of the buildings' interiors as well as the garden landscape designs and layouts. For the construction of his ultimate garden, the administrative team turned to artists and craftspeople from this most culturally refined region of the country along the eastern stretches of the Yangzi River and the literati centers of Suzhou and Yangzhou. *Tangyang* for five of the most luxurious interiors were sent to

Li Zhiying, the regional Salt Commissioner of the Lianghuai area (encompassing today's Zhejiang, Jiangsu, and Anhui provinces). The Lianghuai region was the center of salt distribution in China and, like other provincial officials, Li Zhiying was eager to garner a promotion. What better strategy than to provide artistic service to the connoisseur emperor? The ambitious Li Zhiying agreed to supervise the production of many of the Qianlong Garden's interiors. Letters to the court in Beijing reveal his obsequious, conscientious attention and desire to please. As early as the tenth month of the thirty-eighth year of the Qianlong reign (1773), Li Zhiying wrote that he had received a letter six to seven months earlier from the high officials of the Imperial Household Department and he had already sent people to acquire the materials and selected craftspeople. They were working on the interior decoration of five buildings, including Suichutang, Fuwangge, Cuishanglou, Yanqulou, and Juanqinzhai, and a number of the artisans were working on inlays – including carved bone. Li Zhiying mentioned that he also received a wood model of a *duobaoge* – probably for the massive example on the top floor of Fuwangge. No doubt, Li Zhiying's workmen were also responsible for a magnificent throne from Yanghe Jingshe that incorporated numerous artistic techniques including gold painting on lacquer, bamboo thread marquetry, fine wood carving, and hardstone and jade inlays (plate 27). The work was already sixty to seventy percent complete, and Li Zhiying projected that it should be finished in three to four more months. In a letter one year later, September 6, 1774 (Qianlong 39, first day of the eighth month), he stated that it was on its way to Beijing:

On the twenty-fourth day of the third month, I received one tangyang model for the interior decoration of Suichutang [Hall of Fulfilling Original Wishes] from the official Ying Lian along with five drawings and one architectural ruler. The text asked Salt Commissioner Li Zhiying to have them made. I immediately selected and purchased the materials, selected and hired workers and artisans, chose an auspicious day for starting the work, and hurried to complete it. I personally would go once in a while to watch over the work, and carefully observed as the pieces were being packed and put on the boat. On the first day of the eighth month, I sent a family member to accompany the shipment to the capital. In addition to these documents that I am sending to the Zaobanchu [Imperial Workshops], I am also sending you here drawings of the designs of the carvings and inlays.[14]

Figure 15. Biluoting, fourth courtyard.

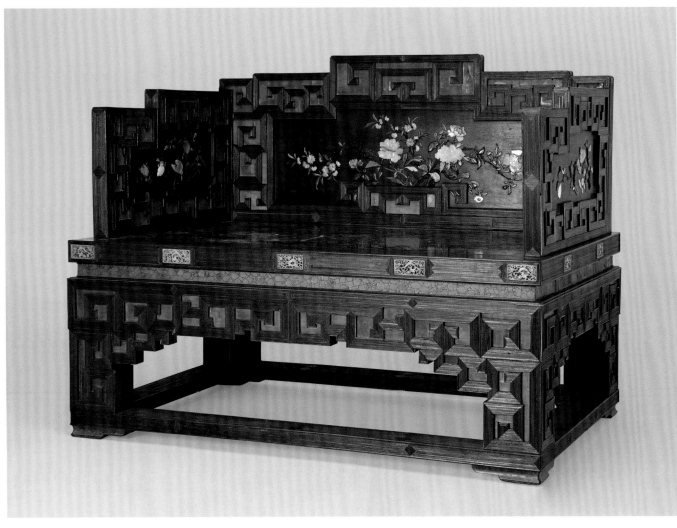

Plate 27. Throne (cat. 36).

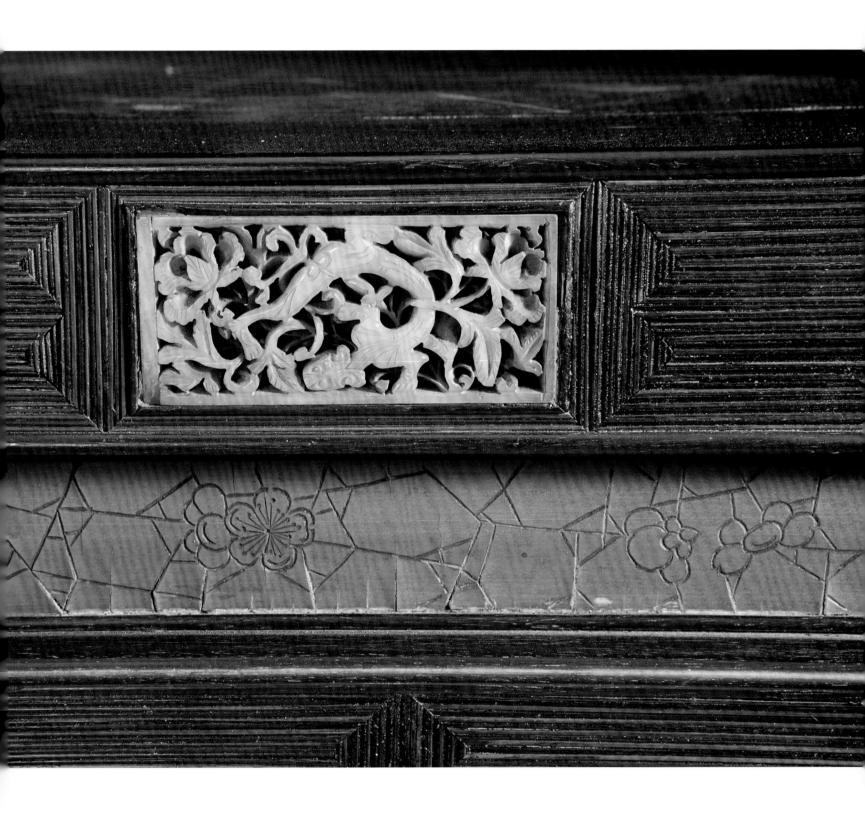

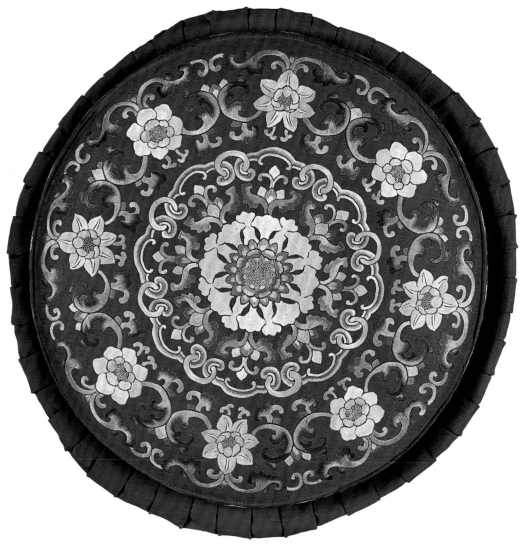

Plate 28. Stool (cat. 30, one of a pair, detail).

Meanwhile, officials in Beijing were likewise scrambling to fulfill the emperor's wishes. They were checking warehouses for expensive glass and glass mirrors to install in the buildings. A directive stipulated that if the warehouses did not contain enough materials, the officials should send the necessary sizes to Canton customs officials to obtain more. Order after order went out to the Ruyiguan, the imperial atelier, for trompe-l'oeil perspective and other paintings. An enormous two-sided clock, fabricated in the imperial clock workshop, was installed in Fuwangge. The archives also describe the textile needs for each room: brocades from Nanjing, embroideries from Suzhou, and seat cushions, arm rests, back rests, curtains, and rugs (plate 28).

Amidst all of the preparations, the unexpected happened. The decorative screens from the humid south reacted to climatic differences in the dry and cold north: inlays began popping and palace artisans were summoned to remedy the situation. Several months later, in 1775, workmen began installing the furniture and hardwood interior architectural elements. By the sixth day of the second month of the forty-first year of the Qianlong reign, the order went out for door god images, traditionally pasted on each of the double doors of buildings to ward against evil forces. Legend holds that the tradition, still popular today, dates back to the Tang dynasty when the Taizong emperor ordered portraits of his loyal generals painted on his doors.

To celebrate the completion of the Ningshougong, the Qianlong emperor composed a lengthy poem incorporating the names of all the buildings and reiterating his anticipation of the chance to cultivate his virtues there upon his retirement. With the completion coinciding with the New Year and the eighty-fifth year of his mother's birth, he held a grand banquet. He entertained the empress dowager and heroic officials involved in quelling a rebellion in Jinchuan with music and opera on the three-story stage (the largest within the Forbidden City) in Changyinge (Pleasant Sounds Belvedere) on the eastern side of the Ningshougong, just steps from the garden's entrance. Just one year later, his mother passed away. To memorialize her and the Ningshougong celebration banquet, he commissioned a sumptuous cloisonné panel depicting a bird's-eye view of the courtyard where

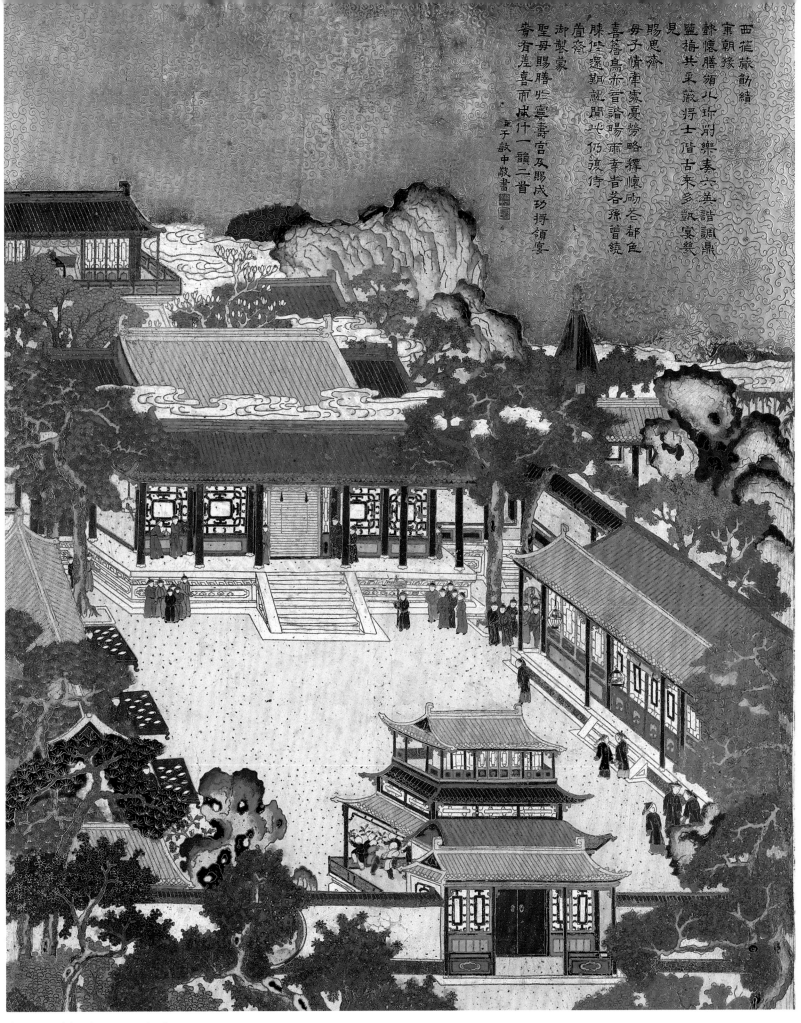

西花蔽勸繪
東朝緣
麟懷膳飧漱水珍削樂奏六英諧調鼎
鹽梅共采嚴將士階古來多凱宴幾
見
賜思深
母子情庫宵勞略釋懷勵蒼都色
喜耆舊亦晉諧賜兩幸昔谷孫曾纘
腆修還期勳間此仍復侍
萱齋
御製蒙
聖母賜膳兮寧壽宮及賜成功將領宴
睿有差喜而成什一韻二首
臣于敏中敬書

Plate 29. Panel (hanging) (cat. 23, detail).

Figure 16. Yanqimen plaque.

Figure 17. Qianlong Emperor, Calligraphic inscription (cat. 51, detail).

Opposite, Plate 30. Lingbi stone (cat. 39).

the event took place along with a poem about his mother and the setting (plate 29). In the panel, mountains (perhaps exaggerated rockeries) and lush trees encircle the enclosure. The open-air, north-facing stage rises at its southern end and features performers. Officials and courtiers wander the courtyard, ready for or just finished with their feast. Manchu-style low tables, covered with small dishes, can be seen at the left behind a magnificent rock almost as high as the stage. Across the courtyard, unseen behind a curtain but not unacknowledged, is the esteemed empress dowager. In the upper right-hand corner of the panel is a rendering of the emperor's poem by the Grand Secretary Yu Minzhong, a respected calligrapher. Spiral and floral patterns in the golden sky surrounding the inscription enhance the surface. Multiple hues delineate the rocks, trees, and mountains in a manner rarely seen in cloisonné work. The colorful treatment of the buildings' walls and roofs gives a sense of the exuberant appearance of the newly minted Ningshougong and its garden.

Despite the official completion of the Qianlong Garden, archives note endless changes in the following years. In 1777, for instance, the emperor asked for adjustments, enlarging buildings, installing frameworks for plum trees, planting bamboo and more trees, adding furniture, constructing the Lutai, creating new caves, placing pedestals for more stones, and adding more Taihu rockeries all over the garden. It was not until 1778 that an order went out to make the metal characters in Chinese and Manchu for the buildings' name plaques (figure 16). Only in 1779 were the last murals installed in Juanqinzhai. The emperor was still asking that rocks be moved in 1780, and a year later he ordered the disposition of seventy to eighty precious Lingbi stones arriving from hopeful officials in the south.

Expression in the Qianlong Garden

As a Confucian, aspiring scholar, devout Buddhist, emanation of the Bodhisattva Manjusri, and a connoisseur of art, the Qianlong emperor felt compelled to express his spiritual tenets through his compact garden. While a young man, he had immersed himself in Confucian classics that dictated ethical and just governing and high standards of social morality. In creating

his garden – which could easily have been mistaken for an extravagance – the Qianlong emperor was intent on displaying his strong adherence to Confucian principles. One way he did this was through careful selection of names and poems to articulate the meanings of the garden's components. The progression through the Yanqimen (Gate of Extending Auspiciousness) and encounters with buildings bearing names such as Yizhai (Studio of Self-Restraint), Juting (Pavilion of Propriety), Cuishanglou (Building for Enjoying Lush Scenery), Sanyouxuan (Three Friends Bower), Juanqinzhai (Studio of Exhaustion from Diligent Service), and a gateway inscribed with the characters *xiuyi* meaning Elegant Retreat, signaled the emperor's deep understanding of the revered Confucian literature.

The character *yi*, as in Yizhai, and meaning self-restraint, references a line in the ancient *Book of Odes (Shijing)*, one of the Five Classics in Chinese literature. The word *ju*, meaning upright, referenced in the name of the building Juting, comes from a section of Confucius's *Analects (Lunyu)*, as does the expression *sanyou*, Three Friends. And the Studio of Exhaustion from Diligent Service, Juanqinzhai, the compositional coda of the garden, uses the characters *juan* and *qin*, referring to *Shangshu (Classic of History)*, another of the Five Classics, that focuses on the legendary eras of Emperor Yao and Emperor Shun and Shang and Zhou dynasties. The text includes a passage offering a precedent for the Qianlong emperor's imperial retirement. The same words, *juanqin*, appear in a calligraphy by the emperor pasted to a wall within the garden describing his aspiration for his future life there (figure 17).

Literati Aspirations By the eighteenth century, the literati culture and its approach to living had shaped many concepts and elements of the garden arts. The emperor embraced this view of life. These elements are readily manifested in the garden's preponderance of trees, bamboo, and naturally shaped rocks, as well as in the interior decorations parading literati themes.

Rocks One of the masterful aspects of the Qianlong Garden is the constant presence of rocks – symbolizing mountains – visible even from within the pavilions (plate 30). Window

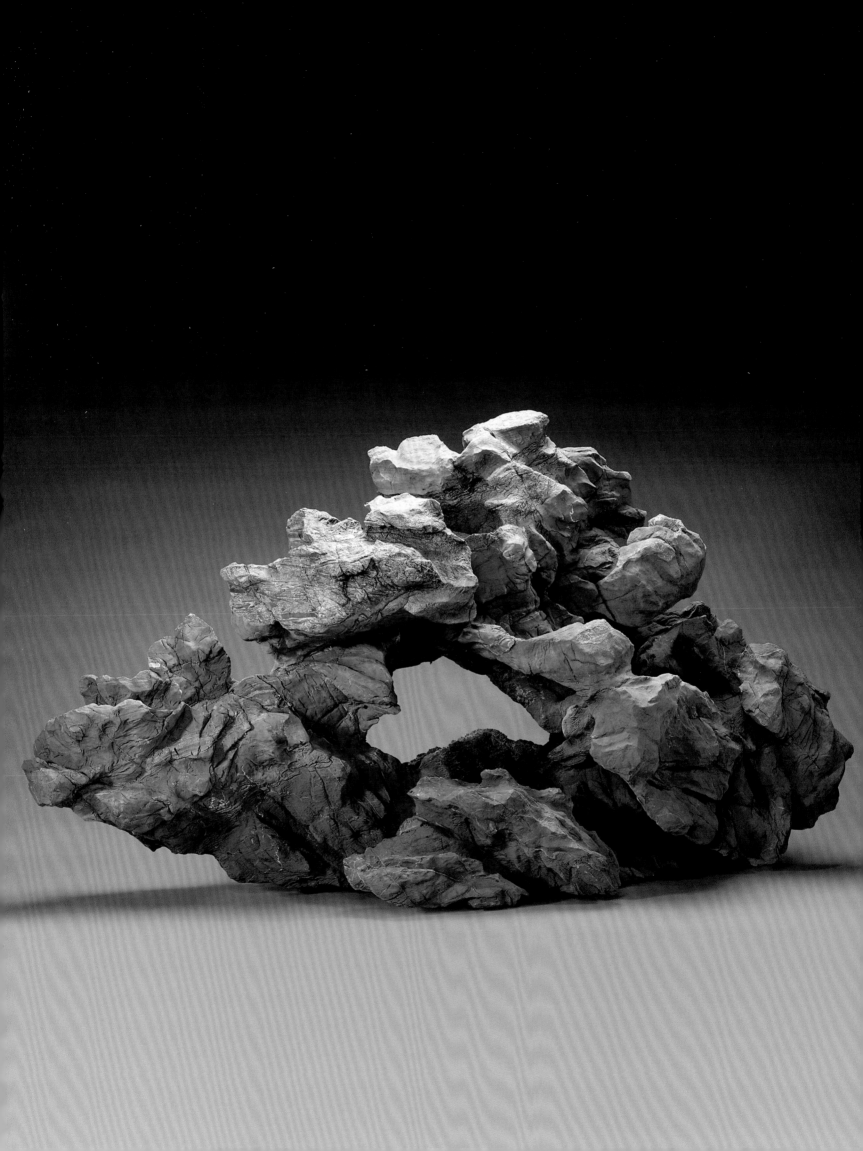

Although they are really just fragments of mountains and chunks of stone, they should have a feel of the wilderness about them.

片
山
塊
石

似
有
野
致

after window offers only views of rockeries. From a tiny opening in a dark wall in Zhuxiangguan (Lodge of Bamboo Fragrance) to large expanses of glass in Yanqulou, looking to the outdoors was an opportunity to see the dynamic irregularity that the natural world expresses.

Meandering through the courtyards and grottos, the visitor encounters in addition to the symbolic mountain rockeries, eighteen solitary rocks on marble pedestals also intended to invoke mountainous realms (figure 18). One rock is even honored with poetic calligraphy carved into its surface: "Strange peak welcomes the summer." In Chinese, the raw and intentionally unprettified quality of such rocks is often described as qi, meaning strange or fantastical, and each of these celebrated chunks of nature exhibits the characteristics so highly sought after by Chinese petrophiles.

Flanking the southern entry steps to Fuwangge in the fourth courtyard are two pedestaled stones that "guard" the building almost like the gilt lions at the front gate of the Ningshougong. Directly in front of the entrance, at the base of the rockery, is a specially selected stone. Its wrinkled surface; asymmetrical, unbalanced shape; and expressive stance exemplify the time-honored attributes of a great rock in Chinese aesthetics. It is placed on a massive oblong hourglasslike marble block with a bronze railing encircling the top surface. On that surface is a raised, off-center bulge to hold the stone. Carved with tumultuous, stylized waves from which arise stone peaks – a design similar to those appearing on imperial robes to represent the emperor's domain – the rock's stand symbolizes the earthly part of the universe (figure 19).

The rocks and rockeries would have provided the Qianlong emperor with an atmosphere unavailable elsewhere within the Forbidden City. In a grotto, alone with ageless stones that were not affected by his status as emperor, he could try to cultivate his humble self according to the example of literati patriarchs such as the poets Wang Wei and Wen Zhenheng. The emperor's intense interest in rockeries is dramatically apparent in one of the most unusual spaces within the Forbidden City: Xiangxuetang (Hall of Fragrant Snow) – a room within the central axis of the Ningshougong that provided a view into the garden. This cham-

ber is accessible only through an extravagantly furnished two-story Buddhist shrine room with storied pagodas, through a moon gate toward a full-length mirror, and down mazelike passageways. Inside, rockeries against three of the walls fill more than half of the 15-by-20-foot room and effectively transform it into a grotto. The fourth wall features floor-to-ceiling glass doors with cracked-ice patterned lattices that offer a view of a small courtyard with trees and more rocks. The ceiling is painted a deep sky blue and along the tops of the walls where the rocks stop are painted pine trees and flying birds. One rock jutting out from the wall functions as a stool; on it a cushion, embroidered with a cracked-ice and plum-blossom design, awaits the emperor. From this humble seat, he could view the tree outside, contemplate his rocks, or peer through a smaller window into the garden's grove of bamboo.

Few visitors have had access to this very private chamber, but Reginald Johnston (1874–1938), tutor to the last Qing emperor, Puyi, did see it and reflected on how the space expressed the character of its unusual creator. He poignantly described the room as:

perhaps unparalleled in any other royal palace. The floor-space was almost wholly occupied by a pile of rocks arranged to represent a wild and rugged mountain. Among the rocks of this mountain, one of the mightiest monarchs who ever ruled a great empire was wont to sit and meditate, and imagine himself to be a lonely hermit qualifying for the high destiny that awaits those who live on herbs and water and commune with the spirits of hills and rivers. . . .

That great Manchu emperor must have possessed that beautiful quality . . . possessed by every great man – the heart of a child. He had real hills among which he could ramble and meditate at will. . . . But there was something in him that craved for a wonderland which . . . would be wholly the creation of his own mind – a wonderland within the four walls of his own house, into which he would step merely by descending from an imperial altitude to the level of ordinary humanity, and by turning "a tiny golden key" in the lock of a commonplace door.[15]

Turning away from rocks to gaze instead at the pavilions and their interiors, the visitor sees a continuation of the emperor's intention to elevate

the virtues of humility, uprightness, and loyalty, though realized with distinctly different aesthetics. These structures represent the continuum of the microcosm, as man is part of nature. In Chinese landscape paintings, the inclusion of a small building high in the mountains, at the foot of the hills, or along a riverway, prompts the viewer to imagine being within the depicted space and recognizes man as part of the larger cosmos. Within his buildings, the emperor ensured that the handiwork of fine artists and craftspeople depicted symbolic messages contiguous with the Daoist and Confucian meanings of the outdoor scenes.

The Three Friends of Confucius, Three Friends of Winter Bamboo and pine remain green throughout the cold months of winter. The pink flowers of the prunus blossom around the Chinese New Year, heralding the arrival of spring (plate 31). Together, these "three friends" have embodied a range of related meanings in poems and visual depictions, including endurance, vitality in old age, and the ability of an official to remain upright during a corrupt regime. The concept can be traced back to the patriarch of Chinese moral integrity, Confucius, and his reference to three types of friends. Transformed during the Song dynasty into the more visually and poetically appealing triad of plum blossoms, pine, and bamboo, the theme became widespread. While the motif was well established as a decorative pattern by the mid-eighteenth century, the emperor certainly appreciated and endorsed the Confucian scholarly allusion. For a retirement estate where he hoped to remain vigorous, the theme was natural, and he specified that the garden contain his third Sanyouxuan:

I use the name "three friends" for pavilions many times.
But my mind is not lofty and at leisure, so I am afraid
(my thoughts) go against the name.
After four springs and autumns I will live here.
Then I will get the lofty leisure and be happy forever in
this place.[16]

In his final rendition of a Three Friends Bower, the emperor strove to perfect the design. This is the only remaining example of the three such bowers he constructed over the course of his reign. Its lavish décor demonstrates his tenacious dedication to presenting the concept in an exquisite artistic metaphor.

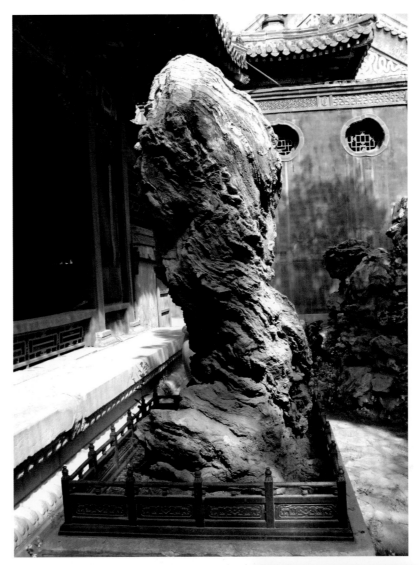

Figure 18. Rock on pedestal, south façade of Fuwangge.

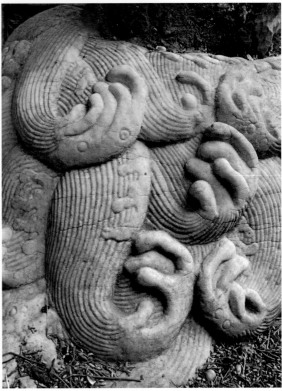

Figure 19. Carved rock pedestal, fourth courtyard.

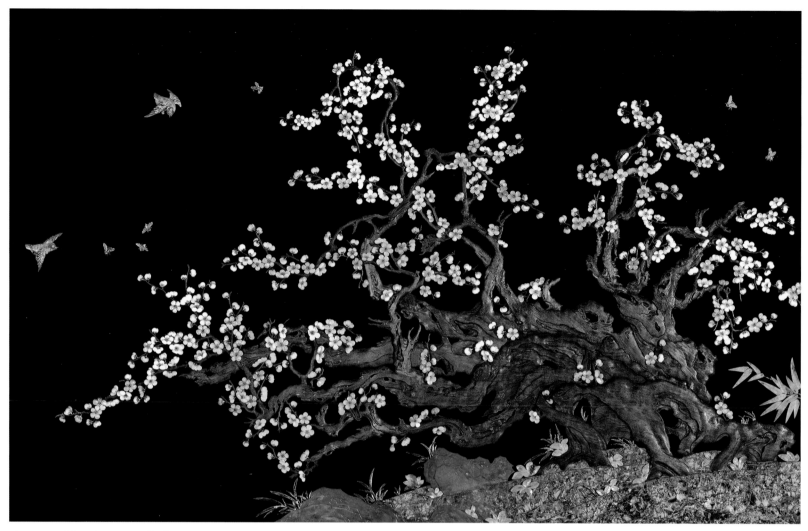

Plate 31. Panel (hanging) (cat. 22, detail).

A set of furniture specially commissioned to portray the motif includes two standing screens, a throne that sat between them, tables, stools, and stands – all displaying the technical innovation and finesse that the Qianlong emperor encouraged and demanded (plates 32, 33, and 34). The screens present pine trees, plum blossoms, and bamboo, all exquisitely carved from *zitan* and inlaid with jade and coral. The reliefs were adhered to either side of a large glass sheet. The unusual throne likewise has a glass backrest and armrests with adhered *zitan*-and-jade carvings of the "three friends." The incorporation of glass in these marvelous botanic panels reveals the emperor's excitement over the transparent European material. Sandwiched between the identically carved reliefs on either side, it contributes the illusion of three-dimensional "friends" floating within the frame, and, for the emperor the intellectual irony of being simultaneously transparent and solid.[17]

The theme reappears throughout the garden in architectural elements and furnishings (plate 35). The prunus in particular blossoms everywhere. As a harbinger of spring in a garden designed primarily for winter use, it was an apt choice. For the topmost floor of Fuwangge, for example, a long *zitan* table has structural components carved to look like branches of an old but still blooming plum tree (plate 36). The quiet restraint and elegance of the carving echo the moral integrity expressed in the symbolism (plate 37).

Biluoting (Pavilion of Jade-Green Conch), a round gazebo perched on a rockery in the fourth courtyard, apparently built along the same construction design in the seventeenth-century garden manual *Yuan Ye*, is wrapped in the prunus theme. From the second-floor balcony of Cuishangtang, where the pavilion can be accessed via a narrow stone bridge, prunus flowers are already visible on the glazed ceramic knob surmounting the double cone-shaped roof (figure 20). Underlying the blossoms is the cracked-ice pattern. The common linking of these two motifs symbolizes the arrival of spring: ice is cracking on a pond and plum blossoms are falling onto the ice. Circling the pavilion below the eaves of the lower roof, a suspended apron displays a filigree of flowering prunus.

Subtle and exquisite reliefs on the pavilion's stone balustrades exhibit a series of plum branches in a variety of compositions (figure 21). Inside the pavilion, unlacquered cedar carvings on the ceiling depict more flowering branches. Surrounded by rockeries, trees, and adjacent buildings, the little Biluoting broadcasts spring and the pure virtues implied by the prunus.

On the second floor of Juanqinzhai hang two sumptuous panels depicting ancient plum trees in full bloom (plate 31). They are composed of precious and semiprecious stones, imported fragrant sandalwood, and kingfisher feathers. Incised in gold onto lapis lazuli "rocks" are inscriptions that tell how the thousand year-old trees located in Yunnan Province still bloom each spring. The panels were a gift to the emperor from Fukang'an, an important and respected Manchu commander and a brother of Fulong'an, who had been involved with the planning and construction of the Qianlong Garden. The panels implicitly express wishes for the emperor's continued vigor and recognize his admiration for the plum blossom and the Confucian virtues it represented.

In addition to the artistic manifestations of the "three friends" theme, this self-styled literati emperor, and prolific poet, penned numerous works articulating the connotations of the motif. His son, the Jiaqing emperor, continued the tradition. Several poems by this heir were pasted on the walls of Sanyouxuan:

The pine tree is chastity, the bamboo is strength, the prunus tree is purity.
The three friends have such a spiritual relationship; they forget the time of year [i.e., the winter]. . . .
Upright, faithful, and knowledgeable are the three friends,
They assist the emperor, nurture the state, and bring blessings to all people.[18]

The custom of pasting calligraphy or paintings – *tieluo* – onto walls probably began during the Qing dynasty. The term, which does not appear in earlier records, literally means "to attach and to take down," signifying the mobility of such features. The practice of writing a poem about a place and pasting it on a wall echoes the

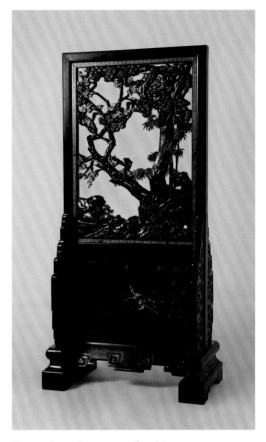

Plate 32. Screen (cat. 27, one of a pair).

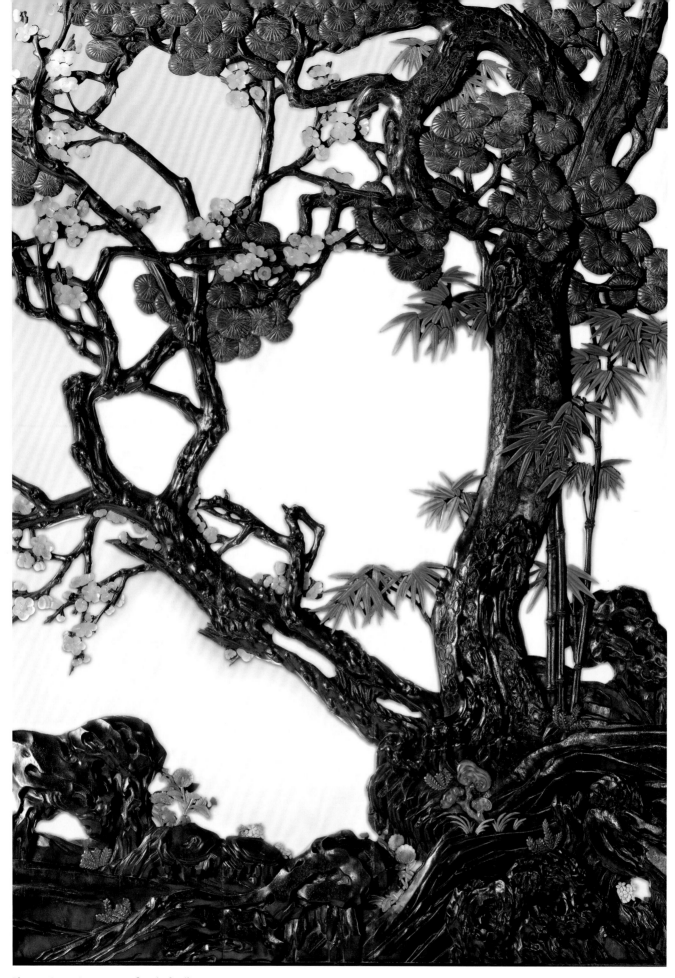

Plate 32. Screen (cat. 27, one of a pair, detail).

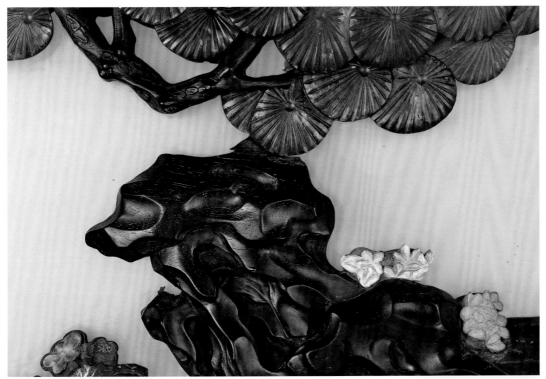

Plate 33. Throne (cat. 35, detail).

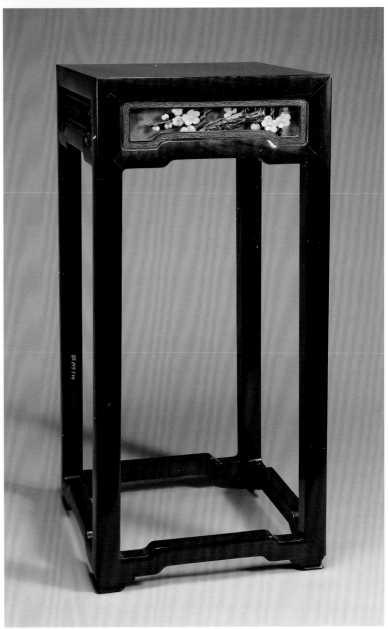

Plate 34. Stand (cat. 28, one of a pair).

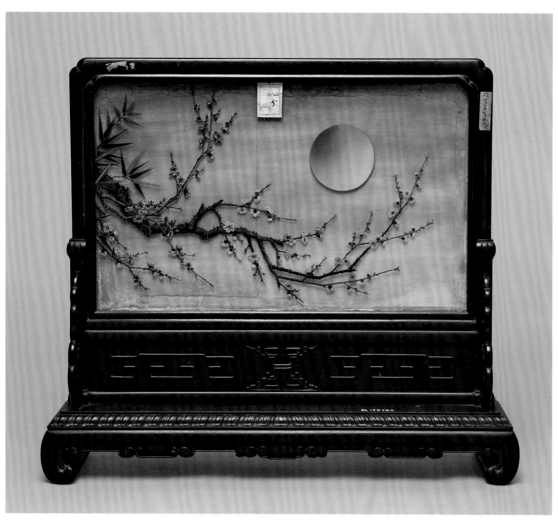

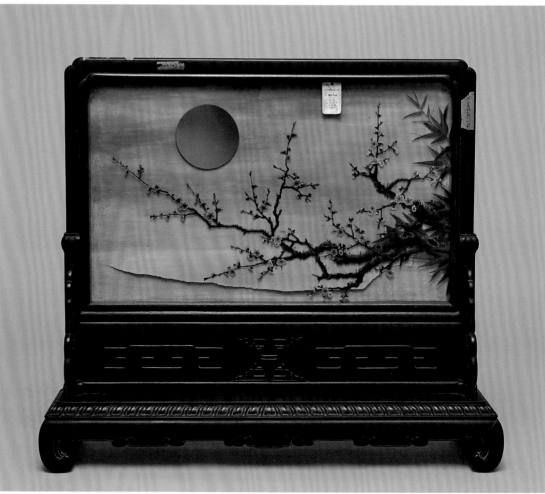

Plate 35. Table screens (pair) (cat. 17).

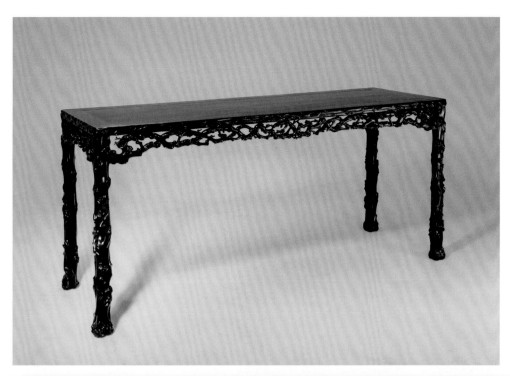

Plate 36. Table (cat. 33).

Plate 37. Inset paintings from partitions (cat. 3, details).

tradition in China of a collector or esteemed expert adding an inscription on a painting he has been privileged to view or own. In his poems on the "three friends" and in the Sanyouxuan building, the Qianlong emperor's heir reiterated reverence for the lofty gentlemanly attributes represented by these hardy members of the natural world (plate 38):

A branch of coldness and beauty [of the prunus tree] announces the lively spring,
Flower buds are blooming on the jade terrace mixed with the jade dust [of snow]
I sit peacefully in front of the window facing the three friends.
Their pure chastity and strong integrity are good for my body and heart.

Written in the winter of 1814.

In Pursuit of Emptiness: Spaces and Substance for a Buddhist Quest

After becoming the emperor of China and therefore the Son of Heaven, the Qianlong emperor remained a devout Buddhist, continuing his daily meditation, study, and practice of Buddhist rituals. He also commissioned copious Buddhist ritual, artistic, and textual projects, and numerous temples and shrines in the Forbidden City, at the Yuanmingyuan, at the Bishu Shanzhuang, and throughout the country. Gardens in China were intended for contemplation, and in the Qianlong Garden Buddhist imagery, textual references, dedicated devotional furnishings, and spaces are abundant. At least six sites within the garden's gates contain Buddhist objects and specific spaces for Buddhist-related practices.[19] Within them, this emperor's personal approach to Buddhism, which he amalgamated with his literati and Confucian pursuits, and his artistic drive, becomes apparent.

The Qianlong emperor adhered to a form of Buddhism practiced in Tibet and Mongolia and followed by some of his recent ancestors. Its ritual practices and some doctrinal forms differ from the Chan and Pure Land Buddhist traditions that were more popular among Han Chinese. The native religious system among the Manchus (known as Jurchens until 1635) was shamanism, and it persisted in Manchu spiritual life through the Qing period. Tibetan Buddhism proved politically advantageous to the Manchu imperial project. The Mongols had converted to Tibetan Buddhism in the course of the sixteenth century. Their support, and that of the Dalai Lama, was strategically valuable for the Manchus. For their part, the Tibetan Buddhists were anxious to encourage the spread of the *dharma* or Buddhist law. The Fifth Dalai Lama, in a letter in 1640, conferred on Hong Taiji (1592–1643), the man who proclaimed himself the first emperor of the Qing dynasty, the title of "Manjusri-Great Emperor," recognizing him as an emanation of the Bodhisattva Manjusri and a *cakravartin* (literally, wheel-turning-king, the wheel being the wheel of the *dharma*, implying an ideal and just ruler who brings peace and prosperity to his subjects). He extended the same recognition to the successor, the Shunzhi emperor, when he visited Beijing in 1653. Thereafter, each Qing emperor was considered an emanation of Manjusri. This connection, and the *cakravartin* status, facilitated the extension of Qing rule across Inner Asia in the eighteenth century, with the Qianlong emperor even claiming that the Manchus were named for Manjusri.

Aside from its practical advantages, the emperor was genuinely a devout Buddhist. While the emperor was still a young prince, Rolpay Dorje, the eight-year-old son of a shepherd in Gansu Province, was discovered to be the third incarnation of the Jangjya Khutuktu, the highest incarnate position in Mongolia. The Yongzheng emperor had him brought to the Beijing court. There, at the school for princes, the two young men studied together. This childhood comrade continued as the Qianlong emperor's most important Buddhist master and advisor for fifty years. Highly skilled in Buddhist representations and an expert in Tibetan Buddhist iconography, he directed the design of imperial temples and participated in the creation of Buddhist sculptural and painted pantheons for the court.[20]

Within the Qianlong Garden, many beautifully wrought masterpieces were undoubtedly the result of Rolpay Dorje's guidance. Immediately upon stepping through Yanqimen, the garden's front entrance, the visitor must choose a curving path leading between the rockeries or turn right and enter an intimate courtyard with an artificial mountain topped with a small pavilion, Xiefangting (Pavilion of Picking Fragrance), a zigzagging covered corridor, and a small building. This is Yizhai (Studio of Self-Restraint), where exquisitely rendered im-

Figure 20. Glazed ceramic roof knob of Biluoting.

Figure 21. Prunus carved stone balustrade of Biluoting.

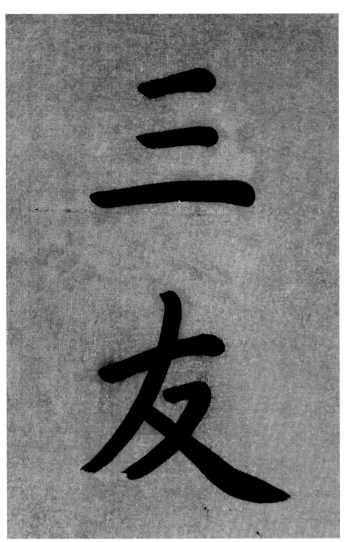

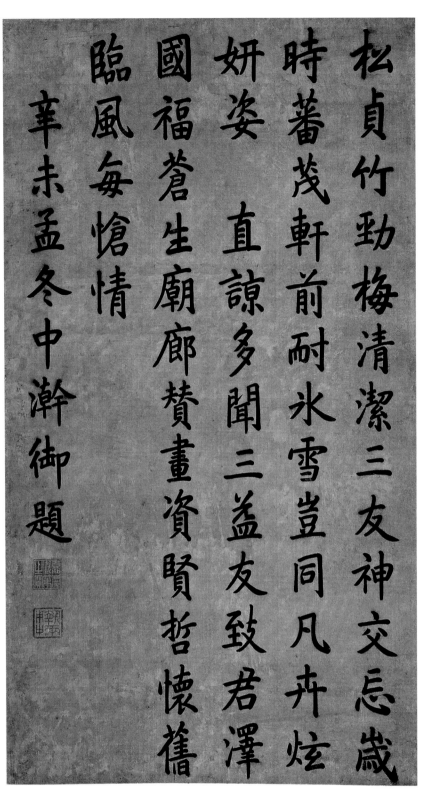

松貞竹勁梅清潔三友神交忘歲
時蕃茂軒前耐冰雪豈同凡卉炫
妍姿　直諒多聞三益友致君澤
國福蒼生廟廊贊畫資賢哲懷舊
臨風每愴情
辛未孟冬中澣御題

Plate 38. Jiaqing Emperor, Calligraphic inscription (cat. 45, details).

ages of Buddhas, bodhisattvas, and *luohans* are embedded into the walls. Continuing along the covered corridor, the space opens out to a high rockery and, at its base, a partially hidden arched doorway. The door opens to reveal a Buddhist grotto shrine within the artificial mountain. There, the emperor could imagine himself a pious hermit.

Deeper within the garden lies Cuishanglou (Building for Enjoying Lush Scenery). Its second-story vistas onto rockeries to the south and north certainly conjured up the realm of spiritual beings for the imperial ruler. A poem he wrote in 1793 elucidates the emperor's decision to locate a Buddhist shrine with such a view:

This is a tower on an artificial mountain. It compares to a heavenly palace where immortals and Buddhas live.[21]

In contrast to the rustic Buddhist grotto hermitage in the first courtyard, the emperor adopted a highly ornamental style to pay homage to the deities in this building. The colorful painted glass insets in the lattice partitions, their jewellike effect brightened by sunlight, evoke a paradisiacal atmosphere (plate 19). A large panel announces the religious focus of the space: it portrays a bejeweled Buddhist realm, glittering with gold (plate 39). In the center of the approximately sixty-five-inch-high panel, framed within a three-story, imperial temple with a yellow-glazed roof, a large gold Buddha sits cross-legged on a dais in a lotus-petal-shaped niche. Similarly shaped windows on the upper stories of the temple hold smaller figures. Dozens more float in the clouds and air above and around the building. The work is a mandala, a Buddhist cosmogram depicting the universe with all of the deities and beings, often arranged in a ritually auspicious geometric design that can aid the meditation of initiated worshippers.

Described in records as a *qinizifo guakan* (painted clay Buddha hanging shrine), it incorporates a brightly colored painting on silk depicting the ornate structure, lotus pond, mountains, trees, clouds, and sky along with figures standing on the clouds. Small round holes and the lotus-petal-shaped openings have been cut into the silk. Painted and gilt clay figures of Buddhas, teachers, and deities have been set into the holes and covered with glass. The volumetric blending of two-

and three-dimensional works both inset and protruding is a shining example of the Qianlong emperor's dedication to exploring the range and potential of combining artistic media. This style of shrine – with the clay votive figures known in Tibet as *tscha-tscha* – did not become part of Chinese court art until the eighteenth century. The earliest known record for a *qinizifo guakan* states that the Qianlong emperor ordered one in 1744 to be made in accordance with a painting hanging within the Jianfugong.[22]

This Cuishanglou shrine, made in 1777 by the Qing imperial workshops,[23] is also a portrait of the emperor seated on the central dais as the Bodhisattva Manjusri (known in Chinese as Wenshu). In the Vajrayana school of Buddhism to which the emperor subscribed, Manjusri embodied enlightened wisdom. Here, he is dressed like a Tibetan high monk. His right hand is in the *mudra* of teaching; in his left hand he holds the wheel of the *dharma*, identifying him as the *cakravartin*. Above his shoulders, on top of lotuses, are a sword and a sutra, specific attributes of Manjusri. A two-line text is inscribed on the green and blue cushions on which he sits: "Wise Manjusri, sovereign of men, playful, unexcelled, great king of the *dharma*. Your feet firmly on the Vajra Throne. May you have the good fortune that your wishes are spontaneously achieved."[24] The words reference both Manjusri and the emperor. Furthermore, in Tibetan, the words "playful, unexcelled" are a play on the name of Rolpay Dorje, who is pictured in the window niche directly above the emperor figure.[25] Above him is Tsongkhapa, the fifteenth-century patriarch and founder of the Tibetan Buddhist Gelug or Yellow Hat Sect that the Dalai Lama leads today. Floating in the surrounding space are other historical teachers, Buddhas, and tutelary deities for a total of ninety-five clay figures. Tibetan script in gold on the red fabric covering the interior of each niche identifies each personage.

The Qianlong emperor, probably the Chinese ruler with the greatest artistic production under his control, was also the emperor most fixated on commissioning his own portraits. Paintings depict him in full armor on horseback, traveling to the south in a boat, hosting victory banquets, as a Buddhist deity, and sitting at a desk writing poetry (Introduction, figure 1). He was neither the first nor the last imperial ruler to be portrayed

as a Buddhist being. His father, the Yongzheng emperor, was similarly depicted as a lama,[26] and the Empress Dowager Cixi over one hundred years later posed for photographs dressed as the Bodhisattva Guanyin.

Of the seven known depictions of the Qianlong emperor as Manjusri in compositions similar to that of the shrine,[27] all are painted directly on silk or other fabric, and none has the three-dimensional *tscha-tscha*. They all portray a pure realm, with the Qianlong emperor/Manjusri figure in the center holding the wheel of the law, Rolpay Dorje above him, and Tsongkhapa at the top.

The temple, depicted with its large basins of colored pearls and coral, jeweled and gold decorations, and pink, blue, and orange walls, dominates the composition of the Cuishanglou panel. Flanking the temple are a tree and a hexagonal lotus blossom rising from a pond; behind the temple loom mountains – most likely Wutaishan, the Chinese abode of Manjusri and the destination of six pilgrimages by the Qianlong emperor. Gold floral designs adorn the columns; sumptuous brocade covers the tile floor. Behind the Manjusri image is a table with sutra wrapped in a yellow cloth, an incense burner and accouterments, an ancient bronze vessel holding peonies, and a bell and *dorje* (thunderbolt), ritual implements in Tibetan Buddhism. Enhancing this pure world are heavenly figures bearing Buddhist emblems and tossing flowers along with heavenly musicians on the clouds and the terraces of the temple.

While such a panel could be interpreted as projecting the emperor's political and spiritual power in the cosmos, it can also be seen as expressing his devotion as a Buddhist, his deep reverence for his teacher Rolpay Dorje, his belief in his role as a *cakravartin*, the righteous and benevolent ruler, and his aspirations for artistic excellence and innovation.

Contiguous to Cuishanglou to the west, through a small gate hidden behind a rockery, the visitor enters the building called Yanghe Jingshe (Supreme Chamber for Cultivating Harmony). In the first room is a large trompe-l'oeil mural of women and children playing with New Year toys; in the next room, around the corner, another wall-size painting depicts a single woman holding

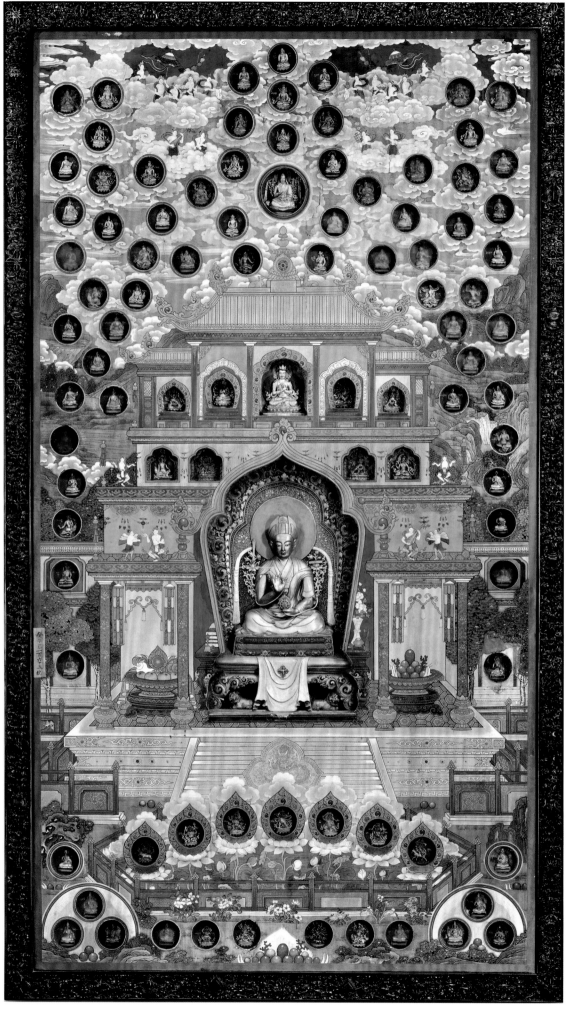

Plate 39. Panel with niches (hanging) (cat. 24).

Plate 40. Interior scene (cat. 44).

Plate 41. Door surround (cat. 1).

Figure 22. Lotus-petal shaped door surround at the Bishu Shanzhuang, in Sekino Tadashi, *Nekka Jehol* (Tokyo: Kokusai bunka shinkokai, 1935). Phillips Library, Peabody Essex Museum.

out a flower to a child in a palace hall (plate 40). Both of these bright and amusing images are also serious representations of Confucian ideals of abundant progeny. Deeper within the building is a space for serious cultivation of harmony. A tiny room contains a lotus-petal-shaped niche that would frame the Qianlong emperor when he sat cross-legged on cushions within, creating an image similar to that in the Manjusri panel (plate 41). Instead of the gold and jewels of the painted example, however, the literati emperor's niche is decorated with paintings and calligraphy. A calligraphic couplet hanging on the back wall framed the emperor when seated. Other calligraphic works and paintings could be viewed only from the perspective of the person sitting within the niche. The seated emperor could have read above the lotus-petal door a delicately ornamented yellow horizontal band of paper with nine characters within roundels: "This religious site for peaceful cultivation is in the Western Paradise." The phrase "Western Paradise" perhaps would remind the emperor that the niche, framing him as the *cakravartin*, was an ephemeral extension of this Buddhist abode of enlightened ones.[28]

The door surround that would have framed the seated emperor is a complex construction of two layers of *nanmu* (cedar) wood outlining a lotus-petal-shaped opening and reticulated, curved frames suggesting additional petals. Between the lattice layers is a green-blue silk damask gauze. Records refer to this gate or door surround as a *lianhuazhao*, a "lotus flower cover." Only one other *lianhuazhao* is mentioned in the Qianlong construction records for the Forbidden City. This was in Jingchenxinshe (Chamber of Dusting Clean the Heart), a Buddhist room in the Ningshougong central axis area, which would have been constructed at the same time as Yanghe Jingshe.[29] A photograph taken in 1933 within a temple at the Bishu Shanzhuang depicts a variation of this form (figure 22), and another photograph of a temple in Tibet may possibly point to a model or inspiration for this unusual design.[30]

The meaning of the lotus-petal shape, which appears in the painted *tscha-tscha* panel and innumerable times in Buddhist imagery, derives from ancient Indian Buddhist notions of cultivating human purity. The lotus, with its root in mud, rises up and out of murky waters to bloom

Plate 42. Qianlong Emperor, Calligraphic inscription (cat. 51).

forth a breathtaking flower – thus symbolizing that any soul, no matter how foul its original circumstances, can reach enlightenment.

Archives from the end of 1776 note a request for two paintings to be placed within the lotus niche, visible only to the person seated within. The emperor specifically requested that the artist Yang Dazhang create a pair of paintings depicting "wax plum blossom" (Chimonanthus) flowers and tianzhu flowers covered in snow.[31] Remnants of both paintings, with Yang Dazhang's signature and seal, can still be seen on the walls: a long vertical scroll depicting a yellow prunus on the north end of the west wall; a matching scroll depicting the plant known as wannianqing is on the southern end. Wannianqing literally means "green for ten thousand years." Because the sound for green, qing, sounds like the name of the Qing dynasty, the plant symbolized good wishes for the longevity of the dynasty, an aspiration reinforced here by the flower flourishing even when covered with snow. This specific request by the emperor – as well as the auspicious trompe-l'oeil murals of women and children intended to encourage progeny – reveals a unique personal belief system that amalgamated his Buddhist quests with his Confucian loyalties and his Daoist sensibilities. Similar blendings of belief traditions appear repeatedly throughout the garden.

A poem the emperor composed in 1777 soon after the completion of the Ningshougong Palace and Garden proclaims this same complex combining of Confucian, Buddhist, and Daoist quests. The poem, inscribed on elegant paper hand-decorated with abstracted gold flowers and produced solely for imperial use is appropriately pasted on the southern wall within the niche (plate 42):

Harmony in the air causes spring. Harmony in principles begets humane-ness.
People should cultivate themselves, and the most important person among the people is the emperor [as]
The blessings of the emperor reach to ten thousand things.
His heart hovers. . . .
Sometimes he uses righteousness
Because of his humane-ness, his behaviors are pure.
So I have conscientiously constructed the Tranquility and Longevity Palace.
I will use it for my exhaustion from Diligent Service.
In naming this the Place of Cultivating Harmony, the

Let's look at how sprouts and buds embody beginnings. They are more beautiful than colorful flowers in full blossom.

試
看
芽
紐
蕾
含
始

却
胜
嫣
紅
姹
紫
羅

naming is not unreasonable.
I work hard at present and I wait for the future when
I can roam at leisure.
If indeed I can achieve the rest for the remainder of my
life, I can be happy.
Humane-ness cannot be ignored, not to mention
righteousness.
Cultivating Harmony is True Cultivation.
I want to be called a person with nothing to do.

The buildings of the Qianlong Garden were designed not only for specific activities – meditation, Buddhist ritual (plates 43–46), musical entertainment, poetry writing (plates 47 and 48) – but also like a private museum for display: interior decoration, architectural elements, paintings, furnishings, and objects were all there to be viewed, if only by the emperor. Within the lofty Buddhist structure, the emperor made room to exhibit a cherished treasure.

Calligraphy by the emperor on paper pasted above a passageway on the second floor of Yanghe Jingshe designates the area as Yunguanglou (Building of Luminous Clouds), a reference to the glow often described as emanating from clouds surrounding a palace in Buddhist realms. Beyond this opening is a sutra storage room or library. On the south side of the corridor, in a long niche with a raised floor facing rockeries through the north windows is a monumental zitan-framed screen with jade Buddhist figures inlaid into lacquer – an impressive sight for Buddhist devotees as well as art connoisseurs (plate 49). Each panel contains a portrait of one of sixteen luohan (Sanskrit *arhat*, enlightened ones), the celebrated, quasi-legendary disciples of the Buddha who achieved enlightenment. The theme of sixteen, or sometimes eighteen, luohan has been a popular subject for Chinese artists. The fabled Tang painter-poet-monk master Guanxiu (832–912) created one of the most famed sets of luohan paintings, depicting the characters in a surprisingly grotesque manner with bushy brows, hunched backs, and bizarre features that he explained came to him in a dream. His renowned rendering was securely stored in a Hangzhou monastery where it was viewed and copied many times over the ensuing centuries. The Ming master Wu Bin (1583–1626), also a devout Buddhist and practitioner of his own personal eccentric and archaic style, created a vibrant interpre-

tation of Guanxiu's work that eventually entered the Qianlong emperor's collection. The visually powerful jade-and-lacquer screen in Yunguanglou was the product of the Qianlong emperor's own encounter with the masterpieces by Guanxiu (or possibly a copy that he mistook for the originals), and his passions for art and Buddhism.

The conceptual relationship between the luohan and the Qianlong emperor is not tangential. Buddhist tradition holds that in addition to being disciples of the Buddha, the luohan were also protectors of the *dharma* and guardians of Buddhist sites until the arrival of Maitreya, the Buddha of the future. Maitreya's arrival would be foretold by the preliminary appearance of a *cakravartin*, which the fifth Dalai Lama had deemed the Qing emperors.

In 1757, the Qianlong emperor visited Hangzhou, the ancient capital of China during the Southern Song dynasty and long considered one of the most beautifully sited cities in China. The temporary palace erected for the emperor's stay was on Gu Shan, the largest island in West Lake, near Shengyin Si, the very monastery that owned the legendary luohan paintings by Guanxiu. The emperor believed the paintings to be the same set that had been recorded in the *Xuanhe Huapu*, the inventory of the Song Huizong Emperor's collection. One report claims that the monastery had sent the paintings to Beijing six years earlier as a birthday gift to the empress dowager, but the emperor determined that such sacred works were best kept at the monastery and sent them back.[32] Now at the temple he had the opportunity to view the masterpieces and he was deeply moved. As was his habit when enamored with an object, he responded in the traditional Chinese manner, with poetry and by making copies. First, he wrote poems narrating his thoughts and reactions to each image. The inscriptions, each with eight four-character lines, provide some physical description of the individual paired with a Buddhist message, such as "His heart is that of a Bodhisattva, his appearance is that of a ghost king." The poems reinforce the Buddhist wisdom concerning what scholar Richard Kent called "the delusive nature of external appearances."[33]

Disconcerted by what he deemed mistaken transliterated names of the luohan and a misnumbering

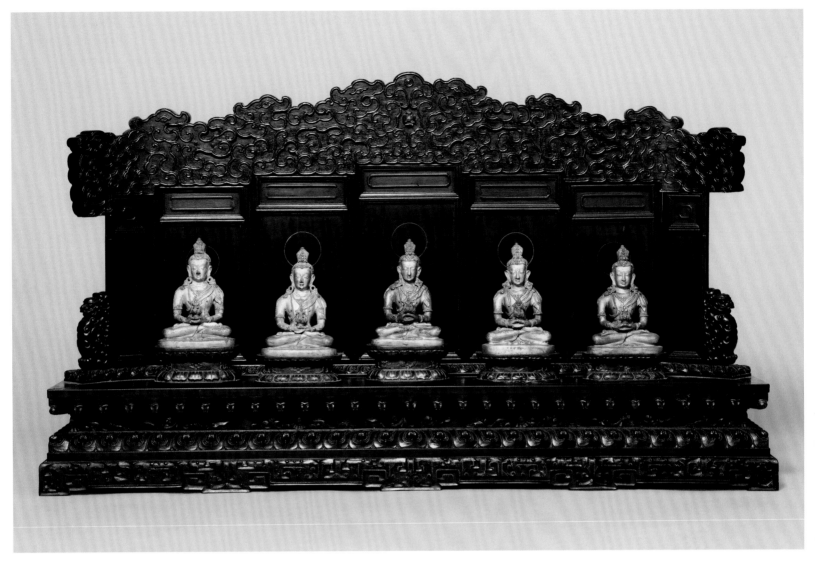

Plate 43. Statues of Amitabha and stand (cat. 13).

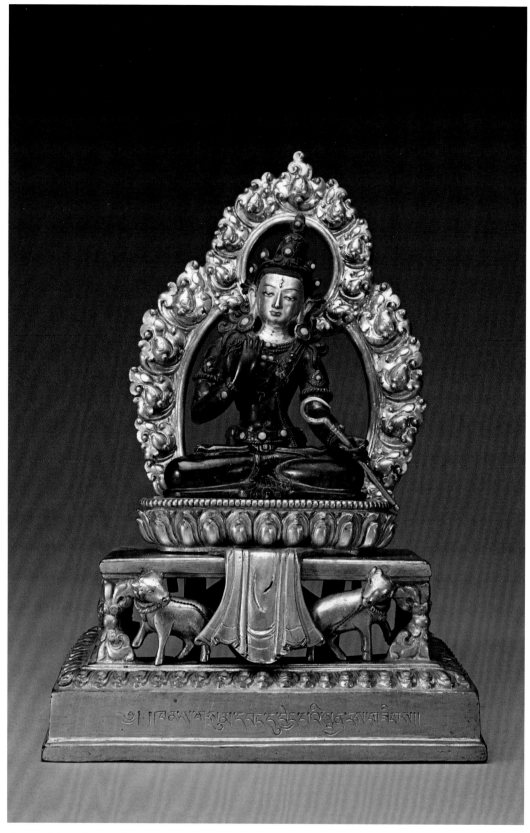

Plate 44. Shrine and statue of Bodhisattva Guanyin (cat. 11).

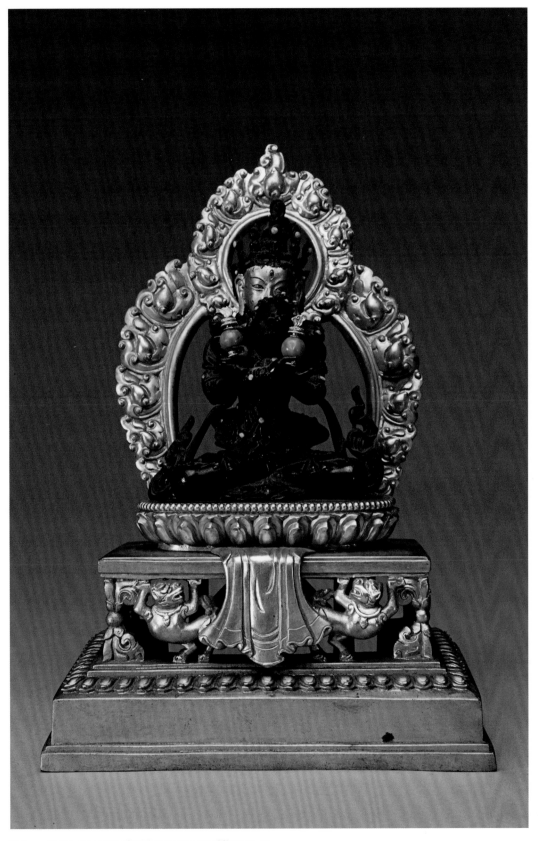

Plate 45. Shrine and statue of Baishang Lewang Buddha (cat. 10).

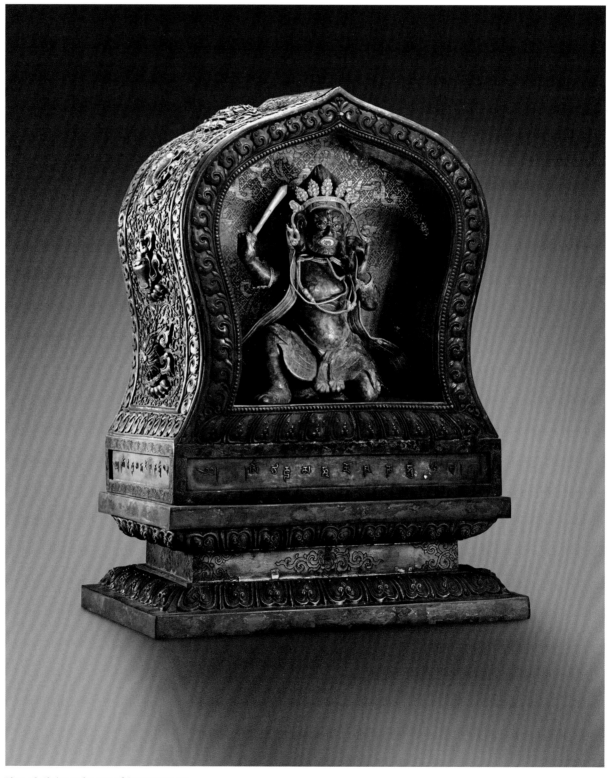

Plate 46. Shrine and statue of Jingang (cat. 12).

Plate 47. Cao Wenzhi, *Bada Pusa jing* (Eight Great Bodhisattva Sutras) (cat. 43, detail).

十四聞佛當来王
即勅傍臣左右皆
悉嚴駕王即行迎
佛遙見佛心中踊
躍歡喜王即下車
步罷傍臣左右持

Plate 48. Liang Guozhi, *Foxingxiang jing* (Sutra on Buddhist Images) (cat. 47, detail).

佛說作佛形像經

佛至拘鹽惟國有

諸樹園主名拘翼

時國王名優填年

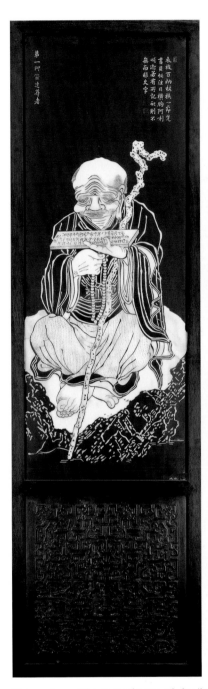
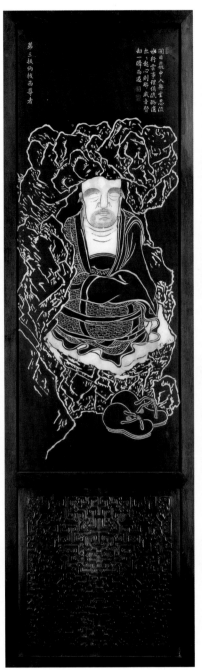
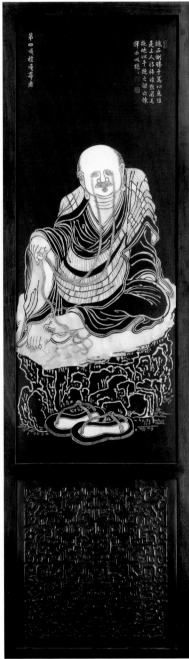
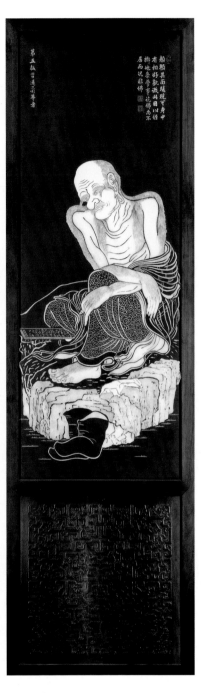

Plate 49. Screen (sixteen panels) (cat. 26, details).

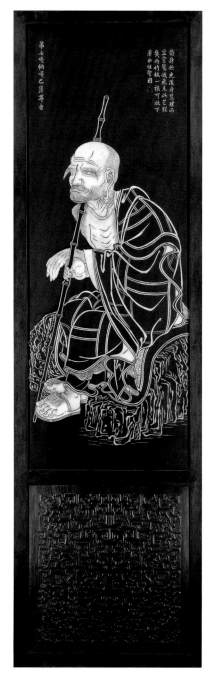
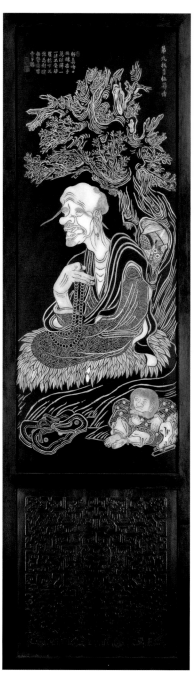
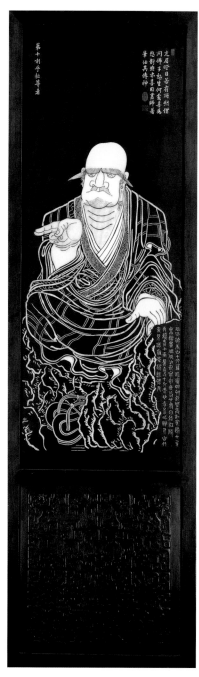
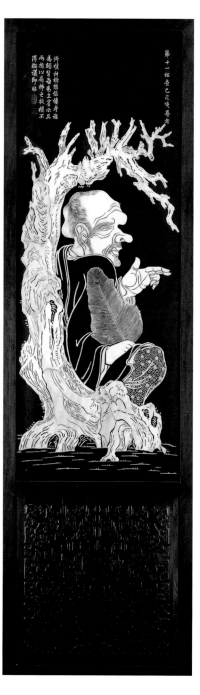

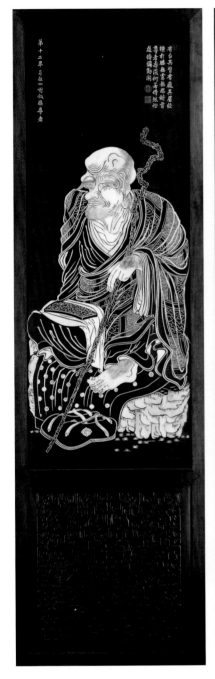
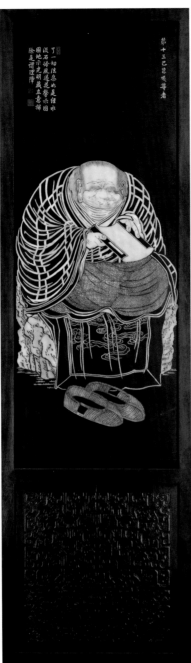
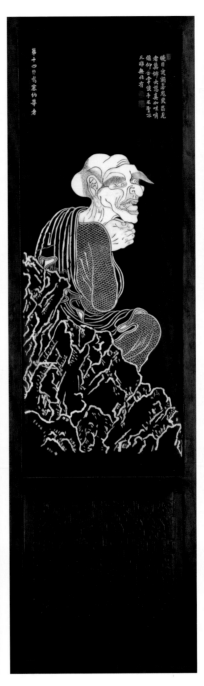
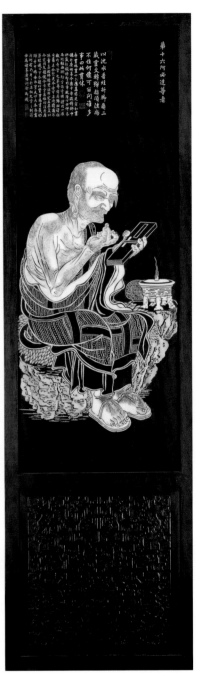

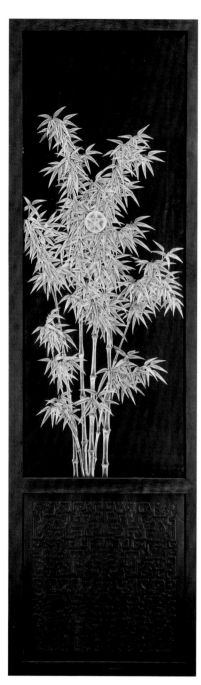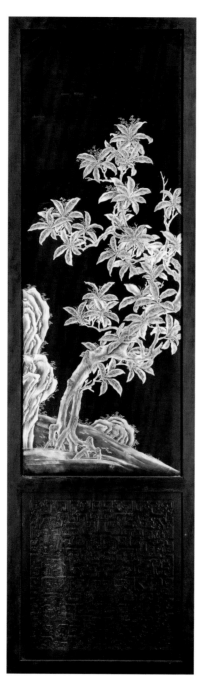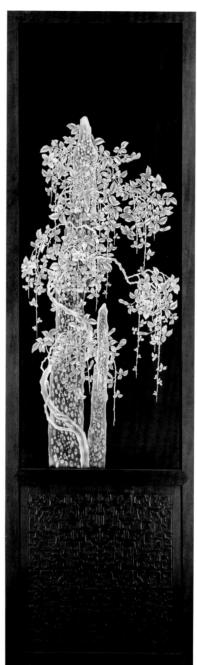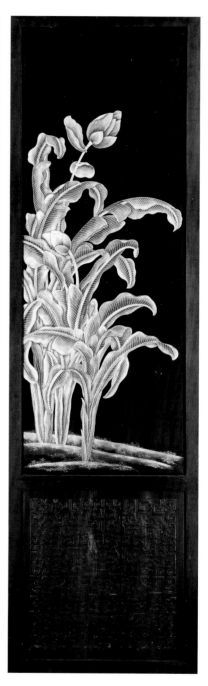

Plate 49. Screen (sixteen panels) (cat. 26, details).

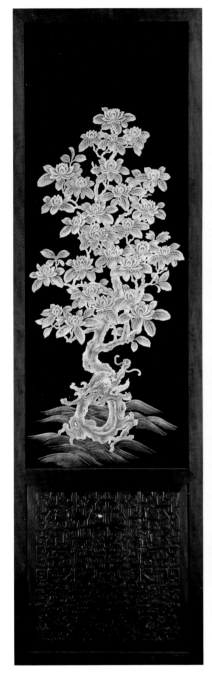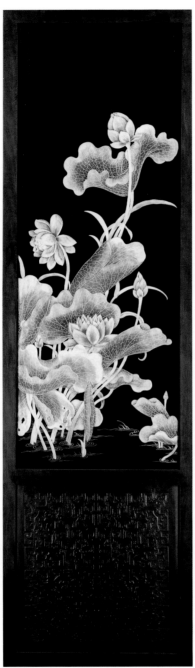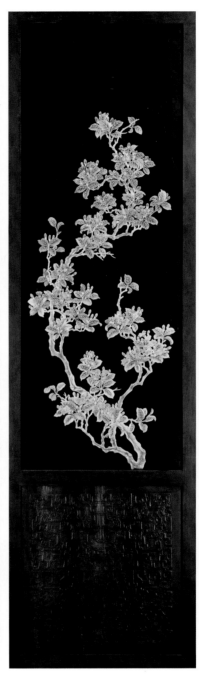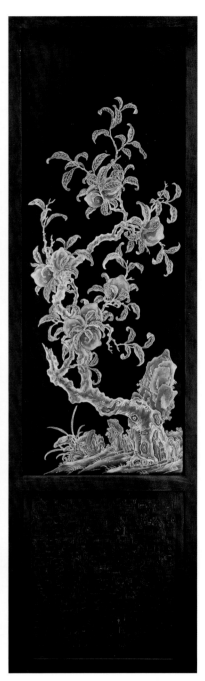

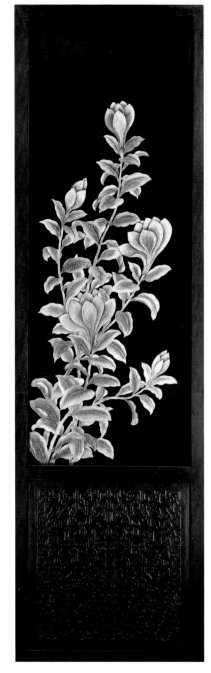
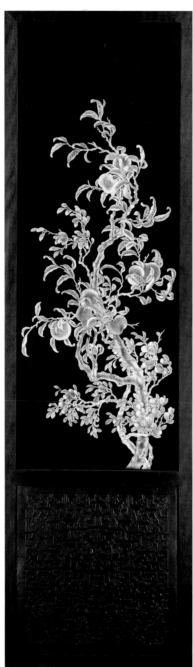
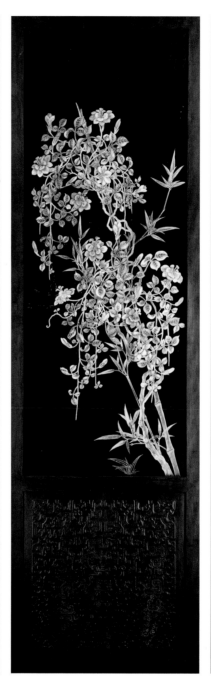
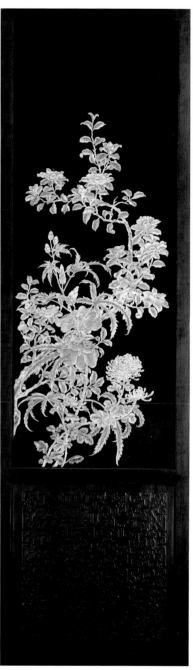

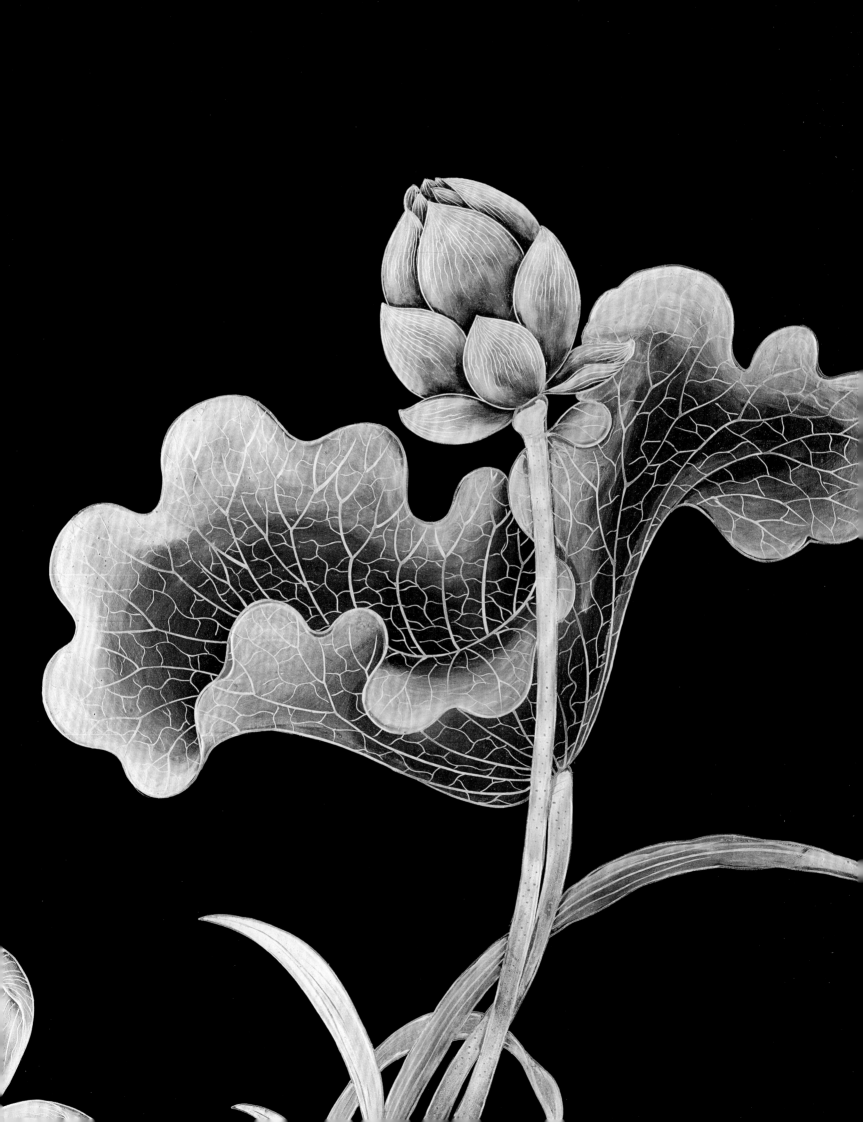

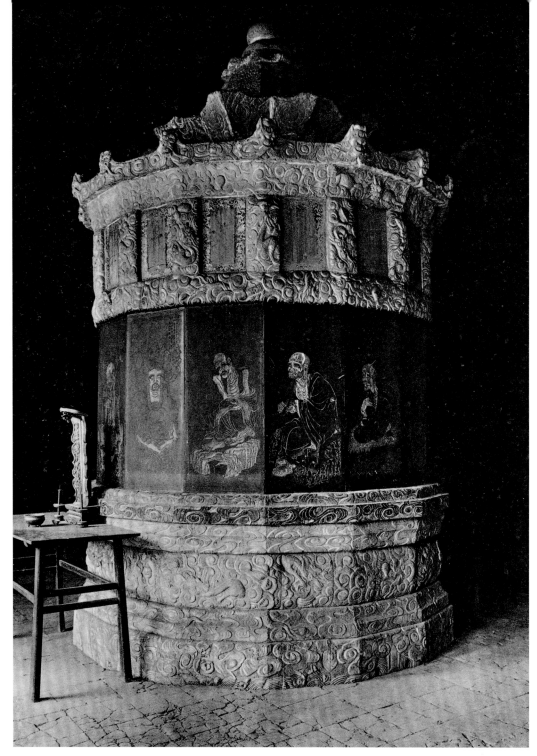

Figure 23. Stone panels at Shengyinsi. Photograph by Ernest Boerschmann, in *Die Baukunst und religiöse Kultur der Chinesen* (Berlin: Reimer, 1911–31), vol. 3, pl. 10. Phillips Library, Peabody Essex Museum.

in their sequence, the emperor renumbered them and corrected the names in accordance with his own master's teachings.[34] He then requested that his court artist Ding Guanpeng create copies of Guanxiu's *luohan*, which the emperor inscribed as well.[35] In the following decades, he had artisans reproduce the images in a variety of mediums, including incising them on jade plaques[36] and weaving them into silk *kesi* tapestries also hung in Yanghe Jingshe. In addition to the widespread tradition of copying works of art in China, copying Buddhist images or texts had another distinct purpose: it furthered dissemination of Buddhist thought and therefore was a fundamental method for gaining merit (*karma*) toward enlightenment. Indeed, in 1764, the head abbot at Shengyinsi, Master Mingshui, surely inspired by the emperor's visit, instructed local stone engravers to copy the sixteen portraits, incising Guanxiu's lines as well as the emperor's calligraphy and seals onto sixteen large flat stones that were embedded into the sixteen sides of the marble Miaoxiang Pagoda, with further inscriptions above the primary images (figure 23).[37] With the images carved into stone, rubbings on paper – highly collectible and respected objects in China – could be made and distributed (figure 24). Today, the Miaoxiang Pagoda rubbings are in museums, libraries, and private collections around the world. The carved stones themselves were also copied and installed at other temples throughout China.[38]

The Qianlong emperor had a fondness for objects of one medium reproduced in another. The great mid-Qing artisans at the imperial kilns in Jingdezhen, for example, fashioned porcelains imitating lacquer, wood, and bronze. The *luohan* screens in Yunguanglou, with their white jade inlaid into jet-black lacquer, use precious materials to reproduce rubbings. The black-and-white palette references the rubbings. That the screens were reproductions of rubbings that were in turn reproductions from stone carvings that were reproductions of paintings surely must have amused the emperor. That the jade images copy the rubbings rather than the paintings can be verified by comparing details. An inscription by Guanxiu at the bottom right-hand corner of the representation of the tenth *luohan*, Rahula, appears only on the stones, the rubbings, and the screen; it is presumably on the original paintings, but neither Ding Guanpeng nor Wu Bin elected to include it on their more interpretive copies.[39]

Luohan imagery appears repeatedly throughout the Qianlong Garden and particularly in Yanghe Jingshe and Yunguanglou. Furnishing records reveal that within Yanghe Jingshe was an album of paintings of the sixteen luohan, two scrolls depicting them, and a large screen portraying the sixteen in the silk tapestry technique of kesi. Other archives describe in detail a series of sixteen kesi panels fashioned from five colors of silk woven into a gold background – copies of the Guanxiu paintings the emperor saw at Shengyinsi. These kesi panels may have been the ones that hung in Yunguanglou as a stunning counterpoint to the jade set.

Palace records report that the screens were a gift to the emperor from Guotai, a Manchu also from the Fuca clan, who had just become inspector general of Shandong Province. The clever official must have heard about the emperor's interest in the Guanxiu paintings; hoping to curry favor, he commissioned these panels of zitan, jade, and lacquer. On the reverse side of each panel, Guotai had the lacquer artists render flower images in gold and silver. The well-calculated gift impressed the emperor, who instructed that the walls and screens in Yunguanglou be taken down and rebuilt to accommodate a special niche for the screen. This placement of the panels into the niche necessitated that the beautiful gold lacquer paintings on the reverse sides would face the walls. Hidden from view for over two centuries, these brilliant works, depicting bamboo, lotus flowers, ancient trees, and other botanical features, were only discovered when conservation processes began in the late twentieth century.

As for Guotai, in 1782 he was charged with corruption and sentenced to commit suicide. The emperor never noted down any thoughts he may have had regarding the possibility that ill-gotten money had created the treasure that now graced his spiritual spaces.[40]

The Guanxiu aesthetic of giving the luohan exaggerated and discomforting features and seating them under ancient gnarly trees or on chunks of rocks is highly reminiscent in style and vision of the Qianlong Garden itself. The Chinese-preferred aesthetic of the awkward (zhuo) had become an integral part of literati aesthetics by the Song dynasty. While much

imperial art aimed to project sensibilities of "prettiness" (mei) or power, this aesthetic came to inform the arts and artifacts of the literati culture, including the garden. The emperor's passion for the raw, powerful representations of the luohan and for unrefined rocks and rockeries evolves out of his acquired literati taste and philosophy. The emperor would surely have enjoyed how these luohan, with their disquieting appearances so carefully carved of precious jade, resonated with the wild natural environment they faced through the windows.

A small table screen in the same building encapsulates a similar sentiment. Because its surface appears to bear the image of the Bodhisattva Guanyin, a stone slab was mounted in a wood frame and stand (plate 50). The Prajnaparamita Heart Sutra was engraved on the frame. This sutra that discusses the duality and co-dependence of all things in the world was a favorite of the emperor, and he had piously copied it numerous times. A scroll of another sutra was displayed in Yunguanglou just above the jade luohan screen niche. The emperor also wrote a poem about the special stone, which was incised on its surface, in which he mused on appearances and illusions:

Appearing to be jade, but not being jade
Appearing to be stone, but not being stone
As if hidden, as if apparent
The Universal Gate (Guanyin) reveals its traces.
The appearance is complete.
Water moon (Guanyin) wanders with grace.
How can it be sketched, how can it be painted
Without carving, without incising. . . ?[41]

Synthesizing the many traditions that developed within China and entered from the outside world was a remarkable skill and vision of the Qianlong emperor. In this building, he welcomed European aesthetics and beautiful women that serve to celebrate and convey his Confucian aspirations, while through his imported glass windows he could gaze outside at the rugged stones that allowed his literati and Daoist soul to wander at will. In a poem he wrote in the Buddhist atmosphere of Yanghe Jingshe, he addressed Buddhist goals while quoting ancient Confucian classics, such as the Record of Music, and one of the most important Confucian philosophers, Mencius (or Mengzi, 372–289 BCE):

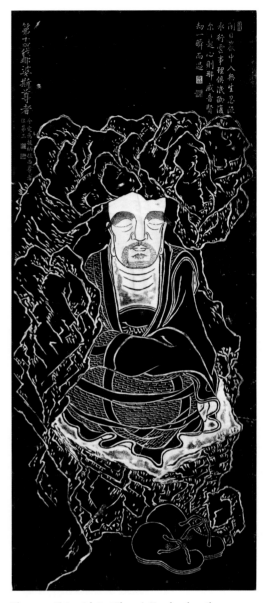

Figure 24. *Sixteen Arhats at Shengyin Temple – the 14th: Vanavasin Arhat*. Rubbing on paper. Rubel Chinese Rubbings Collection, Harvard University.

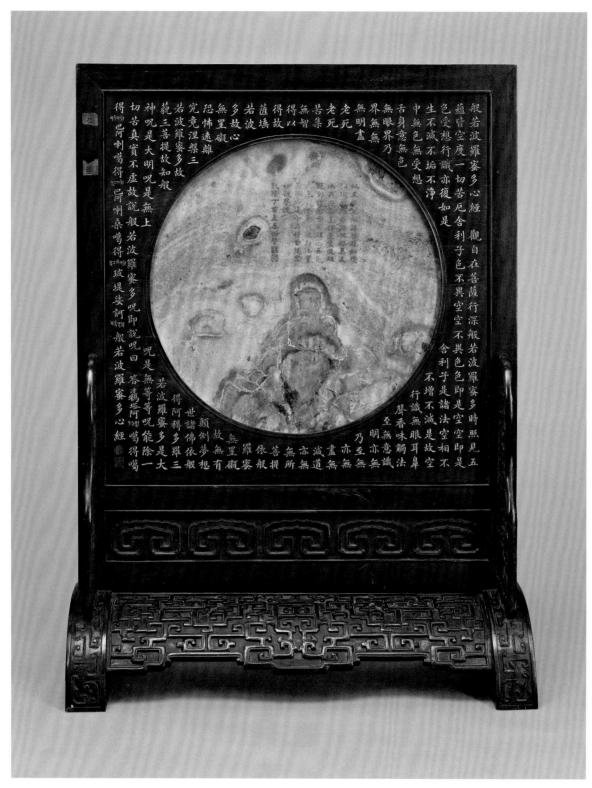

Plate 50. Table screen (cat. 15).

Expression in appropriate rhythm is called harmony
[from Record of Music]
Harmony must come from within and depends on
self-cultivation
Achieving the way depends on the essence of the self
Going back to one's original self, would that not be from
an upright heart [from Mencius]
Let's look at how sprouts and buds embody beginnings
They are more beautiful than colorful flowers in
full blossom
My heart has activity but is without desire
If you don't believe this, how can you speak of
other things?[42]

Delighting in Illusions The composition and
design of the garden offer numerous surprises and
illusions – the fundamental one that of being
within a natural surrounding far from the worries
of palace intrigue. Sitting deep in a grotto was
to trick the senses into believing that one was in a
forest, miles from civilization, nearer to the
immortals, despite the reality of being in the urban
Forbidden City. The caves were illusions of the
larger natural world.

The Qianlong emperor's fascination with
illusions, real and metaphorical, serendipitously
benefitted from the introduction into China
of European glass and mirrors. Large glass plates
and mirrors had begun to arrive in China from
Europe during the seventeenth century, and had
become increasingly popular among the well-
to-do in China during the eighteenth century. The
characters in *The Dream of the Red Chamber*, for
example, to their readers' amusement, were com-
pletely confounded by mirrors:

The whole party readily lost sight of the way by which
they had come in. They glanced on the left, and
there stood a door, through which they could go. They
cast their eyes on the right, and there was a window
which suddenly impeded their progress. They went
forward, but there again they were obstructed by a
bookcase. They turned their heads round, and there too
stood windows pasted with transparent gauze and
available door-ways: but the moment they came face to
face with the door, they unexpectedly perceived that
a whole company of people had likewise walked in, just
in front of them, whose appearance resembled their
own in every respect. But it was only a mirror. And when
they rounded the mirror, they detected a still larger
number of doors.[43]

The Qianlong emperor, while a master of the
great classics and traditions of the past,
was also a man of his own time. In addition to
the techniques of European perspective, he
was fascinated by glass and mirrors, and incor-
porated them throughout his garden: "My glass
windows are bright and shining, clean and
thick. I can see both outside and in. And how
happy I am. . . . All things enter my field of vision,
becoming clear and distinct/All phenomena
display themselves to me in their beauty or ugli-
ness."[44] In Juanqinzhai, in addition to glass
windows, he installed mirrors to bring more light
into the room and – not surprisingly – to play
tricks on his visitors. In one seemingly dead-end
space – the bedroom in the center of the
building – are two standing screens with mirrors
installed against a wall. One of them is hinged
and becomes a door opening to the theater room
with its magnificent trompe l'oeil mural – a
metaphor perhaps of the ability to walk through a
mirror into an illusionary world.

In addition to plain reflective mirrors, the
Qianlong emperor took a liking to the European
verre églomisé decorative technique, which entailed
painting an image or landscape on the back
of a piece of glass and then coating the blank sky
areas with silver leaf or other materials to effect
a mirror. During the eighteenth century, Europeans
commissioned artisans in Guangdong (Canton)
to produce low-cost copies of European works.
Before long, the works also gained popularity in
China. The concept of taking mirrors one step
beyond their straightforward function must have
appealed to the Qianlong emperor's fondness
for optical illusions. Gazing at his numerous *verre
églomisé* screens and hanging panels depicting
imaginary European landscapes and figures, with
his own face reflecting back to him, the emperor
could – as with trompe l'oeil murals – literally
project himself into that very foreign and even
illusionary space (plates 51 and 52).

The first courtyard offered opportunities to be
immersed in illusionary realms of nature. The sec-
ond, more symmetrical courtyard may have been
intended as a counterbalance offering a sense of
stability after the convoluted organic and architec-
tural mazes of the first. Within Suichutang, at the
far north end of this second courtyard, however,
were a number of man-made visual surprises: the

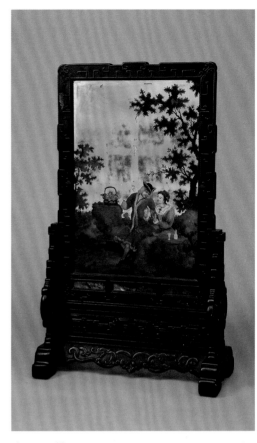

Plate 51. Table screen (cat. 14).

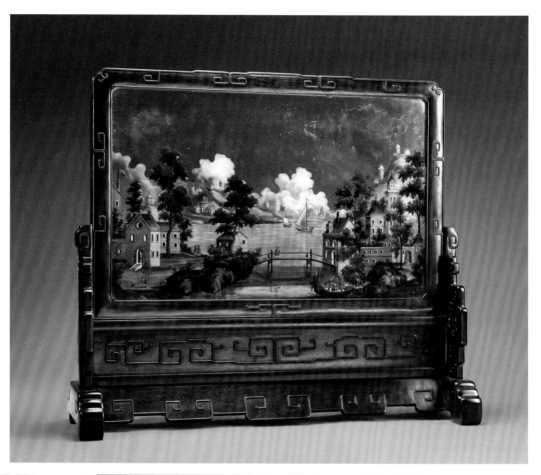

Plate 52. Table screen (cat. 16, one of a pair and detail).

archives record that the emperor ordered a series of trompe-l'oeil works for this space. Eighteenth-century Chinese authors, for whom such types of paintings were exotically new, wrote about the extraordinary sensation of feeling as though one could walk directly into these European-inspired murals. The effect of at least five such large works in one space, probably depicting landscapes and architecture, must have been dizzying.

For the central hall of Suichutang, the emperor requested a "*xianfa tongjinghua*" (two terms literally meaning "perspective panoramic painting" that the records often use together or individually to mean trompe l'oeil painting) to be painted on the western wall by Wang Youxue, and another on the southern wall "behind the room dividers" by Fang Cong and Yao Wenhan, copying a work at the Yuanmingyuan.[45] For the east side, he ordered that a European landscape be painted across five bays by the Bohemian artist Ignatius Sichelbart (1708–1780; known in Chinese as Ai Qimeng), accompanied by Wang Youxue, copying a work that had been in Yulinglongguan (Lodge of Tinkling Jades) in the Yuanmingyuan.[46] There were two additional *tongjinghua* in this small space – one by Fang Cong and another by the artist Yuan Ying.

Today, we can only imagine the appearance of this room, as none of these paintings survives. However, other trompe-l'oeil paintings by some of the same artists scattered throughout the garden offer a sense of the experimental and humorous side of the Qianlong emperor. The illusionary effects include panoramic perspective paintings, glass and mirrors often with paintings on or behind them, and intimations of foreign lands (plates 53 and 54). The emperor's expansion of classical Chinese garden elements through the incorporation of these optical delights must be considered among the primary achievements of the Qianlong Garden.

Of these assorted optical treats, the richest and most glorious accomplishments are the complex trompe l'oeil paintings – called *tongjinghua* or *xianfa hua* – astonishing for their spatially expanding effects on the rooms as well as their pictorial values. These were by no means the first *tongjinghua* in China. The earliest written record containing the term *tongjinghua* is from 1736, the first year

of the Qianlong reign, when the emperor ordered Castiglione to paint six *tongjinghua* oil paintings to hang within Yangxindian (Hall of Mental Cultivation), the emperor's private quarters.[47] One of the very few Qianlong-period trompe-l'oeil works still extant outside the Qianlong Garden is pasted just outside Sanxitang (Hall of Three Rarities), his special study where he stored his most precious ancient calligraphic rubbings. It depicts a blue-and-white-tiled corridor, with lattice windows on either side, leading to a moon gate beyond which two men are standing amidst rocks and trees (figure 25). The figures are understood to portray the Yongzheng emperor handing a flower to his son Hungli, who would become the Qianlong emperor. The painting is believed to be a copy of an earlier work by Castiglione.[48]

European-style paintings were still relatively new to China in the eighteenth century. One of the first European artists to labor under the Chinese imperial auspices was Giovanni Gherardini (1655–1723). The Kangxi emperor had requested that Jesuits bring to China experts in European sciences and arts. Gherardini arrived in 1698.[49] He had been born in Modena and worked in Bologna and in France. One painting by him that still exists in Europe (whereabouts unknown) gives a sense of the baroque architectural perspective that was his specialty. Gherardini painted the ceiling, cupola, and walls of the French Jesuit Church of Our Savior in Beijing (unfortunately razed during the Daoguang reign in 1827), presumably in the trompe l'oeil style popular in Europe at the time. Chinese and Manchus who viewed the works could "hardly believe their eyes."[50] Impressed, the Kangxi emperor ordered portraits from Gherardini.

Gherardini returned to Europe in 1704 but the church sent other experts in the visual arts, including Matteo Ripa and eventually the great master Giuseppe Castiglione. Among these artists, Castiglione probably had the strongest impact on imperial art and the emperors themselves. He arrived in 1715 during the twilight of the Kangxi reign, worked in the Yongzheng imperial court, and continued to serve the Qianlong emperor. Castiglione also worked for the Catholic Church in Beijing, executing vast murals for the South Church. One contemporary Chinese visitor marveled in the details he could see in the church's mural:

Plate 53. Table (cat. 32).

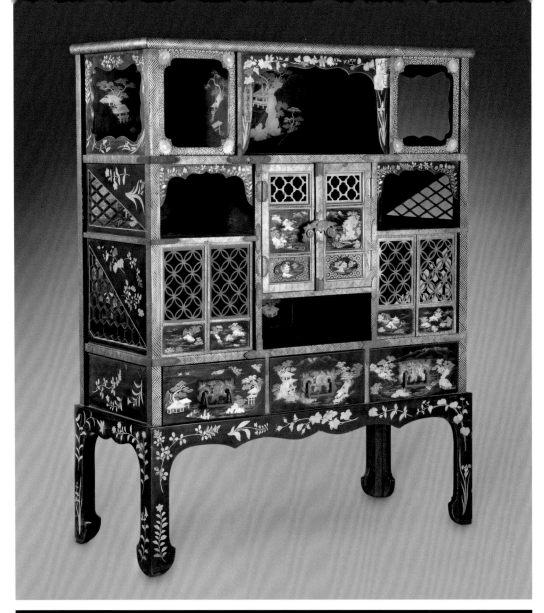

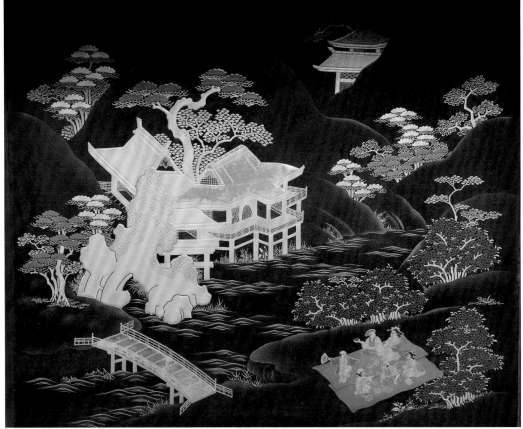

Plate 54. Cabinets (pair) (cat. 18, one of a pair and detail).

Sunlight pours through the window. Three vessels are set up on three tables. The golden color is glaring. On the hall pillars hang three big mirrors. Along the north wall of the hall is a wooden fan. On the east and west there are two tables covered with red brocade. On one of them is an automatic clock; on the other is a machine. In between the two tables there are two chairs. On the pillar is a lamp plate. Four silver candles stand upright on the plate. I look up at the [decorated] ceiling and see flowers made of carved wood. I look down at the ground. It is as bright and smooth as a mirror. One can count the square bricks one by one. Walking from the hall into the sleeping chamber, I see two layers of doors and curtains. From afar I see tables arranged in order in the chamber. It looks as if I can enter it. When I get close, it is just a wall.[51]

Another Qianlong-period author, Zou Yigui, explained: "Westerners are fond of using the perspective plane in painting, with the result that the impression of depth and distance is very accurate. In the painting of human figures, horses and trees, there are always shadows. . . . Mural paintings showing palaces and residences are often so real that one wants to walk straight into them."[52] And, of course, few readers in China would forget Granny Liu's mistaken encounter and conversation with a woman in a trompe-l'oeil mural in the Daguanyuan.

The Qianlong emperor requested Castiglione to pass his techniques on to Chinese artists within the academy. In addition to teaching European-style painting, Castiglione also worked with Nian Xiyao, a member of the Imperial Household Department and a supervisor of the imperial kilns in Jingdezhen, on the translation of *Perspectiva Pictorum et Architectorum* by the Italian painter Andrea Pozzo (1642–1709), first published in Rome in 1693. *Shixue* (Visual Studies), published in Beijing in 1729 and again in 1735, reproduces Pozzo's perspective drawings and helped disseminate the technique in China.

By the time the Qianlong Garden was being designed and constructed, the emperor's favored artist Castiglione had passed away. Other foreigners and disciples, however, were available to integrate illusionism into his garden complex. Archive documents indicate the emperor ordered *tongjing-hua* and *xiangfa hua* for at least five garden buildings, to be created by Castiglione disciples Wang Youxue and Yao Wenhan assisted by

Ignatius Sichelbart, who had entered the Ruyiguan (the imperial atelier) in 1745. Wang Youxue's name in particular appears repeatedly in reference to the panoramic paintings. Wang Youxue was the son of Wang Jie, a palace atelier artist whom he succeeded at the court. At the palace, the younger Wang studied oil painting with Castiglione and participated in numerous painting projects in both European and Chinese styles working with him and others.

Although edicts in the archives are brief ("On the 22nd day of the second month, eunuch Hu Shijie passed on the decrees: in the central room, within the partition, on the western wall of Yucuixuan in the Tranquility and Longeveity Palace, have Wang Youxue and others paint a *xianfa* painting"), an eye-witness to the proceedings, the French Jesuit Joseph-Marie Amiot, revealed the emperor's intense participation in the artists' creations of these paintings:

When the emperor desires a painting for one of his apartments or rooms, he usually conducts the European painter to view the location, where they carefully examine what would be suitable. Whether the Emperor himself selects the subject of the picture or whether he leaves the choice to the painter, it is necessary to prepare a small sketch and present to his majesty. Only after acceptance can work commence on the painting. . . . The emperor himself, who so often used to come the atelier, took such an interest in pictures, as at times to require changes and would himself trace them with a crayon, as we once were a witness, to our great astonishment.[53]

Qianlong imperial household archives reveal that there were at least ten *tongjinghua* in the garden along with numerous "false doors" (*jiamen*). These *jiamen* were vertical paintings imitating door-curtains adorned with actual cloth lintel hangings to further the illusion of being able to enter an adjoining space. Actual curtains – often painted or ornamented – between rooms are a common feature in Chinese architecture, providing privacy and most importantly warmth. At the end of the twentieth century, the garden still contained five *tongjinghua* in three buildings and many false doors, which served both as artistic decoration and as ways to expand the sense of space (plates 55 and 56). Few other examples of eighteenth-century trompe-l'oeil works still exist in the Forbidden City.

Figure 25. *Spring's Peaceful Message*, 1700s, hanging in Sanxitang within Yangxindian (Hall of Mental Cultivation). Ink and colors on silk. Palace Museum.

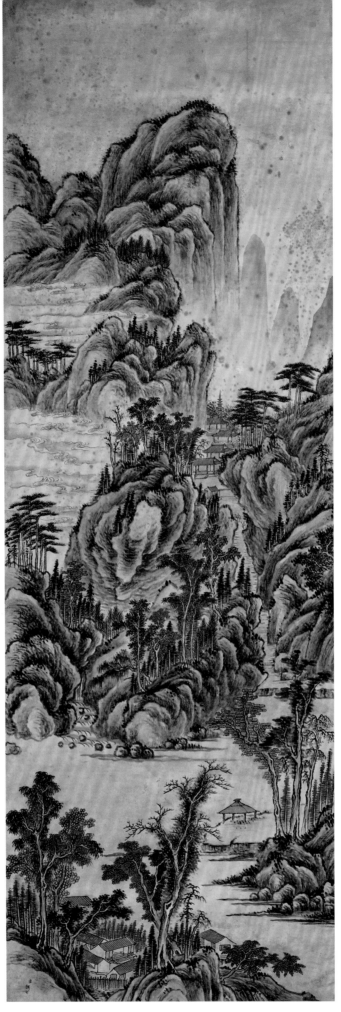

Plate 55. Wei Linghe, Landscape (cat. 52).

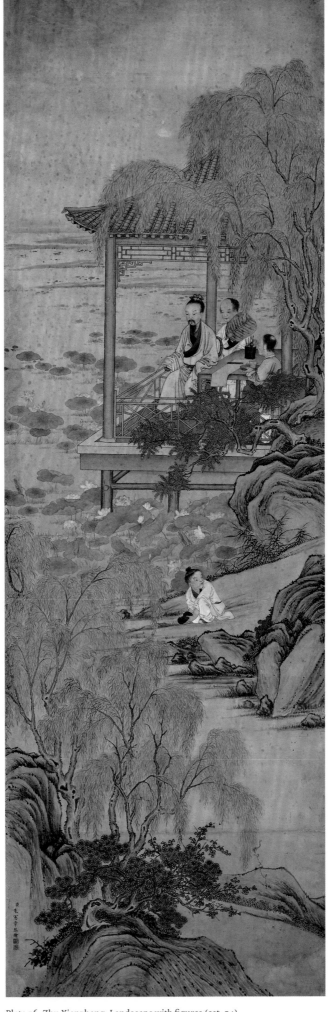

Plate 56. Zhu Xianzhang, Landscape with figures (cat. 54).

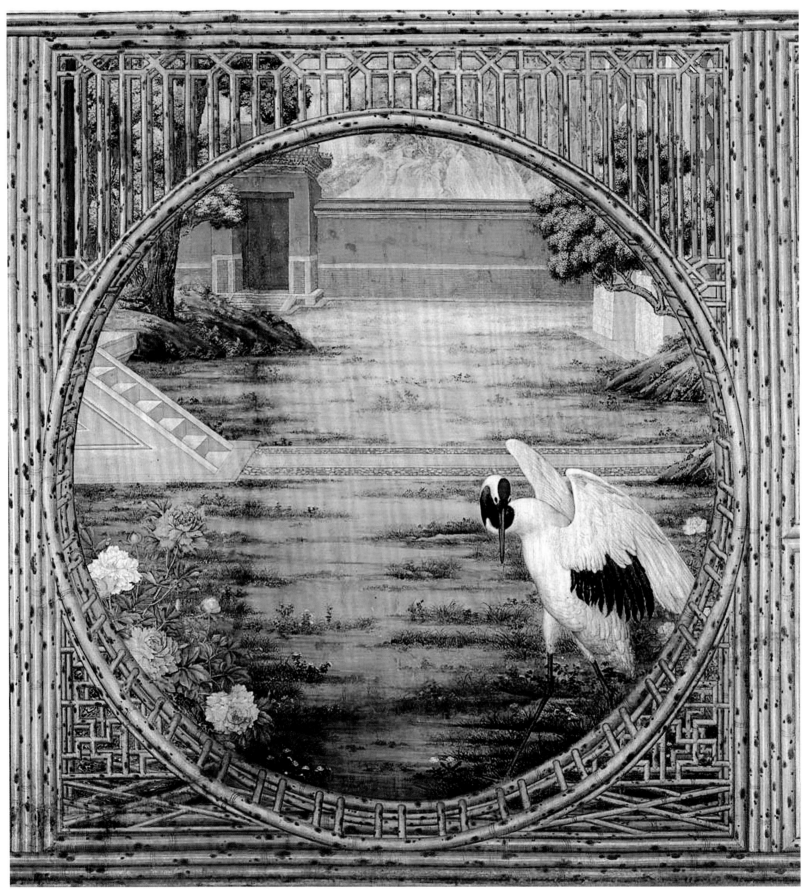

Figure 26. Wall painting in Juanqinzhai, detail.

One of the true glories of the Qianlong Garden is the trompe-l'oeil panorama enveloping the western hall of Juanqinzhai, the concluding moment of the garden's composition. The walls of this personal theater measure about 33-by-23 feet. They display a palace garden scene just beyond a bamboo lattice fence, brightly rendered palace halls, hills, waterfalls, pavilions, flowering trees, and even two cranes symbolizing longevity (figure 26). Created with Chinese brushes and colors on silk, utilizing European perspective, the mural is an inimitable and masterful amalgamation of two distinct painting traditions. The scene is also a conceptual mirror, a musical coda, to the garden complex, extending the experience beyond the terminal wall. Perfecting the illusion, the ceiling's trompe-l'oeil wisteria blossoms above hang from their trompe-l'oeil bamboo trellis (figure 27).

The mural – executed, according to the recorded edict, by Wang Youxue – was a copy of Castiglione's work in Derixin, in the Jingshengzhai, where the wisteria trellis ceiling was itself a copy of earlier works by the great European master.

Additional artists surely contributed to the Juanqinzhai mural: several hands are apparent but Wang Youxue was the artist in charge. The team might have included a specialist in landscape, and perhaps a second who painted the architectural structures, a specialty in Chinese painting called *jiehua* (architectural painting). The most exquisite workmanship can be seen in the two cranes, which add a literati sensibility to the garden and symbolically promise longevity for the emperor. Nie Chongzheng, a painting expert at the Palace Museum who has written extensively on Castiglione and European influences on Qing painting, feels that only Castiglione could have produced this quality of painting.[54] He believes that in designing the murals for Derexin, Castiglione may have made an extra set (not an uncommon practice in the palace) that was kept in storage and later pasted onto the Juanqinzhai walls. While such a development is plausible, no documentary evidence supports this theory.

In addition to this massive mural, at least two other trompe-l'oeil works graced Juanqinzhai. Looking up to the second floor balcony of the theater space, one can see a charming young woman passing through a door curtain into the corridor, translucent embroidered fan in hand, as if she is peeking out to view the performance of the stage. In the corridor outside her curtain are literati-style paintings, hardwood tables, porcelains and bronzes, and a European clock (figure 28). The woodblock-printed wallpaper in the painting reproduces the actual wallpaper used throughout the building, wonderfully increasing the trompe-l'oeil effect. Seen from below, these painted walls in their perfectly executed perspective expand the sense of the theater's size and introduce a feminine touch to the atmosphere. According to Ruyiguan archives, the north wall of the northeast room of the building also had *tongjinghua* by Wang Youxue.[55] The painting must have deteriorated over time and late Qing palace decorators pasted a large landscape painting in its place.

The archives also note that Wang Youxue was commanded to paint a trompe-l'oeil mural on the large western wall facing the entrance in Yanghe Jingshe in the fourth courtyard. Unfortunately, that mural likewise must have failed in some manner. The trompe l'oeil work now on that wall depicting women and children celebrating New Year festivities stylistically appears to be of a slightly later date. The paintings and calligraphic works in the same room all date from the Jiaqing period, just after the Qianlong emperor's death, suggesting that the extant mural is not by Wang Youxue although it fulfills the original intention of offering a joyous entrance to a space for serious meditation and conveying sincere wishes of fecundity and longevity to the emperor and his dynasty.

A mural in the next room, most likely by Wang Youxue,[56] depicts a quieter scene: a solitary palace woman, greeting an excited child, is emerging from behind a lattice partition into an elegant hall decorated with the same wallpaper, an altar table holding books, an ancient bronze, and blue-and-white flower vases. A landscape painting on the wall is bracketed by narrow vertical paintings of plum blossoms – a clue that the image represents the New Year festival (plate 40 and figure 29). As in the work on the second floor of Juanqinzhai, the painted elements and even the lattice partitions echo and blend with the actual surroundings as illusionary extensions of the room. The unusual installation of the scroll – too long for the low ceiling – with its top end suspended from the ceiling rather than the wall – reinforces the illusion

Figure 27. Ceiling painting of wisteria blossoms on a bamboo trellis from Juanqinzhai.

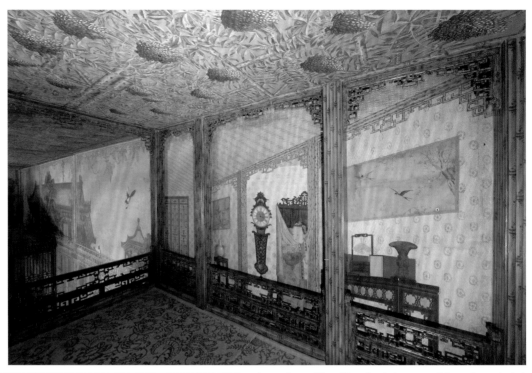

Figure 28. Corridor with wall painting, second floor of Juanqinzhai.

Figure 29. Interior scene (detail of plate 40, cat. 44).

by drawing attention to the dark blue ceiling with gold spotted decorations, identical in color and design to the actual ceiling.

The name of the building, Yanghe Jingshe (Supreme Chamber of Cultivating Harmony), implies a Buddhist orientation, which is reinforced by its *luohan* screen and the Buddhist niche. How then do we make sense of these seemingly secular scenes in a space of worship? The imagery is as auspicious and filial as it is entertaining. Both paintings carry a sense of New Year greetings; the depiction of children suggests the wish for many male heirs. Palace historian Wang Zilin has noted that the woman offering the flower to the child is an auspicious symbol for the Confucian ideal of fecundity.[57]

The artists responsible for this Yanghe Jingshe painting and the paintings within it have not been definitively identified. However, another trompe-l'oeil mural in a building just a short walk through a rockery grotto and through a vase-shaped gateway north of Yanghe Jingshe provides another New Year scene in which artists playfully found reverential ways to record their participation (plate 57).

A bejeweled, opulently dressed palace woman relaxes on a marble-railed couchbed in a richly decorated room while equally splendid children frolic about, playing with tea-making accouterments, flowers in a vase, incense in a brazier, and musical instruments; two of them have run outdoors to pick branches of just opened plum blossoms. The youngest son, perhaps the favorite, is being entertained by the woman and her patient attendant. It is a joyous day in the New Year season. Off to the side of the room, a younger palace girl gazes at her reflection in the sheen of painted lacquer screens.

In the small, rather plain building on the western edge of the fourth courtyard of the garden, Yucuixuan (Bower of Purest Jade), this charming trompe-l'oeil work in the compound boldly greets the visitor. It fills the room with music and sounds of delight. One child is blowing on a *sheng*, a reed instrument that produces high-pitched hums. The palace maiden shakes a double-drummed rattle to amuse the small child on the couchbed. A third child whispers to a servant preparing tea. The boys in the tree outside doubt-less are not controlling their voices, and those arranging the cut branches must be discussing their choices. Only the kneeling child is quiet as he adds incense to the brazier to enhance the aromatic overlay to the scene.

The buzz of activity is an updated, palace-specified variation of the traditional "one-hundred boys" imagery (*baizi tu*) that dates back to at least the Song dynasty. A flourish of children symbolizes the prospect of many male heirs to continue the family line and perform filial duties – an important aspiration in Confucian society. The scene is infused with further auspicious promises, such as the blossoming plum branches being gathered by the boys outside the moon gate, the *ruyi* scepter placed in the ancient bronze on the table, the calligraphic couplet announcing longevity and peace that adorns the wall, and the New Year painting hanging between the calligraphies with personifications of good fortune, prosperity, and longevity. The theme in this central painting depicting three wizened men is also a common motif representing the compatibility of Confucianism, Daoism, and Buddhism, the three great belief systems in China and a philosophical combination that the Qianlong emperor thoroughly advocated and projected within the garden and in his life.

Calligraphy and paintings within the painting add an additional layer of illusion and engagement for the viewer. The lattice partitions, like many in the palace, are inlaid with paintings by palace artists. A total of fifteen inset paintings are visible: two on each door panel (the bottom section depicts a marble or faux-marble inlay); three horizontal works on the lintel above. Additionally, there is the New Year painting above the altar table that is flanked on each side by traditionally located calligraphic couplets. Within the New Year painting, the three men are studying yet another painting – as was not uncommon in this motif.

The seventeen artworks depicted all bear the signature and seal of a palace artist of the Qianlong era; before their names, each added the respectful "chen" character to demonstrate deference to the emperor. The master artist of the painting – or was it the emperor's idea? – invited his colleagues, most of whom were skilled in the orthodox landscape painting popular among

In the central room, within the partition, on the western wall of Yucuixuan in the Tranquility and Longevity Palace, have Wang Youxue and others paint a *xianfa* painting.

宁壽宮玉粹軒明間罩內西牆
着王幼學等画線法画一張

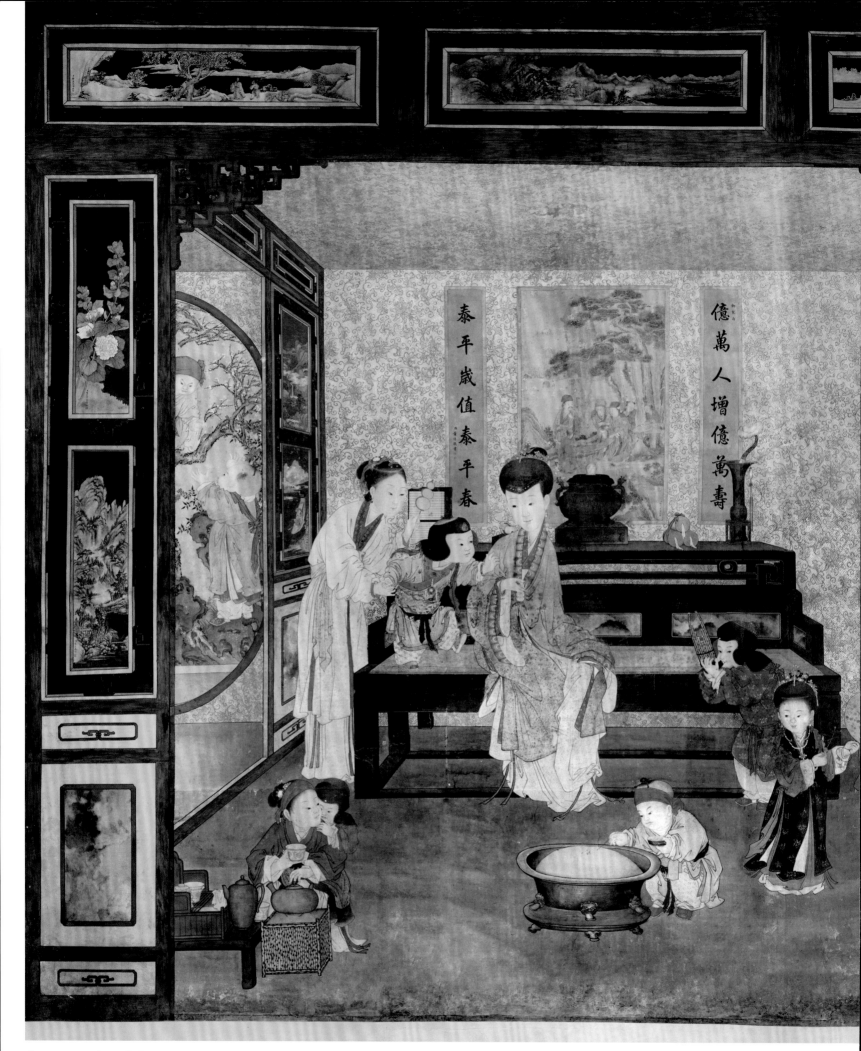

泰平歲值泰平春

億萬人增億萬壽

Plate 57. Yao Wenhan and others, Interior scene (cat. 53).

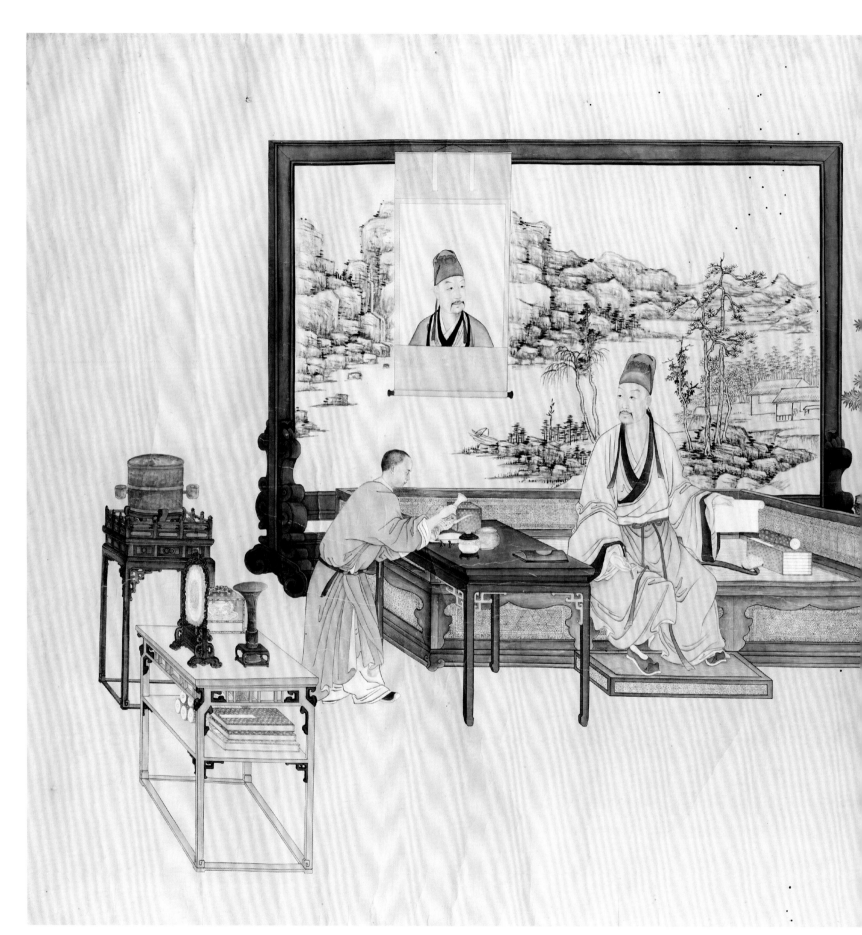

Figure 30. *One or Two?*, 1700s. Ink and colors on paper. Palace Museum.

是一是二不
即不離儒
可墨可何
憲（月）思
那羅延室
題并書

academy artists at the time, to each contribute a miniature composition within the mural. Artist Xie Sui (dates unknown) created a pale landscape with figures in the literati style for a vertical section and a horizontal winter landscape with travelers for the entablature near the ceiling. Jia Quan (dates unknown), recognized for his figures, horses, and landscapes, fluidly delineated a carefree fisherman in his boat playing a flute as he drifts along the water; on a separate panel he painted the immortal Liu Hai, who travels with a three-legged toad that spits gold coins. Fang Cong (dates unknown) was a Zhejiang Province artist who, having entered the imperial atelier in 1751[58] along with his teacher Zhang Zongcang, became highly favored by the Qianlong emperor. He painted a landscape in the archaic blue-green style. Yuan Ying (dates unknown), from Jiangsu Province, entered the atelier in 1765. He contributed a vertical monumental landscape and a horizontal entablature work displaying green mountains and the red trees of autumn. The third entablature composition, a palace on a lake, was painted by the lesser-known artist Huang Nian (dates unknown). In contrast to the restrained literati-style landscapes is a finely detailed, colorful, and lifelike depiction of peonies by Yang Dazhang (dates unknown), famed for his bird and flower works. The peonies are rendered in the challenging *mogu* style that does not utilize inked outlines around the objects. For several works, the signatures are blocked by figures in the composition or otherwise are not visible. These include a painting of fish swimming among reeds, one of sparrows on a branch with red blossoms, and others depicting flowers and butterflies.

These inset paintings were intended to be primarily ornamental in contrast to the more significant painting and calligraphies pasted on the wall above the altar table, by more important artists. The New Year painting of elegant, elderly men unrolling a scroll under towering pines in a mountainous landscape is signed by the respected academy artist Yao Wenhan (dates unknown). A native of the Beijing region, Yao entered the imperial academy in 1743 where he gained a reputation for his figures, religious subjects, and landscapes. Though he assisted Castiglione in one of the first wisteria ceilings in the Forbidden City in 1741, the many other examples of his work still extant and assignments recorded in the archives confirm his expertise in traditional Chinese *gongbi* (meticulous brush) style

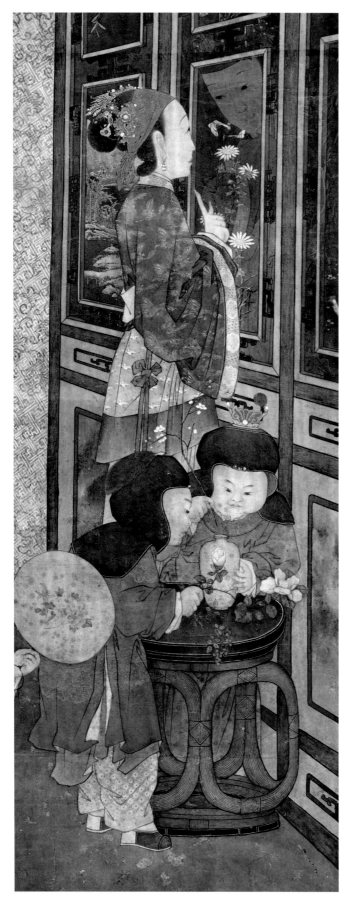

Figure 31. Yao Wenhan and others, Interior scene (detail of plate 57, cat. 53).

painting. Yao's painting is flanked by a couplet composed by the emperor and inscribed in a restrained, calligraphic style by the highly respected government official Dong Gao (1740–1818): "Millions and millions of people bring millions and millions [of years] of longevity; in a peaceful and harmonic time of year; we are in a peaceful and harmonic spring."

Despite all the signatures on this painting, the artist who masterminded the entire composition did not sign it. In fact, none of the large panoramic murals in the garden bears a signature, as they were considered more decoration than works of art. The archives provide some, though confusing, information. There are two notations regarding the Yucuixuan mural, each indicating a different responsible artist. One note, from the tenth day of the third month in the fortieth year of the Qianlong reign, asks that Wang Youxue – whom the emperor had already requested to paint the murals in Juanqinzhai – paint a *xianfa* painting on the west wall in the central room. Seven months later, on the twelfth day of the tenth month of the same year, the request is for Yao Wenhan to do a *tongjinghua* for the same spot. One can only speculate that perhaps Wang Youxue was busy with his many other assignments for the garden and yielded to having Yao Wenhan complete the creation of this rich space within a space. The care with which the complex composition was designed indicates a skilled and inventive artist. Another composition that included paintings within paintings, and multiple portraits of one personage, was painted by Yao Wenhan for the Qianlong emperor at some as yet undetermined date. That painting could be a clue that Yao, already familiar with these visual puzzles requested by the emperor, could have authored this work. His signature on the central New Year painting within the mural may have been his quiet way of announcing his name.

The Ruyiguan archives record that in addition to this mural, the artists Fang Cong, Wei Heling, and Xie Sui were to paint fake doors on the south walls within this same building and Xu Yang, Huang Nian, and Jia Quan were to create paintings to go above them. The space, like most of the buildings' interiors, became covered with paintings pasted to the walls, thus making the room almost indistinguishable from the

painting, and almost an extension of the mural with its multiplicity of paintings.

While the trompe-l'oeil paintings certainly made a deep impression in eighteenth-century China, there were precedents for such visual play in Chinese painting. One of the most entertaining and meaningful examples is a composition depicting a person or people sitting on a couch bed with a large standing screen behind them that displays a painting of people sitting on a couch bed with a screen behind them. In other instances, the screen depicts a landscape and a hanging scroll, draped over the front surface of the screen, with a portrait of the very person sitting on the couch bed. Most of these compositions featuring paintings within a painting – some at least as early as the Song dynasty – are relatively large and there is speculation that they were once pasted on screens themselves, adding an additional layer of illusion.[59]

The Qianlong emperor owned such a painting that he believed was from the Song period, although some contemporary scholars now believe it was early Ming.[60] He was so fascinated by it that over the years he commissioned artists in his atelier, including Yao Wenhan, to create three similar compositions depicting the emperor sitting on a couch bed in front of a wide panel screen displaying a landscape and, on a scroll hanging from the top edge of the screen and overlapping it, a bust portrait once again of the Qianlong emperor (figure 30). Tables and stands displaying a range of precious objects from his collection surround the emperor. His Buddhist-inspired inscription reads: "One or two? My two faces never come together yet are never separate. One can be Confucian, one can be Mohist [philosophical school developed at the same time as Confucianism but with contrary beliefs]. Why should I worry or even think?"[61] As the scholar Wu Hung has noted, the emperor refers to himself in this inscription as Narayana, a Buddhist deity with three faces. With this verbal self-reflection, the complex composition becomes more than pure play and the trompe l'oeil paintings can be understood as far more than mere visual entertainment.

Self-reflection plays a distinct role in the Yucuixuan mural. On the right side of the mural, a beautiful woman seems to stare intently at a painting on the room partition, but in fact she has suddenly noticed her own reflection in the glossy surface of the lacquer-covered partition panels. That the surface is lacquer can be determined by the dark skies, background, and water in all the paintings set into the room partitions. Sky and water are customarily left unpainted in Chinese art, thus allowing the white of the paper to represent those features. The darkness here suggests that these panel works were painted on black lacquer surfaces, much like the gold and silver paintings on the reverse side of the jade luohan screen panels (figure 31). More than a self-absorbed young palace maiden, the woman staring at her reflection in this lacquer surface seems, almost like the Qianlong emperor himself in the painting One or two?, to contemplate the illusion – or the illusion of the illusion – around her. And the mural takes on meaning far deeper than the tricks and technical feats of trompe-l'oeil.

Concluding the Visit

In 1793, while wandering through his garden, the Qianlong emperor stopped in Yucuixuan and composed a poem not about the play of the women and children or the tricks of perception, but about his deeper quest to pursue his inner cultivation within the natural surroundings:

At the foot of the artificial mountain, winding and delicate, the jade-green bamboo sways and swishes. The high wall obstructs the wind. It has the delight of jade. I'm afraid a painting cannot capture its spirit. Inside I cultivate my purity. Do not say it is an empty room.[62]

Like any art form, the Chinese garden is a creation of conscious or unconscious self-expression. Ming and Qing connoisseurs read gardens as reflections of their makers and masters. The Qianlong Garden reveals the wondrous physical realms that the Qianlong emperor bequeathed to the world and articulates a rich perspective on Chinese culture and the potential of garden arts, but it also divulges a broader, more complex, and more intimate understanding of this grand emperor.

Through careful observation of the spaces and structures, and study of the magnificently varied decors, larger philosophical overlays of the emperor's personal aspirations become apparent. In room after room, the designs on the custommade furniture, calligraphic traces, lacquer panels, paintings, texts, and murals loudly convey deep traditional Confucian, literati, and Buddhist attitudes. In the small spaces of the garden, the narrow corridors lined with cracked-ice patterned marquetry of contrasting dark *zitan* and blond *huanghuali* tropical woods, or in the corners of tunnels where an unexpected turn prevents any light from entering, we can hear the echo of this man: a deep appreciation of rocks and ancient trees and all they represent, an inner drive for inner cultivation.

Beyond these more metaphysical journeys, the garden also proclaims this emperor's exuberant personal passion for artistic creation, innovation, and illusions. While an innermost aspect of this ruler yearned to be the *luohan* meditating in a cave, another facet of this man could not be restrained from arranging rocks or colors into aesthetically expressive arrangements – arrangements that would inspire other viewers journeying through his garden.

The Qianlong emperor knew that he had created a unique work – a rich garden following all the classical standards while expanding into worlds and layers of reality never before explored – all within a humble slice of land. Ever craving longevity, he requested that his realm be preserved for future retiring emperors: "These purified rooms, these Buddhist buildings, they are here today, there is no need to destroy them. These palace halls, they should always be as they are today."

Notes

1. From a poem written by the Qianlong emperor and pasted in Fuwangge, 1776.

2. *Qing Gaozong Yuzhi Shi*, 5 ji, juan 69 (Imperial Poems by Gaozong of the Qing, volume 5, scroll 69), 1792.

3. *Qing Gaozong Yuzhi Shi*, 4 ji, juan 85 (Imperial Poems by Gaozong of the Qing, volume 4, scroll 85), 1782.

4. *Qing Gaozong Yuzhi Shi*, 5 ji, juan 62 (Imperial Poems by Gaozong of the Qing, volume 5, scroll 62), 1791.

5. This is according to Wang Zilin as stated in *Zijincheng yuanzhuang yu yuanchuang* (The Forbidden City's Original Appearance and Originality) (Beijing: Zijincheng chubanshe, 2007), p. 275. The painting is not recorded elsewhere.

6. *Qing Gaozong Yuzhi Shi*, 5 ji, juan 51 (Imperial Poems by Gaozong of the Qing, volume 5, scroll 51), 1790.

7. For the sake of some consistency in cross-referencing, the English translations of these names are taken from May Holdsworth, *The Palace of Established Happiness* (Beijing: Forbidden City Publishing Company, 2008), p. 35.

8. Joanna Waley-Cohen, "China, and Western Technology in the Late Eighteenth Century," *American Historical Review* 98, 5 (December 1993), pp. 1525–44.

9. *Qingshi gao*, juan 319, liezhuan 106 (Draft History of the Qing, volume 319, biography 106).

10. *Gongzhong Dang Qianlong Chao Zouzhe, ji* 35 (Palace Memorials of the Qianlong Reign, section 35).

11. Numerous articles have been written about Yangshi Lei in the past couple of years including Geremie Barme, "The Lei Family Builders," *China Heritage Quarterly* 8 (December 2006); Chiu Che Bing, "Yangshi Lei," in Frederic Edelmann, ed., *In the Chinese City: Perspectives on the Transmutations of an Empire* (New York: Actar, 2008), pp. 196–219.

12. *Neiwufu zouxiaodang* (Archives on Imperial Household Expenditure), Qianlong 37 (1772), eighth day of the sixth month (July 8, 1772).

13. Ji Cheng, *The Craft of Gardens*, trans. Alison Hardie (New Haven, Connecticut: Yale University Press, 1988), pp. 104–106.

14. *Neiwufu Zouxiaodang* (Archives on Imperial Household Expenditure), Qianlong 39, first day of the eighth month (September 6, 1774).

15. Reginald Johnston, *Twilight in the Forbidden City* (London: Victor Gollancz Ltd., 1934), pp. 172–73.

16. Jiaqing Emperor (r. 1796–1820), calligraphic inscription pasted in Sanyouxuan, 1811. See plate 38.

17. *Qing Gaozong Yuzhi Shi*, 5 ji, juan 62 (Imperial Poems by Gaozong of the Qing, volume 5, scroll 62), 1792.

18. Palace Museum curators and staff found the two screens and the throne set in the eastern room of Sanyouxuan (Three Friends Bower) during their initial research in preparation for the current restoration process. The presence of such large pieces in the small rooms – they had to be dismantled in order to be removed – seems to confirm that the set was made specifically for the rooms. However, during interviews about the garden with older, retired Palace Museum staff, one man mentioned that he had, many years earlier, brought these "Three Friends set" of screens and throne into the bower because he thought they seemed appropriate there. Whether they were made intentionally for this space, therefore, is still unresolved.

19. These are Yizhai, the cave below Lutai, a shrine room on the second floor of Cuishanglou, the first- and second-floor niches in Yanghe Jingshe, the shrine in the northern section of Yucuixuan, and the second-floor shrines of Juanqinzhai.

20. For a thorough study, see Patricia Ann Berger, *Empire of Emptiness: Buddhist Art and Political Authority in Qing China* (Honolulu: University of Hawaii Press, 2003).

21. *Qing Gaozong Yuzhi Shi*, 5 ji, juan 77 (Imperial Poems by Gaozong of the Qing, volume 5, scroll 77), 1793.

22. According to research provided for the publication by Luo Wenhua, Researcher, History Department, Palace Museum.

23. Ibid.

24. This translation was achieved by consulting translations by Luo Wenhua, Jan Stuart, and Patricia Berger.

25. Berger (p. 61) noted Robert Clark's first discussion on this wordplay.

26. Wu Hung, "Emperor's Masquerade – Costume Portraits of Yongzheng and Qianlong," *Orientations* 26, 7 (July–August 1995), pp. 25–41.

27. According to Luo Wenhua, two are at the Yonghegong Temple, three at the Palace Museum (one each originally at Chengde's Puning Si, Pule Si, and Putuozongcheng, one at the Potala Palace in Lhasa, and one at the Freer Sackler Gallery at the Smithsonian Institution in Washington, D.C.).

28. Even today, abbots in Han Buddhist monasteries sit within a similar curtained enclosure, whose name, *kan*, is the same word for a sculptural niche. Personal documentary description by Raoul Birnbaum, in conversation, October 2008.

29. In the *Neifu Huojidang* (Archives on Imperial Household Handicrafts), Qianlong 40, seventh day of the eleventh month (November 29, 1775), there is a request to the Ruyiguan, the imperial painting academy, to have a hanging scroll created copying "the Buddha portrait by Xie Sui hanging in [the room] *Miaolianhuashe* within Jianfugong," to be hung on the southern wall of Jingchenxinshe (Chamber of Dusting Clean the Heart) "within the *lianhuazhao*."

30. I am grateful to Bruce MacLaren for noticing the Bishu Shanzhuang photograph, and Raoul Birnbaum for pointing out the photograph of the Tibetan niche in Michael Henss, "The Bodhisattva-Emperor: Tibeto-Chinese Portraits of Sacred and Secular Rule in the Qing Dynasty. Part I," *Oriental Art* 47, 3 (2001), p. 13, pl. 14.

31. As noted in the *Zhiyi Didang* (Archives on Imperial Household Department Directives), Qianlong 41, twenty-first day of the eleventh month (December 31, 1776).

32. This information was noted in an inscription on a thirteenth-century handscroll depicting the sixteen *luohan*, now in the Nelson Atkins Museum in Kansas City, by a Qianlong period official who met up with the abbot in 1752. See Wai-kam Ho, Sherman E. Lee, Laurence Sickman, and Marc Wilson, *Eight Dynasties of Chinese Painting* (Cleveland: Cleveland Museum of Art, 1980), p. 88.

33. Richard K. Kent, "Depictions of the Guardians of the Law: Lohan Painting in China," in Marsha Weidner, ed., *Latter Days of the Law* (Lawrence, Kansas: Spencer Museum of Art, University of Kansas, 1994), pp. 183–213.

34. See Berger.

35. Ding Guanpeng's paintings differ slightly from the stone carvings because of their sensitive coloring and the addition of the Tibetan name of each *luohan* at the top center of the work.

36. In the Chester Beatty Library in Dublin. See Nick Pearce, "Images of Guanxiu's Sixteen Luohan in Eighteenth-century China," *Apollo* 501 (November 2003), pp. 25–31

37. Though much of Shengyinsi was destroyed during the Taiping rebellion in the 1860s and the original Guanxiu paintings disappeared, the stones remained. During the twentieth century, they were removed by the local Hangzhou Cultural Relics Administration. They are now on display in the Kongmiao Beilin (Confucius Temple Stele Forest Museum) that opened in Hangzhou in 2009. *Kongmiao Beilin* (Confucius Temple Stele Forest), pp. 270–86.

38. Among the extant carved stones are a set in Beijing embedded into a hexadecagon pagoda imitating the one in Hangzhou, just outside the Forbidden City, within the Chanfusi temple. Another set copying these in Hangzhou was commissioned by a wealthy merchant Li Yimin (1704–1798) for the Huagai'an convent in Guangxi in 1793; they were moved to the Guihai Beilin Museum in Guilin. See *Zhongguo Meishu quanji* (Complete Collected Arts of China) (Beijing: Wenwu Chubanshe, 1988), vol. 19, p. 38 n. 105.

39. Interestingly, records note that a *kesi* tapestry created under the Qianlong emperor also includes the seal script inscription.

40. I am extremely grateful to Luo Wenhua, Historian of Buddhist Art, Palace Museum, for unearthing the documents about Guotai.

41. Dated November 1777.

42. *Qing Gaozong Yuzhi Shi*, 5 ji, juan 43 (Imperial Poems by Gaozong of the Qing, volume 5, scroll 43), 1776.

43. Cao Xueqin, *Story of the Stone*, trans. David Hawkes (New York: Penguin Classics, 1977), p. 232.

44. As quoted in Tim Screech, *The Lens within the Heart: The Western Scientific Gaze and Popular Imagery in Later Edo*

Japan (Honolulu: University of Hawaii Press, 2002).

45. *Neiwufu Huojidang* (Archives on Imperial Household Handicrafts), Qianlong 39, twenty-second day of the tenth month (November 25, 1774), directive to the Ruyiguan.

46. Ignatius Sichelbart was invited to create the perspective layout for the mural inside the east side hall of Suichutang, and then Wang Youxue would paint it. See *Neiwufu Huojidang* (Archives on Imperial Household Handicrafts), Qianlong 39, twenty-third day of the second month (April 3, 1774) and Qianlong 41, eighteenth day of the eleventh month (December 28, 1776).

47. Wang Zilin, *Zijincheng yuanzhuang yu yuanchuang* (The Forbidden City's Original Appearance and Originality) (Beijing: Zijincheng chubanshe, 2007), p. 104. As recorded in *Zaobanchu huojidang* (Archives of the Imperial Palace Workshop), Qianlong 1, fifteenth day of the eleventh month (December 16, 1736).

48. For a longer discussion on this work, see Nie Chongzheng, "Zai Tan Lang Shining de 'Ping An Chun Xin tu' Zhou" ("Speaking again of Castiglione's Scroll 'Spring's Message of Peace'"), *Zijincheng Magazine* 162 (July 2008), pp. 162–73. Nie believes the work in Yangxindian is also by Castiglione.

49. See George Loehr, "Missionary-Artists at the Manchu Court," *Transactions of the Oriental Ceramic Society* 34 (1962–63), pp. 51–67.

50. Ibid., p. 61, in reference to a letter from Jartoux to Fountaney, Peking, August 20, 1704, in *Lettres edifiantes et curieuses concernant; 'Asie, 'Afrique et l'Amérique* (Paris: Société du Panthéon Litteraire, 1843), vol. 3, p. 143.

51. Yao Yuanzhi, *Zhu Ye Ting Zaji* (Bamboo Leaf Pavilion Miscellaneous Notes), juan 3, available online at http://www.ourjg.com/bbs/dv_rss.asp?s=xsl&boardid=22&id=3524&page=8&star=1&count=3.

52. Zou Yigui, *Xiaoshan Huapu* (published circa 1756), chapter ii, folio 19. Chinese text is available online at http://www.esgweb.net/Article/Class138/Class161/Class165/200710/26150_2.htm. English translation from John C. Ferguson, *Chinese Painting* (Chicago: University of Chicago, 1927), pp. 182–83.

53. The twenty-page manuscript by Amiot is at the Bibliothèque Nationale, Paris, in the catalogue of Fonds Brequigny. The translation is from George Loehr, "The Sinicization of Missionary Artists and Their Works at the Manchu Court During the Eighteenth Century," *Cahiers d'histoire Mondiale* 8 (1963), pp. 795–803.

54. Conversation with Nie Chongzheng, September 2008.

55. *Neiwufu Huojidang* (Archives on Imperial Household Handicrafts) Qianlong 40, eighteenth day of the eleventh month (January 8, 1776).

56. Ibid., Qianlong 40, ninth day of the eleventh month (December 30, 1775) directs Wang Youxue to create perspective paintings in Fuwangge and Zhuanjiaolou (later named Yanghe Jingshe).

57. Conversation with Wang Zilin, October 2009.

58. Zhang was invited to join the atelier after the Qianlong emperor was presented with his work while traveling in the south.

59. See Wu Hung, *The Double Screen: Medium and Representation in Chinese Painting* (Chicago: University of Chicago Press, 1996); and Berger, pp. 51–53.

60. Berger, p. 53.

61. Translation from Wu Hung, pp. 233–35.

62. *Qing Gaozong Yuzhi Shi*, 5 ji, juan 77 (Imperial Poems by Gaozong of the Qing, volume 5, scroll 77), 1793.

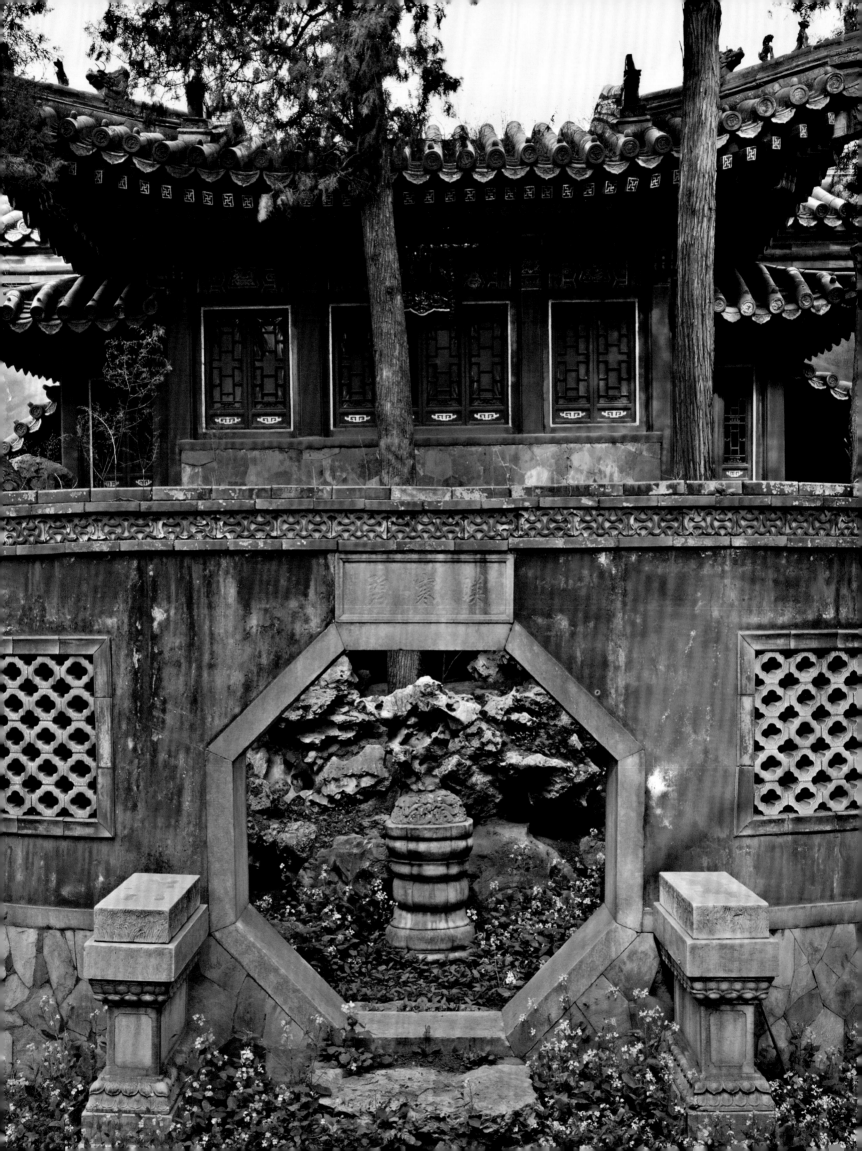

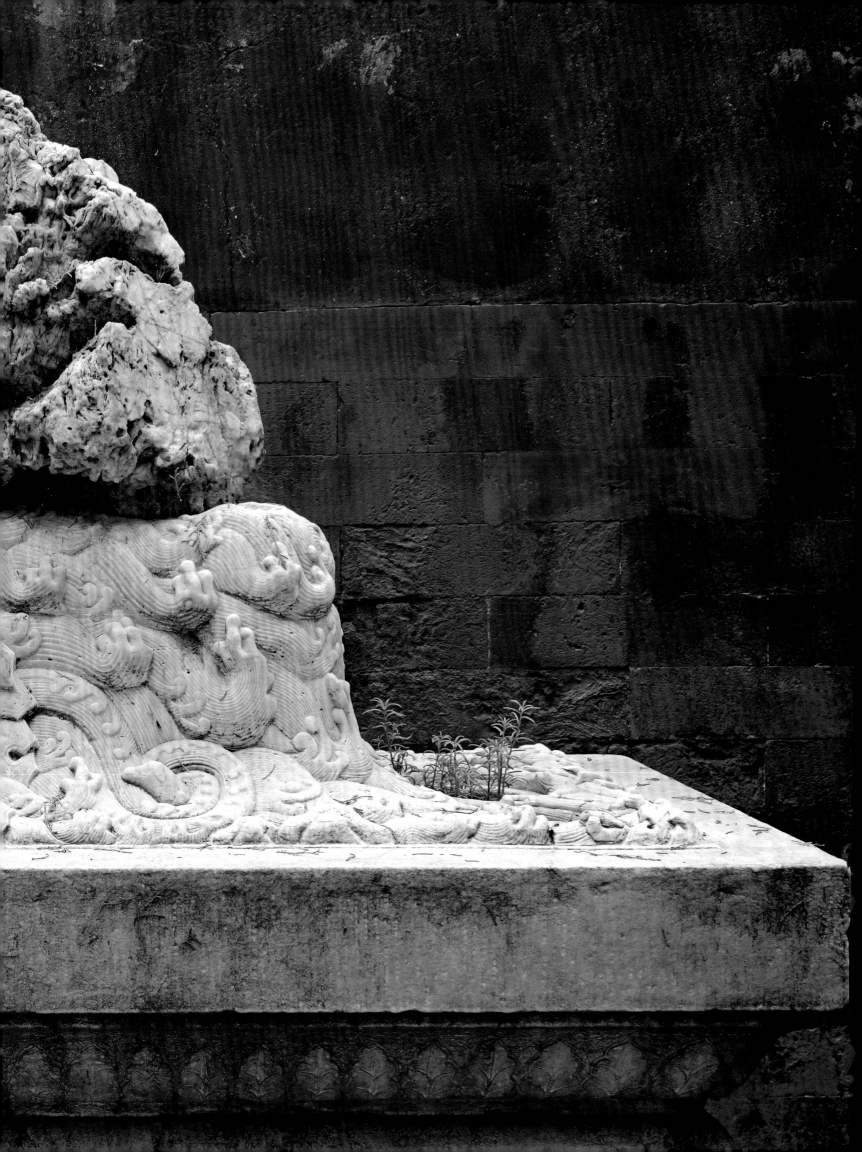

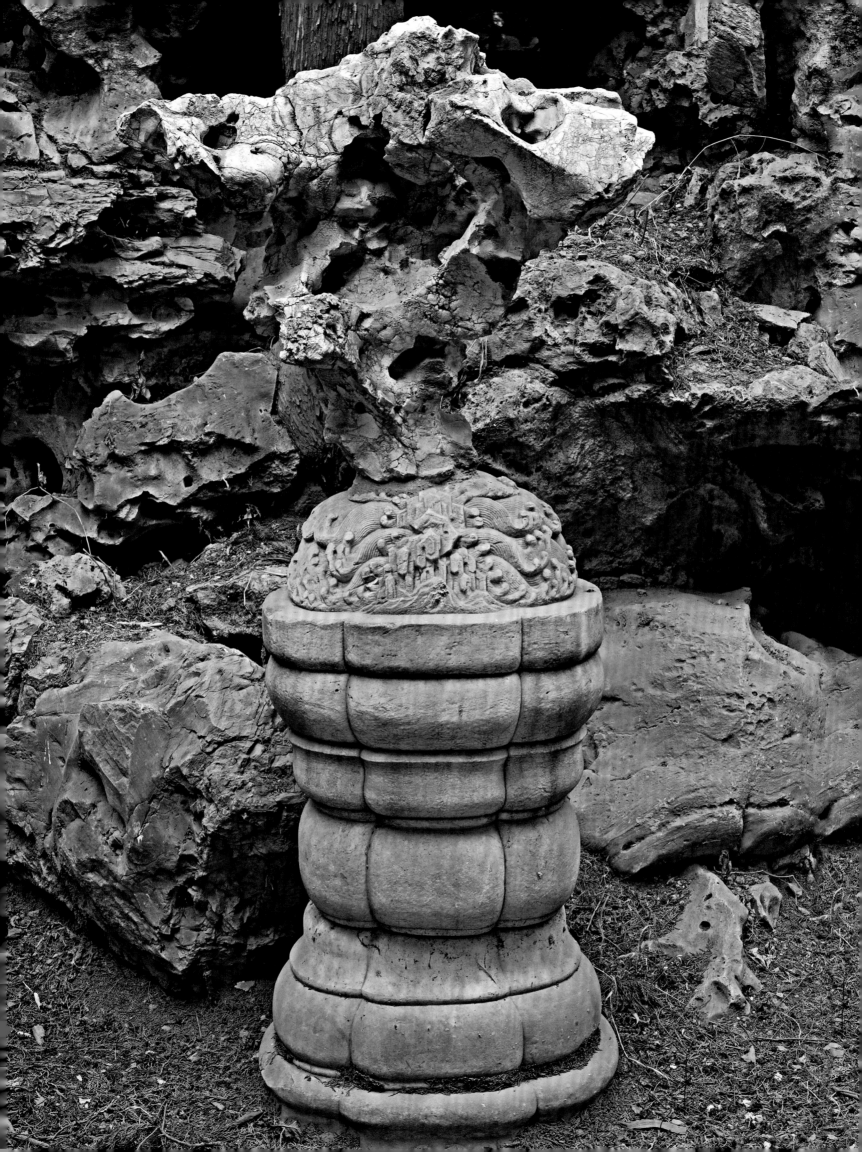

Coda: The Survival and Revival of the Emperor's Vision

皇
帝
願
景
的
存
續
和
復
興

Liu Chang

Yuan Hongqi

Henry Tzu Ng

The Qianlong Garden is prized today because it has survived relatively intact in terms of its original design, layout, construction, and materials (figure 1 and plate 58). This is unusual in a place like the Forbidden City where successive rulers routinely altered buildings, courtyards, and interiors during their reign. The garden is also a treasure trove of imperial Chinese craftsmanship, materials, and techniques at their zenith, many of which have long since disappeared or are no longer easily available in modern China. The high quality of the materials and techniques shaped a conservation and interpretation approach that was developed by the Palace Museum and World Monuments Fund for the conservation of the site. The goal is to respect the history of the garden and preserve as much of the original vision as possible.

The Qianlong Garden from 1799 to 1924

The Qianlong emperor died shortly after the New Year in 1799, at the age of eighty-eight. He was buried in a magnificent tomb east of Beijing close to where his grandfather the Kangxi emperor was also buried, and as might have been expected, he himself had decided on the location and design of the tomb and supervised its construction.

The emperor left behind an enormous amount of the material culture that today is in museums and collections around the world. He was a master builder of sorts – be it of exquisite delicate objects, art and literature, palaces and temples, or of an empire. He also loved and built gardens, but of the many that he created and prized during his lifetime, only the Qianlong Garden survives in its original form. Of his beloved garden palaces and estates, the Yuanmingyuan, or the garden of gardens, originally founded by his father, in the outskirts of Beijing, was destroyed by the English and French invasions in 1860; the Jianfugong Garden in the northwest section of the Forbidden City was totally leveled by a fire in 1923; and other gardens such as the Yiheyuan (now commonly called the Summer Palace) were renovated by his successors.

Perhaps the Qianlong Garden survived because of its intimate scale, or because it was tucked away in the Ningshougong retirement district that was protected by the Qianlong emperor's edict stating that the use of this area was never to change. In the more than two hundred years since his death, the garden has witnessed important historic events.

These include the house arrest of the Guangxu emperor (1898), the forced abdication of the last emperor, Puyi (1911), and the transport of Palace Museum cultural objects to the South because of the threat from the Japanese during the Second Sino-Japanese War beginning in 1933, and then to Taiwan in 1948 during the Chinese Civil War.

Routine exterior maintenance of the structures over the years did not involve modifications, but there were some changes among the furnishings, with a few things added and many removed. Changes in the furnishing of halls would have been expected over two centuries as successive emperors left traces of their activities. Calligraphy, paintings, and *tieluo* (paintings and calligraphy adhered to the walls) of emperors such as Jiaqing (r. 1796–1820) and Daoguang (r. 1821–50), or of senior officials, were mounted and left on the walls. New wallpaper – variations on the original green and white designs – was pasted over the old at periodic intervals.

The Nineteenth Century

Records in the *Register of Furnishings* of various halls in the Qianlong Garden dating to 1814, 1837, and 1897 indicate that many pieces of furniture, literary curios, and books were removed. The 1897 *Register of Furnishings for Juanqinzhai* denotes objects in this northernmost building of the garden as either "verified" or "presently installed." A comparison with the *Register of Furnishings for Juanqinzhai* of 1802 clarifies that "verified" refers to furnishings still in place from the Qianlong and Jiaqing periods. "Presently installed" refers to objects added during the Guangxu period.

One reason for changing displays was the need to replace perishable objects such as wood furniture, silks, and wool blankets that had deteriorated over time. Even works in porcelain and jade suffered degrees of damage. In addition, the various emperors used the imperial halls of the Qianlong Garden differently, rearranging seating and installations according to their lifestyle, and moving objects they were fond of back and forth. The handwritten *Register of Furnishings for the Three Friends Bower* records the arrivals of new objects to the space during the Guangxu period:

No. 111 (received), lacquer armrest for writing, inlaid with mother-of-pearl. One pair. (Installed on the order of Chen Taihe, Palace Eunuch from the Office of Respectful

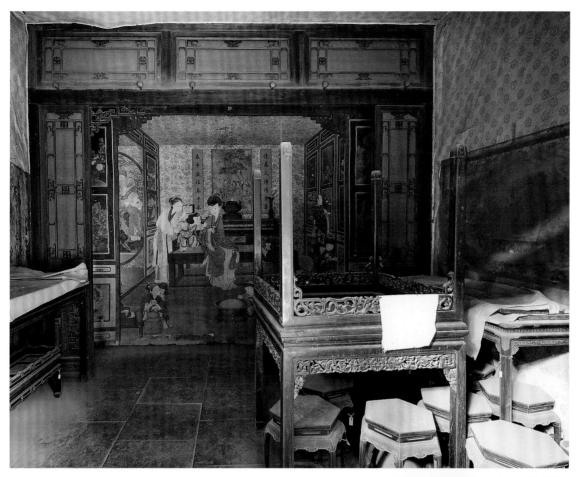

Figure 1. Yucuixuan before conservation with stools and other furniture, 2006.

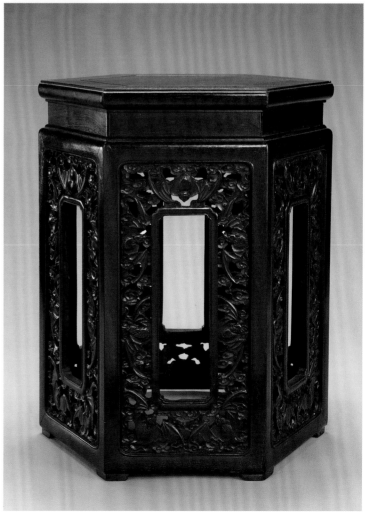

Pages 195–98. Gateway to Zhuxiangguan; stone on carved marble pedestal just north of Xiefangting; Taihu rock on a marble pedestal at the entrance to Zhuxiangguan. Pages 194 and 199, Panel (hanging) (cat. 23, detail).

Plate 58. Stool (cat. 29, one of a pair).

Service, and others, on the twenty-second day, third month, 1871.)

No. 131 (received), calabash jar with lid. One. Has a cracked red sandalwood base. (This one calabash is respectfully inventoried as being transferred for installation by imperial edict on the second day, second month, 1852.)

No. 158 (received), patterned azure jade container with symmetrical handle and eight auspicious markings, with lid. One. (Height with lid, four cun. Affixed with silk braids. A red sandalwood base, type C. This item is inventoried as being ordered immediately transferred and installed by the verbal order of Zhang Dexi, Supervisor-in-Chief, on the twenty-third day, ninth month, 1874.)

No. 216, imperially compiled Spring and Autumn Annals and Zuo Commentary. One set. Four cases. (These items are inventoried as being ordered immediately transferred and installed by the verbal order of Mao Qindian and Liu Zhian on the tenth day, third month, 1880.)[1]

The Empress Dowager Cixi

The Empress Dowager Cixi (1835–1908), mother of the Tongzhi emperor (r. 1861–1875), appropriately resided for a time in the Ningshougong during the reign of her adopted son and nephew the Guangxu emperor (r. 1875–1908), beginning about 1894 when she turned sixty years of age. She lived in Leshoutang (Hall of Joyful Longevity), having free access to the Qianlong Garden. She repaired and restored the complex at the time for a large birthday banquet she organized for herself there. Archives detailing room inventories for buildings in the garden along with redecorating elements clearly indicate that some cosmetic changes occurred in the buildings just prior to the end of imperial rule.

One example concerned the first floor of the towering Fuwangge, the tallest building in the garden, where numerous lattice partitions frame thrones on all four sides of the space. The silk paintings and calligraphies now inset within the lattices are later replacements for Qianlong-period works that would have deteriorated over a century of exposure, although they reflect the originally intended appearance. For instance, on the east-facing set of zitan-and-cloisonné partitions are four works – two calligraphies and two paintings on each of the side panels – and another three – two paintings with a central calligraphic work – across the top entablature (figures 2 and 3).

Research has established that these were done by court artists during the last decade of the nine-teenth century, most probably for the empress dowager's birthday celebrations.

More common than newly installed objects were the many instances when the Empress Dowager Cixi removed items to use in the eastern part of the Ningshougong. It was there that she administered state affairs from behind the scenes as well as attended operas and met friends and relatives during the Tongzhi and Guangxu periods of the late Qing. The archives detail that on the sixth day of the tenth month, 1874, the following objects were removed from the Three Friends Bower:

No. 305 (received), white jade flat vase with a pair of dragons and lid. One. (Height with lid, seven cun. Base made of red sandalwood and silk cord. This item was ordered installed in the eastern section by Zhang Dexi, Supervisor-in-Chief, on the sixth day, tenth month, 1874.)

No. 341 (received), round plantain leaf jar. One. (Mouth diameter, seven cun, one fen. Red sandalwood base, type B. This item was ordered installed in the eastern section by Zhang Dexi, Supervisor-in-Chief.)

No. 497 (received), azure white jade incense burner with dual dragon handle. One. (Length including handle, one chi. "Qianlong era faux antique style" carved on bottom. Red sandalwood lid and base, jade cover, type A. This item was ordered installed in the eastern section by Zhang Dexi, Supervisor-in-Chief.)

No. 550 (received), azure white jade chalice with infant design. One. (Height, four cun, nine fen. Has a silk braid and a red sandalwood base. This item was ordered installed in the eastern section by Zhang Dexi, Supervior-in-Chief.)

No. 570 (received), azure white brush holder. One. (Height, five cun. Has a red sandalwood base with silk braid. This item was ordered installed in the eastern section by Zhang Dexi, Supervisor-in-Chief.)[2]

In addition to the movement of objects narrated in the imperial household records, the process of conservation has provided additional information regarding the history of interior maintenance during the Qing dynasty. Patterned wallpaper, for example, has been mounted

Figure 2. Inset painting from partitions (detail of plate 23, cat

Figure 3. Inset painting from partitions (detail of plate 23, cat

柿陰成列藥
花空却憶桐
江下釣筒亦
以魚蝦供熟
鷺近緣櫻筍
識鄰翁閒分
酒劑多還少
自記書籤白
間紅更愛夜

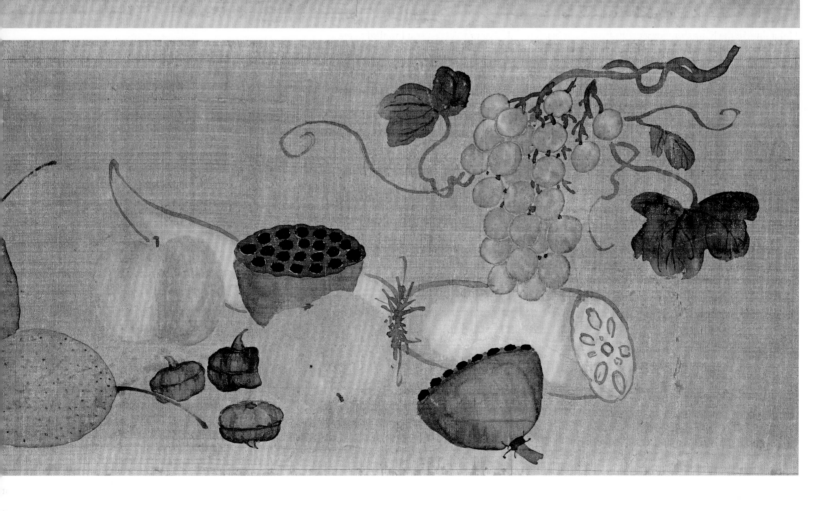

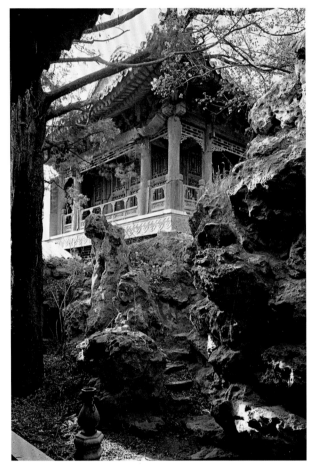

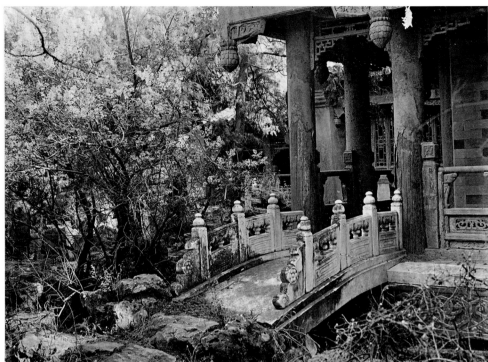

解放后经修缮建北洛红章

解放前姞亭玻璃之状说
（乾隆花园）

近一沱苔遮网，用軍話连还

Top, Figure 4. Hedda Morrison (1908–1991), *Bridge Leading to Yunguanglou*, 1933–46.
Gelatin silver print, 3 1/4 x 4 1/2 inches (8 x 11.5 cm). Hedda Morrison Collection,
Harvard-Yenching Library, Harvard University.

Left, Figure 5. Hedda Morrison (1908–1991), *Upper Gallery of Yanqulou and Rock Hill*, 1933–46.
Gelatin silver print, 5 1/4 x 3 3/4 inches (13.5 x 9.5 cm). Hedda Morrison Collection,
Harvard-Yenching Library, Harvard University.

Right, Figure 6. Album page with photographs of the roof from Juting before and after
restoration, circa 1950. Phillips Library, Peabody Essex Museum.

repeatedly without removing or thoroughly removing the previous work. Five applications exist in most of the Fuwangge rooms, and at least seven generations of wallpaper have been found on the ground floor.

The Last Emperor, Puyi

During the years following the empress dowager's death, the limited imperial treasury funds were probably not allocated toward maintenance of the garden. When the American author Juliet Bredon visited in the years before 1919, she found the garden already in an uncared-for state:

What a quiet, restful, shadowy retreat is this old garden with its moon doors, its mosaic walls of different coloured marbles, and its surrounding temples to which time seems to have given a velvet quality! Here and there falling plaster drips to the ground like blood from a fatal wound, and many a pillar is bent like an old man carrying a heavy load of invisible memories.[3]

Significant changes to the furnishings of the buildings' interiors seem to have taken place in these last years of the Qing and the early Republican periods. Following the revolutionary overthrow of the imperial system in 1911, Puyi, the last Qing emperor, relinquished the throne. He lived in the rear half of the Forbidden City and treated some collectibles and furnishings as his private property. During this time, many objects from the palace and garden vanished.

The Modern History of the Garden from 1924 to 2001

Puyi was expelled from the Forbidden City in 1924 and the Palace Museum was formally established by the Republican government in 1925. Over the following years, vast areas of the former imperial complex were opened to the public, with a focus on the main buildings on the central axis. Courtyards and palaces on the main axis were increasingly converted into exhibition and visitor spaces. Parts of the Ningshougong retirement district were also opened to the public. Perhaps because its intimate scale would not accommodate large numbers of tourists, the Qianlong Garden was basically left alone and access was relatively limited.

A map in a guidebook published in 1935, *In Search of Old Peking*, seems to indicate that only the fourth courtyard, if that, was open to the public. The author, L. C. Arlington, described the area as having "numerous rockeries with small kiosks planted on the top and surrounded by a maze of small, and now dilapidated buildings."[4]

The inattention to maintenance and the loss of objects from the buildings' interiors in the early years of the Republic era was attested to by a visit to the site in the later 1930s by the American scholar George Kates and German photographer Hedda Morrison. They were able, after many requests to the authorities, to gain access to a part of the garden. The initial refusals noted that the site was "so overgrown that it literally could not be shown." When they finally did enter, it was apparent that a great deal of clearing away of plant matter had indeed been done for their visit (figures 4 and 5).

Nothing had ever been restored, nothing, obviously, put back into order; this we could see under the thick dust everywhere, as we hastened to look through traceried doors and windows, long without their usual paper. . . . Paint was everywhere cracked and peeling, and lacquer disintegrating. . . . The charm of such an extended setting, untampered with, made us accept this ruin easily. Yet we saw so many places from which objects, probably all precious, must have been summarily carted away, and we could observe that originally there must have been such numbers of them.[5]

In the 1950s, after the establishment of the People's Republic of China, the public was reportedly allowed for a time to walk through the four courtyards of the garden. Photographs taken by Palace Museum personnel during this period reveal the toll time had taken in the garden in the previous decades and the post-liberation efforts to clear the overgrowth and repair the buildings' exteriors (figure 6). The prominent artist and new president of the Central Academy of Art, Xu Beihong (1895–1953), must have visited during these years when the garden had just been reopened. He painted a work in oils depicting Xishangting in the first courtyard of the garden. Access to all the courtyards was short-lived, however, because the concentrated rockeries and grottos in the third and fourth courtyards restricted visibility and posed security problems. The interiors of the buildings, although well known in artistic and scholarly circles, were never opened due to their fragility.

I have conscientiously constructed the Tranquility and Longevity Palace. I will use it for my exhaustion from diligent service.

洁
治
宁
壽
宮
聊
以
備
倦
勤

After the 1950s, the garden with its exquisite interiors in a state of great disrepair, remained dormant until the beginning of the twenty-first century. The neglect was not willful, but a result of the fact that modern China was undergoing enormous societal, economic, and political changes and there was a lack of financial resources at all levels of society.

As China embraced the economic reforms beginning in 1979 and reentered the world arenas of business, diplomacy, science, and other areas of society including sports, arts, and education, it often turned to foreign sources for ideas to introduce and test in the Chinese environment. The large-scale international cooperation that was organized with the World Monuments Fund to conserve the Qianlong Garden is an outgrowth of China's expanded global perspective: to identify and use the best international conservation approaches for the restoration of the garden and its priceless interiors.

Conservation of the Qianlong Garden: Traditional Craftsmanship and Scientific Methods
The joint project by the Palace Museum and the World Monuments Fund to conserve the Qianlong Garden began in 2001. The WMF is an international historic preservation organization founded in 1965 that brings technical and financial assistance to significant conservation projects worldwide. It will take over a decade and a half to resolve many of the challenges of the garden, such as repairing the rockeries and structures, restoring the horticulture, and conserving the interior screens and furniture (figures 7 and 8).

A master plan, developed in 2005 and updated in 2009, covers conservation principles and guidelines, surveys, assessments, and proposed remedies. The plan was developed over the course of a year during many key planning meetings between the World Monuments Fund, the Palace Museum, and many outside experts. Given the importance of the site and the high visibility of any conservation project in the Forbidden City, the approach complies with the highest international and local charters and standards. The plan was then vetted by conservation specialists and approved by China's State Administration for Cultural Heritage before any physical work could begin on the site. The plan emphasizes careful

research and planning, beginning with material and technique examination, damage/risk assessment, development of implementation plans, and then conservation treatment. The process not only addresses modern scientific solutions but also envisages restoration of methods and traditions now on the edge of extinction. In this regard, the elaborate screens and furniture present the greatest challenges. The work began with the preliminary pilot project to conserve Juanqinzhai, the building with the unique theater pavilion, which was completed in 2008.[6]

The Approach: A Marriage of Science and Craft
The high quality of the original design and construction and its unique survival framed the central, two-fold, conservation challenge: first, how to develop an approach and methodologies to conserve a complex of historic buildings and interiors when much of the craftsmanship and materials used 230 years earlier was no longer readily available; and second, how to marry traditional Chinese craftsmanship with modern conservation science and approaches. The four overall goals for the project include:

Site Conservation: to conserve and maintain the Qianlong Garden, its design and layout, contents, documentations and history, and restore it to its proper place as one of the most beautiful and significant sites within the Forbidden City, the largest imperial complex that survives in the world.

New Scholarship: to contribute to new scholarship about the garden's origins, the private lives of emperors, its moment in imperial and Chinese history, architecture and interior design; and to foster research into specific artistic treasures such as paintings, trompe l'oeil murals, calligraphy, and poetry that have not been available to scholars because of the garden's inaccessibility and state of disrepair. The audience for this new research includes conservation specialists, scholars, students, and members of the public.

Living Heritage: to use the conservation program to revive traditional Chinese materials and craftsmanship that were used in its construction and that are that are no longer readily available in China and are in danger of being lost, and to augment these skills with modern conservation science and methods.

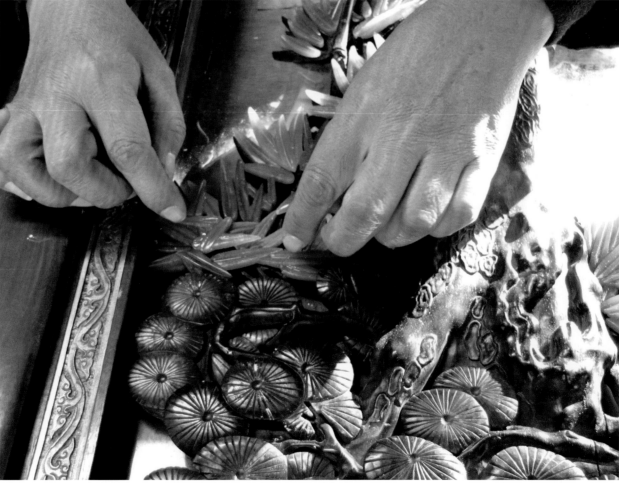

Figure 7. Palace Museum Conservator Yang Zehua working on the wisteria ceiling painting from Juanqinzhai.

Figure 8. Conservation of glass and jade throne (plate 33, cat. 35).

Figure 9. Paste decoration on gauze in Fuwangge before conservation.

International Conservation: to use the conservation of the garden as a learning laboratory for technical exchange on best practices for Chinese and international conservation and interpretation specialists.

Traditional Craftsmanship

Meeting the first challenge required reaching out and building relationships within China's traditional artisan community countrywide. The Palace Museum was crucial in this effort: it possesses encyclopedic collections of Chinese artifacts and a well-staffed conservation department with individual studios specializing in archaeological works, paintings, decorative arts, and imperial architecture. Although the staff has had a great deal of experience during their decades of conserving and restoring objects similar to those in the Qianlong Garden, some of the exotic materials and techniques championed by the Qianlong emperor presented new challenges. Assistance has thus been sought within China and beyond.

One telling example that reveals how particular the Qianlong emperor was in regard to the decorative touches in the garden is a type of textile surface decoration that looks like intricate embroidery traceries. It was used on screen partitions inside Fuwangge and also appears in other buildings in the garden. Samples taken from Fuwangge, however, suggest that the decoration may not be embroidery but a unique fine paste decoration applied on top of the loose woven silk (figure 9). Painted on the swirling paste lines are even finer and contrasting metallic decorations of gold, silver, and copper powders. The design is surprisingly subtle and intricate, especially considering the narrowness of the paste lines. Further analysis and exploration of surviving crafts will contribute to a new understanding of this lost technique. It is but one example of the challenges posed by the emperor's garden that require research, highly trained conservation specialists, and the identification and replication of historical techniques.

Living traditions of crafts are highly valued as the first primary resource when the conservators encounter unfamiliar techniques or materials. During the pilot project for Juanqinzhai, the Palace Museum discovered master craftsman He Fuli from Dongyang, Zhejiang Province, who had expertise in the making, dyeing, and marquetry

of bamboo thread (figure 10) and in the carving of the inner skin of bamboo. When Master He observed the decorative wainscotings inside Juanqinzhai, he was able to distinguish four different types of artistic techniques, including bamboo thread marquetry, bamboo inner-skin carving, boxwood carving, and the slicing of the bamboo culm on a slant to produce a hairy texture for the deer's fur. The master had never seen these techniques applied on one piece of work and they would have not been detected if he had not pointed them out.

The project also used the services of Yu Yifu, a paper maker from Qianshan County in Anhui Province who was just about to close down his business because of insufficient orders. His production of papers for relining the mural that were traditional but could also meet modern conservation standards was an indispensable contribution. The quality of the work of the master craftsmen who helped in the conservation of Juanqinzhai very often exceeded expectations. In addition, the artisans brought to the project a perspective about the materials that profoundly impacted the understanding of the objects being conserved.

Modern Scientific Approaches and Techniques

Meeting the second challenge of applying modern conservation approaches and scientific techniques required the World Monuments Fund and the Palace Museum to build partnerships with international resources, largely with institutions and experts in the United States. The Smithsonian Institution's Smithsonian Center for Materials Research and Education, and the Getty Conservation Institute (GCI), with Shin Maekawa, who has expertise in the acclimatization of historic wood structures, provided the basis for the installation of a climate control system in Juanqinzhai, the first historic building in the Forbidden City to have a modern system designed to protect the interiors. This served as the catalyst for the creation of a preventive conservation department at the Palace Museum. Nancy Berliner, the Curator of Chinese Art at the Peabody Essex Museum in Salem, Massachusetts, joined the team to help address issues of presentation and public accessibility posed by the intimately scaled rooms and fragile interiors in the Qianlong Garden. T. K. McClintock of Cambridge, Massachusetts,

Figure 10. Bamboo marquetry on throne (detail of plate 27, cat. 36).

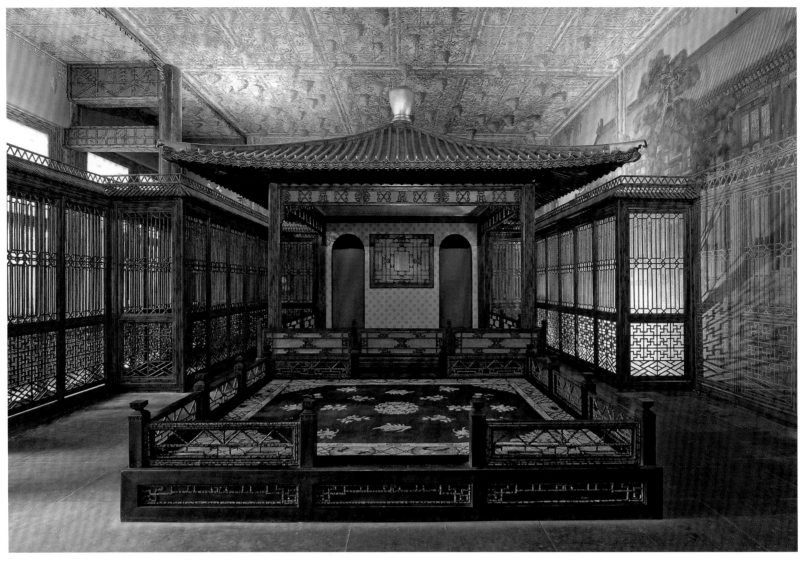

Figure 11. Theater in Juanqinzhai after restoration.

an expert in the conservation of paper and silk works of art, and materials analyst Susan Buck from the University of Delaware, also joined the team to help develop understanding and better techniques for conserving the fragile and unusual materials in Juanqinzhai.

The scientific methods were conducted jointly by conservation experts in China and the United States. The research and analysis phase of the project relied on data from many sources: laboratory instruments such as optic microscope and Scanning Electron Microscopy-Energy Dispersive Spectroscopy (SEM-EDS); X-ray Fluorescence (XRF); Fourier Transform Infrared (FT-IR) Microspectroscopy; and Gas Chromatography-Mass Spectrometry (GC-MS). These were used to identify materials and to view microstructure that would help to reveal technique and sequence.

While masters of traditional artistry can often be the best guarantee of quality, scientific methods can, in a complementary way, provide conservators with high precision on how to proceed and the level of conservation to be implemented. Thus, a training program that employs the expertise of both master craftsmen and conservation scientists has become a highly desirable and important new component of the conservation program for the Qianlong Garden. The immediate beneficiary of the training program will be the garden itself, but the outcome of this marriage is expected to have a profound long-term impact on heritage preservation in China and worldwide.

Preventive Conservation: Improving the Interior Environment

It is useful to know that the Imperial Household Archives noted that the bamboo-thread marquetry

had partly failed in the 1770s soon after these screens made in the South arrived in Beijing under the order of the Qianlong emperor. This was also true of the attachment of the large silk trompe l'oeil murals in the theater in Juanqinzhai. It is also important to keep in mind that it was the emperor's idea to apply lacquer on a number of large screen panels that were exposed to daily wear, even though this exposure sacrificed some of the original bright effects of lacquer.

While employing materials of different sensitivities to various environmental factors was not of concern to the Qianlong emperor, today it is an inevitable issue for the conservators working on the garden. Organic materials, such as wood, paper, and hide glue, can degrade from biological, chemical, and mechanical processes. This in turn can cause further mechanical problems in adjacent inorganic materials. Rates of degradation are related to both temperature and relative humidity. Some materials, such as lacquer and silk, are also sensitive to ultraviolet light.

Control of the micro-environment of every single object made of a special substance is neither possible nor necessary. As Marion Mecklenburg from the Smithsonian Center for Materials Research and Education observed, in conservation, understanding why an object survives is no less important than understanding why it fails. This best illustrates the comprehensiveness of the science: tearing a cultural fabric apart into its elements in the name of preservation may be nothing but a shortcut to exterminating the essence of an object that one originally wanted to save.

Internal environmental control principles were established with the help of scientists and conservators in China and the United States to protect the many materials represented in the Qianlong Garden once they are restored. These include allowing natural yearly fluctuations of temperature and relative humidity; avoiding sudden changes and extreme climatic influences on the interior objects by improved sealing of the building envelope and adding air handlers when environmental standards cannot be reached otherwise; and minimizing unnecessary exposure to daylight. Conservators and engineers will work on the location of air handlers and on all other details, but the data collected inside and outside the twenty-seven buildings in the garden will determine the environmental systems designed for the complex.

Conclusion

The international cooperation that has been established for the conservation of the Qianlong Garden might be considered the bookend to the history of this site. When the Qianlong emperor created the garden, China was the world's largest and richest nation, and was engaged in extensive interactions with Europe and America in trade, politics, aesthetics, and ideas. The emperor made use of the best available materials, artisans and ideas for his garden – both from within China and from abroad – to create sumptuous and elegant interiors that represented the pinnacle of Chinese design and decorative arts at the time.

While the impact of Chinese art and architecture on European art of this period is well known, Juanqinzhai and other interiors of the garden reveal that this influence was reciprocal. The large-scale trompe l'oeil paintings and wall coverings in a number of the garden's buildings were influenced by Giuseppe Castiglione, a Jesuit missionary and painter who settled in China around 1730. The large trompe l'oeil silk murals, which incorporate European methods of perspective and chiaroscuro, are some of the very few surviving examples of their genre not only in the Forbidden City but in all of China. The emperor also built himself a glass-paneled throne, with glass that he imported from Europe, as plate glass was a relatively new material in China.

It is fitting, then, that its restoration more than 230 years later comes at a time when China is once again fully engaged with the international community, which is visiting China in ever increasing numbers. But when he built his garden, the Qianlong emperor never envisioned it as having a public life, or having many regular guests. Unlike so many of the other grand imperial Chinese constructions that were built either to impress or to house timeless rituals, the Qianlong Garden was built for private enchantment. When modern-day guests eventually visit the garden, they will enter a place where few people have ventured – the most beautiful place in the world that the emperor of China envisioned to spend the rest of his life: The Emperor's Private Paradise (figure 11).

Notes

1. *Sanyouxuan Chenshedang*, Sanyouxuan Register of Furnishings, Guangxu period.
2. Ibid.
3. Juliet Bredon, *Peking* (Shanghai: Kelly and Walsh, 1931), p. 99.
4. L. C. Arlington, *In Search of Old Peking* (Peking: Henri Vetch, 1935), pp. 53–54.
5. George Norbert Kates, *The Years That Were Fat* (Cambridge, Massachusetts: MIT Press, 1976), pp. 122–25. Originally published by Harper and Brothers in 1952.
6. Nancy Berliner, ed., *Juanqinzhai, in the Qianlong Garden, The Forbidden City, Beijing* (London: Scala Publishers, 2008).

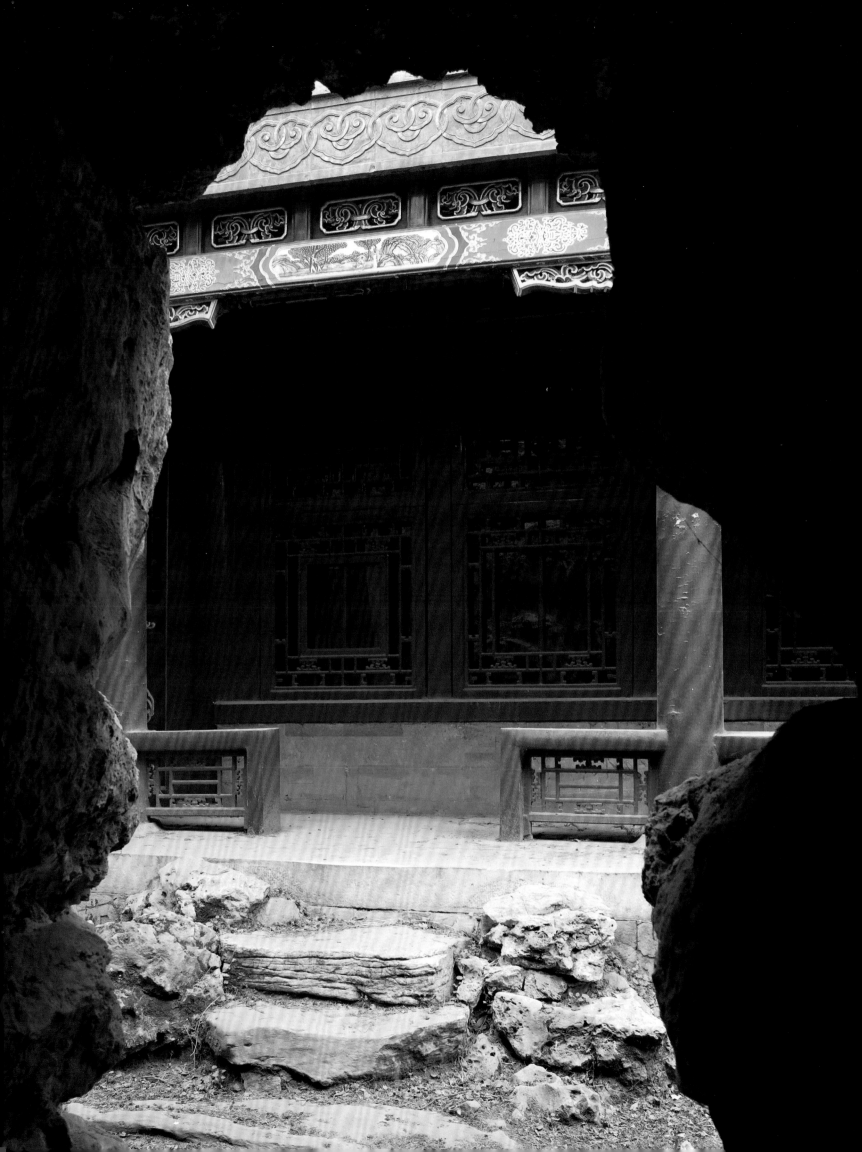

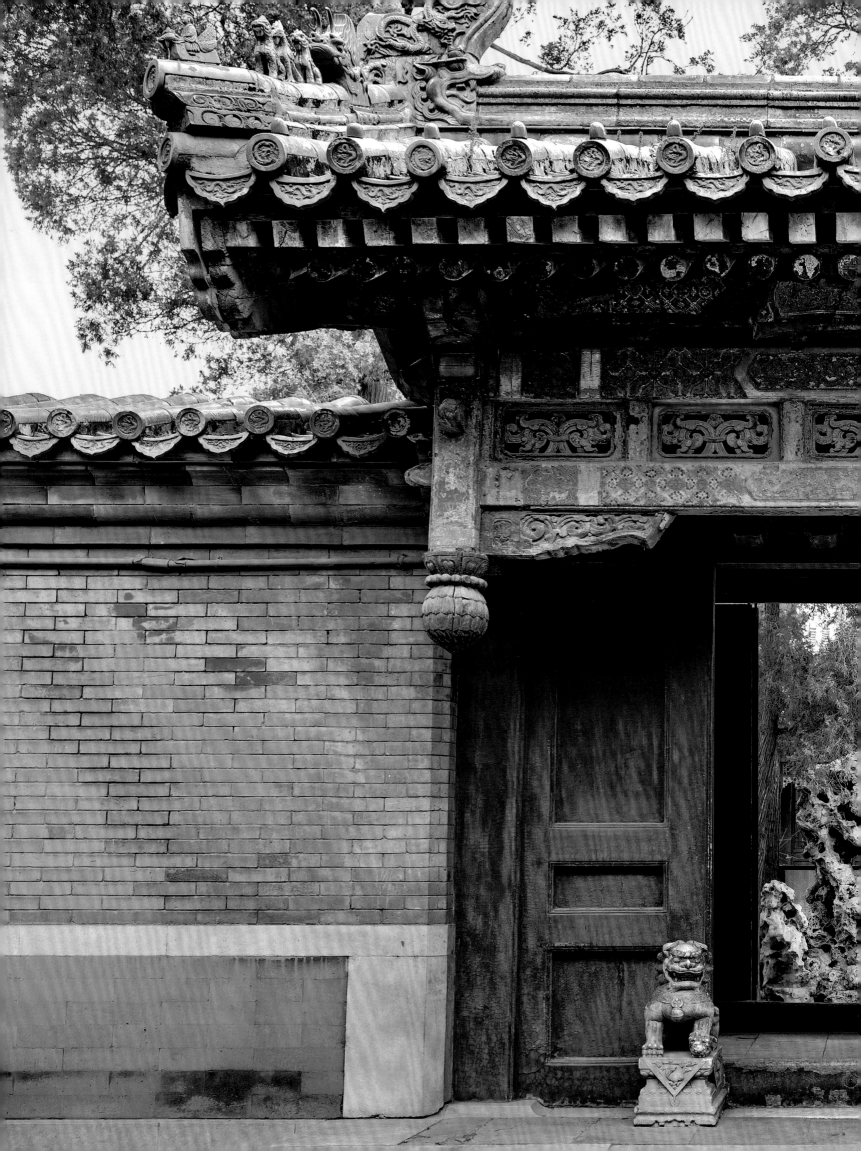

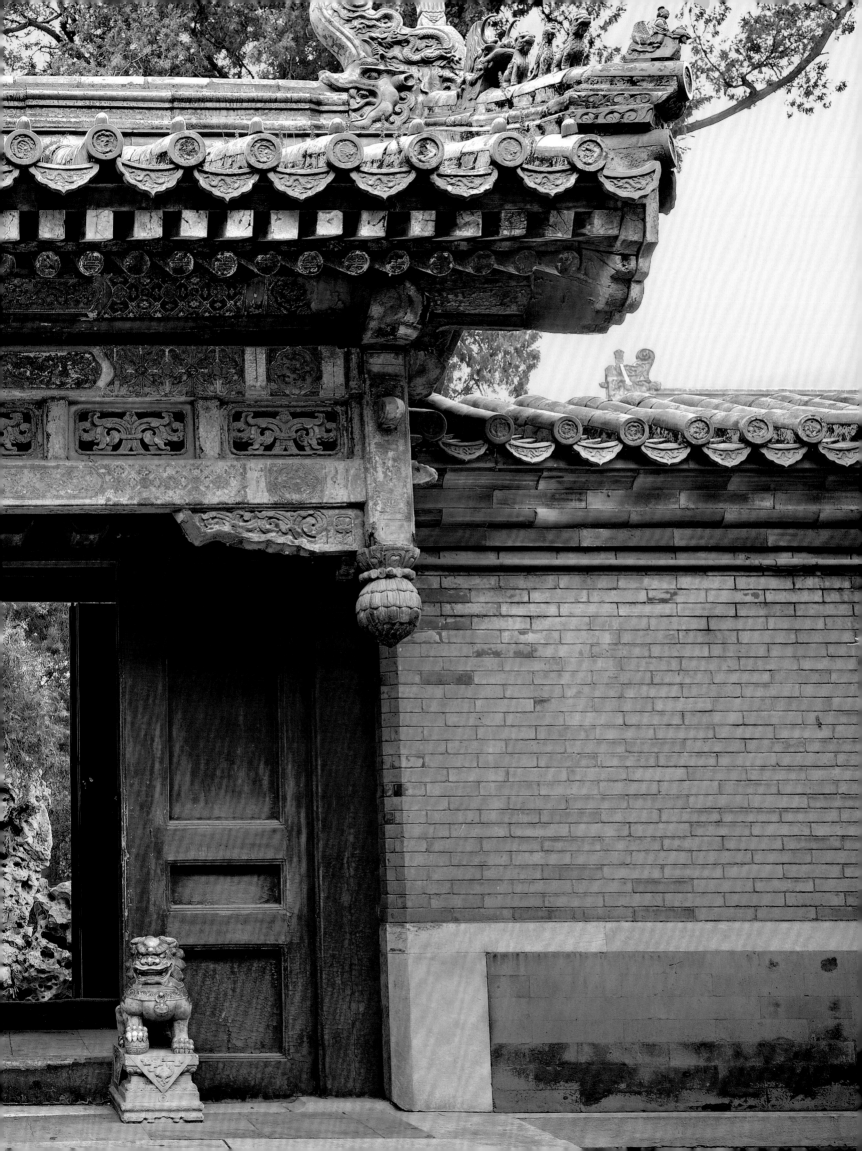

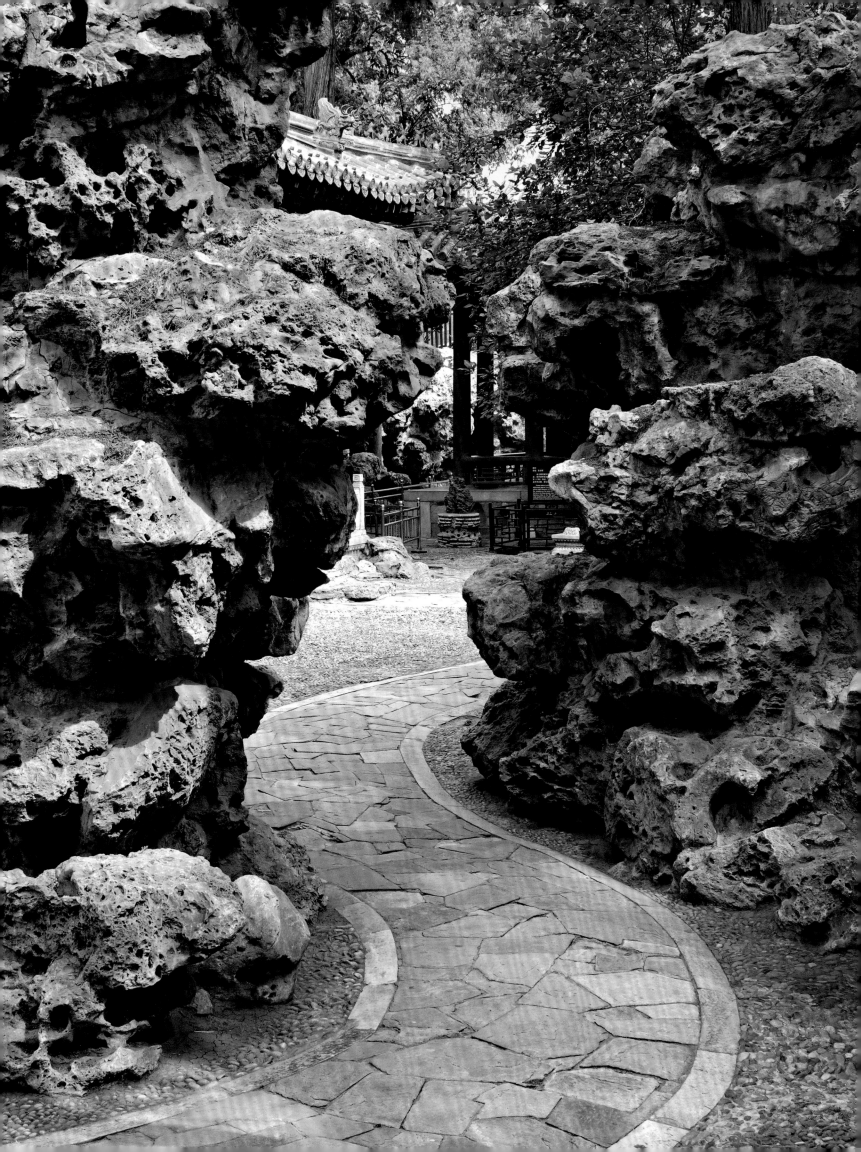

1

2

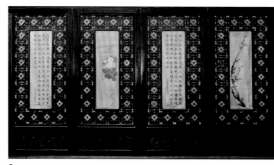

3

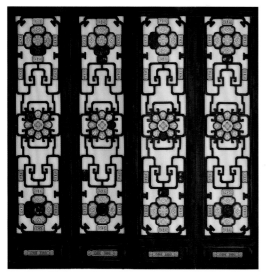

4

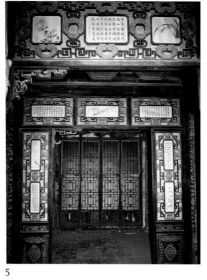

5

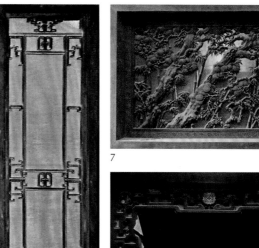

7

8

9

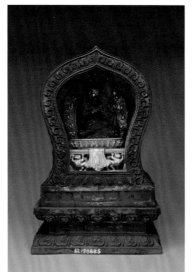

10

6

Catalogue of the Exhibition

Note: The first section of the catalogue includes objects that were originally in the Qianlong Garden, and their entries indicate their location in the garden. The second section of the catalogue includes objects that are comparable to those commissioned by the emperor for the Qianlong Garden, and that might have been used in the garden's interior spaces. Objects within each section are organized according to type. Unless otherwise noted, all works were made during the Qianlong era, and height precedes width precedes depth. Some works are represented by preconservation measurements and photographs.

All works have been lent by the Palace Museum, Beijing. The catalogue information has been compiled with the assistance of Palace Museum staff including Gao Xiaoran, Huang Jian, Li Shi, Li Yue, Lin Huan, Luo Wenhua, Wang Hu, Wang Zilin, Wen Ming, Xu Lin, and Zhang Li.

Objects Original to the Qianlong Garden

Architectural Elements

Catalogue 1
Door surround
From Yanghe Jingshe
Cedar and silk gauze
92 1/2 x 64 1/2 inches
(234.5 x 164 cm)
Plate 41

Catalogue 2
Partitions
From Cuishanglou
Zitan, bamboo, and painted glass
78 x 77 1/4 x 3 inches
(198 x 196 x 7.5 cm)
Plate 19

Catalogue 3
Partitions
From Sanyouxuan
Zitan and jade with inset paintings on silk
39 3/4 x 75 1/2 x 2 1/2 inches
(101 x 192 x 6 cm)
Plate 37

Catalogue 4
Partitions
From Yanqulou
Zitan, silk gauze, and porcelain
66 1/4 x 67 x 3 1/2 inches
(168 x 170 x 8.5 cm)
Plate 18

Catalogue 5
Partitions and entablature
From Fuwangge
Zitan and cloisonné with inset paintings and calligraphies on silk
144 1/2 x 135 x 2 1/2 inches
(367 x 343 x 6.5 cm)
Plate 23

Catalogue 6
Partitions and entablature
From Yucuixuan
Cedar, zitan, and silk gauze
125 1/4 x 147 1/4 inches
(318 x 374 cm)

Catalogue 7
Window
From Sanyouxuan
Zitan and glass
55 1/4 x 80 3/4 inches
(140 x 205 cm)
Plate 16

Catalogue 8
Window surround
From Yanqulou
Zitan and porcelain
36 1/2 x 44 1/2 x 2 1/2 inches
(93 x 113 x 6.5 cm)
Plate 17

Decorative and Religious Objects

Catalogue 9
Clock (wall)
From Fuwangge
Gilt copper and enamel
30 inches (diam.) (76 cm)
Plate 22

Catalogue 10
Shrine and statue of Baishang Lewang Buddha, 1773
From Cuishanglou
Gilt copper, silver, glass, and turquoise
Overall 11 1/4 x 7 3/8 x 5 1/4 inches
(28.7 x 18.8 x 12.8 cm)
Plate 45

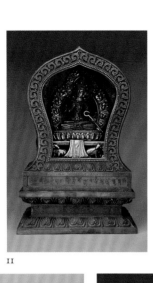

11

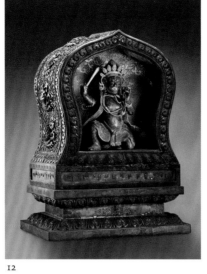

12

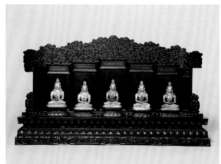

13

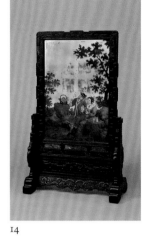

14

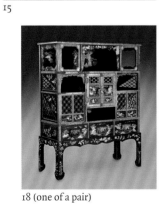

15

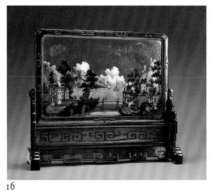

16

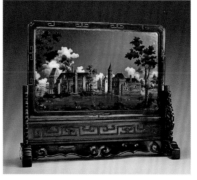

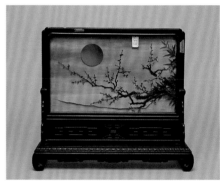

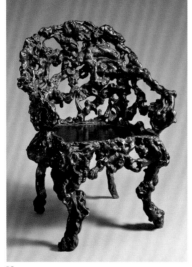

18 (one of a pair)

19

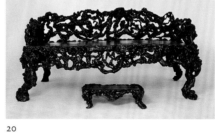

20

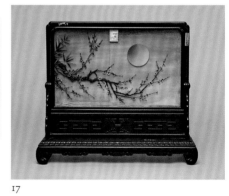

17

Catalogue 11
Shrine and statue of Bodhisattva
Guanyin, 1766
From Cuishanglou
Gilt copper, silver, glass, and turquoise
Overall 11 1/4 x 7 3/8 x 5 1/4 inches
(28.7 x 18.6 x 12.8 cm)
Plate 44

Catalogue 12
Shrine and statue of Jingang
From Cuishanglou
Calcite or lapis lazuli, gilt copper,
silver, and glass
Overall 15 1/2 x 11 x 7 1/2 inches
(39.7 x 28 x 19 cm)
Plate 46

Catalogue 13
Statues of Amitabha and stand
From Cuishanglou
Gilt copper and zitan
Overall 22 1/2 x 39 5/8 x 8 1/4 inches
(57 x 100.5 x 21 cm)
Plate 43

Catalogue 14
Table screen
From Cuishanglou
Zitan, glass, silver foil, and paint
41 1/2 x 25 1/2 x 12 1/2 inches
(105.5 x 64.5 x 32 cm)
Plate 51

Catalogue 15
Table screen
From Yanghe Jingshe
Zitan and stone
32 x 23 1/2 x 12 1/4 inches
(81 x 59.5 x 31 cm)
Plate 50

Catalogue 16
Table screens (pair)
From Cuishanglou
Zitan, glass, silver foil, and paint
Each 26 1/2 x 28 1/2 inches
(67 x 72 cm)
Plate 52

Catalogue 17
Table screens (pair)
From Cuishanglou
Zitan, glass, silver foil, and paint
Each 27 1/2 x 30 3/4 x 7 1/4 inches
(70 x 78 cm x 18.5 cm)
Plate 35

Furniture
Catalogue 18
Cabinets (pair)
From Yucuixuan
Wood, lacquer, and gilding
Each 46 7/8 x 34 1/2 x 14 1/2 inches
(119 x 87.8 x 36.6 cm)
Plate 54

Catalogue 19
Chair
From Xishangting
Rootwood
41 1/4 x 23 1/2 x 29 inches
(105 x 74 x 60 cm)
Plate 8

Catalogue 20
Couch bed with foot stool
From Xishangting
Rootwood
Couch bed 45 1/2 x 93 1/2 x 60 3/4 inches
(115 x 237 x 152 cm)
Foot stool 8 1/4 x 30 1/4 x 19 1/4 inches
(21 x 77 x 49 cm)
Plate 9

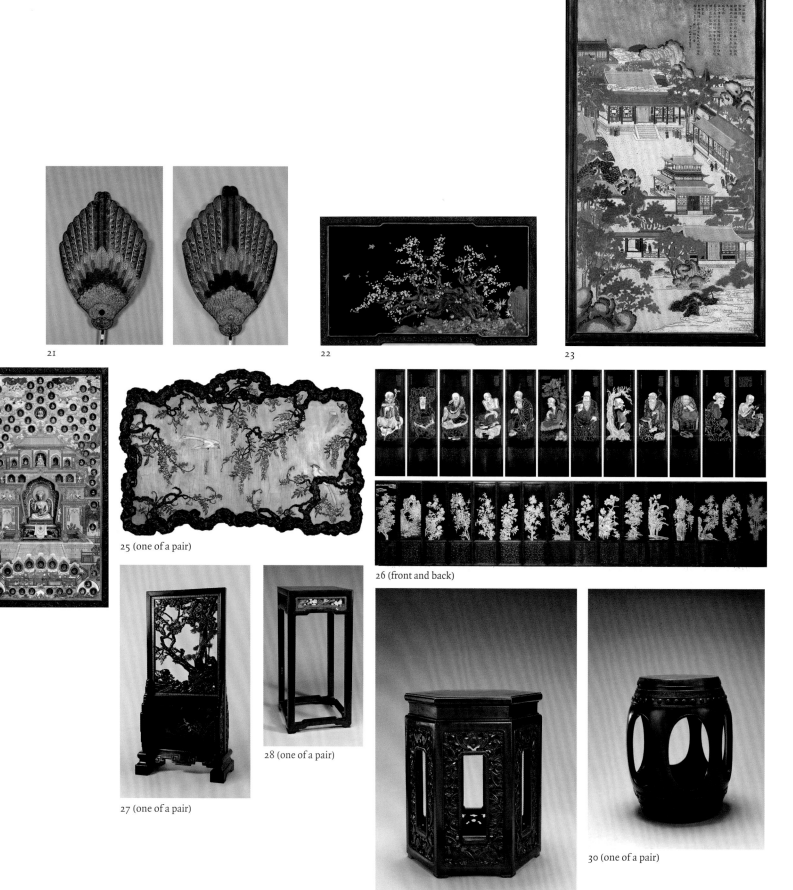

21

22

23

24

25 (one of a pair)

26 (front and back)

27 (one of a pair)

28 (one of a pair)

29 (one of a pair)

30 (one of a pair)

Catalogue 21
Court fans (pair)
From Yanghe Jingshe
Wood, brass, and paint
Each fan 38 3/8 x 25 1/4 inches
(97.5 x 64 cm)
Each pole 69 7/8 x 1 3/8 inches (diam.)
(177.4 x 3.6 cm)
Plate 4

Catalogue 22
Panel (hanging)
From Juanqinzhai
Sandalwood, jade, lapis lazuli,
malachite, zitan, and glass
43 1/2 x 75 3/4 x 3 1/4 inches
(110.5 x 192.3 x 8.3 cm)
Plate 31

Catalogue 23
Panel (hanging)
From Yanghe Jingshe
Cloisonné and zitan
57 1/4 x 29 3/4 inches
(145.5 x 75.5 cm)
Plate 29

Catalogue 24
Panel with niches (hanging)
From Cuishanglou
Zitan, painted and gilt clay,
and colors on silk
63 1/4 x 36 1/2 x 2 7/8 inches
(160.5 x 93 x 7.4 cm)
Plate 39

Catalogue 25
Panels (hanging, pair)
From Yucuixuan
Wood, lacquer, jade, semi-
precious stones, and glass
Each 30 x 49 1/4 inches
(76 cm x 125 cm)
Plate 11

Catalogue 26
Screen (sixteen double-sided panels)
From Yunguanglou
Zitan, lacquer, jade, and gold paint
Each panel 84 x 28 x 2 1/2 inches
(213 x 58.7 x 6 cm)
Plate 49

Catalogue 27
Screens (pair)
From Sanyouxuan
Zitan, glass, agate, and crystal
Each 82 3/4 x 41 3/4 x 23 1/2 inches
(210 x 106 x 60 cm)
Plate 32

Catalogue 28
Stands (pair)
From Sanyouxuan
Zitan, jade, and stone
Each 35 x 16 x 16 inches
(89 x 41 x 41 cm)
Plate 34

Catalogue 29
Stools (pair)
From Cuishanglou
Zitan
Each 19 3/4 x 16 x 14 1/4 inches
(50 x 41 x 36 cm)
Plate 58

Catalogue 30
Stools (pair)
From Sanyouxuan
Zitan
Each 18 1/4 x 10 3/4 inches (diam.)
(46.5 x 27.5 cm)
Plate 28

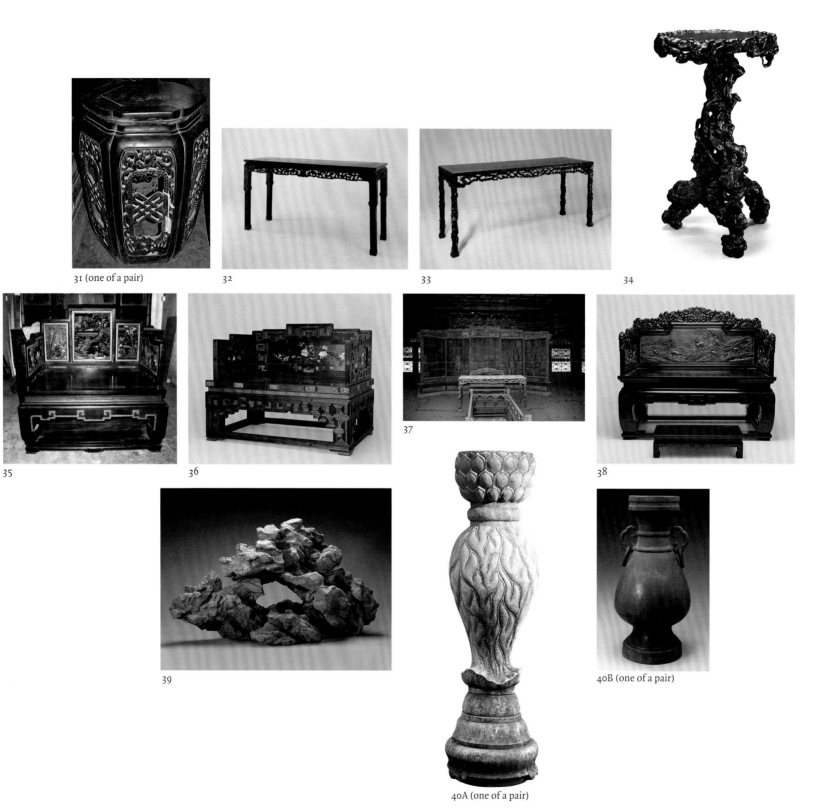

31 (one of a pair)

32

33

34

35

36

37

38

39

40A (one of a pair)

40B (one of a pair)

Catalogue 31
Stools (pair)
From Yanqulou
Zitan
Each 19 1/4 x 14 1/4 x 13 inches
(49 x 36 x 33 cm)

Catalogue 32
Table
From Cuishanglou
Zitan
37 x 69 1/2 x 22 1/2 inches
(94 x 176.5 x 57.5 cm)
Plate 53

Catalogue 33
Table
From Fuwangge
Zitan
36 1/2 x 75 1/2 x 25 1/4 inches
(93 x 192 x 64 cm)
Plate 36

Catalogue 34
Table
From Xishangting
Rootwood
33 x 18 1/2 inches
(84 x 47 cm)
Plates 8 and 10

Catalogue 35
Throne
From Sanyouxuan
Zitan, glass, and jade
46 1/2 x 45 3/4 x 33 inches
(118 x 116 x 84 cm)
Plate 33

Catalogue 36
Throne
From Yanghe Jingshe
Zitan, bamboo, jade, semi-
precious stones, and lacquer
38 1/2 x 46 1/4 x 33 inches
(98 x 117.5 x 84 cm)
Plate 27

Catalogue 37
Throne surround screen and display case
From Fuwangge
Zitan, lacquer, and gold paint
113 1/2 x 207 7/8 x 14 1/2 inches
(288 x 528 x 37 cm)
Plate 24

Catalogue 38
Throne with foot stool
From Fuwangge
Zitan and cedar
Throne 43 1/4 x 50 x 31 1/2 inches
(110 x 127 x 80 cm)
Foot stool 6 1/8 x 25 1/4 x 12 3/4 inches
(15.5 x 64 x 32.5 cm)
Plate 25

Garden Elements
Catalogue 39
Lingbi stone
From second courtyard, in front
of Suichutang
Limestone
25 1/4 x 43 3/4 x 15 3/4 inches
(64 x 110 x 40 cm)
Plate 30

Catalogue 40 A and B
Stands and vessels (pair)
Stands (40A)
From second courtyard
Marble
Each 40 1/2 x 12 5/8 inches (diam.)
(103 x 32 cm)
Vessels (40B)
Original location unknown
Bronze
Each 17 1/2 inches (height)
(44.5 cm)
Plates 14 and 15

41 (one of a pair)

42

佛說八大菩
薩經
如是我聞一
時佛在舍衛
國祇樹給孤
獨園言旨大
歡喜信受奉
行

臣曹文埴敬書

43 (details)

44

臨風每愴情
辛未孟冬中澣御題

國福菁生廟廊
贊畫資賢哲懷舊

妍姿 直諒多聞三益友澤

時蕃茂軒前耐冰雪豈同凡卉炫

松貞竹勁梅清潔三友神交忘歲

一枝冷豔報生春
蕊綻瑤臺穆玉塵
靜坐西窗對三友清
貞勁節益心身
甲戌仲冬之月
御題

46

屢閣延夆肖題
楯意宥存耄期
致勤僾顧著謝
塵宣豫葺優
游地眈慚恭伶
門其誠符我望
惟黔候
天恩
丙申新正月
海堃

50

勒敬書

佛說作佛形像經
佛王拘鹽惟國有
諸樹園主名拘翼
時國王名優填年
十四閒佛當來王
即勅偽臣左右皆
悲嚴駕王即行迎
佛遙見佛心申踊
躍歡喜前為佛
步罷偽臣左右持
沁迦道伸普王作
善者作佛形像其
福得祐如是不唐
其王羣臣皆為佛
作禮以頭面著佛
作禮而去壽終皆
生阿彌陀佛國
臣梁國治奉

47 (details)

花色金標幻海禪

禽音仍唱迦陵偈

49

似闡了義示緣因

便有香風吹左右

48

Catalogue 41
Stools (pair)
From fourth courtyard rockery,
beside Biluoting
Marble
Each 19 3/4 x 19 3/4 inches
(diam.) (50 x 50 cm)
Plate 20

Catalogue 42
Table
From fourth courtyard rockery,
beside Biluoting
Huaban stone
30 3/4 x 43 3/4 x 20 inches
(78 x 111 x 51 cm)
Plate 21

Painting and Calligraphy
Catalogue 43
Cao Wenzhi (1735–1798)
Bada Pusa jing
(Eight Great Bodhisattva Sutras)
From Yunguanglou
Ink on paper
18 1/4 x 361 3/8 inches
(46.3 x 918 cm)
The Metropolitan Museum of Art only
Plate 47

Catalogue 44
Interior scene
From Yanghe Jingshe
Ink and colors on silk
127 1/4 x 119 7/8 inches
(323.4 x 304.3 cm)
The Metropolitan Museum of Art only
Plate 40

Catalogue 45
Jiaqing Emperor (1760–1820)
Calligraphic inscription, 1811
From Sanyouxuan
Ink on paper
58 x 34 inches
(147.5 x 86 cm)
Peabody Essex Museum and
Milwaukee Art Museum only
Plate 38

Catalogue 46
Jiaqing Emperor (1760–1820)
Calligraphic inscription, 1814
From Sanyouxuan
Ink on paper
28 5/8 x 30 7/8 inches
(72.8 x 78.5 cm)
The Metropolitan Museum of Art only
Plate 6

Catalogue 47
Liang Guozhi (1723–1786)
Foxingxiang jing
(Sutra on Buddhist Images)
From Yunguanglou
Ink on paper
11 1/2 x 243 1/4 inches
(29 x 618 cm)
Peabody Essex Museum and
Milwaukee Art Museum only
Plate 48

Catalogue 48
Qianlong Emperor (1711–1799)
Calligraphic couplet
From Cuishanglou
Ink on silk with zitan frame
63 1/4 x 12 1/2 x 1 inches
(168 x 32 x 2.5 cm)
Peabody Essex Museum and
Milwaukee Art Museum only
Plate 5

Catalogue 49
Qianlong Emperor (1711–1799)
Calligraphic couplet
From Yucuixuan
Ink on silk with wood frame
56 3/4 x 15 1/4 inches
(144.5 x 38.5 cm)
The Metropolitan Museum of Art only
Plate 13

Catalogue 50
Qianlong Emperor (1711–1799)
Calligraphic inscription, 1776
From Fuwangge
Ink on paper
37 x 73 1/4 inches
(94 x 186 cm)
The Metropolitan Museum of Art only
Plate 3

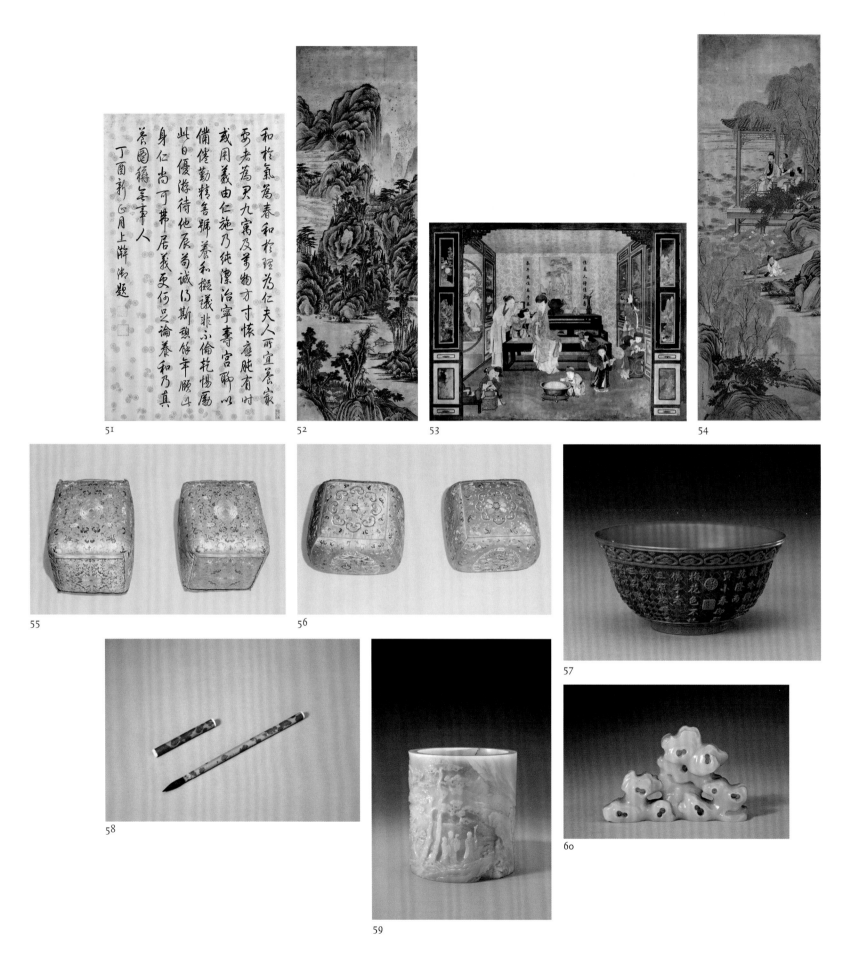

51

52

53

54

55

56

57

58

59

60

Catalogue 51
Qianlong Emperor (1711–1799)
Calligraphic inscription, 1777
From Yanghe Jingshe
Ink on paper
60 1/2 x 38 1/4 inches
(153.5 x 97 cm)
Peabody Essex Museum and
Milwaukee Art Museum only
Plate 42

Catalogue 52
Wei Linghe (1700s)
Landscape
From Yanghe Jingshe
Ink and colors on paper
76 x 26 1/2 inches
(193 x 67 cm)
The Metropolitan Museum of Art only
Plate 55

Catalogue 53
Yao Wenhan (1700s) and others
Interior scene
From Yucuixuan
Ink and colors on paper
124 3/4 x 144 3/8 inches
(317 x 366.5 cm)
Peabody Essex Museum and
Milwaukee Art Museum only
Plate 57

Catalogue 54
Zhu Xianzhang (1700s)
Landscape with figures
From Yanghe Jingshe
Ink and colors on paper
76 3/4 x 26 1/2 inches
(195 x 67 cm)
Peabody Essex Museum and
Milwaukee Art Museum only
Plate 56

Works Not from the Qianlong Garden
Decorative and Religious Objects
Catalogue 55
Arm rest cushions (pair)
Satin with silk thread
Each 9 x 7 1/2 x 7 1/2 inches
(23 x 19 x 19 cm)
Peabody Essex Museum and
Milwaukee Art Museum only

Catalogue 56
Arm rest cushions (pair)
Satin with silk thread
Each 6 3/4 x 10 1/2 x 10 1/2 x inches
(17 x 27 x 27 cm)
The Metropolitan Museum of Art only

Catalogue 57
Bowl
Lacquer
3 1/2 x 4 3/4 inches (diam.)
(9 x 12.2 cm)

Catalogue 58
Brush
Speckled bamboo and hair
8 1/2 inches (length)
(21 cm)

Catalogue 59
Brush pot
Jade
5 1/4 x 5 1/2 inches (diam.)
(15 x 14 cm)

Catalogue 60
Brush rest
Jade
2 1/2 x 4 inches
(6.6 x 10 cm)

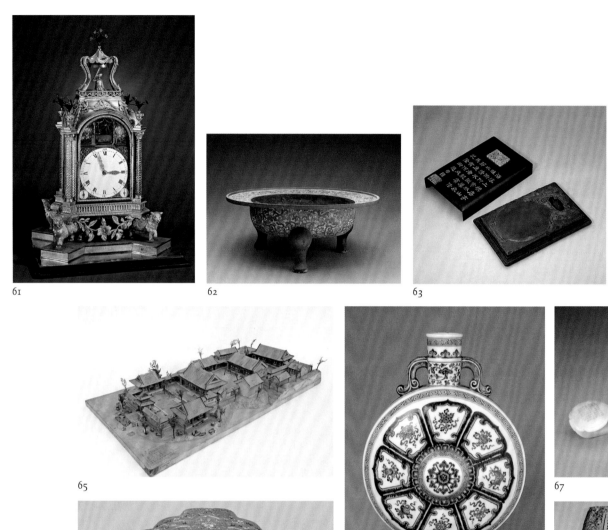

61

62

63

64

65

66

67

68

69

70

Catalogue 61
Clock
Gilt copper, enamel, and glass
41 3/8 x 24 3/4 x 22 inches
(105 x 63 x 56 cm)

Catalogue 62
Heating basin
Cloisonné
8 1/4 x 20 1/2 inches (diam.)
(21 x 51.8 cm)

Catalogue 63
Ink slab, Song dynasty, with incised
poem by the Qianlong emperor
Duan stone, wood, and jade
Ink slab 3/4 x 8 1/2 x 5 inches
(1.9 x 21.5 x 12.9 cm)

Catalogue 64
Mandala
Cloisonné
22 1/2 x 19 inches (diam.)
(57 x 48.2 cm)

Catalogue 65
Model of the Kuaixuetang (Hall of Early Snow)
Garden and pavilions in Beihai,
late eighteenth or early nineteenth century
Paper, millet stalks, and wood
5 7/8 x 42 1/2 x 22 1/2 inches
(15 x 108 x 57 cm)
Plate 26

Catalogue 66
Moon flask
Porcelain with underglaze cobalt
13 1/2 inches (height)
(34.5 cm)

Catalogue 67
Scepter, *ruyi* form
Jade and silk
7 1/2 inches (length)
(19 cm)

Catalogue 68
Seat back cushion
Satin with silk thread
26 3/8 x 26 3/4 x 3 1/8 inches
(67 x 68 x 8 cm)
Peabody Essex Museum and
Milwaukee Art Museum only

Catalogue 69
Seat back cushion
Satin with silk thread
21 1/4 x 37 3/8 x 2 3/4 inches
(54 x 95 x 7 cm)
The Metropolitan Museum of Art only

Catalogue 70
Seat cushion
Satin with silk thread
4 3/8 x 40 1/2 x 40 1/2 inches
(11 x 103 x 103 cm)
Peabody Essex Museum and
Milwaukee Art Museum only

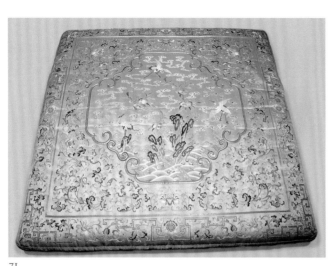

71

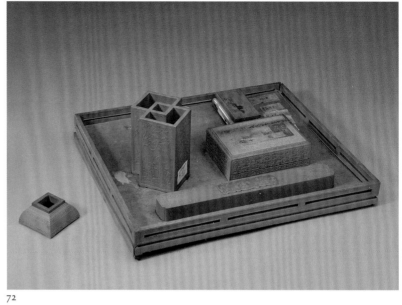

72

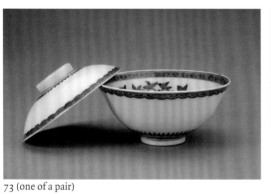

73 (one of a pair)

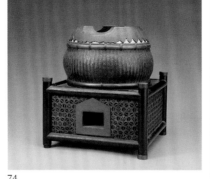

74

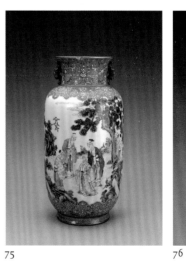

75

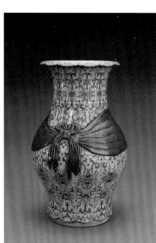

76

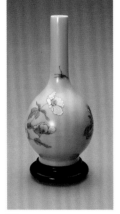

77

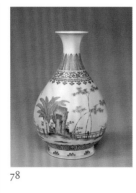

78

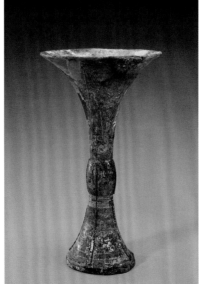

79

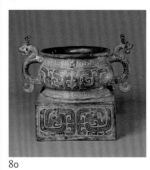

80

Catalogue 71
Seat cushion
Satin with silk thread
2 x 38 1/8 x 26 3/4 inches
(5 x 97 x 67 cm)
The Metropolitan Museum of Art only

Catalogue 72
Stationery set (six pieces)
Bamboo inner skin
Overall 4 x 11 3/8 x 13 1/4 inches
(28.8 x 33.5 x 10 cm)

Catalogue 73
Tea bowls (pair)
Porcelain with underglaze cobalt
Each 3 x 4 1/2 inches (diam.)
(7.5 x 11.4 cm)

Catalogue 74
Tea stove
Bamboo and copper
Overall 7 5/8 x 6 7/8 x 6 7/8 inches
(19.5 x 17.3 x 17.3 cm)

Catalogue 75
Vase
Porcelain
13 3/8 x 4 7/8 inches (diam.)
(34 x 12.3 cm)

Catalogue 76
Vase
Porcelain with malachite glaze
12 1/4 inches (height)
(31 cm)

Catalogue 77
Vase
Porcelain with
polychrome enamel glaze
8 1/2 inches (height)
(21.5 cm)

Catalogue 78
Vase
Porcelain with underglaze cobalt
11 inches (height)
(28.5 cm)

Catalogue 79
Vessel, *gu* form, Shang dynasty
Bronze
10 5/8 x 5 7/8 inches (diam.)
(27 x 15 cm)

Catalogue 80
Vessel, *gui* form, Zhou dynasty
Bronze
13 3/4 x 17 1/2 x 10 1/4 inches
(35.1 x 44.5 x 26.2 cm)

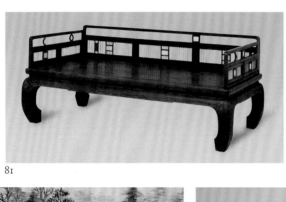

81

82

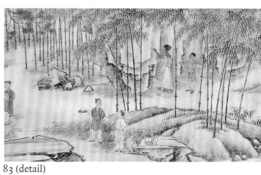

83 (detail)

84 (detail)

85

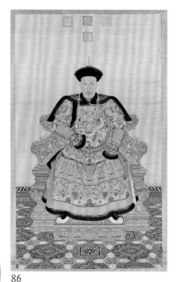

86

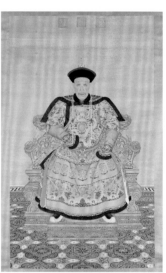

87

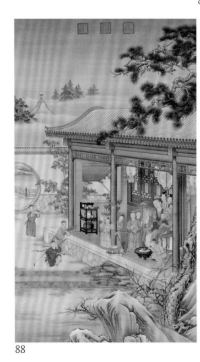

88

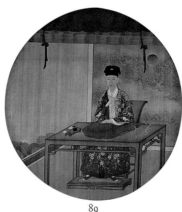

89

90 (detail)

Furniture
Catalogue 81
Couch bed
Zitan and jade
40 1/4 x 81 1/8 x 43 3/4 inches
(102 x 206 x 111 cm)

Garden Elements
Catalogue 82
Jade
29 1/2 x 18 1/2 x 11 7/8 inches
(75 x 47 x 30 cm)

Painting and Calligraphy
Catalogue 83
Du Yuanzhi (1700s)
Seven Sages in a Bamboo Forest (scroll)
Ink and colors on paper
5 1/4 x 50 1/4 inches
(13.1 x 127.7 cm)
Peabody Essex Museum and
Milwaukee Art Museum only
Plate 7

Catalogue 84
Fang Cong (1700s)
Sound of a Brook (scroll)
Ink and colors on paper
5 1/4 x 50 1/4 inches
(13.1 x 127.7 cm)
The Metropolitan Museum of Art only

Catalogue 85
Liu Lun (1711–1773)
Album of poems on the Chengde
summer resort with a box
Ink on paper
Album 5 1/2 x 6 1/4 inches
(13.9 x 15.9 cm)
Contained in a cinnabar laquer box
along with cats. 83, 84, and 90
Box 6 7/8 x 6 1/4 x 4 inches
(17.5 x 16 x 10 cm)
Album Peabody Essex Museum and
Milwaukee Art Museum only

Catalogue 86
Portrait of the Qianlong Emperor
Ink and colors on silk
99 1/2 x 59 inches
(253 x 150 cm)
Peabody Essex Museum and
Milwaukee Art Museum only
Plate 2

Catalogue 87
Portrait of the Qianlong Emperor
Ink and colors on silk
99 1/2 x 58 1/2 inches
(253 x 146.2 cm)
The Metropolitan Museum of Art only

Catalogue 88
Portrait of the Qianlong Emperor
Celebrating the New Year
Ink and colors on silk
151 x 63 inches
(384 x 160.3 cm)
Peabody Essex Museum and
Milwaukee Art Museum only
Plate 12

Catalogue 89
Portrait of the Qianlong Emperor
in Ancient Costume
Ink and colors on silk
42 inches (diam.)
(106.5 cm)
The Metropolitan Museum of Art only
Plate 1

Catalogue 90
Yuan Ying (1700s)
Autumn Scenery (scroll)
Ink and colors on paper
5 1/4 x 50 1/4 inches
(13.1x 127.7 cm)
The Metropolitan Museum of Art only

Pronunciation Guide for Chinese Transliteration

The text in this book uses the *pinyin* system of transliterating Chinese characters into Roman letters. *Pinyin* (literally "spelling sounds") was officially accepted as the Romanization system by the People's Republic of China government in 1958, and by the Republic of China government in January 2009. Many of the consonants and vowels in *pinyin* are pronounced like their English equivalents, however, there are some exceptions. The guide below is intended to assist readers with many of the words appearing in this publication.

X sounds like the "sh" in *she*

Q sounds like the "ch" in *cheer*

C sounds like the "ts" in *beets*

Zh sounds like the "dg" in *fudge*

Ai sounds like "ie" in *pie*

Ang sounds like "ong" in *ping pong*

Ao sounds like "ow" in *how*

Ei sounds like the "ay" in *say*

Ia sounds like *ya*

Iu sounds like *yo*

Ou sounds like *oh*

Ua sounds like *wa*

Ue sounds like *weh*

Ui sounds like *way*

Glossary of Names and Terms

Ai Qimeng 艾啟蒙 Ignatius Sichelbart

Banmuyuan 半畝園 Half-Acre Garden
Beihai 北海 North Sea
Bilinguan 碧琳館 Lodge of Viridian Jade
Biluoting 碧螺亭 Pavilion of Jade-Green Conch
Bishu Shanzhuang 避暑山莊 Mountain Villa
 for Escaping the Heat

Cao Zhibai 曹知白 Yuan dynasty artist
Changchun Shuwu 長春書屋 Study of
 Enduring Spring
Changchunyuan 長春園 Garden of Enduring
 Spring
Chenshedang 陳設檔 Furnishings Inventory
Cininggong Huayuan 慈寧宮花園 Garden of
 the Compassion and Tranquility Palace
Cixi 慈禧 late Qing dynasty empress dowager
Cuishanglou 萃賞樓 Building for Enjoying
 Lush Scenery

Daguanyuan 大觀園 Grand View Garden
Daiyuelou 待月樓 Building for Awaiting the Moon
Derixin 德日新 Virtue Renewed Daily Chamber
Ding Guanpeng 丁觀鵬 Qing dynasty artist
Dong Gao 董誥 Qing dynasty official
Dong Qichang 董其昌 Ming dynasty artist
doucai 鬥彩 "contrasting colors" glaze
Duixiushan 堆秀山 Hill of
 Accumulated Embroidery
duobaoge 多寶格 "many treasures" display cabinet

Fang Cong 方琮 Qing dynasty artist
fencai 粉彩 "powdered colors" glaze
Fuheng 傅恆 Qing dynasty official
Fukang'an 福康安 Qing dynasty official
Fulong'an 福隆安 Qing dynasty official
Fuwangge 符望閣 Belvedere of
 Viewing Achievements

Genyue 艮嶽 Northeast Marchmount [garden]
Gonghouyuan 宮後苑 Rear Palace Garden
Gongting neiwufu dang'an 宮廷內務府檔案
 Notations in the Imperial Household Archives
Gongwangfu 恭王府 Prince Gong's Mansion
Guan Tong 關仝 Five Dynasties artist
Guangxu 光緒 Qing dynasty reign period
Guanhuadian 觀花殿 Flower Watching Hall
Guanyin 觀音 Bodhisattva of Compassion
Guanxiu 貫休 Tang dynasty artist
Guhuaxuan 古華軒 Bower of the Ancient Catalpa
Guotai 國泰 Qing dynasty official

Hanguangshi 涵光室 Chamber Containing Brightness
Hanjingtang 含經堂 Hall for Storing the Classics
Hešen (Manchu pronunciation), Heshen 和珅
 (Chinese pronunciation) Qing dynasty official
Hongloumeng 紅樓夢 *The Dream of the Red Chamber*
Hu Shijie 胡世杰 Qing dynasty eunuch
huayangren 畫樣人 designer
Huancuitang 環翠堂 Encircling Jade Hall
Huang Nian 黃念 Qing dynasty artist
Hudong Xianfahua 湖東線法畫 Perspective
 Paintings East of the Lake
Hungli (Manchu pronounciation), Hongli 弘曆
 (Chinese pronounciation) Qianlong emperor's
 given name
Huojidang 活計檔 Imperial Handiwork Edicts

Ji Cheng 計成 Ming dynasty author
Jia Quan 賈全 Qing dynasty artist
jiamen 假門 false door
Jianfugong 建福宮 Palace of Established Happiness
Jianfugong huayuan 建福宮花園 Garden of the
 Palace of Established Happiness
Jiang Youren 蔣友仁 Michel Benoist
Jiang Zhi 姜質 Tang dynasty poet
jiangren 匠人 artisan
Jiaoran 皎然 Tang dynasty poet
Jiaqing 嘉慶 Qing dynasty reign period
jiashan 假山 false mountain, rockery
Jicuiting 積翠亭 Belvedere of Abundant Greenery
jiehua 界畫 architectural painting
Jieziyuan huazhuan 芥子園畫傳 *Mustard Seed Garden
 Painting Manual*
Jin Ping Mei 金瓶梅 *The Plum in the Golden Vase*
Jing Hao 荊浩 Tang dynasty artist
Jingchenxinshe 淨塵心室 Chamber of Dusting
 Clean the Heart
Jinglianzhai 靜蓮齋 Studio of Calm Lotus
Jingshan 景山 Prospect Hill
Jingshengzhai 敬勝齋 Studio of
 Esteemed Excellence
Jingyiyuan 靜宜園 Garden of Tranquility and Pleasure
jinshi 進士 scholarly degree
Juanqinzhai 倦勤齋 Studio of Exhaustion from
 Diligent Service
Juting 矩亭 Pavilion of Propriety

Kangxi 康熙 Qing dynasty reign name
kesi 緙絲 silk tapestry
Kongzi 孔子 Confucius

Lang Shining 郎世寧 Giuseppe Castiglione
Lanling Xiaoxiao Sheng 蘭陵笑笑生 Ming
 dynasty author

239

Ximen Qing 西門慶 character in *The Plum in the Golden Vase*

Xishangting 禊賞亭 Pavilion of the Purification Ceremony

Xiyuan 西園 West Garden

Xu Yang 徐揚 Qing dynasty artist

Xuantong 宣統 Qing dynasty reign name

Xuhuiting 旭輝亭 Pavilion of Brilliant Dawn

ya 雅 elegant

Yanchunge 延春閣 Belvedere of Extending Spring

Yang Dazhang 楊大章 Qing dynasty artist

Yanghe Jingshe 養和精舍 Supreme Chamber of Cultivating Harmony

Yangshi Lei 樣式雷 model-making Lei family

Yangxindian 養心殿 Hall of Mental Cultivation

Yanqimen 衍祺門 Gate of Spreading Auspiciousness

Yanqulou 延趣樓 Building of Extending Delight

Yao Wenhan 姚文瀚 Qing dynasty artist

Yao Yuanzhi 姚元之 Qing dynasty artist

Ying Lian 英廉 Qing dynasty official

Yizhai 抑齋 Studio of Self-Restraint

Yizhou Minghua Lu 益州名畫錄 *Record of the Famous Paintings of Yizhou*

Yongle 永樂 Ming dynasty reign name

Yongzheng 雍正 Qing dynasty reign name

Yu Minzhong 于敏中 Qing dynasty official

Yuan Mei 袁枚 Qing dynasty author

Yuan Ye 園冶 *The Craft of Gardens*

Yuan Ying 袁瑛 Qing dynasty artist

yuanlin 園林 garden

Yuanmingyuan 圓明園 Garden of Perfect Brightness

Yucuixuan 玉翠軒 Bower of Purest Jade

Yuhuayuan 御花園 Imperial Garden

Yuhubing 玉壺冰 Chamber of Crystalline Purity

Yulinglongguan 玉玲瓏館 Lodge of Tinkling Jades

Yunguanglou 雲光樓 Building of Luminous Clouds

Zaobanchu 造辦處 Imperial Workshops

Zhang Lun 張倫 Sui dynasty garden aficionado

Zhang Zongcang 張宗蒼 Qing dynasty artist

Zhao Mengjian 趙孟堅 Song dynasty scholar and artist

Zhongnanhai 中南海 Middle and South Sea

zhuanjiaolou 轉角樓 L-shaped building

zhuo 拙 awkward

Zhuxiangguan 竹香館 Lodge of Bamboo Fragrance

zitan 紫檀 sandalwood

Zouxiaodang 奏銷檔 Archives on Imperial Household Expenditure

Selected Bibliography

Bruce MacLaren

The bibliography is divided into three sections: Archival Sources, Bilingual and Non-Chinese Language Sources, and Chinese Language Sources. Where appropriate, Chinese characters as well as the *pinyin* Romanization system are given. English translations are in parentheses in Roman type if they are for the reader's convenience; if they are an official translation of the reference itself, they are in italics.

Archival Sources

Qing dynasty imperial archives from the Qianlong and Guangxu periods were fundamental resources in researching the history of the Qianlong Garden.

Neiwufu Huojidang 內務府活計檔 (Archives on Imperial Household Handicrafts).

Neiwufu Zou'an 內務府奏案 (Imperial Household Archives of Memorials).

Neiwufu Zouxiaodang 內務府奏銷檔 (Archives on Imperial Household Expenditure).

Neiwufu Chenshedang 內務府陳設檔 (Archives on Imperial Household Furnishings Inventory).

Zhiyi Didang 旨意底檔 (Archives on Imperial Household Department Directives).

Bilingual and Non-Chinese Language Sources

Adam, Maurice. *Yuen Ming Yuen, L'Oeuvre architecturale des anciens jésuites au XVIIIe siècle.* Beijing: Imprimerie des lazaristes, 1936.

Allain, Yves-Marie, Chiu Che Bing, and Janine Christiany. *Yuanming yuan yi zhi de baohu he liyong* 圓明園遺址的保護和利用 *Protection et Mise en Valeur du Site du Yuanming yuan.* Beijing: Zhongguo linye chubanshe, 2002.

Arlington, L. C. *In Search of Old Peking.* Peking: Henri Vetch, 1935.

Attiret, Jean-Denis and Joseph Spence. *A Particlar Account of the Emperor of China's Gardens Near Peking: In a Letter from F. Attiret, a French Missionary, Now Employ'd by That Emperor to Paint the Apartments in Those Gardens, to His Friend at Paris.* London: Printed for R. Dodsley, and sold by M. Cooper, 1752.

Barmé, Geremie. *The Forbidden City*. Cambridge, Massachusetts: Harvard University Press, 2008.

————. "The Lei Family Builders." *China Heritage Quarterly* 8 (December 2006).

Berger, Patricia Ann. *Empire of Emptiness: Buddhist Art and Political Authority in Qing China*. Honolulu: University of Hawaii Press, 2003.

Berliner, Nancy, ed. *Juanqinzhai in the Qianlong Garden, The Forbidden City, Beijing*. London: Scala Publishers, 2008.

Bray, Francesca. *Technology and Gender: Fabrics of Power in Late Imperial China*. Berkeley: University of California Press, 1997.

Bredon, Juliet. *Peking*. Shanghai: Kelly and Walsh, 1931.

Cao Xueqin. *Story of the Stone*. Trans. David Hawkes. New York: Penguin Classics, 1977.

Chang, H. C., trans. *Chinese Literature: Volume Two: Nature Poetry*. Edinburgh: Edinburgh University Press, 1977.

Chen Congzhou. *Shuo yuan* 说园 *On Chinese Gardens*. Shanghai: Tongji University, 1984.

Chiu Che Bing, "Yangshi Lei." In Frederic Edelmann, ed. *In the Chinese City: Perspectives on the Transmutations of an Empire*. New York: Actar, 2008.

Chuimei Ho and Bennet Bronson. *Splendors of China's Forbidden City: The Glorious Reign of Emperor Qianlong*. London and New York: Merrell Publishers Limited and the Field Museum, 2004.

Chung, Anita. *Drawing Boundaries: Architectural Images in Qing China*. Honolulu: University of Hawaii Press, 2005.

Clunas, Craig. *Fruitful Sites: Garden Culture in Ming Dynasty China*. Durham, North Carolina: Duke University Press, 1996.

————. *Superfluous Things, Material Culture and Social Status in Early Modern China*. Chicago: University of Illinois Press, 1991.

Coleridge, Samuel Taylor. *Coleridge: The Critical Heritage*. London: Routledge & Kegan Paul, 1970.

Confucius. *Confucian Analects, The Great Learning, and the Doctrine of the Mean*. Trans. James Legge. New York: Dover Publications, 1893.

Cranmer-Byng, J. L., ed. *An Embassy to China: Lord Macartney's Journal, 1793–1794*. London: Routledge, 2000.

Doar, Bruce Gordon. "Acquiring Gardens." *China Heritage Quarterly* 9 (March 2007). Online at http://www.chinaheritagenewsletter.org/features.php?searchterm=009_gardens.inc&issue=009.

Eight Dynasties of Chinese Painting: The Collections of the Nelson Gallery-Atkins Museum, Kansas City, and the Cleveland Museum of Art. Cleveland, Ohio: Cleveland Museum of Art in cooperation with Indiana University Press, 1980.

Elliot, Mark C. *The Manchu Way: The Eight Banners and Ethnic Identity in Late Imperial China*. Palo Alto, California: Stanford University Press, 2001.

————. *Emperor Qianlong: Son of Heaven, Man of the World*. New York: Longman, 2009.

Fairbank, John King. *China: A New History*. Cambridge, Massachusetts: Belknap Press of Harvard University Press, 1992.

Ferguson, John C. *Chinese Painting*. Chicago: University of Chicago Press, 1927.

Forêt, Philippe. *Mapping Chengde: the Qing Landscape Enterprise*. Honolulu: University of Hawaii Press, 2000.

Gernet, Jacques. *A History of Chinese Civilization*. Cambridge: Cambridge University Press, 1982.

Hanan, Patrick. *The Chinese Vernacular Story*. Cambridge, Massachusetts: Harvard University Press, 1981.

Hargett, James. "Huizong's Magic Marchmount: The Genyue Pleasure Park of Kaifeng." *Monumenta Serica* 38 (1989–90), pp. 1–48.

Holdsworth, May. *The Palace of Established Happiness: Restoring a Garden in the Forbidden City.* Beijing: Forbidden City Publishing House, 2008.

Hu Desheng. *The Palace Museum Collection: A Treasury of Ming & Qing Dynasty Palace Furniture.* Beijing: Forbidden City Publishing House, 2007.

Ji Cheng. *The Craft of Gardens.* Trans. Alison Hardie. New Haven and London: Yale University Press, 1988.

Johnston, Reginald. *Twilight in the Forbidden City.* London: Victor Gollancz Ltd., 1934.

Kates, George Norbert. *The Years That Were Fat.* Cambridge, Massachusetts: MIT Press, 1976. Originally published by Harper and Brothers in 1952.

Kent, Richard K. "Depictions of the Guardians of the Law: Lohan Painting in China." In Marsha Weidner, ed. *Latter Days of the Law: images of Chinese 850–1850.* Lawrence, Kansas: Spencer Museum of Art, University of Kansas, and Honolulu: University of Hawaii Press, 1994.

Ledderose, Lothar. "The Earthly Paradise: Religious Elements in Chinese Landscape Art." In Susan Bush and Christian Murck, eds. *Theories of the Arts in China.* Princeton, New Jersey: Princeton University Press, 1983.

Liu Chang 刘暢, Wang Shiwei, and Zhang Shuxian. *Qianlong jiazhen: Gugong Ningshougong huayuan yanjiu yu wenwu baohu guihua* 乾隆家珍 故宫宁寿宫花园研究与文物保護規划 *Qianlong's Collector's [sic]: The Study & Master Conservation Plan for Ningshou Gong Garden of the Palace Museum.* Meiguo shijie jianzhu wenwu baohu jijinhui ziju, Guojia '985 gongcheng er qi,' Qinghua Daxue benke rencai peiyang jianshe xiangmu ziju (Sponsored by the World Monuments Fund and the Tsinghua University Architecture Department), unpub. manuscript.

Liu Chang 刘暢. *Shenxiu siyong: cong Yuanmingyuan neidan zhuanxiu yanjiu dao Beijing gongguan shi nei sheji* 慎修思永：从圆明园内檐装修研究到北京公館室內設計 *Shenxiu Siyong: From Study on Yuanming Yuan Interior Design to Design Practice for the Beijing Chateau.* Beijing: Tsinghua University Press, 2004.

Liu, Dunzhen. *Suzhou gudian yuanlin.* English ed. *Chinese Classical Gardens of Suzhou.* Trans. Chen Lixian, ed. Joseph Cho Wang. New York: McGraw-Hill, 1993.

Loehr, George. "Missionary Artists at the Manchu Court." *Transactions of the Oriental Ceramic Society* 34 (1962–63), pp. 51–67.

Lou Qingxi. *Chinese Gardens.* Trans. Zhang Lei and Yu Hong. Beijing: China International Press, 2003.

Makeham, John. "The Confucian Role of Names in Traditional Chinese Gardens." *Studies in the History of Gardens and Designed Landscapes: An International Quarterly* 18, 3 (Autumn 1998), pp. 187–210.

Malone, Carroll Brown. *History of the Peking Summer Palaces under the Ch'ing Dynasty.* New York: Paragon Book Reprint Corp., 1966.

Martin, Louis Aime. *Lettres édifiantes et curieuses concernant l'Asie, l'Afrique et l'Amérique.* Paris: Société du Panthéon Litteraire, 1843.

Naquin, Susan and Evelyn Sakakida Rawski. *Chinese Society in the Eighteenth Century.* New Haven and London: Yale University Press, 1987.

Nie Chongzheng. "Architectural Decoration in the Forbidden City: Trompe-l'oeil Murals in the Lodge of Retiring from Hard Work." *Orientations* 26, 7 (July–August 1995), pp. 51–55.

Oka Oji 岡大路. *Shina Kyuen Enrin Shiko* 支那宮苑園林史攷. Dairen: Manshu kenchiku kyokai, 1938.

Polo, Marco. *Marco Polo, the Travels.* Trans. Ronald Edward Latham. New York: Penguin Classics, 1958.

Purchas, Samuel. *Purchas His Pilgrimage or Relations of the World and the Religions Observed in All Ages and Places Discovered, from the Creation unto the Present.* London: Printed by William Stansby for Henry Fetherstone, 1617.

Qian Yun. *Classical Chinese Gardens.* Hong Kong: Joint Publishing, 1982.

Rawski, Evelyn Sakakida and Jessica Rawson, eds. *China – the Three Emperors, 1662–1795*. London: Royal Academy of Arts, 2005.

Rinaldi, Bianca Maria. *The "Chinese Garden in Good Taste": Jesuits and Europe's Knowledge of Chinese Flora and Art of the Garden in the 17th and 18th Centuries*. Munich: Meidenbauer, 2006.

Schafer, Edward H. "Hunting Parks and Animal Enclosures in Ancient China." *Journal of the Economic and Social History of the Orient* 11, 3 (October 1968), pp. 318–43.

Screech, Timon. *The Lens within the Heart: The Western Scientific Gaze and Popular Imagery in Later Edo Japan*. Honolulu: University of Hawaii Press, 2002.

Scott, Mary. "The Image of the Garden in Jin Ping Mei and Hongloumeng." *Chinese Literature: Essays, Articles, Reviews (CLEAR)* 8, 1/2 (July 1986), pp. 83–94.

Sekino Tadashi. *Summer Palace and Lama Temples in Jehol*. Tokyo: Kokusai bunka shinkokai, 1935.

Sekino Tadashi and Takuichi Takeshima. *Nekka Jehol The Most Glorious & Monumental Relics in Manchoukuo*. Tokyo: Tokyo Institute, Academy of Oriental Culture, 1934.

Shi Nai'an. *The Plum in the Golden Vase or, Chin P'ing Mei*. Trans. David Tod Roy. Princeton, New Jersey: Princeton University Press, 1993.

Sirén, Osvald. *China and Gardens of Europe of the Eighteenth Century*. New York: Ronald Press Co., 1950.

———. *Gardens of China*. New York: Ronald Press Co., 1949.

Strassberg, Richard. "War and Peace: Four Intercultural Landscapes." In Marcia Reed and Paola Demattè, eds. *China on Paper: European and Chinese Works from the Late Sixteenth to the Early Nineteenth Century*. Los Angeles: Getty Research Institute, 2007.

Stuart, Jan and Evelyn Sakakida Rawski. *Worshiping the Ancestors: Chinese Commemorative Portraits*. Washington, D.C.: Freer Gallery of Art, 2001.

Thiriez, Régine. *Barbarian Lens: Western Photographers of the Qianlong Emperor's European Palaces*. Amsterdam: Gordon and Breach, 1998.

Van Hecken, J. L. and W.A. Grootaers. "The Half Acre Garden." *Monumenta Serica* 18 (1959), pp. 360–87.

Waley-Cohen, Johanna. "China and Western Technology in the Late Eighteenth Century." *American Historical Review* 98, 5 (December 1993), pp. 1525–44.

Wang Yi. "Interior Display and Its Relation to External Spaces in Traditional Chinese Gardens." *Studies in the History of Gardens and Designed Landscapes* 18, 3 (1998), pp. 232–47.

Wong Young-tsu. *A Paradise Lost: the Imperial Garden Yuanming Yuan*. Honolulu: University of Hawaii Press, 2001.

Wu Hung. *The Double Screen: Medium and Representation in Chinese Painting*. Chicago: University of Chicago Press, 1996.

———. "Emperor's Masquerade – Costume Portraits of Yongzheng and Qianlong," *Orientations* 26, 7 (July–August 1995), pp. 25–41.

Yang Hongxun. *The Classical Gardens of China: History and Design Techniques*. Trans. Wang Huimin. New York: Van Nostrand Reinhold Co., 1982.

Yi, Jeannie Jinsheng. *The Dream of the Red Chamber: an Allegory of Love*. Paramus: Homa & Sekey Books, 2004.

Zhang Hongxing. *Qianlong: Treasures from the Forbidden City*. Edinburgh: National Museum of Scotland, 2002.

Chinese Language Sources
Beijing Shi wenwu yanjiusuo 北京市文物研究所. *Yuanmingyuan Changchunyuan Hanjingtang yizhi fajue baogao* 圓明园長春园含經堂遺址發掘報告 (Excavation Report of the Ruins of the Hanjing Studio at Changchunyuan in Yuanmingyuan). Beijing: Wenwu chubanshe, 2006.

Beijing Shi gudai jianzhu yanjiusuo 北京市古代建筑研究所. *Jiamo Qianlong Jingcheng Quantu* 加摹乾隆京城全圖 (Complete Map of the Qianlong Capital City Reproduced). Beijing: Yanshan Chubanshe, 1996.

Cao Xueqin 曹雪芹. *Hong lou meng* 紅樓夢 (The Dream of the Red Chamber). Changchun: Jilin renmin chubanshe, 2006.

Chen Zhi 陳植, Chen Congzhou, Yang Bochang, and Ji Cheng. *Yuan ye zhu shi* 園冶注釋 (The Craft of Gardens – Annotated). Beijing: Zhongguo jianzhu gongye chubanshe, 1988.

Chengde Shi (China) and Wen wu ju, ed. *Qing di yu Bishu shanzhuang* 清帝与避暑山庄 *The Qing Emperors and the Chengde Mountain Resort*. Beijing: Zhongguo lüyou chubanshe, 2003.

Du Zhengxian 杜正賢. *Hangzhou Kongmiao* 杭州孔廟 (The Hangzhou Confucian Temple). Hangzhou: Xiling yinshe chubanshe, 2008.

Duan Yong 段勇. *Qianlong 'Simei' yu 'Sanyou'* 乾隆「四美」与「三友」(Qianlong's "Four Beauties" and "Three Friends"). Beijing: Zijincheng chubanshe, 2008.

Feng Jiankui 馮建逵 and Tan Li. *Qingdai neiting gongyuan* 清代內廷宮苑 *Gardens in the Forbidden City*. Tianjin: Tianjin daxue chubanshe, 1986.

Fu Lianzhong 傅連仲. "Qianlong huayuan diandi 乾隆花园点滴 (A Little Bit of the Qianlong Garden)." *Gugong bowuyuan yuankan* 故宮博物院院刊 *Palace Museum Journal* 4, 11 (1980), pp. 92–94.

Gao Jin 高晉. *Nan xun shengdian* 南巡盛典 (Record of the Southern Imperial Tours). Biji xiaoshuo daguan. Taibei: Xinxing shuju, 1988.

Gaozong 高宗 [The Qianlong Emperor]. *Leshantang quanji dingben* 樂善堂全集定本 (Complete Collection of Works from the Leshan Studio). Beijing: Neifu, 1758.

———. *Qing Gaozong yuzhishi. di wu ce.* 清高宗御製詩 (Imperial Poems by Gaozong of the Qing). Haikou: Hainan chubanshe, 2000.

———. *Yuzhi Yuanmingyuan tu shi* 御製圓明園圖詩 (Imperial Poems on Pictures of Yuanmingyuan). Tianjin: Shiyin shuwu, 1887.

———. *Yuzhishi chuji* 御製詩初集 (First Collection of Imperial Poems). Bejing: Neifu, 1749.

———. *Yuzhishi wuji* 御製詩五集 (Five Collections of Imperial Poems). Beijing: Neifu, 1795.

Guan Huashan 關華山. *<Hongloumeng> zhong de jianzhu yu yuanlin* <《紅樓夢》中的建築与园林 (Architecture and Gardens in *The Dream of the Red Chamber*). Tianjin: Baihua wenyi chubanshe, 2008.

Ji Cheng 計成, introduction by Chen Zhi. *Yuan ye* 園冶 (The Craft of Gardens). Beijing: Chengshi jianshe chubanshe, 1957.

Juanqin Studio Work Group. "Juanqinzhai baohu gongzuo jieduan baogao 倦勤齋保護工作階段報告 Report on Work Stages in the Preservation of Juanqin Studio." *Gugong bowuyuan yuankan* 故宮博物院院刊 *Palace Museum Journal* 1, 111 (2004), pp. 72–90.

Li Fumin 李福敏. "Guanyu 'Juanqinzhai chenshe dang' de jidian renshi 關於《倦勤齋陳設檔》的几点認識 Regarding When We Became Aware of the 'Juanqin Zhai Furnishings Report.'" *Gugong bowuyuan yuankan* 故宮博物院院刊 *Palace Museum Journal* 2, 112 (2004).

———. "Gugong 'Juanqinzhai chenshe dang' zhi yi <故宮《倦勤齋陳設檔》之一> Palace Museum's 'Juanqin Studio Furnishings Report' Number One." *Gugong bowuyuan yuankan* 故宮博物院院刊 *Palace Museum Journal* 2, 112 (2004).

Li Yu 李漁 and Wang Gai. *Jieziyuan huazhuan* 芥子園畫傳 (Mustard Seed Garden Painting Manual). Nanjing: Jieziyuan shengguan, 1701.

Liu Chang 刘暢. "Qingdai gongting heyuan you zhong de shinei xitai shu lue 清代宮廷和苑囿中的室內戲台述略 An Outlined Discussion of the Enclosed Theater in the Heyuan Garden of the Qing Palace." *Gugong bowuyuan yuankan* 故宮博物院院刊 *Palace Museum Journal* 2, 106 (2003), pp. 80–87.

Liu Chang 刘暢, Zhao Wenwen, and Jiang Zhang. "Cong Banmuyuan dao Juanqinzhai 从半畝园到倦勤齋 From Half-Acre Garden to Studio of Exhaustion from Diligent Service." *Zijincheng* 4, 171 (2009), pp. 30–37.

Luo Wenhua 羅文華."Qing gong liupin folou moshi de xingcheng 清宫六品佛樓模式的形成 The Formation of the Style of the Building for Worshiping Buddhas in Six Ranks in the Qing Court." *Gugong bowuyuan yuankan* 故宫博物院院刊 *Palace Museum Journal* 4, 90 (2000), pp. 64–79.

Luo Zhewen 羅哲文. *Zhongguo gu yuanlin* 中国古园林 (China's Ancient Gardens). Beijing: Zhongguo jianzhu gongye chubanshe, 1999.

Maqi 馬齊. *Qing Shengzu shilu xuanji* 清聖祖實錄選輯 (Veritable Records of the Reign of Qing Shengzu). Taiwan wenxian congkan, di 165 zhong. Taibei: Taiwan yinhang, 1963.

Miao Bulin 繆步林. "Qianlong yu Shizilin 乾隆与獅子林 (Qianlong and Shizilin)." *Urban Construction Archives* 3 (2003).

Nie Chongzheng 聶崇正. "Zai Tan Lang Shining de 'Ping An Chun Xin tu' Zhou 再談郎世宁的《平安春信圖》軸 (Speaking Again of Castiglione's Scroll 'Spring's Message of Peace.')." *Zijincheng Magazine* 162 (2008), pp. 162–69.

———. *Qing gong huihua yu "xihua dongjian"* 清宫繪画与「西画東漸」(Qing court painting and "Western" paintings' influence on the East). Beijing: Zijincheng chubanshe, 2008.

———. "Gugong Juanqinzhai tianding hua, quanjing hua tanjiu 故宫倦勤齋天頂画、全景画探究" (An Investigation into the Ceiling Painting and Panoramas at the Palace Museum's Studio of Exhaustion from Diligent Service). In Quyu yu wangluo guoji xueshu yanjiu yantaohui lunwenji bianji weiyuanhui 區域與網絡國際學術研討會論文集編輯委員會, and Guoli Taiwan daxue 國立臺灣大學, eds. *Quyu yu wangluo: jin qian nian lai Zhongguo meishushi yanjiu guoji xue shu yantao huilun wenji* 區域與網絡：近千年來中國美術史研究國際學術研討會論文集. Taibei: Guoli Taiwan daxue yishushi yanjiusuo, 2001.

Qinggui 慶桂. *Qing Gaozong shilu xuanji* 清高宗實錄選輯 (Veritable Records of the Reign of Qing Gaozong). Taiwan wenxian congkan, vol. 186. Taibei: Taiwan yinhang, 1964.

Shen Yuan 沈源, Tang Dai, and Wang Youdun. *Yuanmingyuan sishi jing tuyong* 圓明园四十景圖咏 (Pictures and Poems on the Forty Vistas in Yuanmingyuan). Beijing: Shijie tushu chuban gongsi, 2005.

Xu Qixian 徐啟憲 and Zhao Nanquan. "'Dayu zhi shui tu' Yushan《大禹治水圖》玉山 Yushan's Diagram of Yu the Great Controlling the Waters." *Gugong bowuyuan yuankan* 故宫博物院院刊 *Palace Museum Journal* 4, 10 (1980), pp. 62–65.

Xu Yilin 許以林. "Ningshou gong de huayuan tingyuan 寧壽宫的花园庭院 The Garden Courtyards of Ning Shou Gong Palace of the Imperial Palace." *Gugong bowuyuan yuankan* 故宫博物院院刊 *Palace Museum Journal* 1, 35 (1987), pp. 70–80.

Wan Yi 万依. "Qianlong huayuan de yuanyou 乾隆花园的园囿 Gardens and Animal Enclosures in the Reign of Qianlong." *Gugong bowuyuan yuankan* 故宫博物院院刊 *Palace Museum Journal* 2, 24 (1984) pp. 13–20.

Wang Duo 王鐸. *Zhongguo gudai yuanyuan yu wenhua* 中国古代苑园与文化 *Chinese Ancient Gardens and Its Culture*. Wuhan: Hubei jiaoyu chubanshe, 2003.

Wang Ting 王頲. *Hui yuan kuasheng-zaoqi de Shizilin ji xiangguan shi, hua* 會園誇勝 – 早期的"獅子林"及相關詩、畫 (Painted Garden Tributes, Poems and Paintings Relating to the Lion's Grove from Later Yuan and Early Ming). Shanghai: Shanghai Academy of Social Sciences, May 29, 2006. Online at www.sass.org.cn/eWebEditor/UploadFile/.../20060626095927850.pdf.

Wang Wei 王維. *Wang Youcheng ji jian zhu* 王右丞集箋注 (Annotated Collection of Wang Youcheng). Shanghai: Guji chubanshe, 1961.

Wang Zilin 王子林. *Zijincheng yuanzhuang yu yuanchuang* 紫禁城原狀与原創 (The Forbidden City Origins and Originality). Beijing: Zijincheng chubanshe, 2007.

Wei Jiazan 魏嘉瓚. *Suzhou gudian yuanlin shi* 蘇州古典园林史 (History of Classical Gardens of Suzhou). Shanghai: Sanlian shudian, 2005.

Wen Zhenheng 文震亨, annotated by Chen Zhi. *Zhang Wu Zhi Jiaozhu* 長物志校注 (Superfluous Things – Annotated). Jiangsu: Kexue jishu chubanshe, 1984.

Xiaoxiaosheng 笑笑生. *Jin ping mei* 金瓶梅 (The Plum in the Golden Vase). Taibei: Wenhua tu shugong si, 1979.

Yao Yuanzhi 姚元之. *Zhuye ting zaji* 竹葉亭雜記 (Miscellaneous Notes from the Bamboo Leaf Pavilion). Taibei: Guangwen shuju, 1969.

Yu Zhuoyun 于倬云. *Gugong jianzhu tudian* 故宮建筑圖典 *Architecture of the Forbidden City*. Beijing: Zijincheng chubanshe, 2007.

Yu Zhuoyun 于倬云 and Fu Lianxing. "Qianlong huayuan de zao yuan yishu 乾隆花园的造园藝術 Layout of Qianlong Garden." *Gugong bowuyuan yuankan* 故宮博物院院刊 *Palace Museum Journal* 3, 3 (1980), pp. 3–11.

Yuanming cang sang 圓明滄桑 (Great Changes at Yuanming). Beijing: Wenhua yishu chubanshe, 1991.

Zhang Jiaji 張家驥. *Zhongguo zaoyuan yishu shi* 中国造园艺术史 (A History of the Art of Making Chinese Gardens). Taiyuan: Shanxi renmin chubanshe, 2004.

Zhang Jiaji 張家驥 and Ji Cheng. *Yuan ye quan shi: shijie zui gu zao yuan xue mingzhu yanjiu* 园冶全釋：世界最古造园學名著研究 ("Craft of Gardens" Complete Explication: A Study of the World's Most Ancient Garden Manual Masterpiece). Taiyuan: Shanxi guji chubanshe, 1993.

Zhang Shuxian 張淑贤. "Juanqinzhai jianzhu luekao 倦勤齋建筑略考 A Brief Study of Juanqinzhai's Architecture." *Gugong bowuyuan yuankan* 故宮博物院院刊 *Palace Museum Journal* 3, 107 (2003), pp. 53–61.

Zhao Guanghua 趙光華. " Xishangting zhi 'xi' yuanliu xiao kao 禊賞亭之'禊' 源流小考 'A Brief Examination of the Origin of 'xi' in Xishangting." *Gugong bowuyuan yuankan* 故宮博物院院刊 *Palace Museum Journal* 3, 5 (1979) pp. 69–71.

Zhaolian 昭槤. *Xiaoting xulu* 嘯亭續錄 (Further Notes from the Whistling Pavilion). Jindai Zhongguo shiliao congkan, 63. Taibei: Wenhai chubanshe, 1967.

Zhu Jiajin 朱家溍. *Ming Qing shinei chenshe* 明清室內陳設 (Room Interior Furnishings of the Ming and Qing Dynasties). Beijing: Zijincheng chubanshe, 2004.

Zou Yigui 鄒一桂. *Xiaoshan huapu [2 juan]* 小山畫譜 [2卷] (Xiaoshan Painting Manual, 2 vols.). Congshu jicheng chubian. Shanghai: Shangwuyin shuguan, 1937.

Index

Page numbers in *italics* refer to illustrations.

Photography Credits

All plates, checklist images, and atmospheric images of the Qianlong Garden, Forbidden City, © Palace Museum unless otherwise noted.

Pages 17, 23, 48–49, 70–74, 89: Nancy Berliner, courtesy of the Palace Museum. Pages 24–25: with appreciation, based on a drawing by Chiu Kwong Chiu, Design and Cultural Studies Workshop, Hong Kong. Pages 195–97: Jia Yue for the World Monuments Fund, courtesy of the Palace Museum. Pages 214–15: Dennis Helmar, courtesy of the Palace Museum.

Introduction
Figure 2: © Peabody Essex Museum, Photograph by Walter Silver; Figure 4: © Peabody Essex Museum, Photograph by Jeffrey R. Dykes.

Chapter I
Figures 2, 9, 11: Nancy Berliner, courtesy of the Palace Museum; Figures 3, 12, 15, 16: © Peabody Essex Museum, Photograph by Walter Silver; Figure 5: Image courtesy of the Digital Scrolling Paintings Project, Center for the Art of East Asia, University of Chicago; Figures 8, 10, 14: © Peabody Essex Museum.

Chapter II
Figure 1: Palace Museum; Figure 5: © Peabody Essex Museum, Photograph by Jeffrey R. Dykes; Figures 7, 8: © Peabody Essex Museum, Photograph by Walter Silver.

Chapter III
Figure 1: with appreciation, based on a map courtesy of the Palace Museum and World Monuments Fund; Figures 2, 4, 7,10, 16, 18, 19, Plate 22: Nancy Berliner, courtesy of the Palace Museum; Figures 3, 5, 6, 9, 11, 17, 20, 21, 25 – 31: Palace Museum; Figures 8, 15: Jia Yue for the World Monuments Fund, courtesy of the Palace Museum; Figures 22, 23: © Peabody Essex Museum, Photograph by Jeffrey R. Dykes.

Coda
Figures 1, 7, 11: Jia Yue for the World Monuments Fund, courtesy of the Palace Museum; Figures 2, 3: Palace Museum; Figures 4, 5: © President & Fellows of Harvard College; Figure 6: © Peabody Essex Museum, Photograph by Jeffrey R. Dykes; Figures 8, 9: Nancy Berliner, courtesy of the Palace Museum.

Catalogue of the Exhibition
Catalogue 5: Jia Yue for the World Monuments Fund, courtesy of the Palace Museum; Catalogue 8, 9: Nancy Berliner, courtesy of the Palace Museum.

Coordinated and edited by Terry Ann R. Neff,
t. a. neff associates, inc., Tucson, Arizona

Designed and produced by Studio Blue, Chicago
Typeset in Quadraat
Printed by Conti Tipocolor, Italy,
on 150 gsm matt art Burgo R400 vs
Color separations by ProGraphics, Rockford, Illinois

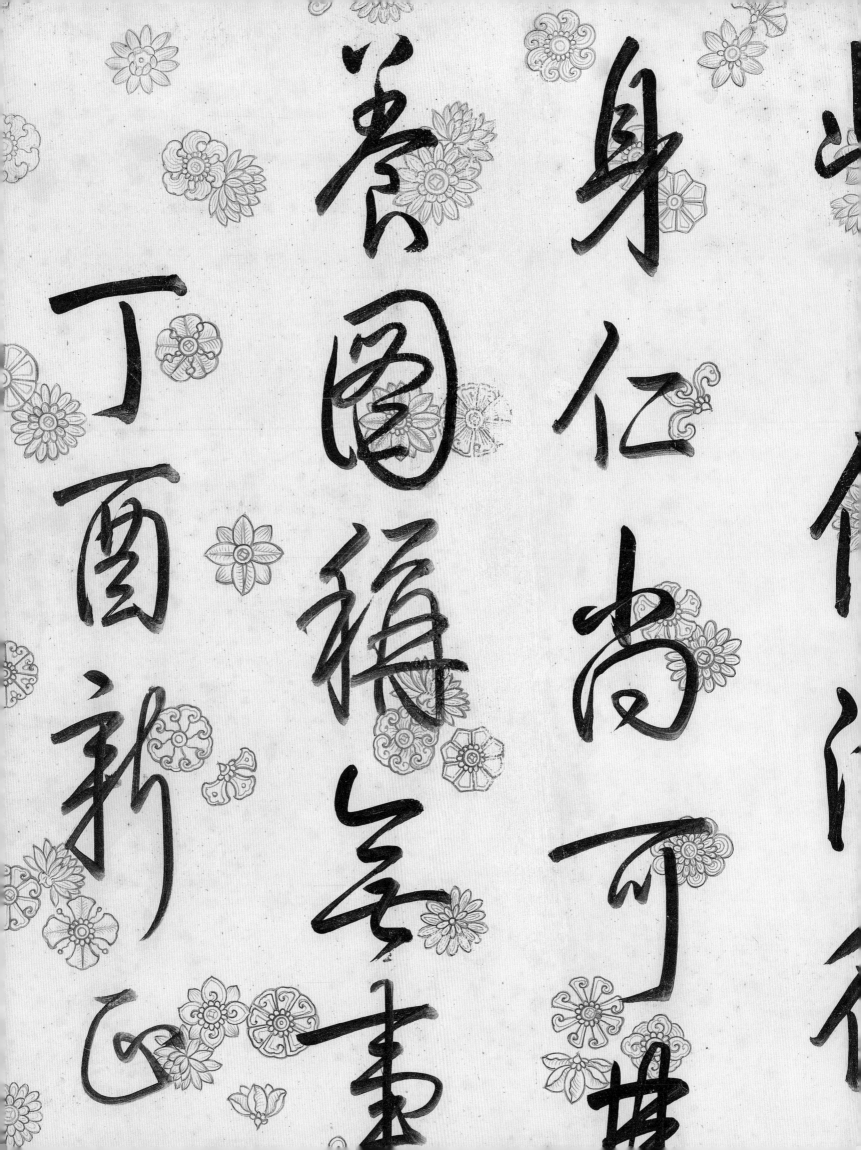